The States of "Theory"

IRVINE STUDIES IN THE HUMANITIES
Robert Folkenflik, General Editor

Irvine Studies in the Humanities Volumes

THE STATES
OF "THEORY"
HISTORY, ART, AND
CRITICAL DISCOURSE

Edited and with an introduction
by David Carroll

Columbia University Press New York

COLUMBIA UNIVERSITY PRESS
NEW YORK OXFORD
Copyright © 1990 Columbia University Press
All rights reserved

Library of Congress Cataloging-in-Publication Data

The States of 'theory' : history, art, and critical discourse / edited
 and with an introduction by David Carroll.
 p. cm.—(Irvine studies in the humanities)
 Includes bibliographical references.
 ISBN 0-231-07086-1
 1. Aesthetics, Modern—20th century. 2. Art—Historiography.
 I. Carroll, David, 1944– . II. Series.
 BH201.S58 1990 89-22090
 001.3—dc20 CIP

Casebound editions of Columbia University Press books are Smyth-sewn
and printed on permanent and durable acid-free paper
∞

Printed in the United States of America

c 10 9 8 7 6 5 4 3 2 1

A NOTE ON THIS SERIES

This is the fourth in a series of volumes published by Columbia University Press on topics in the Humanities. This volume originated in lectures and colloquia organized by the Critical Theory Institute at the University of California, Irvine. The Critical Theory group wishes to thank Anne Tomiche for her translation of the Derrida essay and for her work in copyediting and proofreading.

For help with a broad range of problems, I am indebted to the board of Irvine Studies in the Humanities, especially Ellen Burt. I am grateful to Dean Terence D. Parsons of the School of Humanities and former Executive Vice-Chancellor William J. Lillyman for their support. Jean Symonds and Carol A. Giangola provided secretarial help for Irvine Studies. These volumes are published in conjunction with the Wellek Lectures, given annually through the Critical Theory Institute at the University.

<div style="text-align: right">Robert Folkenflik, General Editor</div>

CONTENTS

The States of "Theory"

INTRODUCTION: THE STATES OF "THEORY" AND THE FUTURE OF HISTORY AND ART

David Carroll

> The idea of a destination or final end
> is a covert form of social control.
> —Theodor Adorno,
> *Aesthetic Theory*

SOME WOULD like to blame "theory" for everything that they consider wrong in the contemporary state of the arts, the humanities, and the social sciences. If there is among certain art historians less interest in connoisseurship, less respect for the canonical history and the modes of descriptive criticism associated with traditional art works, if there is an ever-increasing interest in philosophical, sociological, and semiotic strategies of analysis, an emphasis on the relationship between the art work and other modes of production or creation, an interest in anti-art, fringe art, and the nonaesthetic or extra-aesthetic aspects of art—it must be the fault of "theory." If there is to be found among a small but growing number of historians a tendency to reject the neutrality or objectivity of historical data, if there is growing concern with the form of historical narrative as a fundamental component and even limitation of history writing, if the very grounds of history are more and more being questioned and techniques of analysis more and more borrowed from other fields—"theory" must be at

fault. If the study of literature has become too philosophical, rhetorical, or political, if an important number of literary critics no longer see the literary text as an integral, self-sufficient organic unity and challenge the neutrality of "close reading" or *explication de texte*, if they seek to challenge the traditional foundations and values of the study of literature and complicate its links with various nonliterary contexts—the fault must be with "theory." And finally, if the disciplines can no longer be easily and conclusively distinguished one from the other—this too must be the fault of "theory." If all of these phenomena are considered to be ailments, weaknesses, even evils, then the solution to the growing crises in the various disciplines is self-evident: attack and do away with "theory" in order to restore the simplicity, integrity, truth, or health of each of the fields and that of the "human sciences" in general.

But what is this strange thing called "theory" that seems to be the source of so many problems in so many different disciplines and that appears to provoke such violent reactions? What has it actually done to provoke such reactions, and is the bad reputation it has in the eyes of many in any way deserved? Most important, are the changes it has helped bring about really to be denounced, and should they be, can they be reversed? What is at stake in these questions is the future: not just the future of the various disciplines and the research done within them, but a certain relation to the possibility of (necessity for) movement, reevaluation, transformation in general, the future not as the logical outgrowth of the past and present but as the indication of and relation to what has not been anticipated or programmed.

Responses to polemical attacks made "against theory" have often been overly defensive and taken on in the name of theory the very strategies of enclosure, exclusion, and repression that theory in its critical form should confront and argue against. But it is undoubtedly time to move beyond polemics and get on with the difficult task of keeping theory an active, critical endeavor (or making it one, if it is not already). Critical theory—in the general sense in which this term is used today rather than in the specific sense given to it by the Frankfurt School—could then rightfully be considered to designate a diversified and open field in which

certain kinds of questions are raised that are not raised elsewhere, or at least, that are not pursued elsewhere with the same concern for their complexity and their implications.

Doing theory in this sense would mean *raising theoretical questions*—questions that are theoretical in nature and that are also about theory, its presuppositions, its critical effects, its limitations, and, above all, its possibilities. The best forms of theory could be said to imply a critical practice that does not seek to institute itself and its way of doing theory and thus exclude or dominate of all others. Rather, these forms of theory attempt to confront the unexamined aspects of the dominant critical strategies and analytical methods and to deal with the contradictions and complexities inherent in traditional questions. They seek to ask different kinds of questions or to ask questions in a different way, to make possible other forms of critical practice. Theory in this sense has the goal of keeping the critical process open, of undermining and exceeding the state of theory at any particular moment, as well as the states of the various fields and disciplines with which it intersects.

In its critical form at least, theory may be best described as the hybrid and open field in which the possibilities of the various disciplines and fields it crosses through and which cross through it are pursued and experimented with, where alternate critical practices are developed and tried out. It is where the assumptions, presuppositions, and limitations of the various fields and disciplines are analyzed, confronted, and exceeded, where "the given" or "the unquestioned' is never taken as determining. In this critical sense, theory should never be dogmatic or predetermined—which does not mean it should be without rigor or lacking in historical awareness—for the determination of the theory of any field or discipline and the modes of analysis derived from such predetermination are precisely the principal obstacles to the critical practice of theory. Above all, then, theory itself must remain in question in theoretical investigations; it is what is at stake in analysis but not what determines it.

In 1985, the theory group at Irvine completed a three-year research project on the problem of representation, published in this same series as *The Aims of Representation: Subject, Text,*

History, edited by Murray Krieger (New York: Columbia University Press, 1987). The group decided to devote the next three years to the problem of the transformation of the notion of the sign in contemporary criticism and theory and to how that transformation had affected the various disciplines of the humanities, the social sciences, and the university institution as a whole. In particular, the group decided to examine how the questioning and even the rejection of the "natural origin" of or model for the sign had disrupted and transformed research in the various fields.

But, as we soon found out, a project, no matter how focused, is one thing, and its realization another. The realization of the project is in fact the collection of essays that follows. As can already be seen from the title given to the collection, the problem of the sign, the loss of its "natural origin," and the institutional effect of this transformation of the role and function of discourse—though still evident in all of the essays and the principal focus of some— was itself transformed in the course of the conferences, seminars, and discussions devoted to it. Even though we had given no particular directions to the invited theorists (or to ourselves in our own discussions), by the middle of the second year it had become clear that two areas of concentration had emerged "on their own": the historical and the aesthetic. When we began planning the colloquium that was held in the spring of 1987, we decided not just to accept passively the focus that had now emerged in our research project but also to assist its emergence. The colloquium was in fact organized around the problems of history and art, with conferences and discussion sessions devoted to each, and the present volume had by that decision already been given its shape and, as it turns out, its title. The question of the nonnatural origin of the sign had thus become "The States of 'Theory,' " with a special emphasis given to the place of theories of discourse and language in the current rethinking of art and history.

The present volume represents a selection of essays from the three-year project (including a number from the colloquium) classified under the rubrics "The Question of History" and "The Question of Aesthetics." Neither of these two sections of the volume is self-sufficient or integral, however, The essays that directly address the question of art and literature also have to do

with the status of history in the aesthetic realm, with the historical implications of theories of art and literature, with both the specificity of art and the fundamental links between the aesthetic and the historical. Those essays that focus on history also have to do with art and literature, with the implications for history of narratology, discourse analysis or theories of textuality, with the overlapping of aesthetic, literary, and historical concerns in a movement such as the "new historicism" and other recent approaches to history and literature, with the role and status of art, literature, and even architecture in the questioning of the foundations and critical implications of history. In this sense, there are continuous exchanges among the essays not only within each section but also back and forth across the two sections of the collection, as a critical perspective on history leads to the question of art, a critical perspective on art leads to the question of history. Each question is in this way in question in the other. History and art thus come to be involved in the same critical-theoretical task of transforming not only their own *state* but the *state* of theory as well.

The colloquium organized in the spring of 1987 was ostensibly meant to mark the foundation of a Critical Theory Institute at Irvine. The title of "Institute" as well as its structure obviously presented serious problems for a *critical* theory group, for the formal, bureaucratic separation of theory from the fields and disciplines with which it has to interact to remain alive and critical and even the fact that theory was being given a privileged status and assigned *a state* within the university system of research units were signs of the normalization of theory. In other words, the Institute itself constituted a serious threat to the critical endeavors it was meant to foster by encouraging or demanding the foundation and establishment of a state of theory, necessitating definitive statements about what theory is and how it works and a general defense of theory to justify its own formation and support.

There is, of course, no way to avoid such contradictions, which are built into any critical project. The naive, utopian wish to be free of such institutional constraints, or the assertion that one is free of them, underestimates institutional effects and is usually

self-serving. Institutions are neither good nor evil in themselves; everything depends on how they function and what they do. Forced to face directly the fact of the Institute meant that one of the tasks imposed on us or that we would have to impose on ourselves was to be as vigilant as possible with regard to the stabilizing effects of our state or status as an institute, the tendency of all institutes to produce stasis rather than change, to promulgate closure and exclusion in defense of their own identity rather than encourage the openness and receptiveness to alterity and difference that makes theory truly critical.

This in part explains the quotation marks around "Theory" in the title of our colloquium and now in the title of this volume (see Jacques Derrida's essay in which he has much to say about his view of the critical sense of such marks). It was our way of saying, of reminding ourselves, that the thing to be instituted, to be made institutional, was not for us an already established, definable, determined concept but rather the complicated, heterogeneous, even contradictory object of our research, something whose systematization and institutionalization we had to approach critically and resist as much as possible. It might even be said, then, that the Critical Theory Institute has as its aim to remain as much as possible an "Institute" (in quotation marks) constantly *à la recherche de,* rather than having already found its not lost but perpetually to be reevaluated, even reinvented object, "theory."

This collection is heterogeneous in terms of the critical perspectives included in it, although it is far from being representative of all important contemporary perspectives and would make no claim to be so. Such heterogeneity has important critical effects precisely when it allows different and even opposed positions to overlap or intersect in their approaches to a problem, to come at the same issue in different ways and with different aims. At crucial moments, these intersections or overlappings concern precisely the complicated position or status of theory in a particular discipline or field and the difficulty of situating critical discourse in terms of its "object."

A heterogeneity of critical perspectives or the heterogeneity of a critical perspective also produces conflict and contradiction, a

clash of differing approaches, opinions, and implications. At its best, it is an indication of unresolved issues to be pursued and of a direction or a nondetermined "space" in which to pursue them. This kind of heterogeneity is thus not a simple pluralism, even if it is a manifestation of a certain form of plurality or multiplicity, for if it signifies and demands a respect of singularity and alterity, it does not assume or defend the peaceful coexistence of positions that are supposedly noncontradictory, self-sufficient or autonomous, each onto itself. Heterogeneity thrives on productive conflict but should resist the violence of polemics, which is rooted in the desire for homogeneity, the domination of the one over the others. Heterogeneity should imply that the different, the contradictory, even the opposed are in various kinds of relations to each other from the start and that these relations, conflictual as they often are, can also be productive.

For example, the first part of this collection, "The Question of History," opens with an essay by Carolyn Porter with the intriguing title "Are We Being Historical Yet?" Her answer at the end of her essay is "Not yet." The section concludes with an essay by Jean-Luc Nancy that comes at the issue of the possibility of "being historical" from what seems to be a radically different if not opposed perspective. For Nancy, history is not something that awaits us or that we must somehow achieve in the future. It is rather something that is behind us. "Our time is no longer the time of history," claims Nancy near the beginning of "Finite History"; for us, today, "history is past." Nancy's answer to Porter's question would therefore be the opposite of hers: not "not yet," but "no longer." But he would argue this not in order to posit a posthistorical age, whatever that would be, but to suggest the possibility of a "history" that continues beyond history and provokes thinking beyond "the Idea" regulating history.

In the case of both Porter and Nancy, therefore, the critical awareness that "we" are not *simply* historical or historical in any simple sense—whether it is because we are not yet historical or because we are no longer historical is only one aspect of the question—clears the way for a critical investigation of the possibility of history. Porter's critical "culturalist" position and Nancy's critical philosophical strategy thus intersect in terms of this

crucial issue. In the name of "history" that is not yet/no longer, each is responding in a different way to the demand for and the demands of history and to a very definite historical-political obligation to "be historical," which is perceived by each in very different terms.

There are other crucial moments when the two essays overlap on their way to responding to what I want to call the historical demand for history. Porter's essay is a detailed dialogue with and critique of the new historicism, and she argues that the major new historicists are not sufficiently critical of the assumptions and practices that characterize their approach to literature and history, of the kind of history serving as the model for their particular form of historicizing. Nancy addresses the problem of historicism in a general sense, in what could be called its "old" form, with no specific references to its "new" form in English Renaissance studies. But his critique intersects with Porter's in that he argues that historicism, whether old or new, presupposes history and does not analyze it critically, that it assigns a history to historicity and thus reduces its potential meaning and impact. Historicism for both, then, is not a way of "being historical" in the strongest or most critical sense but a way of limiting the historical to narratives, anecdotes, or some other form of a regulatory and determining process. "Are We Being Historical Yet?" No longer/not yet, always and in the future, no longer/not quite yet. In other words, the assumption or declaration that we "are now or are still being historical" is a sure sign that we are not yet/ no longer historical in a critical sense.

Near the end of Jacques Derrida's essay, which is in large part directed against the restrictive effects of the various "isms" in vogue today, he too addresses the question of historicism and reminds us of Husserl's critique, which he claims is still indispensable for his own approach to history, even though not sufficiently critical of its own assumptions and limitations. Any historicism that would ignore or not take seriously Husserl's critique of empiricisms, relativisms, and skepticisms would by that decision alone reveal itself to be strangely ahistorical in its claims to history or to being historical. Derrida argues that what he calls here the "deconstructive jetty" has always been motivated by a

concern with history, even if it constantly destabilizes the concepts of history that would absolutize it, empiricize it, or stabilize it in some other way. This entire essay could be read not just as a "defense" of a certain form of critical, destabilizing deconstruction (differentiated from though not opposed to deconstructionism as a theory or fixed set of reading strategies), but as an analysis of how theory, a certain critical practice of theory, can be historical, that is, open to history, receptive to the unexpected, the unforeseen, the unprogrammable—in other words, receptive to alterity and even to what he calls here "monstrous [as opposed to normal] monstrosities."

By referring to theories as jetties, as he does in his essay, rather than as positions, theorems, systems, ideologies, etc., Derrida stresses the way in which each theory that strives for dominance (to establish itself as a solid, founded, and self-protective position, or as a functioning system and thus a "stabilizing jetty") does so by incorporating and thus by being transformed, complicated, and destabilized to some extent, most often in spite of itself, by other theories (jetties). This creates a conflictual situation in which, when a theory is arguing against its other (Marxism or the new historicism, for instance, arguing against poststructuralism), it is at the same time arguing against an incorporated part of itself. Not only does this make it impossible to situate each theory in one place on a table or in an ordered historical sequence, it also makes it impossible to close off the field of theory as a whole.

All attempts to deal with the complicated historical dimension of such "theoretical jetties" by resorting to labels such as "new" or "post" necessarily come up short in their attempts to historicize what resists and exceeds historicization. The history of theory, or rather its *historicity*, is far too rich and complex for any form of historicism, new or old, to account for adequately. No jetty, however, the deconstructive jetty included, escapes having stabilizing effects, but Derrida here clearly insists that it is the destabilizing effects of the deconstructive jetty that give it its critical force and historical importance. This is why it is so difficult to turn the deconstructive process into just another object of theory, another moment of history, even if many of those who

have declared themselves to be either for or against deconstruc-
tion have attempted to do precisely that. "History" in this essay,
then, could be considered to be best "signaled" (Nancy's term) as
a certain resistance not to theory in general but to the establish-
ment of theoretical objects, to the construction of protective the-
oretical jetties, and finally to the delineation and stabilization of
theory and history in general.

Lynn Hunt, in "History Beyond Social Theory," addresses the
more specific disciplinary question of the history profession's
general hostility to theory, its reluctance to deal seriously with
anything that might challenge its claims to objectivity or question
the task of the "connoisseurship of documentary evidence" it
gives itself and in terms of which it defines itself. She first ana-
lyzes the fate of social theory in the 1960s as a paradigm for
history's general resistance to theory: at the start, social theory is
attacked as a threatening other, much too rooted in sociology and
one or all of a series of alien "isms" or "izations"—Marxism,
modernization, urbanization, etc.—to be admitted easily into the
historical profession. Then, in a second phase, it is gradually
incorporated into the discipline of history as a supportive, non-
threatening subdiscipline. The price for Hunt of this incorpora-
tion into history is precisely the "self-conscious theorizing" that
she claims is to be found in the work of the most important social
historians, at least for a time. As she puts it, "Positivistic empiri-
cism once again had gobbled up the newest forms of historical
inquiry, diverting them from the cutting edge of theoretical devel-
opment." In other words, the "success" of social history today is
precisely due to its having been what I would call "de-theorized"
and in many cases having, ironically, itself taken on the role of
defending the integrity of the historical profession against "alien
theories," often even attacking theory in general in order to stabi-
lize and protect the current *state* of history it has in large part
helped to define.

The main part of Hunt's essay addresses the current interest
among an important group of historians in cultural studies (here
her analysis intersects with Porter's in important ways). Hunt
analyzes the use of "discursive or literary models" by certain
cultural historians (especially Clifford Geertz) and the way once

again "the theoretical impetus" of this mode of interpretation "was lost in the crush to study cultural *topics*" when historians began applying anthropological discoveries and strategies of analysis to history. Hunt's essay demands that historians take seriously the challenge offered by discursive models of culture and pursue the new forms of historical investigation opened up by them, but this does not mean that they should accept without question narrative models, discursive strategies, or rhetorical-textual techniques of analysis developed in other disciplines— largely by critical philosophers and literary theorists and critics —which could lead or has already led, her essay implies, to the aestheticization or formalization of history. It does mean that historians have to be willing to risk suspending their belief in history and in the paradigms of conventional historical explanation in order to become more critical of the history they do in fact write. For Hunt, it seems clear that history will not develop critically if it continues to fear and resist theory, if it does not open itself to the possibilities offered by various "alien theories." In her view, critical history is the constant problematization of accepted theories and practices, the refusal to accept "things as they really were" or "things as they really are" for what they were or are. At stake in her essay also, then, is the future of history, the possibility of a "history" beyond history.

Claude Lefort focuses on Machiavelli's *Discourses* in order to raise the question of the limitations and possibilities of history. In his essay, as well as in Fredric Jameson's analysis of the work of the architect Frank Gehry, the problem of history is directly related to the theoretical-historical category of modernism (and, in Jameson's case, to that of postmodernism). Lefort returns to Machiavelli, an author he had already treated in *Le travail de l'oeuvre: Machiavel* (Paris: Gallimard, 1972), in order, I would say, to accomplish two principal tasks. The first is to study Machiavelli's treatment of the differences and connections between the ancient and modern worlds in order to situate better our own sense of "the modern." The second is to disassociate the most important critical historical-political contributions of Machiavelli from humanist discourse and, by doing so, suggest that humanism today still represents a serious limitation to historical and

political thinking, one that must be constantly confronted and undermined.

For Lefort, Machiavelli's entire work is opposed to the ideology of civic humanism, which was based on the ideal of harmony, stability, and moderation. Machiavelli shows, however, that civic humanism in fact masked the imposition of a new oligarchic order and the weakening of democratic relations. Through Machiavelli, Lefort argues for the irreducibly heterogeneous and conflictual substance of historical reality (and thus of any narrative or theory pretending to present, represent, or account in some other way for that reality). Conflict and division are not, he suggests, signs of the degradation of Being or of the historical-political sphere; they are rather "a source of endless questioning," indications to the political actor that he must accept "ultimate indeterminacy" when he judges or acts, incentives to the city (the body politic) for "historical creation." In Lefort's analysis, Machiavelli therefore becomes an important theoretician of the modern, a defender of a radical form of democracy rooted in fundamental differentiation, a writer whose "Discourses" are a model for a critical form of theoretical-historical investigation.

Fredric Jameson, in "Spatial Equivalents: Postmodern Architecture and the World System," focuses on the work of Frank Gehry and especially the house he rebuilt for himself in Santa Monica in 1979. The relation to history Jameson finds indicated in the complicated, heterogeneous space(s) Gehry's house comprises, the spaces constituting and deconstituting it, could be taken in this context as a possible critical response to the chaos and oppression of the "world system," a "material statement" about the very possibility of historical existence in or as this chaos.

At one moment, Jameson seems to characterize the postmodernism in question in his essay and suggested by Gehry's house negatively, in terms of the "messiness of a dispersed and fragmented existence, . . . the sixties gone toxic, a whole historical and countercultural 'bad trip' in which psychic fragmentation is raised to a qualitatively new power, the structural distraction of the decentered subject now promoted to the very motor and existential logic of late capitalism itself." In such a generalized "mes-

siness of an environment . . . things and people no longer find their 'place.' " But in general, throughout his essay—and this, I feel, could be considered an indication of an important transformation that has been visible in Jameson's approach to postmodernism in recent years—important elements of the "messiness" of the structure of the house are characterized as representing a "revolutionary spatiality," a "radically new spatiality beyond the traditional and the modern alike," perhaps, he suggests, even "opening up historically new and original ways of living—and generating so to speak a new Utopian spatial language." In other words, what is revolutionary—that is, profoundly historical—is to find ways to live historically in this messiness, or to live this messiness in some new, unimagined way *as history*—that is, as an opening to the future.

Jameson focuses on Gehry's "meditation" on the problem of space, and especially on the way he works to efface or rearrange the categories of inside and outside, that is, to bring the inside out and the outside in. The remains of the old house persist in the new, as if history and the past related to the new "as a content which could be seen through the newer elements," but, I would add, whose relation to the new is tenuous and/or ambiguous, a relation of conflict, heterogeneity, nonrelation. As Jameson admits, the new "hyperspace" does not resolve the clash of spaces and times constituting it but rather consists of the ambiguities created by this clash. The spaces are and remain incommensurable. In this context, the modernist aesthetic is "meaningless"; the "Utopia of a renewal of perception has no place to go." At the same time, no new aesthetic has effectively replaced it. In fact, it could be argued that there really is no aesthetic of the postmodern, because postmodernism is always the interruption in or postponement of an aesthetic rather than its projection, application, or realization.

Ultimately, the historical sense of the postmodern and the postmodern sense of history are to be found in incommensurability, in an incommensurability that eludes representation and which must nonetheless still be thought (i.e., presented in its incommensurability). For Jameson, this incommensurability of space parallels the incommensurability of a "world system" in which

unimaginable wealth and unbearable poverty, the increasingly rapid development of technology and misery, and the exaggerated abstraction of power and concretization of misery all go hand and hand. Jameson's essay is thus an attempt to think (with Gehry) the unrepresentable as postmodern history and to attribute to elements of postmodernism an important critical, even revolutionary historical function. The postmodern, then, could in this sense be considered to be the attempt to live this "messiness" or conflictual and unrepresentable heterogeneity as the possibility of a radically other, less oppressive, but not yet/no longer imaginable future.

If it can be said that the demand to "be historical" in these essays is rooted in the double awareness that we are not yet/no longer historical in any traditional or modern sense, something similar might be said about art and the aesthetic in terms of the essays in the second part of the collection. If there is a common assumption shared by these diverse essays, it would seem to be an extremely limited one: that the aesthetic, like the historical, cannot be taken for granted. Contemporary art—and a certain form of critical theory—at the very least forces us to acknowledge that the very foundations of art have been shaken in the last century and that we cannot assume any longer, if we ever could, that we really know what art is or what its future will be. Like history, art is a question (and in question) rather than a given, and theory is thus an important way of pursuing the implications of the question(ing) of art.

One can sense that each of the essays in this section in its own way attempts to challenge the state and function of traditional art and aesthetics and point to the possibilities not only of other forms of art but of other forms of theory as well. Rosalind Krauss, in "The Blink of an Eye," opens this section by challenging what could be considered the most fundamental assumption of traditional art history and criticism: the neutrality and integrity of the eye of the "ideal" viewer of art (the eye of the connoisseur), totally receptive to the presence of the painting it stares at with undivided attention. What makes such an "eye" possible in the first place is the unquestioned assumption that the "domain of painting is that of the natural sign," thus making painting "im-

mune to all those analyses that depend on the sign as conventional, arbitrary, constructed." This "eye" is, therefore, art history's most valuable and visible defense against theory, its primary line of resistance against all philosophical, linguistic, rhetorical, or discursive strategies of interpretation that would complicate, differentiate, and defer the presence of the painting to this eye (or the integrity and unity of the eye before the painting).

Krauss focuses her analysis on Marcel Duchamp's experiments with the transformation of the field of painting, that is, with the transformation of "both the visual field itself, and the field—art history—that attempts to account for the intelligibility of the field of vision." For her, such a transformation of the field has to occur, if theory (here specifically "deconstruction") is to be more than just another form of thematics. Another way of saying this might be that the need or demand for theory emerges as much from transformations and challenges *within* the field and history of painting itself, from the uncertainty of the nature and limits of the field and of history, as it does from *outside* the field. Duchamp represents for her a crucial moment in this critical process, for his is a critique of "the whole system of the visual . . . put into place by mainstream modernism," a critique which is based largely on his objection to the "stopping of the analytic process at the retina, the making of the interactions between the nerve endings . . . a kind of self-sufficient or autonomous realm of activity." Krauss' analysis is a powerful attempt to push vision (and therefore art criticism) beyond the retina and into the body, that is, "to capture the effect of this projection of desire into the field of vision." It is nothing less than an attempt to make art criticism and history respond and be receptive to the very transformations in their "object" that they resist most strenuously, to transform the state of art history from the obituary of an art that is no longer to the critical rethinking of the possibilities of forms of art that are not yet.

In "The Aesthetic and the Imaginary," Wolfgang Iser also challenges the integrity, autonomy, and self-sufficiency of the aesthetic realm by showing how throughout its history it has been linked to the imaginary; how it can rightfully, therefore, be considered the "offshoot" of the imaginary. He argues that whether

the imaginary is considered primarily as a faculty (from Aristotle through Kant to the Romantics), a creative activity (Sartre) or an "Urfantasy" (Gehlen), it is in each case "marked by a split. . . . Thus the imaginary is not a self-activating potential, and it would not become operative without its being split. The split highlights an interaction." It is this interaction with "otherness" that Iser characterizes as the aesthetic, an in-between state of "wavering," "possibilizing," and "play-movement," unstable, transient, transformative. Krauss' "blink of the eye" becomes in Iser the fundamental split in the imaginary itself—it is only the eye that represses its own blindspots by being fixed on form as an accomplished, unified entity that misses or represses this split and in this way misses or seriously reduces the aesthetic itself by making it a *state* rather than an *activity*.

Iser argues that it was Adorno who among contemporary theorists perhaps best captured the divided or differentiating aspect of the aesthetic when he argued that "a genuine work of art . . . is permeated by a basic rift." This rift or incompleteness of form gives to the aesthetic its performative, dynamic qualities: "The aesthetic dimension as a generative matrix operative in [a] painting . . . prevents the figment from turning into a perceivable object." He then argues that such constant overturning and toppling is characteristic of the literary text as well as the painting, and in the former it is called play. Play is defined as "a particular gestalt of the aesthetic." As such, it "comprises the coexistence of what is mutually exclusive, and it is able to do so because it is not subjugated to any definite pragmatic end." The aesthetic is thus equated with the nonteleological, and the end of the aesthetic is postulated as being neither in itself nor outside itself but in the constant play between the aesthetic and the extra-aesthetic.

It could be concluded, then, that no matter how vigorously certain philosophical traditions have attempted to postulate the integrity and autonomy of art, the "aesthetic" in a critical sense is never a field or state onto itself, for the question of the aesthetic is rooted deeply in a split or rift that is never mended or overcome. Art thus is always in a fundamental relation with nonart, with what the rift opens art onto, perhaps in spite of itself. And because the "aesthetic" is never in itself, "theory" can never

capture or encompass the aesthetic as such, and this institutes a rift at the heart of theory that it can also never overcome.

Murray Krieger, in "The Semiotic Desire for the Natural Sign: Poetic Uses and Political Abuses," is also interested in a certain split within the aesthetic, a split that is produced when nature no longer functions as the unquestioned ideal or model for art. He focuses on what could be called the "political context" of the aesthetic question of the natural sign as a way of linking the aesthetic and the historical-political in a critical manner. Krieger shows how the metaphysical dream behind the timeless myth of "nature" governing traditional and, in a different way, modern aesthetic and literary theory could be shown not only to have important social-political causes but, more importantly, also to have universalizing hegemonic, ethnocentric consequences. His point, however, is not to save art from this "political contamination" but on the contrary to challenge the foundations of ideological configurations by analyzing them from the critical perspectives provided by art when it challenges, in terms of its own "aesthetic concerns," the "naturalness" of its signs. He argues that the way the "natural sign" gives way to the arbitrary in art, the way in which it is constantly subverted in modern theories of the aesthetic and the poetic by the nonnatural sign, could and should serve as a model for challenging the illusory sense of the natural sign in ideology, thus introducing the nonnatural sign as a subversive element within the universalizing and "naturalizing" closures of ideology.

The aesthetic thus serves as a device for analyzing what Krieger calls "the semiotic desire for the sign" and for studying and countering the "pretenses to authority" always accompanying such desire. He focuses especially on drama and dramatic theory because of the special place drama occupies in the long history of the desire for and illusion of a natural origin for the sign. Drama, with its "flesh and blood creatures . . . constitutes signs that far more closely resemble the living world beyond, far more easily fool the naive among us, than sculpture or painting does." Krieger's interest in this history and his discussion of the most important theorists comprising it have as their purpose to turn the tradition against itself: "Drama, through its inevitable self-contra-

dictions and self-exposure, also helps the aesthetic to produce its own model corrective that should produce a resistance to being taken in by the myth of the natural sign—in society as in art, though thanks to art." The critical privilege he gives to drama (and through it, to art in general) derives not from the fact that art is untouched by "the natural" but rather that it is from its origins inextricably entwined with it, thus necessitating a constant undoing (often in spite of itself) of the hegemony of nature.

The complexity of the question of the sign in the aesthetic realm—that is, the critical awareness that art never achieves natural status even though the desire either to equal nature or to realize fully its own "aesthetic nature" will not go away—and the way aesthetic theory inevitably turns against and undermines the natural model for the sign both indicate for Krieger the critical potential of art and literature. This is how art can be "salvaged" as long as its consciousness of the tension between the arbitrary and the natural is not transformed into an argument for the organic integrity of art. As he puts it, such self-consciousness is to be "encouraged, for in this reflexive action [the arts] serve their culture well, as emblems of the semiotic ambivalence each healthy culture ought to have, cherishing the illusions it has created, provided it never stops distrusting them and their claims to be its 'natural' reality. In examining those illusions and those claims, a culture discovers itself as it questions its reasons for attaching itself to them." For Krieger, then, it could be argued that art is most effective in an "historical" and "political" sense when it is the most selfconsciously "aesthetic," that is, when it displays openly the tensions between, on the one hand, the unifying, form-giving, totalizing tendencies of traditional aesthetics and, on the other, the detotalizing, heterogeneous, disruptive "carnivalesque" tendencies it also contains within it.

Juan Villegas takes a very different, if not opposed position on the possible political sense of the aesthetic. In fact, his essay could just as easily have been placed in the first part of this collection, for it seems evident that he is more interested in the historical-political implications of literature than in literary-aesthetic questions as such. For Villegas, the aesthetic is one code among others, a category to be considered in the study of litera-

ture, but far from the dominant category. His essay could even be read as being anti-aesthetic inasmuch as traditional aesthetic categories have tended to support what he calls European hegemonic discourse and the thesis of the universality (the ahistorical nature) of all true literature. It is included in part 2, however, precisely because it does raise more questions for art and literature than for history, whose foundations and form it tends to take for granted.

Like Krieger, but for different reasons, Villegas focuses on drama and proposes various types and levels of categories in order to develop a model for the history of the theater that would not be closed to marginal, excluded, non-European forms of theater. His text attempts to make theater fundamentally a historical-political *act* of communication. In order to do this, he emphasizes the role of the audience, both real and potential, rather than that of the author, in the determination of this history, and thus proposes what could be called a modified form of reception theory. The addressees of the theater are, he argues, not just those who have seen the play performed in specific circumstances but also those "potential addressees" indicated by the theatrical text itself and who are not all of the same type or kind, not a "single entity." The "act of communication" of the theater can never be completed or finalized if its addressees are not completely determinable. Thus, in what is otherwise a fairly closed historically determined contextualism, there appears a rift, an irreducible potential heterogeneity of reception, which could in fact—at least in, for example, Adorno's (or Krieger's) sense—be called "aesthetic," but which Villegas insists is historical-political. Out of this rift of (or as) the "aesthetic," a critical "history" could in fact emerge, one that would not be the universal history of (bourgeois, European, masculine) "Man," but a conflictual, heterogeneous history where the marginal, the excluded, the non-European—and one should add the feminine—are not submerged under the dictates of *history* or *art*, nor under any other substantial and determining concept, identity, or process.

J. Hillis Miller raises directly neither the question of history or art in his essay, but both are implicitly at stake in the analysis he gives of the possibilities of collective research in the humanities,

or what could be called in this context the possibilities or the future "states of 'theory.' " Addressing Plato's *Protagoras* in terms of the models it provides for research in the humanities, Miller proceeds to undermine the sufficiency and authority of all of them. It is not just the authority of the teacher (theoretician) that is in question, it is also and above all the authority of all of the various forms of dialogue represented by research and teaching. By focusing on the trope of prosopopoeia in Plato's dialogue, Miller shows how the personification of authority, of any authority, turns back on itself and is undermined in the dialogue and as dialogue. In a certain sense, the authority of the theoretician speaking the truth in his own voice, or in a dialogue of voices he pretends to master or direct, or even in a dialogue in which he is given the last and deciding word, is undermined by the rhetorical, literary characteristics of all language—Miller's version of the "rift." The undeniable "literary" characteristics of (the) dialogue (of philosophy) complicate, defer, and ultimately undo the enunciation of the truth.

Research in the humanities, without the authority of the system of science, of the expertise and wisdom of the solitary scholar, of the determining rules and procedures of the established group or collectivity, thus takes place in uncertainty. As Miller puts it, "like reading in general . . . [it] is always different from what the researchers intended or expected. In that sense it is out of their control." What critical theory should be about, then, is "making something happen," or better, being receptive and open to something happening, letting it happen. This is not, however, a statement that implies that anything goes—on the contrary, the "future" suggested by this kind of "happening" imposes grave responsibilities on the "theoretician" and demands rigorous and developed analytical skills, a sensitivity to what inevitably reimposes authority on a process that is aimed at challenging authority. Miller's rhetorical approach to the question of theory and literature is thus directed at keeping their futures open, at making history in the form of "something happening" always possible.

In the last essay in the collection, Jean-François Lyotard analyzes the state of contemporary aesthetics and art. As the title of his essay indicates, "contemporary" is defined as being "after the

sublime," that is, according to Lyotard, coming after an incurable wound has been inflicted on the imagination by Kant's notion of the sublime. Lyotard insists that what he calls "the collapse or failure of the power of presenting, ... of putting matter into forms," indicates the "irrelevance of forms in the sublime feeling." If contemporary art must be thought in terms of the sublime and if in the sublime forms are irrelevant, it would seem, as Jameson's analysis of the critical sense of postmodernism also implies, that there can be no aesthetics of the sublime (the postmodern). After the sublime, the state of aesthetics would be to have no status or state. In other words, with the sublime we come not to the end of art but to the end of aesthetics, at least to the end of an aesthetics of the beautiful and the formalism associated with it, formalism being "the ultimate attempt to place art within the frame of the beautiful by elaborating the very conditions of presentation." In line with what Nancy argues for history, aesthetics, for Lyotard, must be considered a thing of the past.

If form is not the issue any longer in art, one could legitimately ask what is. Lyotard argues that it is "the access to matter itself, ... to present without recourse to the means of presentation." This makes art "after the sublime" stateless, a process of experimentation that is constantly testing and exceeding the boundaries assigned to it, continually challenging what it is to be art. It is not the closed, teleological, purposive formal space of traditional aesthetics but an open space of nuances and timbres which are "imperceptible differences between two sounds or colors. ... [They] are what differ or defer within the identical." These material differences of color, tone, sound, etc. have no purpose; they are precisely "what doesn't address the mind (what doesn't in any way partake in a pragmatics of communicational and teleological destination)." Thus, the critical reconsideration of aesthetics "after the sublime' would also entail the critique of teleological destination in general, not only in art, but in communication, literature, politics, and history. The "after" of "after the sublime" indicates a "post" that does not determine a particular future but that questions destination and the means of achieving or guaranteeing it. "After the sublime," art is in question, and those elements, forces, or movements in art that escape the confines of

form (of aesthetics) challenge the very foundations of art, aesthetics, and critical theory in general.

AT A time of great controversy within the various disciplines of the humanities, fine arts, and the social sciences, at least (in part) provoked by the continually growing interest in "theory" within each, these essays all attempt to pinpoint and analyze crucial issues at the heart of these controversies. I would not claim, nor do the essays themselves claim, that they have solutions to the problems dividing (sometimes in a polemical way) the various fields and disciplines. On the contrary, they seem rather to be intent on treating some of the most controversial issues as unresolvable—as rift, split, marginality, heterogeneity, incommensurability, unrepresentability, etc. They strive in this way to force open and undermine the traditional boundaries of the disciplines so that they will begin to admit serious, critical, theoretical investigations within themselves and thus be receptive to their own transformation and rethinking.

This is not to imply that all will be right if theory is no longer treated as a threatening evil but rather admitted freely into the different disciplines. "Theory" is easily transformed into *theory* (this undoubtedly occurs at times in these essays as well as in others, no matter how self-consciously and meticulously the theoretical task is carried out) and takes on a dogmatic quality if it does not meet some resistance, if it does not in fact resist itself. As I have argued, any institutionalization of theory prohibits or programs (it is almost the same thing) the very thing it is supposed to make possible: the reevaluation of the grounds and practices of theory and the transformation of the "states of 'theory.'"

The States of "Theory" then could be considered to consist above all in a conflictual process of confrontation with the states of the various disciplines and with the states of "theory" itself. This collection will have served a critical purpose if it has made some of the fundamental questions concerning the nature, limitations, and possibilities of the fields and disciplines of art and history—questions which most often go unasked in each discipline—more precise, if it has suggested new types of questions

to ask, and if it has demonstrated the force of the critical process of questioning itself. Nothing less than the futures of art and history, as well as the future of "theory," depend on such questions being pursued and on the ends of art and history being constantly put into question.

THE QUESTION OF HISTORY

1

ARE WE BEING HISTORICAL YET?
Carolyn Porter

THE LEAD article in the May 1987 *PMLA* tells us that "A specter is haunting criticism—the specter of a new historicism." In contrast to Marx and Engels, who proposed to publish the views of Communists themselves, so as to counter a "nursery tale of the Spectre of Communism with a Manifesto of the party itself," Edward Pechter, in "The New Historicism and Its Discontents," projects his own nursery-tale specter of the new historicism as "a kind of 'Marxist criticism.'" Effectively taking the new historicist manifesto as granted, Pechter proceeds axiomatically to ally the "new historicization of literary studies" with "a new politicization" so that political criticism of any kind becomes an example of new historicism.[1]

Like those whom Marx and Engels referred to as joining "a holy alliance" against Communism, Pechter joins another alliance. In order to exorcise this specter of new historicism, he appropriates a weak version of new pragmatism in support of a weak version of traditional humanism. Isn't the belief that "life makes the world go round," he suggests, at least as "useful" as the belief that "it's a jungle out there?" (p. 301) But such an alliance between humanism and the new pragmatism is likely to strike humanists, at least, as a little unholy. Stanley Fish may have "stopped worrying and learned to love interpretation," on the strength of his own conclusion that "we have everything that we always had," but as anyone in literary studies these days can testify, plenty of people are hardly so worry-free.[2] Certainly, from a traditional humanist vantage point, a choice between clichés cannot compensate for the prior reduction of beliefs to clichés,

which, in Pechter's argument, proves the consequence of the new pragmatist reduction of knowledge to belief.[3]

However new pragmatists may respond, I suspect that few humanists will find such an alliance altogether comfortable. Nor will many new historicists find appropriate their supposed derivation from and alliance with Marxist criticism, especially one so ill-defined. Finally, whether they identify themselves as Marxist critics or not, those who have participated in and drawn intellectual sustenance from the work of Marxist critical theory and practice over the last twenty years will find the conflation of new historicism and Marxism on which Pechter premises his critique singularly disquieting, to put it mildly. More broadly, such a generalized vision of "the new politicization" of literary studies undermines our ability to keep in view the specificity and value of other forms of political criticism, whether generated by feminist, Afro-Americanist, ethnic, or colonial studies. At the least, those who share my own belief in the value of a politically self-aware critical practice are unlikely to be able to understand what kind of politics may be at work in the project of new historicists if we begin by regarding it as part of the rag-tag and bob-end construction to which Pechter attaches the label "Marxist."

It is worth disentangling Pechter's contextualization of new historicism as Marxist from his critique of various new historicist arguments, since the latter is often quite astute.[4] Pechter dismisses the relevance of any distinctions between "classical Marxism" and "some of the different, 'softer' revisions prefaced by new or post," attributing to all of them the view that "history and contemporary political life" are "determined, wholly or in essence, by struggle, contestation, power relations, *libido dominandi*" (p. 292). Clearly, no one familiar with Marxist theory would conflate "Althusser, Foucault, and Jameson" together with "classical Marxism" by reference to a defining belief that "power relations" determine "history" (p. 292).

For one thing, classical Marxism is hardly defined by its focus on "power relations." Rather, it is commonly understood to be based on (and in recent years, to be flawed by) an economic determinism founded on a historically specific and now much debated theory of the relations of production as the key issue in

understanding history in terms of class struggle.[5] One could go
on enumerating the marked differences of emphasis *within* clas-
sical Marxism, the crucial differences *between* the latter and var-
ious "neo-Marxist" theoretical positions, as well as the often stark
oppositions *among* these theoretical positions. Specifically, Al-
thusser, Foucault, and Jameson hardly form what one might call
a homogeneous group. When the names of Edward Said and
Frank Lentricchia are added to the list, the description verges on
incoherence.

What coherence it retains derives, ironically, from the one
clearly non-Marxist figure cited. For as it turns out, it is Fou-
cault's model of "power relations" that operates most importantly
in the work of Stephen Greenblatt and the other new historicists
addressed by Pechter's analysis. Yet Foucault attacked various
tenets of classical Marxism repeatedly, and in his later work he
did so precisely in support of his model of power, a model in
many ways designed to critique and go beyond the classical Marxist
insistence on economic determinism as well as more recent Marxist
theories of ideology. Pechter's ensuing analysis demonstrates per-
suasively enough that Foucault's model of power relations is
critically important to some new historicist work, but by ignoring
this critical opposition between Foucault and the specific strains
in Marxism that he was resisting, Pechter beclouds from the
outset the question of new historicism's relationship to Marxist
theory and to Marxist forms of historical criticism. In short, when
they deploy Foucault's model of power, new historicists are by
no means necessarily embracing, or even fostering, a "kind of
'Marxist Criticism.'"

On the contrary, in some instances, new historicists have spe-
cifically disavowed such an alliance. For both Stephen Greenblatt
and Louis Montrose, for example, Marxism is one of several criti-
cal perspectives to which new historicism is opposed.[6] Another
is formalism, which Montrose describes as a view of literature as
"an autonomous aesthetic order that transcends the shifting pres-
sure and particularity of material needs and interests" (p. 8). Still
another is an 'old' historicism, which Greenblatt describes as
"monological" in that it posits an "internally coherent and con-
sistent" vision which then "can serve as a stable point of refer-

ence, beyond contingency, to which literary interpretation can securely refer."[7]

Pechter argues that regardless of such claims, in practice new historicism characteristically relapses into a form of determinism most readily identifiable with Marxist criticism, and further, that it operates in ways that make it resemble old historicism. While I would agree on the resemblance to old historicism, it seems to me that some new historicist work, at least, relapses into formalism rather than into Marxist determinism. Further, it seems to me that its effort to explore, in Greenblatt's phrase, "both the social presence to the world of the literary text and the social presence of the world in the literary text" would actually benefit from a closer scrutiny of Marxist critical theory (*Renaissance Self-Fashioning*, p. 6). In short, the problem with this strain of new historicism is not that it is Marxist, but on the contrary that it has seemed at times remarkably inattentive to the theoretical and methodological issues that Marxist critical theory—especially in its more recent forms—has raised regarding the historicization of literature. For lest the new historicism seize "the ruling definition" of the historical, to borrow Raymond Williams' phrase, it is salutary to remind ourselves that there *was* a historically focused criticism before 1982, the year "the new historicism" was christened.[8]

Since the late sixties at least, the effort to develop new means for resituating the literary in relation to the historical has, in fact, been much in evidence. In my own field of American literature, such efforts are readily documentable.[9] What is more pertinent here are the contributions made by Marxist critical theory toward developing strategies for rehistoricizing literary studies. The record of these developments is, of course, far too complex and extensive to rehearse adequately here. But among the various strains of Marxist literary studies that have emerged in the last two decades, the project to which Raymond Williams gave the name "cultural materialism" needs to be underscored, since Pechter follows others in underestimating its differences from the new historicism.[10]

Although cultural materialism may be traced back to "Left-Leavisism," specifically to the early work of Richard Hoggart and

E. P. Thompson as well as to that of Williams, and more broadly to the larger cultural and political formations which were to generate the Centre for Contemporary Studies at Birmingham University, it is the career of Raymond Williams that traces most clearly the significance of cultural materialism for literary studies. By the seventies, with the publication of *The Country and the City* (1973) and especially of *Marxism and Literature* (1977), Williams' work was squarely situated within a Marxist tradition, one now heavily influenced by Gramsci and reinvigorated for Williams by his reading of Bakhtin. By the early 1980s, Williams could look back and describe the social and professional forces and issues that had propelled him and his colleagues toward the study of what he has called "language in history: that full field."[11] His work helped to stimulate a variety of neo-Marxist critical strategies, many of them based on the perceived need for a return to the historical as the crucial ground for understanding the social, ideological, and political dimensions of both literary production and critical reception.

Of course, Williams was by no means alone in stimulating a new Marxist approach to rehistoricizing literary studies. In France, Althusser's revisionary Marxist theory fostered another set of approaches to the questions entailed by this project, of which Macherey's *A Theory of Literary Production* (1978) is the best-known example. In the United States, Fredric Jameson developed yet another line of approach, grounded by his early studies of both Russian Formalism and continental Marxist theory and finally articulated in *The Political Unconscious* (1981). Meanwhile, Terry Eagleton, Tony Bennett, and a host of other critics set about working through the relation—sometimes hostile, sometimes not—between poststructualist theories of language and Marxist theories of culture. Despite the conflicts between British Marxists and the French approach of Althusser, of which Edward Thompson's *The Poverty of Theory* (1978) is probably the high-water mark, the differences between those working out of a structuralist or a poststructuralist position and those working out of a cultural materialist position has led to what now appears to be a reinvigorated conversation, judging from the recent publication of Attridge, Bennington, and Young's *Post-Structuralism and the*

Question of History (1987). If this volume represents, as it certainly appears to, a significant attempt to bring together historical cand poststructuralist critical agendas, the rapprochement to which Raymond Williams looked forward in the years before his death may now be imminent.[12]

If the "turn toward history" has been apparent for some time, as I am suggesting, this development is by no means exclusively the result of either Marxist or theoretical criticism. To review it fully, one would have to address the impact of Hayden White's analyses of historical discourse, for example, analyses in which Marx's tropological axiomatic is exposed as readily as that of any other historian. One would need as well to rehearse the evidence of historicization in specific fields of literary studies, especially those on which the now massive interdisciplinary scholarship proceeding from Women's Studies, Ethnic Studies, and Third World Studies has had such a marked impact. What needs to be emphasized here is that there are theoretical and methodological issues to be faced in any effort to historicize literature, issues which have been addressed and debated in the work of cultural materialists, Althusserians, and even some poststructuralists.

What is new historicism's relationship to these pre-existing, and ongoing, forms of critical theory and practice, in which the effort to historicize both literature and literary studies is readily visible? What kind of relationship does exist remains in doubt; what kind *might* exist depends upon the outcome of a conversation now in process, to which I hope this essay is a contribution. Faced with the evident and apparently growing prominence and influence of a set of critical practices called "the new historicism," and yet lacking any fully articulated statement of a theory or methodology on which those practices are supposedly based, Mr. Pechter is not alone in finding it difficult to assess new historicism's origins, direction, and implications. This task has recently been rendered more feasible by some new historicists in the field of Renaissance studies who have begun to raise questions about this enterprise, so that its "assumptions, principles, and procedures," as Montrose notes, are "beginning to be systematically articulated, discriminated, and subjected to scrutiny."[13] For example, Don Wayne and Louis Montrose both readily iden-

tify themselves as new historicists, but are among those who wish to pose questions to their colleagues within the movement, specifically about its relationship as a critical project to other forms of criticism, and to the contemporary political context in which it has arisen.

These and other Renaissance critics who have begun to pose questions to their own enterprise as new historicists deserve encouragement. This said, all of us who are concerned with fostering a more fully historicized view of literature also deserve a more serious discussion from those in the forefront of new historicism of the critical methods, theoretical assumptions, and political implications of their work. The critique I offer here, then, issues from a sympathetic desire to foster a historically inflected critical practice in literary studies that is attentive to the political implications of its methods. Specifically, I wish to address that strain of new historicist analysis which is indebted to Foucault's revisionary model of power, since those who have employed this model, often with stunning effect, need—in my view—to ponder its possibilities and implications more thoroughly.

To that end, let me begin by focusing on new historicism as a movement primarily grounded in Renaissance literary studies. I shall assume as a given that Stephen Greenblatt's work is an example of at least one kind of new historicist critical practice.[14] I want primarily to address the treatment of power in Greenblatt's work, in particular, his appropriation of a Foucaultian model that enables him to conceptualize a power that produces the subversion it contains. By examining how this concept of power functions, we can explore two problematic sets of issues. One set is methodological, and concerns the limits within which this form of new historicist practice grasps the relations between literary texts and the social discourses used to historicize them. The other concerns limits as well, the theoretical limits of the concept of power at work here, but since these limits have political implications, we might call them political issues. I will focus first on the methodological issues, although—as will quickly become evident—these cannot be wholly separated from the political ones.

In order to address the methodological issues, it is useful to distinguish between what Greenblatt called for in the article "In-

visible Bullets" in 1981—a "poetics of Renaissance power"—
and "the new historicism" which he described in his introduc-
tion to *The Forms of Power and the Power of Forms in the
Renaissance* (1982; p. 5). I want to suggest that there is a signifi-
cant gap between "cultural poetics"—as Greenblatt called his
project in *Renaissance Self-Fashioning* (1980)—and "the new
historicism," as he has subsequently called it. We can begin to
observe this gap, I believe, by looking at "Invisible Bullets: Re-
naissance Authority and Its Subversion."[15]

In this essay, Greenblatt situates his perspective in opposition
to both those who have tended "to consign to nonexistence those
elements that appear to threaten or subvert the dominant order,"
and those who indulge in "the recurrent notion that major Re-
naissance artists participated with considerable subtlety and de-
viousness in a kind of opposition party" (p. 42). In other words,
subversion is neither total not totally absent. Surely, we can
agree, the truth lies somewhere in between these extremes. Yet it
is already clear which extreme is more extreme in Greenblatt's
eyes.

He has recited the story told by Carlo Ginzberg in *The Cheese
and the Worms*, the now famous tale of Menocchio, whose liter-
ate and radical opposition to the religious orthodoxy of sixteenth-
century Italy led Ginzberg to argue that Menocchio's subversive
ideas revealed in residue a radically materialist peasant culture.
Such a conclusion, according to Greenblatt, "while it may be true,
depends more upon a modern political act of faith than upon
available historical evidence." If the evidence does not support
Ginzberg's claims, he continues, what it *does* "suggest" is "that
it was possible for a sixteenth century reader to *find* subversive
notions *contained* within an apparently untroubled expression of
orthodoxy" (p. 42; my emphases). It is crucial to notice that
Menocchio, as a particular, named, class-defined person, has been
reduced, at least rhetorically, to an unspecified "reader." It is
even more crucial to notice that the "subversive" has been dis-
placed from the attitudes or ideas he may have brought to his
reading, to elements in the orthodox text in which these are
"contained," since the consequences of this displacement will
prove critical to the essay's procedures.

Greenblatt adduces the example of Menocchio in the first instance in order to underscore his own claim that "radical subversiveness . . . *was* possible in the Renaissance," a point he wishes to "stress," since his ensuing argument is likely "to imply that it was virtually impossible" (p. 41; my emphasis). And so it does. But then, the story of Menocchio is also interpreted so as to support that "ensuing argument"; that is, it serves to illustrate how what *looks* subversive turns out not to be. How is it that this anecdote can demonstrate both subversion's existence and its prior containment?

Having designated the case of Menocchio as "the extravagant, zany exception" to the rule of containment, Greenblatt actually interprets the Menocchio story so as effectively to recontain the very subversiveness it is cited to illustrate. He accomplishes this by making two related moves, one of which we have already observed. By displacing the subversiveness in question from Menocchio to the orthodox texts he read, Greenblatt shifts the site of subversion from the larger culture to the texts of its dominant discourses. Further, he also shifts the frame of reference from the cultural space of "containment after the fact, the containment of prison and the stake" to that of "a prior form of restraint" in which "subversive insights are generated in the midst of apparently orthodox texts and simultaneously contained by those texts" (41). Menocchio is now positioned as "reader" of texts in which he is able to find "something subversive," but these texts, in turn, exercise a "prior form of restraint" over the subversive readings they elicit, so that "the society's licensing and policing apparatus" is unnecessary. In short, the frame of both subversion and containment has been narrowed considerably—to that of a dominant culture and its discourse (p. 41).

Now this reduced frame is readily understandable in view of the fact that it is finally these texts, that is, those "not prohibited" but in fact resolutely above "official suspicion," whose "subversive elements" Greenblatt wishes to call to our attention, as preparation for his analysis (pp. 41, 42) of how power and subversion are interrelated in Thomas Harriot's *A Brief and True Report of the New Found Land of Virginia* of 1588. But while our attention is being focused upon the subversive potential of such orthodox

texts, it is all too easy to miss the slippage that has taken place. For while subversion's presence in orthodox texts is being insisted upon, its absence from other sites in the culture is being assumed.

In other words, by rejecting Ginzberg's interpretation of Menocchio's case as an example of the "unspoken radical materialism" of a peasant culture tied to "oral modes of discourse" in favor of his own view that Menocchio's subversive ideas could be found in the written, orthodox texts he read, Greenblatt effectively brackets the option of reading Menocchio's ideas as disclosing a subversiveness not necessarily the exclusive product of an oral, peasant culture, but still deriving at least in part from some larger cultural matrix which extends beyond the orthodox texts in which Greenblatt wishes to see it inscribed.[16] That subversive elements may well be so inscribed in orthodox texts, of course, is not in question here; Greenblatt goes on to demonstrate one way in which that inscription may operate. Nor do I mean that he is obligated to turn full-fledged historian and respond to Ginzberg on the basis of other "historical evidence" (p. 42). The methodological problem is that the "subversive" has been displaced from the large, and still problematic, social, political, and cultural space which produced and then contained Menocchio by sending him to the stake for heresy, to the limited site of orthodox texts on which Greenblatt wishes to focus, and yet this reductive displacement is never addressed as problematic.

Greenblatt's treatment of Menocchio's story already demonstrates, at least in embryo, the difference between a cultural poetics and a new historicism. That is, the slippage I have noted here, between the question of subversion's existence, sources, and effects in a historically specifiable culture and that of the presence of subversive elements in an orthodox text, begins to define a gap between two discursive spaces, one of which may be said to enclose the other while far outstripping it in extent. In his analysis of how power produces subversion, Greenblatt is addressing the smaller discursive arena whose locus is projected from certain Renaissance texts (an arena which may yet provide a legitimate field for a "cultural poetics"), but drawing inferences from that analysis which are represented as applicable to a much larger

domain (that larger discursive space to which a new historicism would presumably lay some kind of claim). The larger discursive space is rhetorically designated by the Menocchio story, which serves as a synecdoche for History, but then what happens to this space once Menocchio is marginalized? For so he is. Indeed he is marginalized twice over.

First, as a historical instance, Menocchio represents the subversive, but since his subversive notions constitute the "exception" that proves the rule of containment, he is marginalized *as* an exception—indeed as an eccentric (p. 41). For the historian, such eccentricity still requires explanation. Ginzberg's may be faulty, but Greenblatt's interpretation does not provide a symmetrical alternative to it. Rather, in what seems a methodologically rigorous reduction of what claims can be made on the basis of the "historical evidence," Greenblatt eludes posing the *order* of question that Ginzberg has tried to put and to answer. Abjuring the "modern political act of faith" that has allegedly misled Ginzberg, Greenblatt offers a more modest and confined reading, that a sixteenth-century "reader" could have found subversive ideas in orthodox texts. But this is not an answer to the same question, the historical question addressed by Ginzberg, although it is doubtless viable as an example adduced to formulate a hypothesis which might resolve the conflicting views of literary scholars of the Renaissance regarding the status of "subversive elements in Renaissance texts" (p. 42). Reduced, then, to an historical exception whose eccentricity remains unaccounted for, Menocchio is then marginalized once again when his subversiveness is displaced from the culture to the exclusive domain of orthodox texts. In effect, the cultural domain of history which produced him is rhetorically invoked only to be itself marginalized.

Possibly because of these difficulties, the Menocchio anecdote was dropped from the second, enlarged version of the essay. Yet the same procedure is observable in the next section of both versions. The analysis of Thomas Harriot's *Report* identifies two forms of the "paradox" by which power produces subversion. The first has to do with the subversive "Machiavellian hypothesis" confirmed in Harriot's report, that religion is a "set of beliefs manipulated . . . to help insure social order and cohesion" (p. 46).

In England at the time, such beliefs are unequivocally subversive
—even to be suspected of them "could lead to imprisonment and
torture." Yet the "coercive power" of the Europeans' religious
belief over the Algonkians, though it demonstrates the validity of
such a subversive belief, works in the service of the social order
it ostensibly subverts. Greenblatt concludes: "Thus the subver-
siveness which is genuine and radical . . . is at the same time
contained by the power it would appear to threaten. Indeed the
subversiveness is the very product of that power and furthers its
ends. One may go still further and suggest that the power Harriot
both serves and embodies not only produces its own subversion
but is actively built upon it" (p. 48). As the bond tightens between
"subversiveness" and a "power" that first contains it, then pro-
duces it, and finally is "actively built upon it" we are left in
doubt as to the specific frame of reference in which this "power"
is operating. Clearly enough, that frame circumscribes more than
Harriot's text per se, but what discursive space does it define?

We do not seem to be attending to the Algonkians, nor even—
to any significant extent—to the English colonizer's encounter
with them. That encounter simply affords a unique opportunity,
according to Greenblatt, to "test" the Machiavellian hypothesis.
Thus, the problematic of power and subversion articulated here
is only illustrated by the colonial encounter; structurally, it re-
mains unrelated to the politics of colonialism in this period. The
"power Harriot both serves and embodies" presumably refers to
English state power in the late sixteenth century. Apparently,
then, the relationship between power and the subversion it is
said to produce is a feature of Elizabethan culture, where, after
all, the Machiavellian hypothesis is so demonstrably subversive.
In which case, Harriot's Report of his encounters with the Algon-
kians functions primarily as another illustrative anecdote, one
which provides a useful resource for describing a cultural feature
of state power in Elizabethan England which can then be found
in certain Shakespearean texts. Although other problems develop
once we get to Shakespeare, the frame of reference issues would
seem to be resolved. That is, the power/subversion model is to be
located within Elizabethan culture, to which Harriot's report is
pertinent because it illustrates that model at work. So far, so good.

But when Greenblatt turns to the second form taken by this power's paradoxical production of subversion, the frame blurs once again.

Harriot records the "alien voices" and "interpretations" of the Indians, among which is the report's most riveting revelation, the native's belief that the massive deaths which follow in the Europeans' wake are caused by "invisible bullets" floating in the air. Why, Greenblatt asks, should Harriot bother to record such "other voices"? "The answer may be in part that power, even in a colonial situation, is not perfectly monolithic and hence may encounter and record in one of its functions materials that can threaten another of its functions; in part that power thrives on vigilence, and human beings are vigilent if they sense a threat: in part that power defines itself in relation to such threats or simply to that which is not identical with it" (pp. 49, 50). The term "power" here has somehow been liberated from any entangling references and become abstract. We are no longer talking about Elizabethan state power, but power *per se*. This abstracted, indeed essentialized, concept of power not only expands the frame of reference, but has other consequences as well. For example, Harriot can no longer be understood as a man who "serves" a state power, strictly speaking, since to serve a power presupposes at least a minimal agency on the part of the servant. But there is no agency here save that of power itself. It is power that records, encounters, defines, etc. People may be vigilent, but it is power that "thrives on" that vigilence. By means of a rhetorical personification, power has been essentialized so as to absorb all agency.

This abstracted and expanded notion of power may help us to understand the rather startling claim that is made in answer to the question, "why . . . should power record other voices?" (p. 50):

> The recording of alien voices, their preservation in Harriot's text, is part of *the process whereby Indian culture is constituted as a culture* and thus brought into the light for study, discipline, correction, transformation. The momentary sense of instability or plenitude—the existence of other voices— is *produced* by the power that ultimately denies the possibility of plenitude, just as the subversive hypothesis about

European religion is tested and confirmed only by the im-
position of that religion. (p. 51; my emphases)

What is unacceptable here is obvious. Manifestly, the Europe-
ans did not "constitute" the Algonkian culture "as a culture."
Rather, what Harriot's text helps to constitute is an *image* of an
alien and colonized culture, a culture understood *within* the Eu-
ropeans' discourse as a potential object of and for "study, disci-
pline, correction, transformation." Nor, clearly enough, does
Greenblatt mean to suggest that the Algonkians did not exist as a
culture before the arrival of the English, as he indicates when he
notes that he is only addressing "events as reported by Harriot.
The history of subsequent English Algonkian relations casts doubts
upon the depth, extent, and irreversibility of the supposed Indian
crisis of belief" reported by Harriot (p. 47). Such a disclaimer
sharpens the focus on Harriot's *Report,* and thus helps to explain
the textualization of "the existence of other voices" as (by appo-
sition) identical to a "momentary sense of instability or pleni-
tude," (or ambiguity and tension?) *in* a text. Yet the same dis-
claimer excludes the very discursive space of "English Algonkian
relations" which has served to accord the analysis a large part of
its claim to being historicist. Just as the Menocchio story was
invoked only to be marginalized by the reduction of Menocchio
to an eccentric and the displacement of his subversiveness to
orthodox texts, here the cultural domain of "English Algonkian
relations" is rhetorically invoked only to be itself marginalized.
Foregrounded by the colonial encounter between Harriot and the
Algonkians, the paradox of power is not treated as an expression
of *colonial* power, nor is it situated in the colonial situation of
invasion. As in his treatment of Menocchio, in short, the drive to
focus in on a set of texts in which "subversive elements" are both
produced and contained, often in a volatile way, effectively mar-
ginalizes the very site of the essay's most vividly "historicizing"
discourse.
 Meanwhile, another question arises: what kind of relationship,
precisely, is being posited between Harriot's *Report* and Elizabe-
than culture so as to underwrite the transposition of the power/
subversion from the one to the other? Notably, this question never

arises for Greenblatt. Why it does not become clear when we examine the steps by which he actually moves from Harriot to Shakespeare, from New World to Elizabethan theatricality. Greenblatt makes a point of the fact that the "process" he is describing is by no means "applicable only to works that address themselves directly or allusively to the New World" such as *The Tempest* (pp. 49, 53). *I Henry IV*, then, becomes a kind of test case which serves to expand the provenance of the model derived from Harriot's text beyond its reference to the New World. But more immediately, *I Henry IV* also serves as a relay point in the essay: that is, by delivering a reading of Shakespeare's text which parallels that of Harriot's, Greenblatt shifts the locus of his analysis from the New World back to Elizabethan culture. Only after this transfer has been effected can the frame be expanded to its full dimensions as a lens on Elizabethan culture.

The rest of the essay unfolds in two stages. The first is devoted to a reading of *I Henry IV*, where the "theatrical equivalents" of "testing, recording, and explaining"—the "three modes" at work in Harriot's text—are identified again, so as to reveal in Shakespeare's play the same model of power producing and containing subversion (p. 53). Once this "resemblance" has been established, the frame of reference is rapidly expanded in the final pages of the essay (p. 55). If the "ideal image" of English character which Maynard Mack saw in Prince Hal presupposes "as its positive condition the constant production of its own radical subversion and the powerful containment of that subversion," this "positive condition" in turn becomes a paradigm for Elizabethan theatricality (p. 53). This paradigm not only informs both royal power and Shakespeare's stage, but defines their relation to each other. That is, the "apparent production of subversion" as "the very condition of power" defines an "English form of absolutist theatricality" in which "royal power is manifested to its subjects as in a theater." "Theatricality," in turn, is "one of power's essential modes" (pp. 57, 56). Accordingly, "Shakespeare's drama . . . can be so relentlessly subversive" since "the form itself, as a primary expression of Renaissance power, contains the radical doubts it continually produces." The paradox of power, first read out of Harriot's text, in effect becomes a ruling trope in "a poetics of

Renaissance power." Thus generalized, this theatrical power can then be duly specified as "an historical phenomenon, the particular mode of this particular culture" and "not a theoretical necessity of theatrical power in general" (p. 57).

Several observations are in order here. First, the method that operates in the first stage—where Shakespeare's text is read to reveal the same techniques identified in Harriot's—is basically analogy. The same paradox by which power produces its own subversion in Harriot's text is observable in Shakespeare's because the same techniques operate to produce analogous effects. Now both of these readings are quite persuasive, indeed often mesmerizing. Further, up to a point, the similarities between the two texts are convincingly presented. But analogy has some strict limits. Let us assume that "recording," for example, does have the same function in Shakespeare's play that it has in Harriot's text, that is, that "the same yoking of the unstable and the inevitable" is to be observed in the process through which the English equivalents of "alien voices" (apotheosized in Falstaff) are produced and contained by the power embodied in Prince Hal (pp. 54, 51). How far, and in what terms, can the analogy be extended?

Formally, the analogy being drawn here conforms to the pattern A:B::C:D. That is, there is a "resemblance" between A's relation to B and C's relation to D, specifically between Prince Hal's relation to Falstaff and the Englishman Harriot's relation to the Algonkians. Both Prince Hal and Harriot participate in a recording act which serves the same function—to produce and contain subversion—and which creates the same effect in each text—of "yoking the unstable and the inevitable" (p. 54). As long as we agree to bracket what such an analogy represses, that is, the specific social content of "the unstable" and "the inevitable," the analogy holds. That is, the "alien voices" which Falstaff represents may well be "the very types of Elizabethan subversion— masterless men, the natural enemies of social discipline," but the content of this subversive threat, self-evidently, is differently determined than that posed by the Algonkians' existence in the New World (pp. 51, 54). Among other pertinent differences, the Algonkians not only "seem to dwell in realms apart from that

ruled" by Elizabeth, but actually *do* so dwell, at least at this date (p. 54).

The point is that the analogy holds, but only with regard to a functional similarity: A *is to* B *as* C *is to* D. What makes such a similarity striking is precisely the differences that serve as its precondition, differences that remain between the specific terms of the analogy. It is such differences that disappear from our view when the limits of analogy are effaced in order to expand the frame of reference. For how can we move from these textual analogies to the claims that follow hard upon them: that the model of power at work in these two texts is replicated as theatrical power, as royal power, and finally, as an "Elizabethan power" which dictates that the relation between royal and theatrical power conforms to the same model? Obviously, the analogy between the two texts simply cannot ground these larger claims. Instead, by means of a process we might describe as translating analogy into homology, the functional resemblance between two relationships (A:B::C:D) serves to support a structural equivalence (A:B = C:D, as well as A = C, B = D)) which is grounded—and can logically only be grounded—by that essentialized model of power of which both textual cases are instances.

Acknowledging that it may seem "slightly absurd" to liken moments in a play to aspects of a "tract for potential investors in a colonial scheme," Greenblatt concedes that "the only values we may be sure that Shakespeare had in mind were theatrical values." But "such appeals to the self-referentiality of literature," he says, raise questions that would lead "beyond the scope of this paper." Further, these "appeals" are belied by the text of *I Henry IV* "itself," which "insists that it is quite impossible to keep the interests of the theater hermetically sealed off from the interests of power" (pp. 55–56). Faced with the limits of the textual analogy, Greenblatt first reductively characterizes them as a function of the difference between literature and propaganda, then seizes upon the opportunity he has thereby created to involve the bogeyman of formalist aestheticism, and finally offers an escape from that horror—ironically enough—by an appeal to the text "itself," wherein Hal's "theatrical improvisation" demonstrates how blurred

are the boundaries between power and art. Since Prince Hal is always performing a "part in the scheme of power," it follows that "theatricality . . . is not set over against power but is one of power's essential modes."

But the "power" of which theatricality is an "essential mode" is itself a Power that is now simply given. Whether it is "improvisational," "theatrical," "royal," or more broadly "Elizabethan" as opposed to Victorian, such power can manifest itself in any mode you like (p. 56). Analogies can once more proliferate: theatrical power resembles royal power, since Elizabeth's power is constituted in theatrical celebrations . . . and theatrical violence," and "royal power" operates "as in a theater." Further, given such power, "historical" specifications can be made: unlike nineteenth-century forms of power, this "Elizabethan power . . . depends upon its privileged visibility." We are not dealing with "a theoretical necessity of theatrical power in general," but with "an historical phenomenon" (p. 57). What, in a historicist perspective, would "theatrical power in general" be? In short, it is only because power has been transcendentalized that it *can* be particularized in these terms.

It should now be clear why Greenblatt never addresses the question of the relationship between Harriot's text and Elizabethan culture. The only moment in the essay at which this question could arise is the one in which he begs it by shifting his analysis from one in which analogous power relations are observed in two contemporary texts, to one which hypostatizes those relations on the basis of an essentialized power.[17] In fact, when we look back at the treatments of Menocchio and Harriot, it now becomes clear that this essentialized power has all along served as the basis for moving the analysis from one site to another, expanding or contracting the frame of reference whenever necessary.

It is as if Foucault's model of power exercises a "prior form of restraint" on the argument (p. 41). For example, when Greenblatt says "theatricality . . . is not set over against power but is one of power's essential modes," he echoes the Foucault who says that power is not simply "a law which says no," but rather something

that "traverses and produces things," something that "induces pleasure, forms knowledge, produces discourse."[18] In *The History of Sexuality*, Foucault undertakes to transpose sexuality from something against which power works, as a negative, proscriptive, censoring force, to something which is "a positive product of power."[19] Greenblatt invokes the same logic of inversion from negative to positive when he transposes "theatricality" from the site of opposition to power to the site of "one of power's essential modes" in the process of rejecting formalism's belief in the "self-referentiality of literature" ("Invisible Bullets," p. 56).

According to Edward Pechter in "The New Historicism and Its Discontents," a false choice is offered here between "a parody of formalist autonomy" and Greenblatt's alternative, which is "equally extreme on the other side" (p. 294)—a point with which I would agree, although on different grounds. If theatricality, or literature, or art in general, is understood as *either* "set over against power" *or* "one of power's essential modes," and if this either/or allies the first choice with a formalist belief in literature's autonomy, then only formalists can believe that literature might harbor any socially resistant or oppositional force. Meanwhile, to believe that literature might have social or political weight as a form of cultural agency entails also believing that such agency as it has is by definition already co-opted by "power." What is thus excluded is the possibility that literature might well—at least occasionally —act as an oppositional cultural agent in history. It is this kind of possibility that has been foreclosed by the reading of Foucault at work here.

This is not to say that Foucault does not have much to teach us about the discursive analysis of modern power relations. The problem arises when this model is essentialized, so that instead of historicizing the object of analysis, it effectively dehistoricizes it as one mode in which Power is manifested. Thus essentialized, no matter what period the model is applied to, it totalizes the discursive field and readily operates as a kind of transhistorical *epistème*. It is useless to deny that at times Foucault himself authorized such a totalization. Power, he said in *The History of Sexuality*, "is everywhere; not because it embraces everything,

but because it comes from everywhere."[20] The "moving substrate of force relations," power constitutes "a dense web that passes through apparatuses and institutions, without being exactly localized in them" (pp. 93, 96). "The omnipresence of power," in short, legitimates regarding power as immanent in all the "force relations" which it sustains as "a chain or system," a system "whose general design or institutional crystallization" is then embodied in "the various social hegemonies," themselves thus understood as merely "the terminal form power takes (pp. 92–93).[21]

Such a model of power can work to produce a totalized vision of history which, to be sure, is innocent of certain sins of an old historicism that wanted to periodize it by reference to world views magisterially unfolding as a series of tableaux in a film called Progress. On the other hand, this new historicism projects a vision of history as an endless skein of cloth smocked in a complex, overall pattern by the needle and thread of Power. You need only pull the thread at one place to find it connected to another.

Nevertheless, within certain limits, the method does work to reopen negotiations between literary and historical studies. For the literary critic, the analogies drawn between Harriot's text and Shakespeare's represent a crucially important move toward expanding the frame of our analysis to include extraliterary texts. This is not all we need to do, obviously, but it is just as obviously a necessary precondition for any historicist critical practice. Secondly, insofar as Shakespeare's theatrical practice has been resituated within a set of historically specific political conditions themselves rendered potentially "readable" by reference to "theatrical power," Greenblatt's argument has much to teach any historican who still regards cultural evidence as merely secondary. In other words, a "cultural poetics" of Renaissance power is useful for both literary critics and historians working on the Elizabethan period, since it can enrich the discursive field on which both depend. But a good deal—one might even say everything—depends upon how this field is defined and how one frames one's analytic object within it, if it is to support a genuinely historicized analysis. One way to begin addressing these

issues is to focus more directly on the political implications of the procedures I have tried to identify in this essay.

AS WE have seen, what enables the argument to get under way is the initial displacement of the "subversive" from culture to text which we first noted in Greenblatt's treatment of Menocchio. If, as I have argued, this move marginalizes the larger discursive space of history, with serious methodological consequences for a new historicism, what is its effect on the "subversive"?

Quite obviously, if the subversive is displaced from the realm of the subordinate culture—whether that of the Italian peasantry or the Algonkians—to the orthodox texts authorized by the dominant culture, the orthodox discourse *necessarily* produces the subversion it contains. Where else could it come from, once it has been so displaced? In other words, no doubt subversion *is* both produced and contained by Harriot's discourse, just as Caliban is Calibanized in order to be neutralized and recontained, but the "subversion" in question cannot be construed as referring to any form of resistance or opposition arising beyond the boundaries of this dominant discourse. But if this is the case, then we have, to quote Oliver North, a separate, free-standing, full-service operation, in which a dominant discourse is busily producing and recontaining its own subversion.

Now there is no question but that this can happen, at least in certain specifiable historical conditions. As Michael Rogin's recent work demonstrates, there is no doubt that twentieth-century American politics has been heavily effected by precisely such an ideological operation. The alleged threat of Communism still provokes a virulent countersubversiveness on the part of the state, and there is surely no question, in the wake of Oliver North's performance, about the astonishing efficacy of countersubversive ideology as an apparent infinite resource for fueling state power.[22]

But in Greenblatt's argument, this operation is at once localized within a dominant discourse and then totalized. The most stunning example of how such totalization works to erase subversiveness is to be found in Greenblatt's treatment of the Algonkians' theory of "invisible bullets" as a precursor of modern medicine's germ theory. It is Harriot's recording of this as well as other

Algonkian responses to the lethal effects of the English which specifically provokes Greenblatt's question about why "power" should "record other voices" (p. 50). As we have already seen, his answer rhetorically expands the provenance of power and facilitates its essentialization, but when we observe more closely how the question is posed, its political implications become clearer.

Greenblatt first notes that "for the English the deaths must be a moral phenomenon," which only occurred, in Harriot's words, in those towns "where they used some practice against us," and then he draws our attention to the invisible bullet theory which so "uncannily resembles our own" (pp. 49, 50). Since this theory "metaphorically" represents the modern one which will "ultimately triumph over the moral conception of epidemic disease" to which Harriot's account testifies, Greenblatt concludes that "in the very moment that the moral conception is busily authorizing itself, it registers the possibility (indeed from our vantage point, the inevitability) of its own destruction." It is in the light of this "inevitability" that Greenblatt asks why power should "permit subversive inquiries" and thus "register at its very center the transgressions that will ultimately violate it" (p. 50). But if the "transgressions" that will finally "violate" Harriot's moralized reading and the power served by such a reading lie centuries ahead, it is a little difficult to see how they can represent the subversive within the specific historical context under consideration. As it turns out, they represent a concept of the "subversive" which, like the concept of power upon which it depends, transcends historical specificity.

For how else are we to understand the account which follows, of "how our perception of the subversive and the orthodox is generated"? The "subversive is for us," Greenblatt says, "a term used to designate those elements in Renaissance culture that contemporary authorities tried to contain . . . and that now conform to our sense of truth and reality," such as, for instance, a metaphorical version of germ theory. "Conversely," what was orthodox in the Renaissance is defined as what we would find "subversive for ourselves: religious and political absolutism, aristocracy of birth, demonology," etc. Accordingly, it follows that

if "we do not find such notions subversive," this is because we inhabit a "version of the process of containment that licensed what we call the subversive elements in Renaissance texts: that is, our own values are sufficiently strong for us to contain almost effortlessly alien forces" (pp. 52–53). The effortlessness with which we can today contain such alien and subversive forces as demonology, aristocracy, and so forth is no more remarkable than the effortlessness with which Harriot and his contemporaries contained the "subversive" threats posed by the Algonkians' prescient version of germ theory, since in neither case are the subversive threats in question historically salient. Indeed, as defined here, subversion is evacuated from history altogether, or perhaps it would be more accurate to put it that all historicity had been evacuated from subversion. In any case, such an ahistorical approach to their relationship accords prescriptive force to Kafka's line about hope which Greenblatt adapts in his conclusion to this section of the essay: "There is subversion, no end of subversion, but not for us" (p. 53).[23]

It is because a specific ideological operation has been totalized as a paradigm of power *per se* that these peculiar definitions can be presented. Power is reified into a monolithic presence, always already invested in, determined by, and flowing from and back to the dominant cultural and political authorities. And thus reified, "power" can travel. As we have already seen, the "power" of the nineteenth century outlined by Foucault's vision of "a massive police apparatus, a strong, middle-class nuclear family," etc., will have one set of cultural results, while "Elizabethan power" will have another (p. 57). Power, in this view, is historically specifiable only at the level of abstraction at which a social, economic, or cultural dominance is expressed in different forms at different times. One may investigate how those forms (aesthetic, cultural, social, etc.) produce their own subversions, if one wants to do that. But one is by definition limited to addressing the cultural economy of domination from a standpoint which simply reiterates a tautology—that domination dominates. By an appeal to often riveting anecdotes drawn from "local episodes" and "particular historical encounters," this tautology takes on the clothing of historical specificity, so that each time that it is found, once

again, that resistance or opposition serves the interests of the powerful, the conclusion seems to be derived from a densely textured understanding of a particular, historically localized cultural space.[24] But this tendency to find that "any apparent site of resistance ultimately serves the interests of power," which Walter Cohen is not alone in seeing as characteristic of much Renaissance new historicism, is not empirically grounded in the discursive analysis it displays.[25] It is built into a procedure which frames the discursive field in such a way that sites of potential or actual resistance are either excluded from that field or incorporated within in it in terms that confirm the tautology's rule.

It is important to note that the problem here is not a function of the limits of discourse. The problem lies rather in being limited to one set of discourses—those which form the site of a dominant ideology—and then reifying that limit as if it were coterminous with the limits of discourse in general. It is this issue of framing the discursive field that new historicists need most urgently to address.

As we all know by now, the relation between the literary and the historical has been radically reproblematized. To put it far too simply, in trying to approach literature as a historically situated cultural phenomenon, we no longer regard "history" as a given backdrop against which to see the literary text. Literature is neither something that springs forth from that backdrop, spotlighted by its transcendent expression of "the human spirit," nor is it the result of the fellow working the lights, exposing it within a fixed, historically "set" scene. Neither lamps nor mirrors will do anymore.

Further, the metaphor of the stage itself breaks down, as was already remarked in Wallace Stevens' "Of Modern Poetry." According to Fredric Jameson, the entire range of conceptual models dependent on depth (e.g., essence/appearance, latent/manifest, authenticity/inauthenticity, signifier/signified) has given way to "a new kind of flatness or depthlessness" which he finds characteristic not only of postmodernist art, but of contemporary theory as well.[26] No longer on, or behind, or in front of a stage, we instead inhabit a discursive field.

Jameson's model of depthlessness is useful as a way of reori-

enting ourselves theoretically, but it can easily lead us to misconstrue that discursive field, if "depth" is taken to refer to a realm which lies outside of discourse, for this would be to misunderstand Derrida's claim that there is nothing outside the text. The "text" for Derrida encompasses the entire range of the discursive field, within which intradiscursive depth is everywhere apparent. As Jameson's own work reveals, he cannot readily function without making the moves the depth models facilitated. A "political unconscious" presupposes at least some version of the "repressive hypothesis" which Foucault tried to undermine. The discursive field which Derrida designates as a text is not depthless in the sense of being flat, or two dimensional, nor does it preclude repressive operations. On the contrary, repression is foregrounded, put on display as an engine of the signifying process.

From this point of view, one might well argue that a major virtue of Derrida's critical perspective for the purposes of a historicist criticism lies in its capacity to keep in focus, within the intradiscursive depths of signification, the work of repression, exclusion, "othering," but also of the resistance and subversion that is always at work there. So much is evident in Derrida's recent discussion of the truth of pain that lies beneath, and resists, the rhetoric of apartheid in "Racism's Last Word."[27] Derrida's assertion that there is nothing outside the text (that there is no Transcendental Signified) is not the same as the assumption that there is nothing outside the range of the dominant ideology. Foucault's perspective on the discursive field apparently fosters this tendency in new historicist practice—a tendency to exclude, which is a necessary precondition for addressing a particular cultural discourse, but then to repress the fact of that exclusion, so that a particular discourse, or set of discourses, come to stand for the horizonless field of Discourse. Indeed, one might put it that this notion of the discursive field is itself a reification of the Derridean "Text." In short, if we are to use "the discursive" as a basis for relating literary and extraliterary discourse, we need to consider seriously the consequences—both theoretical and political—of a repressed exclusion.

Lukács might be helpful in such a consideration. He addressed a related problem in his analysis of Kant's thing-in-itself as a

formalized barrier of rationalist thought that serves to place off-limits the irrational realm previously recognized as, and/or propitiated through, magic, ritual, or religion (as in "Fortune is a woman."). According to Lukács, Kant's thing-in-itself renders this realm unknowable, by definition, to the rational subject of modern science. The binary of phenomenal/noumenal henceforth functions to repress as unknowable all that cannot be comprehended within Kant's rational system, including—most importantly for Lukács—any nonreified consciousness of history and its active human subjects. For our purposes, it might be fruitful to consider whether other binaries, such as *langue/parole* in Saussure, symbolic/imaginary in Lacan, and form/content, function in the same way. That is, they might be viewed as serving to repress, exclude, occult the area designated by the second term as unknowable in itself, treating it as a precondition for, or substratum of, the knowable territory marked by the first term.

From this vantage point, new historicists might consider whether the potential scope of discursive analysis is not seriously limited by a functional equivalent of Kant's thing-in-itself, as analyzed by Lukács. For example, in reference to Greenblatt's argument, one might put it that while there is no Algonkian-in-itself, no extra-discursive Algonkian, this does not mean that those "othered" by colonial discourse reside beyond the boundaries of the discursive. Not even the Algonkians. Scholarship in colonial ethnohistory and Native American history has made available a good deal of information about the language and culture of the Indians who first encountered Europeans. Greenblatt is clearly aware of this scholarship when he acknowledges the separate "history of . . . English-Algonkian relations" with which he is not concerned ("Invisible Bullets," p. 47). Insofar as what is excluded here can be understood as a range of discursive practices, the procedure is quite legitimate. That is, Greenblatt is by no means *logically* obliged to address the interdiscursive relations between the Indians and the English. Of course, one might argue that he is *politically* obliged to say more than this about all that such a limit excludes, yet even a critic as politically oriented as Edward Said falters when he tries to justify a similar exclusionary move. When he focuses his analysis in *Orientalism*, for example, Said remarks,

"There were—and are—cultures and nations whose location is in the East, and their lives, histories, and customs have a brute reality greater than anything that could be said about them in the West. About that fact this study of Orientalism has very little to contribute, except to acknowledge it tacitly."[28] Despite the reference to "brute reality," the analytic focus whose limits are here acknowledged seems to me entirely justifiable. Said wishes to address the West's discourse about various Eastern cultures in which different and quite heterogeneous discourses abound, but are placed off limits for the purposes of his analysis. By the same token, Greenblatt wishes to address a dominant discourse in which the appropriation of "other voices" is part of a process by which power produces subversion; those "other voices" may be generating a separate set of discursive practices, but this is not what concerns him here (p. 50). Yet is this precisely what is being excluded here? No. For the Algonkians are nonliterate, and further, untextualized, save through the distorting texts of Harriot and others like him. Consequently, the limit here acknowledged between the Algonkians' culture and that of the English functions as if it defined the boundary between the nonliterate and untextualizable, on the one hand, and the literate and textualized on the other. This coincidence, as it were, falsely equates the line dividing literate from nonliterate with that which marks the boundary of the discursive field. Two consequences, at least, may be seen to follow.

First, ironically enough, Greenblatt's exclusion of the Algonkians from his analytic focus effectively leaves nothing but the Algonkian-in-itself. That is, the Algonkians are there. They are recognized as existing, but, in effect, only as a "brute reality," since not only are their own cultural responses to invasion necessarily filtered through the invader's textualization of them, but their potential cultural agency is eradicated. So there are Algonkians there, but they might as well be unknowable, and it doesn't matter that this is the case, since, politically, they lack the capacity for agency which inclusion within a discursive field would entail. Secondly, the political implications of this false equation become apparent when the analysis shifts its focus from the New World to the Old. For when the same relations of production

between power and subversion are found at work in Prince Hal's relations with Falstaff and his subversive milieu, a crucial fact has been occulted—that the specific forms of resistance and opposition at work among England's masterless men are by no means always coming from the nonliterate, at least not in the sense that the Algonkians were nonliterate. In other words, there is a distinction of some importance to be made between the subordination of a nonliterate culture in the New World and the control of at least partially literate, partially textualized oppositional cultures in the Old.

It is not that the latter speak for themselves in some alternate set of purely oppositional texts; questions about the circuits of appropriation and exchange across a range of discourses remain. That is, as with the slave's narratives published in the United States during the antebellum period, the oppositional discourses of such subordinated people are by no means pure expressions of resistance: they are rather, in Bakhtinian terms, multivoiced discourses in which both dominant and oppositional ideological voices may be heard. And indeed, since the slaves' narratives quite regularly "rehearse"—to use Steven Mullaney's term—the dominant culture's ideologies,[29] these voices are by no means invulnerable to the neutralizing force of containment. But once seen as belonging to a heterogeneous discursive field, they may finally be contained, but they cannot be denied agency. By the same token, the "masterless" men of Elizabethan England may ultimately be subdued, disciplined, controlled, but their subversive resistance cannot be understood simply as the product of the dominant culture's power. Thus, the political economy by which Falstaff's oppositional force is recontained no doubt conforms in many respects to Greenblatt's descriptions of it, but the point is won by means that falsely totalize that model of political economy by weighting the scales against the oppositional culture. What most clearly weights the scales is the appeal to a colonial relation, in which the culture being subordinated is nonliterate, as a model for understanding the subordination of literate and semiliterate native opposition.

I would insist that neither of these cultures is without agency

of some sort, but it is, after all, easier in some ways to "other" a people whose language you need not even bother translating, unless you are John Eliot and are willing to textualize it first, than one whose polyglot vernacular can be deployed to foster a threatening ideological opposition. This is no doubt one reason that, as Steven Mullaney notes, Elizabethans appealed to a "commonly drawn analogy" between the "ethnics of the Americas" and "Indians in Cornwall, . . . Wales, . . . Ireland" (pp. 49–50). From the vantage point of those drawing on such an analogy for the political purposes of subordinating such homegrown Indians, the category of the Other so well established in the kind of discourse of which Harriot's is one example is already convenient and ready to hand for "othering" those native groups which resisted subordination—a process which subsequent events in England through 1660 would suggest was nonetheless not easy at all.

Despite these consequences, Greenblatt's appeal to colonial examples proves far less egregious in its effects than Steven Mullaney's in the article to which I have been referring, "Strange Things, Gross Terms, Curious Customs: the Rehearsal of Cultures in the Late Renaissance." This essay's procedures resemble those we have seen in Greenblatt's "Invisible Bullets" in many respects, but more pertinent here is a striking difference—the difference made by Greenblatt's at least minimal acknowledgement of the Algonkians. For Mullaney's argument suggests that if the colonized others are not at least recognized as having a separate existence, as in Greenblatt's essay, then it is all too easy for the analysis to re-enact the discursive practice of effacement and appropriation that it is ostensibly disclosing.

Mullaney addresses the alien, the marginal, the other as an already constituted category of analysis, and it proves a remarkably commodious one. The "strange things" of Mullaney's title refer not only to the "curiosities gathered from around the world" which are collected and exhibited in Walter Cope's "wonder-cabinet," but finally to everything "perceived as alien, anomalous, dissimilar, barbarous, gross, or rude" at the time (p. 43). From the outset, then, the marginal is always already a cultural product of a dominant discourse: "what the period could not

contain within the traditional order of things, it licensed to remain on the margins of culture," where it was "maintained and produced as something Other" (pp. 43, 44).

The crux of the argument concerns one particular way in which this production and maintenance of the Other is effected, that is, through a "process of cultural production synonymous with cultural performance," which Mullaney designates as a "rehearsal of cultures," during which the "distinction between the alien and its representation . . . virtually ceases to exist" (pp. 43, 48, 45). An extended anecdote serves to describe what is meant by "rehearsal." The story is told about how, in 1550, the French reproduced at Rouen a Brazilian forest replete with two villages "stocked with over fifty Tabbagerres and Toupinaboux Indians freshly imported for the occasion" (p. 45). What is most noteworthy about the events at Rouen is a paradox. A highly elaborate and detailed reproduction of Brazil was erected, but then destroyed during the dramatized enactment of tribal battles performed for Henry II and Catherine as they entered the city. Thus, on the one hand, Rouen tells the same story as the wonder-cabinet; just as in the latter "the New World coincides with the Old," here "the New World is both recreated in the suburbs of the Old and made over into an alternate version of itself, strange but capable of imagination" (p. 46). On the other, it adds a dramatic new element to the picture of the "rehearsal of cultures," for the "consumption of Brazil," as Mullaney calls it, demonstrates not only the re-presentation of an "alien culture," but its "effacement" as well (p. 48). In a move now familiar to us, Mullaney then notes that Rouen's treatment of Brazil "was by no means reserved for New World cultures" (p. 49). Whereupon we are back in England, where the "genealogy" of the "rehearsal of cultures" is traced to "the reign of Edward I, whose colonization of Wales in the thirteenth century" is to be understood as a rehearsal of the "subcultural excursions of sixteenth-century England" (p. 49). This transition felicitously accomplishes at once two strategic imperatives: it shifts the focus from the "merely colonial" to English domestic culture, and it regrounds the analysis in "the larger dramaturgy of power" (p. 49).

The shift from New World to Old is made easier for Mullaney than it was for Greenblatt by the fact that "the field cleared by the

conflagration of Brazil was, of course, French to begin with" (p. 45). But what makes Mullaney's job easier is also what makes more obvious the strategic function in this essay of those "strange things" brought home from abroad, among which are those "genuine Brazilians" imported by the French (p. 45). The use made here of the colonial as a resource for telling anecdotes makes it clear that such choices serve to constitute the "marginal" as always already subordinated, dominated, othered. It matters not at all, for instance, whether the "alien culture" being "represented" and "effaced" at Rouen is literate, textualized, or resistant to European domination, since what is true of the Europeans being analyzed is also true of Mullaney's analysis—for both, that is, the "distinction between the alien and its representation" has "ceased to exist" (pp. 48, 45). The Europeans' "rehearsal of cultures," after all, amounts finally to a discursive practice of appropriation and effacement aimed at the discursive "erasure or negation" of the alien cultures they were trying to subordinate (p. 48). Properly speaking, it is part of what will produce and sustain a colonialist ideology. But in Mullaney's essay, a similar discursive "erasure or negation" of the heterogeneous cultural spaces in which those being subordinated may also have been engaged in their own discursive practices is not only presupposed—as a historical inevitability—but also re-enacted, in the sense that the entire discursive space of the colonial is raided for cultural anecdotes and then marginalized as "merely colonial" (p. 49). This procedure, then, enables him at once to exclude from his frame and to appropriate as exemplary the case of the already muted other.

The use of anecdotes is one of the techniques most often remarked upon by the more skeptical members of new historicism's audience. Although it may yet prove possible to demonstrate the value of an anecdotal method, I would suggest that anecdotes which serve as illustrations of what the analysis will in turn treat as an interpretive model cannot historicize either the model in question or the analysis that is built upon it.[30] On the contrary, it seems to me that they serve as a "marginal" upon which literary analysis itself operates in much the same way that Mullaney's argument operates on the events at Rouen—to appropriate the

"strange things" to be found outside the "literary," while effacing the social and historical realm that produced them, at once plundering and erasing the discursive spaces to which the argument appeals. This operation, in effect, retextualizes the extraliterary as literary. I would call it Colonialist Formalism, not new historicism.

Among the central theoretical issues still to be addressed by new historicists, then, are two related ones: first, how one frames the discursive field under consideration, and second, how one proceeds to analyze what is going on there. I have said a good deal more about the first issue here than the second, which—I readily admit—is the more difficult one. But what I wish to stress in closing is that both of these issues have political dimensions. To historicize literary discourse does not entail any particular politics, but it does, necessarily, assume or imply some politics. For if one asks the quite basic question, "Why historicize?," it soon becomes evident that however one responds, certain political assumptions are at work. New historicists, along with everyone else involved in this enterprise, need to address that question squarely.

Finally, in answer to the question posed in my title, I would say, no, we are not being historical yet. But that is not for lack of trying. As I indicated at the outset, there has been a lot of groundwork done, both theoretical and practical. And as I have tried to indicate in my critique, new historicism deserves encouragement as a part of that effort. For I share with at least some new historicists the view that it ought to be possible, once we are licensed to explore the horizonless field of the social text, to produce not only a cultural poetics—as valuable as this might be—but more ambitiously, a cultural critique. Freed from static "world pictures," and faced with the opportunity to approach literary texts as agents as well as effects of cultural change, as participating in a cultural conversation rather than merely representing the conclusion reached in that conversation, as if it could have reached no other—at least partially freed from these tired habits and the collapsed assumptions on which they rested, we ought to be able to produce a criticism that would at least make significant strides toward understanding "language in history: that full field."[31]

Notes

1. Edward Pechter, p. 292 of "The New Historicism and Its Discontents: Politicizing Renaissance Drama," *PMLA* (May 1987), 102:292–303.

2. Stanley Fish, *Is There a Text in This Class?* (Cambridge and London: Harvard University Press, 1980), p. 367.

3. On new pragmatism, see Steven Knapp and Walter Benn Michaels, "Against Theory," *Critical Inquiry* (1982), 8:723–742; Fish, *Is There a Text in This Class?*, p. 198; Cornel West, "The Politics of American New-Pragmatism," in John Rajchman and Cornel West, eds., *Post-Analytic Philosophy* (New York: Columbia University Press, 1985), pp. 259–272; and Frank Lentricchia, "The Return of William James," *Cultural Critique* (1986), 4:5–32.

4. Pechter's article appeared after I had written the paper of which this is a revised and expanded version. There are several points of agreement between us, especially in our critiques of Stephen Greenblatt's work, and specifically in reference to the consequences of Foucault's influence. But our agreement derives from quite different premises and leads to quite different conclusions. Like Pechter, I object to the way in which new historicists appeal to colonialism, but not because such a focus *can* be marginalized by other readings, as he argues, but rather because it *is* marginalized by theirs.

5. The literature on these issues is, needless to say, extensive. A sample of its scope and complexity may be deduced from Fredric Jameson, *The Political Unconscious: Narrative as a Socially Symbolic Act* (Ithaca: Cornell University Press, 1981); Jean Baudrillard, *Mirror of Production* (St. Louis: Telos, 1975); Louis Althusser and Etienne Balibar, *Reading Capital* (New York: Pantheon, 1970); Louis Althusser, *For Marx* (London: Verso, 1979); Raymond Williams, *Marxism and Literature* (London and New York: Oxford University Press, 1977) and *Politics and Letters* (London: Verso, 1979); E. P. Thompson, *The Poverty of Theory* (London: Merlin, 1978); Gayle Rubin, "The Traffic in Women," in Rayna Rapp, ed., *Toward an Anthropology of Women* (New York: Monthly Review Press, 1975); Ernesto LaClau and Chantal Mouffe, *Hegemony and Socialist Strategy* (London: Verso, 1985); and Norman Geras, "Post-Marxism?," *New Left Review* (1987), 163: 40–80.

6. According to Montrose, in "Renaissance Literary Studies and the Subject of History," *ELR* (1986), 16:5–12, among the "alternative conceptions" to which new historicism opposes itself is the classical Marxist view of literature as "a superstructural manifestation of an economic base" (p. 8). Greenblatt has also made clear his desire to avoid any critical approach that regards literature as "being absorbed entirely into an ideological superstructure"; see his *Renaissance Self-Fashioning: From More to Shakespeare* (Chicago: University of Chicago Press, 1980), p. 6.

7. Stephen Greenblatt, p. 5 of "Introduction," in Stephen Greenblatt, ed., *The Forms of Power and the Power of Form in the Renaissance* (Norman: University of Oklahoma Press, 1982), 3–6.

8. See Williams, *Marxism and Literature*, and Greenblatt, *Forms of Power*.

9. Two developments may serve to support this point. One is the effort to construct what Roy Harvey Pearce, in *Historicism Once More* (1969), called new

historicism, a project which achieved its most fruitful expression in Wesley Morris' *Towards a New Historicism* (Princeton: Princeton University Press, 1972). The other is the American Studies movement, which began much earlier, reaching its first significant expression with Henry Nash Smith's *Virgin Land* (Cambridge: Harvard University Press, 1950). In the last twenty years, American Studies has generated a variety of approaches toward the historicization of literary and cultural studies. For an excellent review of American Studies scholarship, especially as it is related to Marxist cultural studies, see Michael Denning, "The Special American Conditions: Marxism and American Studies," *American Quarterly* (1986), 38:356–380. For an incisive review of Americanist literary studies in relation to theoretical issues bearing on historicization, see John Carlos Rowe, "Deconstructing America: Recent Approaches to Nineteenth-Century Literature and Culture," *ESQ* (1985), 31:49–63.

　　10. In "The New Historicism and Its Discontents," Pechter says that "cultural materialism" is Dollimore and Sinfield's "phrase for the new historicism" (p. 299). In fact, in his introduction to *Political Shakespeare: New Essays in Cultural Materialism*, ed. by Jonathan Dollimore and Alan Sinfield (Ithaca: Cornell University Press, 1985), pp. 2–17, Dollimore addresses "some of the . . . important and shared concerns of cultural materialism and the new historicism" (p. 4). Although Dollimore clearly sees the two movements as distinct, Don Wayne has recently criticized *Political Shakespeare* for failing to attend as thoroughly as it should to the historical and political differences between them; see Wayne's "Power, Politics, and the Shakespearean Text: Recent Criticism in England and the United States," in Jean Howard and Marion O'Conner, eds., *Shakespeare Reproduced* (London and New York: Methuen, 1987), pp. 47–67. Louis Montrose makes a similar point in "Renaissance Literary Studies" when he notes the difference between the labels themselves: "Predictably, English 'Cultural Materialism' (a term with an explicitly contestatory resonance) remains a marginal academic discourse, whereas American 'New Historicism' (a term appealing to our commodifying cult of the new) is on its way to becoming the newest academic orthodoxy" (p. 7).

　　11. See Raymond Williams, *Writing and Society* (London: Verso, 1984), p. 189, for a lengthy gloss on "that full field." On the Centre for Contemporary Cultural Studies, see Michael Green, "The Centre for Contemporary Cultural Studies," in Peter Widdowson, ed., *Re-reading English* (London and New York: Methuen, 1982), pp. 77–90.

　　12. At least as early as 1981, for example, Williams emphasized that "cultural materialism is the analysis of all forms of signification, including quite centrally writing, within the actual means and conditions of their production," and went on to note that his work had "found new points of contact" with the "radical semiotics" of "deconstruction," so that "a fully historical semiotics" might well come to resemble "cultural materialism" (*Writing and Society*, pp. 208–210).

　　13. Louis Montrose, "Renaissance Literary Studies and the Subject of History," p. 5.

　　14. The question of how exemplary Greenblatt's work may be is vexed. My aim here is neither to characterize *all* of Greenblatt's own work nor to treat it as a definitive example of *all* new historicist criticism. Rather, my point is to identify certain problems evident in at least one instance of Greenblatt's work, since these problems seem to me—and to others—to haunt other corridors of the new histo-

ricism. See Walter Cohen, "Political Criticism of Shakespeare," in Howard and O'Connor, *Shakespeare Reproduced*, pp. 18–46; Jean Howard, "The New Historicism in Renaissance Studies," *ELR* (1986), 16:13–43; and Jonathan Goldberg, "The Politics of Renaissance Literature: A Review Essay," *ELH* (1982), 49:514–542.

15. I will refer primarily to the earlier and shorter version of this essay, which appeared in *Glyph* (1981), 8:40–61. The second version, which appeared in Dollimore and Sinfield, *Political Shakespeare*, pp. 18–47, differs in two essential respects, only one of which is pertinent to my criticism. The reading of *I Henry IV* is more fully elaborated, but not altered in its basic perspective, but the Menocchio anecdote *is* omitted.

16. As Anne Middleton suggests in her unpublished paper, " 'New Historicism' and Medieval Studies: A Report from the Time Warp," depending upon how one frames the larger context, one might regard Menocchio's views as unexceptional within the oral, peasant culture, but *rendered* subversive by the Inquisition's own "oppositional" intervention in that culture; from this viewpoint, Menocchio's beliefs might turn out not to be as "heterodox" as both Ginzburg and Greenblatt think. I am indebted to Anne Middleton for sharing her paper with me. For yet a different critique of Ginzberg, see Dominick LaCapra, *History and Criticism* (Ithaca: Cornell University Press, 1985).

17. There are, of course, other ways to relate text and culture. Adorno and Benjamin tried to do so by means of a dialectical image; Goldmann tried a rigorous theory of homology. Neither approach proved thoroughly satisfactory, but both at least addressed the issues involved at some depth. See Theodor Adorno, *Negative Dialectics* (New York and London: Seabury Press, 1973); Walter Benjamin, *Illuminations* (New York: Harcourt, Brace and World, 1968); and Lucien Goldmann, *The Hidden God* (New York: Humanities Press, 1964). For problems with these approaches, see Fredric Jameson, *The Political Unconscious*, especially chapter 1, and Jameson et al., eds., *Aesthetics and Politics* (London: Verso, 1977); Williams, *Marxism and Literature*, especially chapter 1; and Eugene Lunn, *Marxism and Modernism* (Berkeley: University of California Press, 1982).

18. Michel Foucault, "Truth and Power," in Colin Gordon, eds., *Power/Knowledge* (New York: Pantheon, 1980), p. 119.

19. Ibid., p. 120.

20. Michel Foucault, *The History of Sexuality* (New York: Random House, 1978), p. 93.

21. Representative critiques of this tendency in Foucault may be found in Charles Taylor, "Foucault on Freedom and Truth," in David Hoy, eds., *Foucault: A Critical Reader* (New York: Basil Blackwell, 1986, pp. 69–102; Lentricchia, *Ariel and the Police* (Madison: University of Wisconsin Press, 1988), pp. 29–102; and Peter Dews, *Logic of Disintegration* (London: Verso, 1987), pp. 144–170. But it should also be noted that Foucault can be read quite differently, particularly if we attend to the political conditions in and against which his project took shape. As I hope to make clear in another place, the most radical potential of Foucault's project lies in his effort to chart the new territory of the discursive by means of a "genealogy" he described as a form of tactics" designed "to emancipate" "subjugated knowledges," to "render them, that is, capable of opposition and of struggle versus the coercion of a theoretical, unitary, formal and scientific discourse" (*Power/Knowledge*, pp. 85, 81). The translation here of "emancipation" to the

different register of "opposition" and "struggle" is characteristic of Foucault's larger purpose—a concerted attack on the discourse of liberation politics, with its vocabulary of repression, subjects, truth, humanism, and freedom, in the interests of an "insurrection of subjugated knowledges"—both popular and erudite—inscribed with "the memory of hostile encounters" (*Power/Knowledge*, pp. 81, 83).

22. See Michael Paul Rogin, *Ronald Reagan, the Movie, and Other Episodes in American Demonology* (Berkeley: University of California Press, 1987).

23. It is noteworthy that this vision of subversion—as that which looms across an always receding horizon, always dreamed of, but never realized—resembles a tendency Tony Bennett has recently noticed in certain strains of deconstructionist criticism, which "keeps alive the demand for transcendence simply by neverendingly denying its possibility—a criticism of essentialism which can rapidly become a lament for its loss, a consolation for the limitations of the human condition which is simultaneously a recipe for political quietism"; p. 66 of "Texts in History: The Determinations of Readings and Their Texts," in Derek Attridge, Geoff Bennington, and Robert Young, eds., *Post-Structuralism and the Question of History* (Cambridge: Cambridge University Press, 1987), pp. 63–81.

24. Stephen Greenblatt, p. 164 of "Shakespeare and the Exorcists," in Patricia Parker and Geoffrey Hartman, eds., *Shakespeare and the Question of Theory* (New York: Methuen, 1985), pp. 163–187.

25. See Walter Cohen, "Political Criticism of Shakespeare," in Howard and O'Connor, eds., *Shakespeare Reproduced*, pp. 18–46.

26. Fredric Jameson, p. 60 of "Postmodernism, or the Cultural Logic of Late Capitalism," *New Left Review* (1984), 140:53–92.

27. See Jacques Derrida, "Racism's Last Word," *Critical Inquiry* (1985), 12:290–299, and his "But, beyond . . . (open letter to Anne McClintock and Rob Nixon)," *Critical Inquiry* (1986), 13:155–170.

28. Edward Said, *Orientalism* (New York: Random House, 1979), p. 5. I am grateful to Michael Harper for directing my attention to the relevance of Said's statement.

29. See Steven Mullaney, "Strange Things, Gross Terms, Curious Customs: The Rehearsal of Cultures in the Late Renaissance," *Representations* (1983), 3:40–67.

30. In an unpublished paper which he graciously shared with me, Joel Fineman argues that anecdotes may well be the sole means of historicizing literary texts. For skepticism about anecdotes, see Cohen, "Political Criticism of Shakespeare," in Howard and O'Connor, *Shakespeare Reproduced*, and Howard, "The New Historicism in Shakespeare Studies."

31. Raymond Williams, *Writing and Society*, p. 189. I would like to thank the following friends and colleagues who read and commented on one version or another of this essay: Janet Adelman, Sacvan Bercovitch, Mitchell Breitwieser, Jim Breslin, Joel Fineman, Cathy Gallagher, Gayle Greene, Michael Harper, Richard Hutson, Anne Middleton, David Minter, Kathleen Moran, Pat O'Donnell, and Michael Rogin. Many disagreed with my argument, some violently, but all were helpful, some crucially.

2

SOME STATEMENTS AND TRUISMS ABOUT NEOLOGISMS, NEWISMS, POSTISMS, PARASITISMS, AND OTHER SMALL SEISMISMS

Jacques Derrida

(Translated by Anne Tomiche)

WHEN I started preparing for this symposium, I realized I had misread the suggested title. Probably because of a lack of attention I had read, instead of "The States of 'Theory'" (with states in the plural and "theory" in quotation marks), "The State of Theory" (with state in the singular and theory without quotation marks).

And I thought that the answer to this question—What is the state of theory today?—was then self-evident, it was obvious, hic et nunc. The state of theory, now and from now on, isn't it California? And even Southern California?

You take this as a play on words or as a way of avoiding the issue. But this answer may be more serious, more realistic, more historical, and "historian" than it seems.

This symposium—under this title, with these participants coming from other states (American and non-American states) to think together about "theory" today—why do you think it is happening in California? Why do you think it is possible and

necessary in Southern California? Do you think it is just a coincidence?

Try to analyze the phenomenon of this colloqium, in its various dimensions—politico-institutional, socioeconomic, psychohistorical, phantasmatical-libidinal—and I bet that the passages which necessarily occur between the two meanings of the word "state" will impose themselves upon you.

The play between the two states of the word state is more than mere play. The mark of the plural might emphasize, in the mind of the organizers whom I didn't consult, that several meanings can be given to the word "state"—one of which must be assigned to the geopolitical, to the geography and politics of theory, in the United States and elsewhere.

Once I got over my distraction and paid closer attention to the title, I saw both the plural and the quotation marks.

Before even beginning to suggest a few comments about "the states of 'theory,' " I would like to tell you how I interpreted the plural and quotation marks. They indicate an extreme cautiousness on the part of the organizers. I presume that they didn't want to appear to be presuming that there might be a single possible state of theory—the theory—that is the possibility of totalizing all theoretical phenomena, all theoretical productions, all theorems in a chart, a table, hence in a legible surface, which would, like any stable and stabilized table, allow for the reading of the taxonomic tabularity, the entries and the places, or else the genealogy, finally fixed in a tree of theory, of identities, entities and names—whether common or proper—of theory. A botanical table.

The plural of states destabilizes or points out the instability, indeed the essential destabilization of such a table—a *table* which never goes without the corresponding and hierarchizing structure of an *establishment*.

What this plural calls into question, I told myself, is therefore the very possibility of a discourse which would today quickly assume such a taxonomic objectivization—an assumption made by so many people, within and outside the university, when the *doxa*—which must nevertheless always be taken seriously—plays with the titles of theories and theorems as with chessboard pieces: New Criticism, structuralism, poststructuralism, postmodernism,

post-Marxism, new historicism, and so on. In fact we cannot—
who could?—and hence we must not claim to put before our very
eyes, in front of our faces and face to face, theorems, theoriza-
tions, theories which share or postulate a field which surely isn't
common and unifiable, indeed identifiable.

Structural reasons make this static and taxonomic tabulariza-
tion impossible in its very principle—or limited in its possibility.

Here is the first reason: the open and nonunified field of this
"States General" is also a field of forces; in their usual phenom-
ena and titles, those forces may be called libidinal forces, politi-
cal-institutional or historical-socioeconomic forces, or concurrent
forces of desire and power. Forces never go without their repre-
sentations, their specular images, the phenomena of refraction
and diffraction, the reflection or reappropriation of distinct or
opposite forces, the identification with the other or the opponent,
etc.—so many structures which divide each identifiable force,
de-identify it, displace it in its very proliferation.

In this field of plural forces, where even counting is no longer
possible, there are only theoretical *jetties*. By the word "jetty" I
will refer from now on to the *force* of that *movement* which is not
yet *subject*, *project*, or *object*, not even rejection, but in which
takes place any production and any determination, which finds
its possibility in the jetty—whether that production or determi-
nation be related to the subject, the object, the project, or the
rejection.

Each theoretical jetty—as well as its reappropriation as a the-
oretical set, a theory with its axioms, its methodical procedures,
its institutional structures—enters *a priori*, originally, into con-
flict and competition. But it isn't only a matter of antagonism, of
face to face confrontation, that is, a matter of *opposition* between
two jetties which would face each other with their own stabilized
identities. It isn't an *antagonistic* confrontation, for two correla-
tive reasons.

The first reason is that each *jetty*, far from being the part in-
cluded in a whole, is only a theoretical jetty inasmuch as it claims
to comprehend itself by comprehending all the others—by ex-
tending beyond their borders, exceeding them, inscribing them
within itself. Each jetty is structured, constructed, designed in

order to explain and account for all the other jetties (past, contemporary, and yet to come). And no jetty could escape from such a constitutive claim without ceasing to be what it is. This claim *is* the jetty, what the jetty is interested in and what makes it interesting.

As a theoretical jetty, this design—to explain and account for all the other jetties and for the very constitution of its field of inscription—follows the principle of reason *(principium reddendae rationis)* and a thorough investigation of this issue and on this subject—an investigation which I cannot undertake here—should lead to a problematic as ambitious and risky as that which would confront the history of the principle of reason.

The second reason, which is actually closely related to the first —why the competition cannot be a mere antagonistic confrontation and doesn't allow any jetty to give rise to the reading of a table, the reason of a table which would classify the totality of the theoretical potentialities—this second reason is that each *species* in this table constitutes its own identity only by incorporating other identities—by contamination, parasitism, grafts, organ transplants, incorporation, etc. . . . For example, if one wanted to identify what is called or what calls itself Marxism, today in 1987, as a theory in the subspecies of Marxism at work in what is called "literary theory" in the United States (so many problematic titles already), one could not identify it without immediately perceiving the traits of the elements integrated by that Marxism —and which are concepts, themes, questions, words, sentences which belong to that which this Marxist discourse opposes today in a privileged way: that is, for example, structuralism, psychoanalysis, neo- or poststructuralism. For as much as I know of Eagleton's and Jameson's texts (but even more of younger theoreticians such as Sprinker), the most specific, original, active aspect of this work assumes the integration of motives which come from the very places they themselves consider to be the places of an opposing theory. There would be much to say about the modes of such an integration, of the transformations, the distortions, the macro and micro strategies to which they give rise—and this is always what interests me the most, from sentence to sentence, in the close readings I may do of these texts. But I cannot follow this

direction here. One might naturally use other examples: the incorporation of some Marxist philosophemes into French structuralism, of structuralism into poststructuralism, of psychoanalytic theories into all of the above. And you can imagine to what kinds of monsters these combinatory operations must give birth, considering the fact that theories incorporate opposing theorems, which have themselves incorporated other ones.

The principle of taxonomic disorder which I am touching on here can give rise to reasoned and ordered translations or else to comic collapses, which can sometimes be glimpsed in some course descriptions, in blurbs, sometimes in books. It is the serialization of things which are as heterogeneous but nonetheless in a relationship of contaminating and teratological coincorporation as psychoanalysis, poststructuralism, postmodernism, feminism, Marxism, etc. This teratology is our normality. I'll come back to this.

Those within the university and elsewhere who aren't completely asleep know that those titles do not respond, do not correspond to any classifiable identity, to any corpus which can be delimited. However, for all that, this doesn't make those titles empty or insignificant. What they name is the mainstyle of each jetty and that which stabilizes it precisely in the form of a state— but state in what sense, from now on?

Let's resume. Each part of the table (of this table which, from now on, has no totality and hence no borders), each entry, each jetty is not both a part and the whole, a part for the whole, synecdoche and metonymy, indeed a part larger than the whole, but a jetty whose momentum, movement, and structure, both internal and internalizing, takes it beyond the whole and folds it back on the whole to comprehend it and speak before it. Consequently, each jetty claims to extend beyond the borders of the entire state and to reflect it, by means of a fold.

There is then a state within the state in the two senses of the word "state": both in the sense of the political organization (and these theoretical jetties are also institutional fortifications—and we are paid and we pay to know this, even if it is clearer to some than to others—fortifications which are increasingly flexible, mobile, and the state of California is once more exemplary in that

respect: we are used to theoretical earthquakes here, and institutional architectures are erected to respond to the seisms or seismisms of all the new *isms* which might shake the structures, both post and new structures); and in the sense of state as report, assessment, account = *statement*. Each theoretical jetty is the institution of a new statement about the whole state and of a new *establishment* aiming at state hegemony. Each jetty has a hegemonic aim, which isn't meant to subjugate or control the other jetties from the outside, but which is meant to incorporate them in order to be incorporated into them.

It would thus be easy to show that what has recently been called or what calls itself new historicism—assuming it had a stable identity outside the institutional place which makes this new species grow in Northern California after transplants from French vineyards—new historicism introjects while denying it, incorporates without admitting it, a *concern with history* which (and I will come back to that concern later, to show its extent and form) was already active, present and fundamental, for example, in the very poststructuralism which the supporters and promoters of new historicism think it is absolutely crucial to oppose. What I am saying here of new historicism was also true of Anglo-American New Criticism—which rhymes with it and recalls it as its opposite. The bringing together of those two titles would once more remind us, as if it were necessary to do so, of what tends to become the technique of self-legitimation, self-institution, and self-nomination. There was a time when titles and letterheads followed the establishment of the institution and the work of its founding members. Today we know that it is sometimes better to start with letterheads and self-representation. All the founders of institutions know this. As for deciding if titles in "new" are more efficient than those in "post," if the best strategy is a "pousse-toi de là que je m'y mette" ("shove off") in the "new" or in the "post," if it is more appropriate to periodize violently and make the historicist telos the herald who announces a new era or the hero who outdates or brings down an old dragon, it is a matter of detail. It is basically the same gesture, the cultural strategem as an inevitable by-product of the oldest of historicisms.

Why did I choose the example of new historicism rather than

others which, up to a certain point, would have had the same
relevance, that is, rather than structualism, poststructuralism, post-
modernism, Marxism, post-Marxism, or any of the other "new-
isms" and "post-isms?" They all make the claim to reinterpret
globally the state and their own inscription of and within the
state. The formalization of both the past and the future of the state
has to be read *in* the present; and the *new* and the *post*, what they
announce and what they outdate, give the exact measure and the
clear, synchronic, and systemic formulation of that present.

If I chose the example of new historicism rather than some
other example, it is because what is called New Criticism and
structuralism would probably have privileged the tabular, syn-
chronic, and combinatory model in the description of the states
of theory or of the state of theories, while Marxism and new
historicism would probably prefer a diachronic model. And the
taking into account of the periodizing and successive elements in
the more or less jubilatory handling of new-isms and post-isms is
in itself and *a priori historicist,* even if the supporters of pro-
moters of such new-isms and post-isms want to be antihistoricists
or claim that they are.

I may try to say later, in a more direct and internal way, how I
today perceive this question of history and historicism, old or
new. For now, I insist rather on the following point: if static and
tabular totalization isn't possible, it isn't only because of a histor-
ical process, because things change fast and because only a dy-
namic or diachronic view can grasp again the *states* rather than
the one state of theory, as if cinematography would be more
appropriate than photography for this landscape of theory to
enable us to see the *theoretical,* that is, what it already pauses to
see. No, if tabular totalization is impossible, it is because of the
very structure of the jetty, of all jetties whose introjective multi-
plicity corresponds neither to a linear and temporal order of
succession, nor to the order of a juxtaposing simultaneity.

And if I am still musing about the semantics of the word
"state," it is because I am trying to relate it to what I have to
assume about a preoccupation which we share and about the
common concern which brings us together here. Let me play at
imagining what a political-institutional approach might be which

would define as the rules of its game, precisely, that everything had to be conceived in terms of the economy of those words, "state" and "states." One would then take into account the frenzied competition which activates and accelerates the production of titles in "new" and "post-isms," and the elements which this ever-increasing buildup owes, on the one hand, to interstate differences within the United States, and, on the other hand, to interstate differences among nation states such as England, France, Germany, Italy, Japan, etc; and finally and most importantly between different forces—cultural, editorial, and above all academic—different teaching and research systems, depending on whether they are predominantly public and state organized, on the one hand, or private and dominated by free enterprise in a capitalist style, on the other. The difference between these two types of systems doesn't exclude, on the contrary it calls for the invention of transplants, relays, parasitisms, shifters—they can be interpreted, as the case may be, as contaminations, or as salutary provocations; moreover their configurations can be very original, and they have been radically renewed, I think, in the past ten years—in Europe as well as here.

I'm thinking here of many of the analyses I just read in the remarkable volume edited by Derek Attridge, Geoff Bennington, and Robert Young, *Post-Structuralism and the Question of History* (Cambridge: Cambridge University Press, 1987)—a book which is truly Anglo-Franco-American with respect to its academic and editorial places of origin as well as to its authors, its themes, its problems, etc. This work answers beforehand and in a very elaborated way many of our questions. Among others, and among all those which would deserve to be quoted at length here, I will have to limit myself to mentioning for my purpose one of the directions pointed out by Jonathan Culler in a text entitled "Criticism and Institutions: The American University." It concerns particularly the different modes of intervention of the state or of national norms within the academic institution—and their consequently inevitable effects on critical theories, the replacement of paradigms (in Kuhn's sense)—a notion which indeed Culler discusses in detail. Culler's comparison deals with England and the United States; however, this kind of comparative analysis

could be extended and adapted to other nations. He approaches the issue from five different points of view, which I can only mention here: 1) comparison between tenure procedures and evaluation practices; 2) comparison between the statutes and structures of graduate education; 3) comparison between undergraduate studies in the two countries in terms of their respective specialization; 4) comparison between wages, defined on the national scale over there and subject to the law of the free market here; 5) and comparison between the structure of professionalization—Culler describes and explains the uneven developments of what is called "theory" in the two academic systems and he even suggests, and rightly so in my opinion, that the word "theory" is "the most convenient designation" for what happens in some literature departments in the United States when a certain number of corpus, fields, and authors are studied there—and I would add that this actually happens neither in other departments of this country nor in the literature departments of other countries in any statistically noticeable way. This will lead me in a moment to consider the word and the concept of "theory"—such as it appears in the title of our colloquium—as a purely North American *artifact*, which only takes on sense from its place of emergence in certain departments of literature in this country. I mean literature and not simply Humanities, if sometimes the Humanities includes historical disciplines. I emphasize this last point— and I will come back to it—in order to stress that if what is called "new historicism" exists and has any interest whatsoever, it is inasmuch as it claims to be part of what is called "theory" and inasmuch as—and this is an interesting paradox—it is most often represented, not by historians in history departments, but mainly by literary thinkers debating with theoretical movements which are themselves at work in departments of literature.

But I will come back to this.

For now, I would like to end and somehow formalize these very preliminary remarks concerning the pluralization of the "states" of theory.

There are two general interpretations possible for this plurality which cannot be reduced to any form of eclecticism or conceivable dialectic. Those two interpretations of this *convergent com-*

petition are themselves engaged in a nonsymmetrical *convergent competition.*

One of the two interpretations gives or lends meaning to this *convergent competition.* In that sense, it is really an interpretation, it is more literally interpretive than the second one. It takes account of conceptual contents, semantics, and teleology. It is enough for this interpretation to say that conflicts of theories are conflicts of interpretation, competitions aiming at the hegemony of one interpretation and of what an institution or a community of interpreters represents. For this interpretation it is enough to say that each jetty is a part larger than the whole, the violent projection of a metonymy towards the total account or statement of all the others; that each jetty thus spreads according to a double and yet singular law of the principle of reason and of the will to power. That is sufficient for the *order* of convergent *competition,* be it a war order, to be saved.

The other relationship to competitive plurality would not be strictly and rightly through and through interpretive, even if it includes an interpretive moment. Without excluding the first interpretation, above all without opposing it, it would deal with the multiplicity which cannot be reduced to the order I just mentioned, be it a war order or not. It would deal with this multiplicity as a law of the field, a clause of nonclosure which would not only never allow itself to be ordered and inscribed, situated in the general *Kampfplatz,* but would also make possible and inevitable synecdochic and metonymic competitions: not as their normal condition of possibility, their *ratio essendi* or *ratio cognoscendi,* but as a means of disseminal alterity or alteration, which would make impossible the pure identity, the pure identification of what it simultaneously makes possible—which would thus delimit and destabilize the state or the establishment to which it gives rise in order for this state or establishment to take place. But that which thus allows them to take place has no stable or theorizable place. It is in this non-place that the appearance of the effects of deconstruction can be situated, and I will later distinguish this process from a state, from a "deconstructionist" theory, or an unlikely set of "deconstructionist" theorems.

Those are the reasons, I told myself, why the organizers of the

Irvine colloquium may have signed the title which they chose with this grammar of the plural, which, by the way, doesn't only point to a strategy of the free market and of liberal pluralism, to an eclectic tolerance or to the good manners of hospitality, but may also be an eager commemoration of the "Estates General" of theory—just as we had in Paris, ten years before the commemoration of the Revolution, the Estates General of Philosophy.

But this time, something unseen in history occurs: the Estates General of something which one dares to put in quotation marks, the states of "theory."

Among the titles I thought I might give to my presentation, I had at first: "From One Newism to Another Through Some Postisms (New Criticism, Postmodernism, Post-Marxism, Poststructuralism, New Historicism)," or "Estates General of the Quotation Market," or else "Inverted Commas Auctioned Off."

Why are there quotation marks around "theory?"

Let us imagine the possibility of a careful study—which wouldn't be merely sociohistorical—of the generating modes of the usage values (as well as of the "usure" value, both usury and deterioration) of the production and consumption of the titles of theories in "new" and "post." Such a study would make clear the recurrence of the stratagem which consists in responding to what is new by giving it straight out the title "new" (for whoever wouldn't have thought of it on his own) or else announcing as old fashioned and out of service precisely that which is preceded by a "post" and which is seen from now on as a poor word with a "post" tacked on to it—and all of a sudden, the front of the word resembles a cat's tail with a tin can attached to it. This recurrence of the stratagem is sometimes widespread and reveals too much impatience, juvenile jubilation, or mechanical eagerness. It then becomes vulgar. But this matters little; what the same study would make clear is that the functioning of such titles always assumes that they are inside invisible quotation marks.

Nobody presents himself, speaking in the first person, singular or plural, as a "*new* something" or a "*post* something." If somewhere you come across a statement which rigorously affirms "I am a new-something or I am a post-something," please show it to me. It would be the exception and the sign that the author of such

a self-referential statement did not understand the socioacademic game.

So that, as I suggested a moment ago, there actually is selfnomination and self-promotion without anyone—or almost anyone—ever presenting himself as a "I am a new-something or a post-something." One might say or hear "I am a Marxist" (in terms of "theory," as it is currently being determined in this country under circumstances that I will make more precise in a moment), but one would never say "I am a new-something or a post-something."

The demarcation by quotation marks or inverted commas means that these labels have the exchange value of currencies meant to circulate and make possible the circulation of goods, the allocation of places, the situation and evaluation of pieces on a chessboard or in some Wall Street of the academy (that is, in a place of quotations on the stock exchange as well as in the linguistic sense —"cotations" and quotations), but without ever allowing anybody to appropriate them or make claims for them as a monopoly. And above all without any Central Bank or Federal Reserve Bank or First Interstate Bank ever guaranteeing the issue of titles. Those titles are always declared as the discourse of the other. They always have the doxographic value of a quasi-quotation, of the mention "the so-called."

But more seriously—and this is the reason why I talked of a quotation market—these quotation marks impose themselves at a time when the relationship to all languages, to all the codes of tradition, is being deconstructed *as* a totality and *in* its totality to an ever-increasing extent—and here a certain number of comments.

1. First, on the one hand, this form of deconstruction is such that it is no longer possible to use seriously the words of tradition. They are no longer ever *used*, merely *mentioned*. And even this speech-act theory distinction between *use* and *mention* (a distinction whose limits I have, elsewhere, attempted to indicate, in spite of its interest and of its necessity), this distinction between *use* and *mention*, I can only *mention* it here and not simply *use* it. Things take place as if the effects of a deconstructive process (which, again, I will distinguish from so-called deconstructionist

discourses or theorems) compelled us to add, more or less legibly, the mention "mention" to all the words. And the more serious and weighty the words are, the more necessary the mention "mention" and not "use" becomes. A "don't use" is from now on attached to each concept, each word. Don't use that concept, only mention it. As could be read, above a tap: don't drink that water, nondrinkable water. One can make other uses of it, but do not take it on or in oneself, do not consume it.

This is probably one reason, and only *one*, why the organizers of the colloquium have put the word "theory" in quotation marks. We don't use it seriously, we only mention it. This reservation, the general irony which, I think, modifies to such a great extent discourses today—first of all modifies them by "inverted commas"—makes all the more rare, strange, unbearable too, those events of writing whose force nevertheless consists in "using" language again, but in "using" language again by submitting it to the effects of deconstruction, that is, without reconstituting what is being deconstituted and thus without giving up the quotation marks. What is at stake, then, is another writing of the quotation marks themselves, which, being doubly vigilant, being doubly in quotation marks and redoubling the quotation marks in an inventive way, destabilizes even the opposition between discourse *with* and discourse *without* quotation marks, mention and use, and the entire system of associated values; that is, philosophy in its entirety, theory in its entirety. So, of course, these events of writing which *use* quotation marks, which make use of them and exhaustively use them up in order to write something else, these kinds of forcings are taken for play. And the anxiety which they create —as they leave no criterion to distinguish between use and mention—explains the defensive discourse which consists in exposing this writing as gratuitous play (aestheticism) devoid of scientific or theoretical seriousness, as well as of political or ethical responsibility.

I would say that even on the side where one generally tries to situate "deconstruction" (quotation marks within quotation marks), even there, "deconstructionists" and "deconstructionism" represent an effort to reappropriate, tame, normalize this writing in order to reconstitute a new "theory"—"deconstructionism" with

its method and its rules, its criteria of distinction between use and mention, the seriousness of its discipline and of its institutions, etc. This distinction between, on the one hand, deconstruction or deconstructions, the effects or processes of deconstruction, and, on the other hand, the theorems or theoretical reappropriations of "deconstructionism," this distinction is a structural, not a personal one. To say that it isn't personal isn't saying that it is *real* for all that. It doesn't have the reality of a border which some would cross and others wouldn't. It is always being crossed, erased and retraced, retraced by being erased. I dare not say of this border that it is "ideal," "regulating" or "theoretical" for the very reasons I just mentioned. However "il y en a," "there is something of it," "Il y a" ("there is") this border which doesn't exist, either as real or as ideal.

2. Second and on the other hand, the generalization of the quotation marks (whether the use of the quotation marks be normal or already perverted by the instability of the borderline between the state of *use* and the state of *mention*) indicates today that the only "theoretical" attitude possible, the only consequent relationship to language, the only relationship of vigilant and formalizing analysis, the only objective and objectifying relationship to discourse and to what this discourse says, necessarily involves the consequent use of quotation marks—that is, the mention, awareness, and practice of the organized totality of our lexicon and syntax.

This means the constitution of a radical metalinguistics, which, however, integrates within itself, in its very jetty, the impossibility of metalanguage. Hence this writing I talked about a moment ago which writes the quotation marks here writes the metalanguage, writes each time according to a new writing and a new signature this proposition that is itself metalinguistic and says: "There is no metalanguage"—this is a literal quotation from both Heidegger and Lacan. There is, therefore, no possible theory today which could integrate and take account of its own language without generalizing the practice (either visible or invisible) of quotation marks, going as far as putting in quotation marks the very word "theory." This is the "theory," this is "theory."

3. Third, this ("This is 'theory' ") infers at least three paradoxes.

A. The first paradox lies in a sort of reversal between what is proper and nonproper. Quotation marks generally function as small clothespins meant to keep at a distance, without really touching them, clothes which, whether dirty or still wet, won't be freed from their clothespins and really touched until they are properly clean and dry. In this case, the quotation marks around "theory," far from keeping an impure concept at a distance, convey a distrust towards a concept which is pure from any contamination and from an absolutely reappropriable proper sense: the proper sense of the word "theory" and "theory" as determined by the *telos* of proper sense which would elude quotability or, more generally, general terability. It is this proper sense of propriety which, this time, is put in quotation marks and not the opposite, as has always been the case. And in this discrete graphic mark of reversal, it is possible to take the measure of a displacement which is by definition measureless, if not without rules.

B. The second paradox makes apparent what escapes sight only for being too obvious, that is, that the generalization of quotation marks—at least under these conditions—far from being a neutralization of reference, a formalist sophistication which keeps history at a distance, rather conveys the sharpest sense of *history*, of the history of concepts, of course, and among others, of concepts accredited by those who so easily think they know what they are talking about when they refer to "history," "society," "reality," and other similar things—but also the history of the concept of history which, as I attempted to suggest a long time ago, cannot be a history among others. There is thus no attitude, let's say, in quotation marks, more historical, more "historian" (that is, pertaining to the specific work of the historian), more responsible in front of history (*Geschichte* or history) than that which puts into practice a vigilant but, in its very principle, a general *use* of quotation marks. Responsible before history and before the political-socioinstitutional "realities" which constitute the solid jetty of these concepts. I will come back later on to these words.

C. Third paradox. You have understood that I am not describing the intentions of whoever decided to put quotation marks around the word "theory." I don't know who the author is and I don't really want to know. I'm just explaining to you, not how and why *I* would have written those quotation marks, but how today they can be read in what is, I think, our situation. And the third paradox is that the quotation marks are not only the mark of a reservation or distance with regard to a concept or a word. They recall the general quotability, they cite this quotability as a summons, once again not as a formalist neutralization concerned with propriety but as the reminder of the necessary general contamination, of the transplants and irreducible parasitism which affect any theorem. This is why, as I suggested a moment ago, instead of treating pseudo-identities, labels, or slogans as little wooden horses in a merry-go-round where New Criticism, structuralism, poststructuralism, new socio-historicism, and then again formalism, nonformalism, and so on would follow one another, instead of these merry-go-round effects, it would be much more urgent, interesting and exciting too, at least less boring, to *read* and to *elaborate* theoretical configurations whose structure, writing, conceptual and institutional modes, and social and historical inscription were irreducible, precisely because of a certain force of transplant, to the dialectic of the merry-go-round or to the merry-go-round of the parody of dialectics in "post" and in "new." In view of the rise of journalistic and doxographic discourses from those who, within and outside the university, think that they are witnessing a series of theoretical rounds, their hand on the gong, it is urgent to take interest in what, in the most inventive "theoretical" work, cannot be confined to these boxing rings, merry-go-rounds, and round-tables. It is urgent to analyze, for example, in the assumptions and assertions of discourse which is taken to be Marxist or claims that it is, what is usually attributed to poststructuralism or New Criticism, or else to recognize that there is more concern and respect for the so called sociohistorical "reality" in certain texts identified as poststructuralist than in certain "Marxist" or "new sociohistoricist" texts . . . but I'll come back to that later, in another mode.

The *prescriptive* lesson I would like to draw from these three

paradoxes about a pair of quotation marks would be the following one. I state it without many illusions, but nevertheless I think I have to state it. I give this prescription the form of a question. Instead of going on playing the overall boring game which consists in applying the most worn-out schemes of the history of ideas to the specificity of what is happening now, especially in this country; instead of giving in to normalizing and legitimating representations which identify, recognize, and reduce everything too quickly, why not rather be interested in "theoretical" monsters, in the monstrosities which announce themselves in theory, in the monsters who, beforehand, outdate and make comical all classifications or rhythms such as: after New Criticism comes an "ism" and then a "postism," and then again another "ism," and today still another "ism," etc. These last normalizations are themselves monstrous from the perspective of what happens in the most singular and inventive work and texts, in the most idiomatic writings; but these monstrosities are normal. They can be found everywhere. It is a normal monstrosity to say that everything the word "poststructualism" embraces is formalist, aestheticist, apolitical, little concerned with history or with socioeconomic reality. It is a normal monstrosity to say of a thinking which started out by putting logocentrism into question that it confines itself to language and language games. It is a normal monstrosity to think that to get back finally to reality, history, society, politics, it suffices to leave behind these plays on words. It is a normal monstrosity to go on setting the textual—as this notion has been re-elaborated in the last twenty years—against the social, the political, and the historical, as if the text were still the book on the bookshelf of the library. I shall distinguish between normal monstrosities and monstrous monstrosities which never present themselves *as such*. A monstrosity never presents itself; or else, if you prefer, it only presents itself, that is, lets itself be recognized, by allowing itself to be reduced to what is recognizable; that is, to a normality, a legitimacy which it is not, hence by not letting itself be recognized as what it is—a monstrosity. A monstrosity can only be "mis-known" (*méconnue*), that is, unrecognized and misunderstood. It can only be recognized afterwards, when it has become normal or the norm.

What does this mean, especially in the field of "theory"? Well, for example, the following: if there are "theoretical" events which mark an institution (for the moment it is a mere hypothesis), they must have the formless form of a monstrosity; that is, they cannot be recognized or legitimated at the time and even less programmed, announced, and anticipated in any way.

I take an example from that *doxa* which is for us the most common: the *doxa* of "They say" *[on dit]*. It is more and more often said that the Johns Hopkins colloquium ("The Languages of Criticism and the Sciences of Man") was in 1966, more than twenty years ago, an event in which many things changed (it is on purpose that I leave these formulations somewhat vague) on the American scene—which is always more than the American scene. What is now called "theory" in this country may even have an essential link with what is said to have happened there in 1966. I don't know what happened there, and I have neither the tools nor the time necessary to talk about it here. I limit myself to the following comment, in its stark insufficiency. What is certain is that if something happened there which would have the value of a theoretical event, or of an event within theory, or more likely the value of the advent of a new theoretical-institutional sense of "theory"—of what has been called "theory" in this country for about twenty years—this something only came to light afterwards and is still becoming more and more clear today. But what is also certain is that nobody, either among the participants or close to them, had any thematic awareness of the event; nobody could take its measure and above all nobody could have or would have dared to program it, to announce or present it as such an event. This is certain; and it is just as certain that if somebody claimed *today* to program or present a similar event, that person would be mistaken—no doubt about it. It is even the safest recipe for being mistaken. Monsters cannot be announced. One cannot say: "Here are our monsters," without immediately turning the monsters into pets.

This last series of comments or questions had, as I have already said, at the very least a prescriptive connotation. This prescription isn't *stricto sensu* theoretical, ethical, or political. And if I say now that if we hear this prescription we'll do more interesting

things, less boring and more original things, I say it neither in the name of taste nor in that of an aristocratic aestheticism. It very simply means: something would finally have a chance of happening or taking place, that's all. It isn't certain, it isn't predictable— simply, it is better that something happen. That's all: that something happen, that's what is better, that's all. But it is a breathtaking choice: it precedes all ethics, all politics, all aesthetics, all historical and social reality.

Since I have already taken up too much time to say nothing, I am finally going to get to the subject. What is the subject? What is the question of "the states of 'theory' "? Considering the premises I just brought together, the question might be: 1) What is happening? 2) What is happening between the quotation marks of "theory"? In order to understand what is happening one has to understand the quotation marks around "theory." Beyond all the hypotheses I have ventured up to now, I think that the concept of "theory," which is here at stake in the expression "states of 'theory,' " is a concept which could only take form "in the States," which only has a value, a sense and a specificity "in the States" and at a specific moment, namely the last twenty years, that is, during the time of its formation.

What is this "theory"?

First, it isn't what is called "theory" in mathematics or physics. "Theory" isn't *a* scientific theory; it isn't a theorization or a set of theorems. Scientists would shrug their shoulders if what is being done in the name of "theory" in the American departments of literature was put forward as a scientific, indeed epistemological "theory." They would indeed be right if there was a claim to adjust this concept of "theory" to *their* models of scientific theory. But since no such claim is being made, they would be wrong because they wouldn't have understood *this* concept of theory.

Second, this concept, which isn't scientific in the classical sense, isn't a philosophical concept of "theory" either. No philosopher—*stricto sensu*—in no tradition and in no philosophical institution in the world, including this country, will recognize this concept of "theoria" or of theoretics in what is done, said, published under the name of "theory" in some American departments of literature. All the philosophers in the world would say:

this isn't, strictly speaking, worthy of what, in philosophy, we call *theoretics.*

If this "theory" is admissible neither from the point of view of science nor from that of philosophy, that is, from the point of view of the *episteme,* which, opposing the *doxa,* has always legitimated, valorized, and distinguished theoretics, what, then, constitutes, determines, legitimates what for the last twenty years has been called "theory" in this country? What exactly is it? And why are there also so many people, and not only among scientists and philosophers, who are—quotation and quotation marks again—"against 'theory' "? The fact that what I will call from now on "the states of theory"—instead of each time saying "theory" in quotation marks—is neither scientific nor philosophical must not be interpreted negatively. The "States' theory" isn't *a* theory but the opening of a space, the emergence of an element in which a certain number of phenomena usually associated with literature will call for trans-, inter-, and above all ultra-disciplinary approaches, which, up to now, met nowhere, in no department, in no area of any discipline. They will call for a multiplicity of problematics which are now often classified, serialized in a sometimes comical and irrational way in the programs of some universities and departments, in the blurbs of some books, and which Jonathan Culler mentioned in the article I quoted a moment ago. Forgive me for quoting a long passage, especially a long passage in which I am referred to, but I don't want to play here the purposeless game of academic politeness, and it wouldn't be fair not to quote, for this one reason, a text which seems to me important here if we want to start thinking what "the States' theory, " "theory" with quotation marks, means here.

> The major critical development of the past twenty years in America has been the impact of various theoretical perspectives and discourses: linguistics, psychoanalysis, feminism, structuralism, deconstruction. A corollary of this has been the expansion of the domain of literary studies to include many concerns previously remote from it. In most American universities today a course on Freud is more likely to be offered in the English or French Departments than in the Psychology Department; Nietzsche, Sartre, Gadamer, Hei-

degger, and Derrida are more often discussed by teachers of literature than teachers of philosophy; Saussure is neglected by linguists and appreciated by students and teachers of literature. The writings of authors such as these fall into a miscellaneous genre whose most convenient designation is simply 'theory,' which today has come to refer to works that succeed in challenging and reorienting thinking in fields other than those to which they ostensibly belong, because their analyses of language, or mind, or history, or culture offer novel and persuasive accounts of signification. ("Criticism and Institutions: The American University," p. 87)

The emergence of this new element (with the exportation of discourses outside of their field, with the taking into account of those transplants, of those multiplicities of languages and axiomatics, of the irreducibility of the literary and of language, of sexual difference, of the unconscious, etc.) is *positive:* it is a mutation which no area of the institutional discipline had been able to perform, neither in this country nor in any other. However, this mutation, as enriching and positive as it may be, remains dangerous and is felt to be so. For it remains to be explained why this "States' theory"—in its irreducible emergence —cannot, does not, and must not want to claim the title of a science or a philosophy.

It is because it has been accompanied, carried on, provoked, penetrated (as you wish, I don't know which word is best and no classical schema of causality seems relevant here) by a form of questioning and of writing, of questioning writing but *not* only questioning, which destabilized the axiomatics, the founding and organizing schemas of science and philosophy themselves—and even the new categories in the history of ideas (such as episteme or paradigm) that allowed one to think this new configuration in the mode of self-consciousness.

Let us call this an effect of deconstruction. And with this word I refer neither to specific texts nor to specific authors, and above all not to this formation which disciplines the process and effect of deconstruction into *a* theory or *a* critical method called deconstructionism or deconstructionisms. This effect of deconstruction disorganized not only the axiomatics of philosophical and scien-

tific discourses as such, of epistemological discourse, of the various methodologies of literary criticism (New Criticism, formalism, thematism, classical or Marxist historicism), but even the axiomatics of knowledge simultaneously at work in the "States' theory" (I quote Culler again): "linguistics, psychoanalysis, feminism [wherever, I want to add, 'feminism' formed itself into an institutional discipline and into a corpus of philosophical—hence phallogocentric—axioms], structuralism." Hence an element of the series, that is, deconstruction, no longer simply belonged to the series, and introduced into it an element of perturbation, disorder, or irreducible turmoil—that is, a principle of dislocation. I'm now going to describe, in the most schematic way, a certain number of *typical* consequences—i.e., general and regularly occurring consequences. For convenience, I'll use again the word "jetty," in which I distinguish, on the one hand, the force of the movement which throws something or throws itself (*jette* or *se jette*) forward and backwards at the same time, prior to any subject, object, or project, prior to any rejection or abjection, from, on the other hand, its institutional and protective consolidation, which can be compared to the jetty, the pier in a harbor meant to break the waves and maintain low tide for boats at anchor or for swimmers. Of course, these two functions of the *jetty* are ideally distinct, but in fact they are difficult to dissociate, if not indissociable. All the difficulties of analysis, all the confusions, all the ambiguities lie not only in the difficulty of an effective principial distinction of the two jetties, of the two phenomena of the jetty, but also in the strategic interests involved—for all sides and for various reasons—in confusing or creating a certain interdependence between the two.

For the convenience of terminology, and again in relation to the title of the colloquium, I will call the first jetty the *destabilizing* jetty or even more artificially the *devastating* jetty, and the other one the stabilizing, establishing, or simply *stating* jetty—in reference to the supplementary fact that at this moment of *stasis*, of stanza, the stabilizing jetty proceeds by predicative clauses, reassures with assertory statements, with assertions, with statements such as "this is that": for example, deconstruction is this or that.

For instance, one assertion, one statement, a true one, would be, and I would subscribe to it: Deconstruction is neither a theory nor a philosophy. It is neither a school nor a method. It is not even a discourse, nor an act, nor a practice. It is what happens, what is happening today in what they call society, politics, diplomacy, economics, historical reality, and so on and so forth. Deconstruction is the case. I say this not only because I think it is true and because I could demonstrate it if we had time, but also to give an example of a *statement* in the *static* form of the jetty.

In its essential vagueness—which in my opinion is in no way negative—the concept of "theory" that we are discussing at the moment had no counterpart, either in this country or anywhere else in any discipline, as I have already said, until the end of the 1960s. I quote here Paul de Man, who writes in *The Resistance to Theory* (Minneapolis: University of Minnesota Press, 1986)—the resistance to theory, a concept and a slogan which I will comment on in a moment—"Yet with the possible exception of Kenneth Burke and, in some respects, Northrop Frye, none of these authors (Brooks, Wellek, Warren, Brower) would have considered themselves theoreticians in the post 1960 sense of the term, nor did their work provoke as strong reactions, positive or negative, as that of later theoreticians—there were polemics, no doubt, and differences in approach that cover a wide spectrum of divergences, yet the fundamental curriculum of literary studies as well as the talent and training expected for them were not being seriously challenged" (p. 6). Hence, it is all this, and especially the *curriculum*, which has changed, which has been challenged within the institution by the devastating or destabilizing jetty.

But the paradox, as far as the effects of the deconstructive jetty are concerned, is that it has simultaneously provoked in the last twenty years several absolutely heterogeneous types of "resistance to theory." In trying to classify their "ideal types" I will try to conceptualize both what "theory" means in that context and what is here the strange and disconcerting logic of resistance.

There is to begin with, I would say, the *destabilizing* and *devastating* jetty itself, and its effects of deconstruction—a jetty which is paradoxically, in itself, a "resistance to theory." It is a resistance which produces theory and theories. It resists theori-

zation *first* because it functions in a place which the jetty ques-
tions, and destabilizes the conditions of the possibility of objec-
tivity, the relationship to the *object*, everything that constitutes
and institutes the assurance of *subjectivity* in the indubitable
presence of the *cogito*, the certainty of self-consciousness, the
original project, the relation to the other determined as egological
intersubjectivity, the principle of reason and the system of repre-
sentation associated with it, and hence everything that supports
a modern concept of theory as objectivity. Deconstruction resists
theory then because it demonstrates the impossibility of closure,
of the closure of an ensemble or totality on an organized network
of theorems, laws, rules, methods. The coherence or the consis-
tency of the deconstructive jetty is not a theoretical set, nor is it a
system either, inasmuch as the system, in the strict sense of the
term, is a very determined form of assembling, of being-together
of a set of theoretical propositions. And it is not a *system* because
the deconstructive jetty in itself is no more propositional than
positional; it deconstructs precisely the *thesis*, both as philosoph-
ical thesis (and deconstruction is no more philosophical than
scientific) and as *theme*. As a matter of fact, it has included as
one of its essential paths in the literary field a deconstruction of
thematic, or rather thematicist, reading.

Neither philosophical, nor scientific, nor critical (in the sense
of literary criticism but also in the Kantian sense, inasmuch as
criticism assumes propositional judgment and decidability), the
deconstructive jetty isn't theoretical, it resists theory in another
sense. From the start—and this has become more and more pro-
nounced—it has never simply been concerned with discursive
meaning or content, the thematics or the semantics of a discourse.
The reason is because it isn't simply a reading or an interpreta-
tion, but also because the deconstruction of phallogocentrism
placed itself in a place where insulating semantic content (on the
one hand, the signified, and, on the other, the signifier, as we
used to say twenty years ago)—that is, thematic and conceptual
content—was impracticable in a rigorous way. Hence the neces-
sity for deconstruction to deal with texts in a different way than
as discursive contents, themes or theses, but always as institu-
tional structures and, as is commonly said, as being political-

juridical-sociohistorical—none of these last words being reliable enough to be used easily, hence their relative rare use in the most cautious texts called deconstructive. This in no way means a lack of interest or a withdrawal as regards those things—reality, history, society, law, politics—and moreover this is absolutely consistent with the concept of text which is based on the deconstruction of logocentrism and irreducible to discourse or the book or to what some still delimit as the textual by trying to distinguish it from or oppose it to reality, to the social, the historical, etc. This is the normal monstrosity I talked about a moment ago. Using an outdated language, one might thus say that the deconstructive jetty isn't essentially theoretical, thetic or thematic because it is also ethical-political. But of course, for the most obvious reasons, this assertion calls for the strictest vigilance and quotation marks. Finally, the deconstructive jetty affirmatively resists theory, particularly literary theory, because it isn't regional—it not only doesn't fix the text in a thematic or thetic station, a stanze, but it also first deconstructs—and this was my primary concern in Of Grammatology—the hierarchizing structure, which, in philosophy, as a general metaphysics, a fundamental ontology, a transcendental critique or phenomenology, orders a multiplicity of regions, discourses, or beings under a fundamental or transcendental agency. The deconstructive jetty institutes itself neither as a regional theory (for example, of literature) nor as a theory of theories. It is in this way that it is a form of resistance. And in addition, it was articulated with a thinking of resistance (or rather of restance) which I cannot discuss here.

As I have said, this form of resistance to theory didn't consist in reactively opposing theorization but on the contrary in regularly deconstructing the philosophical assumptions of existing theories or the theories implicit in discourses denigrating philosophy or theory. What was at stake then was to exceed the theoretical rather than to hinder it and take positions "against theory." The result, both paradoxical and foreseeable, is that the very thing which exceeds at the same time the theoretical, the thematic, the thetic, the philosophical, and the scientific provokes, as gestures of reappropriation and suture, theoretical movements, productions of theorems, which, in the sort of hyperactivity, tur-

moil, and turbulence which has characterized the past twenty years, are themselves so many forms of *resistance*, but this time in another sense, to the deconstructive jetty. This time the resistance institutes—it is indeed essentially instituting—the consolidating and *stabilizing* structure of the jetty. It constructs and fortifies theories, it offers thematics and theses, it organizes methods, disciplines, indeed schools. But there again this institutional and stabilizing jetty, in which the term "resistance" could have the meaning it has in the French expression *résistance des matériaux* (strength of materials)—that which architects must carefully calculate in order to avoid collapses—(this jetty) constructs *fortifications* whose relation to the deconstructive jetty may be of two, or, depending on the case, three types. But in any case, the resistance concerns what threatens, exceeds, or destabilizes the *stanza* of a coherent theory, its standing or statement. This time, the resistance reconstitutes the stanza into a system, a method, a discipline, and in the worst case an institution with its legitimating orthodoxy.

The closest type, the stabilizing jetty which resembles the destabilizing jetty most, is what is called poststructuralism, alias deconstructionism. It's not bad, it isn't an evil, and even if it were one, it would be a necessary evil. It consists in formalizing certain strategic necessities of the deconstructive jetty and in putting forward—thanks to this formalization—a system of technical rules, teachable methodological procedures, a discipline, school phenomena, a kind of knowledge, principles, theorems, which are for the most part principles of interpretation and reading (rather than of writing). Deconstructionism isn't monolithic—among deconstructionisms and deconstructionists there are differences in style, orientation, and even serious conflicts—but I think one can say that there is *deconstructionism in general* each time that the destabilizing jetty closes and stabilizes itself in a teachable set of theorems, each time that there is self-presentation of *a*, or more problematically, of *the* theory. We know that deconstructionism mainly developed in the space of literary studies, concerned precisely with the difficulty, which remains total, of delimiting a field or an essence of literature. It wouldn't be correct

to say that the elements in deconstructionism which may *sometimes* be stabilizing and normalizing with regard to the effects of the deconstructive jetty stem from the fact that deconstructionism mainly developed in the space of literary studies. For this would give in one way or another the impression that, as the crudest readers sometimes suggest, deconstruction gives into formalism or aestheticism, indeed to a textualism which would confuse text and discourse, page, book, and the world, society or history and the library. No, I think that the most advanced things happening in literary studies avoid these traps. And this is not fortuitous. It is undoubtedly due to literature. When Gasché, for example, in his latest book,—*The Tain of the Mirror: Derrida and the Philosophy of Reflection* (Cambridge: Harvard University Press, 1986) —and elsewhere, reproaches certain literary deconstructionists for not being radical enough because they fail to reexamine the premises of or even the kind of priority given to the deconstruction of philosophy, his gesture seems to me at the same time necessary and risky. Necessary, because to reconstitute the deconstructive jetty into theory, into *a* theory, into a deconstructionist jetty, runs the risk of losing the essential force and excess which consist in unsettling the entire philosophical foundation of which I have already spoken. It runs the risk of reconstituting an old concept of text, of confining oneself to one area (the literary one), etc. But conversely, the equivocal risk that Gasché's book runs—not necessarily in the texture and in the careful and cautious details of his analysis, which are subtle enough to avoid this risk, but in the global and massive effect to which books are unfortunately reduced once they have been closed and once they start being discussed—this risk would be to reconstitute the deconstructive jetty as a *philosophy of deconstruction,* with—I use Gasché's words, without keeping the "quasi" and the quotation marks that attenuate and complicate them—with its "infrastructures," its systematicity, etc. One would then be faced with a deconstructionist philosophy or metaphilosophy, with a theory of theories, a deconstructionist supertheory. Once again it doesn't seem to me that it is Gasché or what he writes that runs this risk, but rather it is the global effect of this nevertheless necessary

appeal to the philosophical scene of deconstruction. Besides, this appeal should be addressed more to philosophers than to literary critics.

It is in reaction against a certain deconstruction*ist* post-structuralism, against the image of a certain stabilizing jetty, that the most recent and most interesting developments of Marxism and of what is called new historicism posit themselves. If deconstructionism were what it is accused of being, and *when* it is and *where* it is formalist, aestheticist, ignorant of reality, of history, enclosed in language, word play, books, literature, indifferent to politics—I would consider Marxism and new historicism absolutely legitimate, necessary, urgent. Moreover I believe in a certain necessity, sometimes in a certain novelty, if not of the theory at least of style of investigation, and thus of certain objects or areas of research, of what presents itself under the title of Marxism or new historicism. I very sincerely wish that they develop even more, and I would be very happy to contribute to this development. It doesn't seem to me that any rejection of these attempts is desirable or interesting. But as theories, this Marxism and this new historicism have at least one trait in common (for I don't want to confuse one with the other) in the *present* stage of their critique. It is that they institute themselves in reaction to a deconstructionist poststructuralism which is itself *either* nothing but a figure or a stabilizing reappropriation of deconstruction *or else* a caricatural myth projected by Marxists and new historicists out of self-interest or misunderstanding.

I will say a few concluding words, very rapidly and very dryly, about these misunderstandings. Marxism and new historicism are very different theoretical phenomena. The former is a theory, the latter sometimes associates itself with reactions "against theory" (to quote the by now well-known title which won its fame more as a symptom of resistance than for its content). Nevertheless they have in common only that their most *significant* present traits come from *within* the space of the deconstructive jetty and consist *in* their marked opposition to stabilizing deconstructionism. This is why they seem to me more interesting than any reaction which is directly conservative or simply and precisely "reactive" and of which I won't say anything for lack of time,

although it is much more widely represented and much stronger than what we say about it in a small circle concerned with more subtle differences. Of course, it sometimes happens that the different types contaminate each other.

I will disregard—for lack of time and because these mistakes are really too crude, even if they are long lasting—everything that consists in reducing the concept of text to that of written discourse, in forgetting that deconstruction is all the less confined to the prisonhouse of language because it *starts* by tackling logocentrism. I refer here to Dominick LaCapra's book *Rethinking Intellectual History: Text, Context, Language* (Ithaca: Cornell University Press, 1983), which, in its reading of Jameson and Hayden White, discusses some of these misinterpretations and points out some essential complications.

Disregarding these misunderstandings, I'll nevertheless say a few words about *history*, although they could be transposed to "reality," "society," "politics," and other similar big words. The criticism addressed by certain Marxists or new historicists concerning the treatment of history relies on a fundamental misunderstanding, which is sometimes shared by certain deconstructionist poststructuralists. For deconstruction starts, so to speak, with a *double gesture*.

It starts, on the one hand, with a critique of *historicism*, which radicalizes the Husserlian critique of historicism, as it is developed in "Philosophy as a Rigorous Science" against Dilthey, the critique of the theory of "world views," the empiricisms, relativisms, and skepticisms, which follow each other in their inability to account for something like a theorem or a philosopheme, for science, philosophy, or philosophy as science, and for any project of universal and true discourse. I have totally subscribed, and I still do, to this Husserlian argumentation, to this critical sequence of phenomenology, which seems to me to be indispensable for any deconstruction, even if it isn't enough and if it meets there its own limit. It is especially indispensable to free from historicist empiricism the original possibility of ideal objects—whether they be scientific theorems or cultural productions—for example, aesthetic or literary productions.

For, on the other hand, as you know, Husserl doesn't stop with

this critique of empirical historicism. And he didn't present it in the name of an ahistorical Platonism. He only carries through the critique of empirical historicism in order to bring out, recognize, and describe the historical specificity of the *theorems*, of the ideal objects of science—for example, of mathematics—and indeed he does it in the name of a transcendental historicity. To pay attention to history, to history in general and to the original historicity of culture, language, and above all of theory, of the institutions which theorems are—since this is what we are here to talk about —all this assumes at least that one follow this sequence, which I call Husserlian, through to its end. It has been indispensable for me—since *The Origin of Geometry*—for what later developed under the title of deconstruction, even if it led to a deconstructive reading of Husserl and Heidegger. This is also the reason why the philosophical re-reading of the relation of deconstruction to philosophy is so necessary, so constantly necessary.

Finally, for this very reason, the deconstructive jetty is, throughout, motivated, set into motion by a concern with history, even if it leads to destabilizing certain concepts of history, the absolutizing or hypo*stasing* concept of a neo-Hegelian or Marxist kind, the Husserlian concept of history, and even the Heideggerian concept of historical epochality. I refer here to Bennington's text "Demanding History" in *Post-Structuralism and the Question of History*, which offers a remarkable elaboration and which formalizes in the most rigorous and economical way—as always —the givens of this strange situation. As Young and Bennington remind us in the introduction to the same book: "If post-structuralism reintroduces history into structuralism (or, more accurately, shows that effects of history have been reduced), it also poses questions to the concept of history as such" (p. 2). This is the very difference between *New Criticism* and *poststructuralism*, the analogies between which, given their careful approach to texts, have been underlined by certain critics. But poststructuralism—and deconstruction in general—also dislocates the borders, the framing of texts, everything which should preserve their immanence and make possible an internal reading, or merely reading in the classical sense of the term. And, by the way, I think that the problematic of the border and of framing—that is, of

context—is seriously missing in new historicism; and I think that this is the question new historicists should address with the utmost urgency in some of the texts called deconstructionist. This would avoid the reconstitution of a new archivism or of a new documentalism.

I have taken up more than enough of your time and abused your patience. I won't conclude with a *statement*. Having thrown out (*jeté*) a few disordered aphorisms about the *jetty*, I want simply to make it clear, for the *chute* or the *envoi* that this word or concept of "jetty" remains essentially equivocal, in the same manner as "theory." But the equivocation which I would like to clear up, at the moment of the *chute*, concerns precisely the *chute*, the fall. You may have had the impression that I was making a distinction between the destabilizing jetty (for example, deconstructions) and the stabilizing jetty (for example, the reappropriations and the reactions in the form of deconstructionism, Marxist or new historicist theories, or discourses "against theory"), as a distinction between the movement which gives momentum, on the one hand, and, on the other hand, the inert fallout which, in a style that would remind us of Bergson, would take momentum and life back down, towards inert solidity. It would be a final and very serious misunderstanding. The destabilizing jetty doesn't go up. On the contrary, it is the stabilizing jetty that goes upwards. It stands; it is a standing, a station, or a stanza; it erects, institutes, and edifies. It is edifying, essentially edifying. The destabilizing jetty goes neither up nor down; it may not go anywhere. Since it is late and there would be too much to say about this topology, let's assume that the jetty—a jetty with or without a relation to its other—doesn't exist. It doesn't consist in anything, it doesn't have any *status*, it simply doesn't take place, doesn't have an exclusive place which could be attributed to it. Deconstruction, in that sense, doesn't have any status, any theoretical status. There is no manifesto for it, no manifestation as such. Those who set themselves against it know this very well. In Northern California, in this very state, I was told last week that Searle, once he had explained his views on literature, announced to his audience that for twenty years deconstruction hasn't existed, or, more precisely, that it has consisted of, and here I quote

Searle, a "mist" hiding everything. This is true, it has neither consistency nor existence, and besides, it wouldn't have lasted very long anyway if it had. Especially in the States. All I would have liked to say, if I had had time, is something concerning the "jetty" (for example, through and beyond Heidegger's *Geworfen-heit* and Artaud's *subjectile*). Can we, do we have the right to ask the question: What is this "jetty" before and outside any object, subject (the "subject in question," someone has said), project, or reject, before and outside any consistency, any existence, any stanza? What is this jetty whose *restance* defies all questions in the form of "What is?" and of "What does it mean?"

In short, I have tried to introduce here in a very preliminary way this quasi-concept of "jetty" which has no status yet either in the state of theory or in the "States' theory" today. And I have tried to explain the reasons why it would be very difficult to turn it into a theorem or a "theoretical object."

3
HISTORY BEYOND
SOCIAL THEORY
Lynn Hunt

HISTORY'S RELATIONSHIP to social theory is now radically in doubt. Before this contention can be developed, however, it must be admitted that history's relationship to theory of any sort has always been problematic, especially for those who actually research and write history as professional historians (rather than as historiographers or philosophers of history). Book reviews of theoretically inspired work, history department promotion meetings, and graduate seminars all provide evidence of this ingrained resistance to thinking theoretically. Only art history can compare to history in its fundamental hostility to the intrusion of theory into the discipline; both share as disciplines, moreover, a similar self-definition based on the common denominator of the connoisseurship of documentary evidence.

The hostility to theory has gone through many phases. In the 1960s, when I was a graduate student, social theory was at the center of debate, and the most threatening discipline (threatening the boundaries of history as a discipline) was sociology. Those were the days of the "isms" and the "izations": Marxism, modernization, urbanization, and the like. Some of the best—and most controversial—work in history was directly inspired by Marxism or modernization theory. E. P. Thompson's *The Making of the English Working Class* (1963) and Charles Tilly's *The Vendée* (1964) are prime examples. Thompson's book reworked the Marxist categories of class through an examination of English working-class activities in the late eighteenth and early nineteenth centuries, and Tilly's provided an application of theories of urbanization to the French Revolution. Both, in their way,

inspired virtual schools of students and admirers.[1] They also aroused determined criticism of their theoretical apparatus. In his review of Tilly's book, for instance, the historian Richard Cobb concluded: "This is a good and welcome book. It could have been so much better—and shorter—if Dr. Tilly could have been induced to forget his sociology, abandon his jargon, and show less desire to accommodate everything neatly."[2]

The most obvious consequence of history's contamination by social theory was the rise of social history as a subdiscipline. Following in the footsteps of pioneers such as Thompson and Tilly, younger historians increasingly turned their attention to "history from below," that is, to the history of social groups or practices that were usually excluded from or ignored in more traditional histories of political elites and institutions. Between 1958 and 1978, the proportion of American doctoral dissertations in social history quadrupled, until it overtook political history as the leading area of research.[3] But as social history triumphed, it also came under attack. Social history could be inspired by Marxism, modernization theory, or the *Annales* school, and some commentators felt that its very eclecticism proved to be its ultimate undoing. The more social history advanced, the less it was tied to any particular theoretical project.[4]

What this shows, I think, is not the reactionary politics of social historians but rather the inherent disciplinary resistance of history to self-conscious theorizing. What began—in the work of Thompson and Tilly, for example—as a research agenda set by social theory in order to shed light on theoretical questions, ended as (some would say degenerated into) the pursuit of a new set of topics defined only by their quantifiability and their putative relationship to social existence as conventionally defined. Research and writing on class struggle and state formation, for example, were rapidly overshadowed by work on infanticide rates, prenuptial customs, and the history of food. These are not inherently dubious topics. Still, it is the case that the pursuit of such new topics in the absence of any clear theoretical agenda led to fragmentation and diversity rather than to the building of a new social theory (or even any clear testing of already existing ones). An analytical chasm seemed to separate prenuptial customs, for

instance, from class formation or conventional struggles for power. Even the *Annales* school conviction that these topics could all be fruitfully included under the rubric of *histoire totale* failed to satisfy the critics, because the topics seemed to proliferate endlessly without provoking any new thinking about the structures or relationships within this admittedly vague notion of "total history."[5] Positivist empiricism once again had diverted the newest forms of historical inquiry from the cutting edge of theoretical development and transformed them into building blocks of a construction without plan or clear shape.

I have no interest, however, in joining the critics of social history or in arguing for a return to a concentration on the problems of political power, narrowly construed.[6] Whatever the weaknesses of social history, during the 1970s it began to be supplemented and in some ways challenged by a growing concentration on culture. The interest in culture had already been present in the work of E. P. Thompson, who had argued that class consciousness was "the way in which these experiences [of productive relations] are handled in cultural terms: embodied in traditions, value-systems, ideas, and institutional forms."[7] The study of culture got added impetus from the work of Natalie Zemon Davis. Her influential essays in *Society and Culture in Early Modern France* (1975) promoted an interest in anthropological theory. By the end of the 1970s, anthropology had in many ways taken the place of sociology as the critical discipline of influence on historical work. At first, the anthropology in question was closely aligned with social theory; the symbolic anthropology of Victor Turner or Mary Douglas, for example—which was very prominent in Natalie Davis' work—was informed by the desire to create new theoretical understandings of the working of society through the window afforded by cultural formations. At the end of the 1970s and in the 1980s, however, anthropology itself began a major reorientation that paralleled that of the other "human sciences," as the French call them.

This reorientation was the produce of discursive or literary models in cultural studies (a better term in English than "human sciences"). By discursive model of culture, I mean the insistence that culture is inscribed in and through rhetorical and narrative

as well as semiological means. According to discursive models, a culture cannot be simply read as a transparent representation of some more basic set of codes; it has to be interpreted, and its interpretation involves issues like those current in literary theory. John E. Toews captures the impact of what he calls "the linguistic turn" in these terms:

> [structuralists and poststructuralists] have constructed a sweeping and apparently devastating critique of the traditional foundations of knowledge claims in both the natural and the human sciences. If we take them seriously, we must recognize that we have no access, even potentially, to an unmediated world of objective things and processes that might serve as the ground and limit of our claims to knowledge of nature or to any transhistorical or transcendent subjectivity that might ground our interpretation of meaning. Knowledge and meaning are not discoveries but constructions. The world and the subject that confronts it are "always already" present to us as culturally constructed.[8]

I do not intend to give a history of the coming to prominence of discursive models, which would have to include a history of the reception of approaches as diverse as those of Foucault, Derrida, Gadamer, and Jauss, to name only a few. Discursive models have become very explicit in work that is critical of anthropology's unspoken assumptions about interpreting and writing (for example, Clifford and Marcus, *Writing Culture*, 1986), just as they have been most explicit in historical work that is critical of historians' unspoken assumptions about their interpreting and writing functions (especially in the work of Hayden White).[9] But these forms of criticism of disciplinary discourse have until recently been relatively rare and lacking in much influence, at least among practicing ethnographers and historians (i.e., those who write ethnographies and histories of other cultures and times rather than analyses of their disciplines).

The most influential discursive model in the work of practicing historians (and ethnographers) is the interpretive one put forward by Clifford Geertz. In his celebrated essay, "Thick Description: Toward an Interpretive Theory of Culture," Geertz described his project in these terms: "culture [defined as 'interworked systems

of construable signs'] is not a power, something to which social events, behaviors, institutions, or processes can be causally attributed; it is a context, something within which they can be intelligibly—that is, thickly—described."[10] Anthropology, by this definition, was to be an interpretive science in search of meaning rather than an experimental one in search of law. In this essay, Geertz had already joined the major issues: causal analysis vs. interpretation of meaning, text vs. context, social theory vs. a more literary or discursive understanding. In a later essay, "Blurred Genres," he explicitly linked his "interpretive theory" to what he called "the Text analogy . . . the broadest of the recent refigurations of social theory."[11]

Historians soon flocked to the interpretive banner, but again, as with social history, the theoretical impetus of interpretive anthropology was lost in the crush to study cultural *topics*. Geertz had been concerned to reconstitute anthropology as a discipline based on interpretation, with a grounding in hermeneutical philosophy and literary theory. Historians who followed his lead focused instead on the cultural forms that he and other anthropologists had studied as their point of departure. Festivals, rituals, and charivaris were discovered everywhere, but for historians who studied them, they seemed to constitute an end in themselves rather than an occasion for the construction of new social theoretical understandings.

Some of the blame for this state of affairs can be laid at Geertz's own door. Just how the text analogy represented a refiguration of social theory was unclear. Moreover, as some critics have observed, Geertz could not offer a method of interpretation that could be followed by others or be set firmly within a social theoretical framework because his approach rested on virtuosity —on the *tour de force* of a single, individual, creative mind. As one anthropological critic put it recently,

> the events described [speaking of the Balinese cockfight] are subverted by the transcending stories in which they are cast. They are sacrificed to their rhetorical function in a literary discourse that is far removed from the indigenous discourse of their occurrence. The sacrifice, the subversion of the event described, is in the final analysis masked . . . by the author-

ity of the author, who, at least in much ethnography, stands above and behind those whose experience he purports to describe.[12]

Geertz's virtuosity was the virtuosity of the literary critic looking for a text that could exemplify the central, unifying meanings of a culture. Crapanzano's criticism of Geertz in this passage leaves many questions unanswered, however. Is the objection to Geertz's virtuosity tied exclusively to Geertz's predilection for the story of unity as opposed to one of conflict and subversion (as the title of Crapanzano's essay seems to imply)? Or does the problematic authority of Geertz implicate all anthropological analysis as fundamentally literary and aesthetic? Would the authority of Geertz be acceptable if the plot line he chose were more "politically correct"?

Historical critics, too, have been bothered by some of the consequences of Geertz's assimilation of his role as anthropologist to that of the literary critic. As Ronald Walters complained, "Geertz is not especially clear on how to avoid the potential for silliness in extracting the general from the particular." Even more disturbing, as Walters notes, is the fact that "words like 'class,' 'exploitation,' and—most important—'power,' recede, drop out of the analysis, or take on new, less strident meaning."[13] As was the case with his mentor Talcott Parsons, for Geertz culture seems to exist everywhere, and it seems ineluctably to serve the cause of social regulation and equilibrium. The aestheticizing of culture on Geertz's part, then, might serve a conservative political function (even if that were not Geertz's intention).

Less commonly noted but at least as important has been the confusion inherent in Geertz's statements about his relationship to social theory, my concern here. In "Blurred Genres," Geertz describes the "text analogy" as a variation—he calls it a refiguration—of social theory. In fact, however, that text analogy threatens to undo social theory altogether. Already apparent in Geertz's statements above is the instability of the relationship between text and context, causal analysis and the interpretation of meaning. In touting thick description, he refers to himself as interested in context, yet when referring to himself as a literary critic, he

textualizes his objects of scrutiny. How can culture (or symbols, which Geertz more or less equates with culture) be text and context at the same time? And if they are, and I think that they are in Geertz, then how can the analysis of either one lead to a social theoretical understanding?

By the question, of course, I am implying that a social theory rests on a heuristic separation of text and context. Because the separation of text and context is effaced in Geertz, the possibilities of constructing social theories are also effaced. Put another way, Geertz's particular form of narrativizing has cast, paradoxically, an enormous shadow over the consideration of the merits of any metanarrative (I am equating social theory with metanarrative). The very seamlessness of the Geertzian story makes social theory impossible. The more "thickly described" an event is, the less susceptible it is to being integrated into a generalizable story about cause and effect. This same point is made in a slightly different way by the American literary critic Giles Gunn, when he concludes, speaking of Geertz, that

> to assume, then, that we can always successfully differentiate between the interpreted transformations of the translated object and the social contexts of its various forms of existence is as treacherous as supposing that we can work our way back through the phases of translation and recover the immediacy of experience from which it springs.[14]

Just as Geertz himself has moved steadily in the direction of literary theory, so too historians' construal of culture has become more and more discursive. It is premature to claim that this is a major movement; there are still not too many historians properly speaking—that is, aside from those few who are self-defined as historiographers or philosophers of history—who have completely embraced a literary or discursive model. And it would be misleading to claim that historians' construal of culture is univocally influenced by Geertz's model of analysis. Still, the influence of such models is growing steadily in every quarter, whether due to the impact of Geertz, Foucault, or, much more rarely, Derrida. At the very least, it has raised the hackles of traditional historians.

What forms does this influence take and what problems does it pose to those who are sympathetic to its major premises? There is a growing literature on the writing of history, especially provoked by Hayden White and Dominick LaCapra, their followers and their critics, but most of it has had only an indirect impact on the writing of history itself. History, after all, is one of those fields of endeavor in which even those who are interested in the avant-garde can write in perfectly traditional fashion about the most outrageously novel and threatening forms of discourse. Intellectual historians have long specialized in this genre of naturalization.[15] I am more interested here, however, in the direct consequences of discursive models for historical research and writing.

Discursive models of culture have some obvious attractions, even to those who research and write "normal" history (in Thomas Kuhn's sense of normal).[16] These bear repeating because it is possible to lose sight of the fact that the attractions are political as well as epistemological. The interest in culture, in the first place (whether in the work of Talcott Parsons or Natalie Davis or even Michel Foucault), was a way of disengaging oneself from Marxism, or at least from the most unsatisfactory versions of economic and social reductionism. By focusing on culture, one could challenge the virtually commonsensical assumption that there is a clear hierarchy of explanation in history (that is, in all social reality), running from biology and topography through demography and economics up to social structure and finally to politics and its poor cousins, cultural and intellectual life. As John Toews argues, "The tides of psychological and sociological reductionism seem to have been damned and turned back. The history of meaning has successfully asserted the reality and autonomy of its object."[17]

Toews was referring to intellectual history when he made that remark, and it is less clear that it applies to social and cultural history. The assumption that there was a clear hierarchy of explanation running from economy and society up to politics and culture was present in both the *Annales* school and in Marxism, and it can still be seen in the table of contents of many if not most social history monographs. The focus on culture, and especially discursive models of culture, challenges this view by showing

that all social reality is in fact culturally constructed (and discursively construed) in the first instance. The importance of this challenge to the base-superstructure model of Marxism or the three-tiered model of the *Annales* school should not be underestimated.[18] How can culture be considered a phenomenon of "the third level" in *Annales* terms, if the "basics" of life (demography, economy) are themselves constructed in and through culture? Not only does the challenge of discursive models (again, whether Geertzian, Foucaultian, or Derridian, to name only three of the most dominant versions) throw into doubt all the conventional language of historical explanation, but it also opens up the way to new forms of historical investigation. Foucault's work is perhaps the best-known example of such a new form with direct historical relevance, but in the future it will be joined by other new varieties.[19]

In my own work on the French Revolution, I tried to take seriously the challenge to the conventional views of explanation that I have outlined here. Rather than presenting a book that began with social structure and then analyzed politics and culture, as if it were clear that the latter followed from the former in some way, I inverted the order, so as to cast doubt on the reigning assumptions. By beginning with "the poetics of power," under which rubric were included rhetoric, symbols, and imagery of various sorts, I was able to argue that the discursive structures of politics shaped the possible political outcomes and even the ways in which social being impinged on politics. The manner in which people talked about the nation, for example, set limits on the ways in which different social groups entered the political arena; the emphasis on consensus and unity precluded the formation of organized political parties and encouraged the occlusion of social difference.

At the same time, however, rhetorical and narrative strategies also opened up new, previously unimagined possibilities for social participation and for social conflict; the nation, after all, implied no necessary social boundaries, and there were immediate and lasting struggles about the social meaning that should be attached to the new discursive and symbolic practices. Neither the limits imposed nor the new possibilities afforded by the dis-

cursive structures followed from the social identity of the groups in question. In this sense, the text—the unities and contradictions implicit in revolutionary political culture—configured the context.

Many commentators have objected to the discursive determinism that they see lurking behind this kind of analysis. As Norman Hampson remarked, for example,

> Politics . . . is a matter of making decisions. Unless one is a rather extreme determinist, this implies that the people concerned could have acted differently and that what actually happened was only one of the possibilities implicit in a situation. . . . From Hunt's aerial view, it all has to be taken as somehow inevitable if the generalisations are to hold good. This leads not so much to compression as to the distortion of the evidence and a reluctance to consider how the revolution lurched one way and another under the impact of events that need not have happened.[20]

More charitably, Robert Darnton attributes the difficulties that he sees in the book to just those general disciplinary problems that are addressed in this essay:

> The failure [to communicate the sense of men struggling to create some meaningful order out of difficult, dangerous circumstances] is symptomatic of a problem facing all the humanistic disciplines today, for all of them are shifting from causal to textual modes of analysis.[21]

So, though Darnton can charge that in its theoretical eclecticism and "lack" of flesh-and-blood revolutionaries, my book "conveys the campus culture of the 1980s rather than the political culture of the 1790s," he nonetheless traces the problem ultimately to a kind of Geertzian influence: "Like literary scholars and anthropologists [the conjunction is significant], historians increasingly tend to define their task as one of interpretation."[22]

In order to avoid the problem of linguistic determinism—what John Toews calls in another context "the reduction of experience to the meanings that shape it"[23]—I tried to insist that neither the symbolic nor the social was primary in the usual sense. I was not trying to turn the commonsense hierarchy on its head; I was

trying to escape from it altogether. This attempt at escape was formulated as follows:

> This is not to say, however, that the Revolution was only intellectual or that politics had primacy over society rather than vice versa. The revolution in politics was an explosive interaction between ideas and reality, between intention and circumstance, between collective practices and social context. If revolutionary politics cannot be deduced from the social identity of revolutionaries, then neither can it be divorced from it: the Revolution was made by people, and some people were more attracted than others to the politics of revolution.[24]

In searching for a metaphor to replace the dominant one of "levels," I seized upon the knot or Möbius strip because in both cases, the two sides—social and symbolic—were inextricably intertwined, with no fixed "above" and "below." This formulation, though it has the merit of avoiding materialist reductionism, also leaves some questions unanswered. In particular, it creates great problems for social theorizing, which depends, after all, on the ability to generalize from cases. Is the interaction between discursive practices and social "realities" (using that word advisedly, of course) always particular, only empirically determinable, and hence never generalizable? Is there no pattern in the interaction that is theorizable? If we reject reductionist Marxism, we are left with no social theory whatsoever?

Another way of putting these questions is to ask, what is the narrative in which such interactions can be inscribed? A social theory, after all, is a species of metanarrative, that is, a narrative that organizes other sets of narratives. It is, in short, a narrative that can offer systematic connections between the social and the symbolic. My work, it seems to me now in retrospect, was driven (or riven) by an unconscious ambivalence about the status of metanarrative in my own analysis. Like most social historians, I avoided any conventional narration, as if I could thus avoid the usual pitfalls associated with narrative history.[25] Yet even the most resolutely "analytical" history has an inherent narrative form.[26]

I did try to talk about the narratives offered unconsciously by the revolutionaries themselves (an approach which in general has much promise); in revolutionary rhetoric, I saw a movement from comedy, to romance, and then to tragedy as the underlying narrative form. Although I think that this analysis is defensible, it is not clear what it implies; what difference does it make that there is this movement? It seems to me now that the reason that I could not answer this question—or even pose it—was that I did not want to face the problematic status of narrative in historical work as it has been recently discussed by any number of commentators. I presented my analysis as if it were simply the one which best accorded with the evidence; I did not want to call attention to its status as a strategic deployment in the never-ending contest for political control over the past. To call attention to its political status is, of course, to invite dismissal as a propagandist, but the cost for me was that I did not develop the relevance of narrativizing to the deployment of power *within* the historical process. The movement from comedy to romance to tragedy within revolutionary discourse was a way of establishing superiority over one's opponents, just as the implicit narrative in my work as a whole (which moved from comedy to romance to tragedy, itself, all the while rejecting the ironic mode so dominant in historiographical discourse about the Revolution) was a way of establishing superiority over other analysts of the Revolution. Much work remains to be done, however, on how narrativizing is implicated in and constituted by power relationships. Another way of putting this is to say that what Fredric Jameson has attempted for literature has not yet been tried out by historians.[27]

I am not alone among historians, then, in my problematic relationship to narrative and metanarrative. I do not want to engage the debate about narrative history per se, since many others have already covered that ground.[28] But the status of narrative forms of historical representation is not very easily separated from the question of metanarratives such as social theory. The most radical criticism of the historical discipline seems to throw both into question. Sande Cohen, for example, concludes that

there is no strong reason to consider story a form of pre-predicative handling of events and actions or one of the root forms in which intellect itself speaks. I concur with Barthes's de-idealization of story and, by implication, of the entire historiographical tradition, scientific or not, which has valorized story and narration; through story (or the far better term, storification) academic culture encourages a consciousness that is never able to arrive at criticism.[29]

Cohen appears to categorize metanarrative with all forms of transcendence, which he identifies with "ideological writing, academic writing treated as a mode of bureaucratic-ideological organization" (p. 8). No one escapes his wrath, since his primary objects include Peter Gay, Edward Thompson, and Fernand Braudel, none of whom are primarily identifiable as traditional narrative historians. Cohen argues that all of these "promote the myth that history is a condition of knowledge" (p. 12). Even Jameson, in this view, reproduces "cultural overcoding: history is released from its full semantic workup and is empowered to serve as the category in the name of (common sense, desire, and so on), an activity that creates confirmation of passivity" (p. 21). It is less clear what Cohen would have us do instead. Cohen describes his own view as a "combination of semiotic theory, existential-anarchist attitudes toward cultural passivity, and the original Marxist focus on unpaid labor" (p. 12), but, significantly, his critique of the three men—and of many others in passing—issues in no particular conclusion, except, perhaps, that we ought not to do history.

Even the great defender of narrative, Hayden White, leaves us "normal" historians perplexed about the role and status of metanarrative. Although he stoutly defends narrative as "a meta-code, a human universal on the basis of which transcultural messages about the nature of a shared reality can be transmitted," White is evasive about metanarratives (just as he is evasive about the politics of narrative, a not unrelated point). At the end of his consideration of Jameson's *Political Unconscious*, for example, he seems to endorse the Cohen position; the Marxist master narrative and possibly narrative itself, he argues, are tainted with

what Benjamin called the guilt of culture and history. "And could not the death of 'History,' politics, and narrative all be aspects of another great transformation, similar in scope and effect to that which marked the break with Archaicism begun by the Greeks?"[30]

Significantly, White structures *The Content of the Form*, his most recent book, around a discussion of Foucault, Jameson, and Ricoeur in that order, clearly implying an intellectual development from Foucault's failed attack on ethics, to Jameson's failed attempt to substitute politics for ethics, to Ricoeur's successful but overly metaphysical redemption of narrative (for Ricoeur, as for White, this seems to imply an evasion of politics—or is it a transcendence of politics?). In the final chapter, White retreats again to his own formal analysis of texts, in which questions of causality and metanarrative are bracketed in favor of what he there calls a "semiological conception of texts" (p. 191). As he has argued before, he maintains that "the form of the text is the place where it does its ideologically significant work" (p. 204), yet White avoids the entire issue of context (and by implication causality) by insisting that "what conventional historians call the context is already in the text in the specific modalities of code shifting by which [the text] produces its meaning" (p. 212).

This may enable us to appreciate the text in "its richness and power as a symbolizing process" (p. 213), but it does not really resolve the question of history's relation to social theory that I raised above. It evades the issue of the relationship between text and context in essentially the same fashion that Geertz evaded it: by textualizing context and thereby effacing the distinction between them. The context may be already present in the text, as White maintains, but the question is how we identify "the specific modalities of code shifting." Is this simply a formal question (in which case we would seem to be back at literary New Criticism with its rigid separation of text from context)? If we are to understand the "symbolizing process," must we not have a view of the relationship between symbols and the world (experience, context) they are imagined to symbolize? In other words, don't we need a social theory?

Historians interested in the discursive models of culture are more likely than most to be willing to suspend (perhaps literally

to hold in suspense, that is, not to reject altogether but to hold at arm's length) the conventional (commonsensical) paradigms of historical explanation, not because they do not believe in causal explanation or social theory or metanarrative, but because they have learned at least to be deeply suspicious of facile connections. It may be that for now, their—our—emphasis must necessarily rest on untangling the workings of discursive practices in all their specificity; this emphasis is critical not only to greater elaboration of discursive models in general but also to the most vital subsets of discursive analysis that have popped up in recent years, namely, feminist analysis and psychoanalytical investigations (meaning here not psychohistory but psychoanalytical models of personality development as they apply to processes of reading, for example). Of those mentioned in this essay, only Jameson has paid *any* attention to either of these. Neither feminist nor psychoanalytic historical criticism can be very well accommodated in the old social theoretical models, but they have proved quite compatible with the discursive model of culture in literary studies, all the while enriching it in new and unexpected ways.

In history, however, feminist and psychoanalytic criticism have only begun to win a few footholds within the more general, and still quite marginal, discursive models of culture. Most strikingly, within the discipline of history, there has as yet been almost no alliance between feminist and psychoanalytic critical forces. When that alliance occurs, as I think it will in the next years, historians will be in a position to not only further reduce the old social theoretical models to shambles but also to begin constructing new ones. The conjunction of feminist and psychoanalytic historical criticism will be central because it is particularly compatible with the most radical implications of an analysis linking narrativity and power (even though this link has not yet been recognized).

As Giles Gunn notes, we must remember that "discourse is rhetorical, that rhetoric is a form of persuasion, and that persuasion is a form of power, an instrument of social manipulation and control."[31] Any discursive model that emphasizes a kind of aesthetic unity in culture at the expense of social differences in reception and use risks making us forget the moral and political elements of discourse and culture. The advantage of feminist

analysis is that it takes gender differences in power as its starting point; the advantage of psychoanalytic inquiry is that it attempts to theorize both the different routes to subjectivity and the importance of narratives of individual and social development to identity. In the end, with these techniques or with others still, historians will have to try to develop new social theories, new metanarratives, even while making problematic their old ones. For metanarratives are the kinds of stories that make action possible; there is no action without a story about how the world works. Those stories will always be changing (they are in fact stories about how change works), but we will always have to tell them.

Notes

1. See Ellen Kay Trimberger, "E. P. Thompson: Understanding the Process of History," and Lynn Hunt, "Charles Tilly's Collective Action," in Theda Skocpol, ed., *Vision and Method in Historical Sociology* (Cambridge: Cambridge University Press, 1984), pp. 211–243 and 244–275.

2. Richard Cobb, "The Counter-Revolt," in *A Second Identity: Essays on France and French History* (London: Oxford University Press, 1969), pp. 111–121; quote on pp. 120–121.

3. Robert Darnton, "Intellectual and Cultural History," in Michael Kammen, ed., *The Past Before Us: Contemporary Historical Writing in the United States* (Ithaca: Cornell University Press, 1980), p. 334.

4. See, for example, the essay by Elizabeth Fox-Genovese and Eugene D. Genovese, "The Political Crisis of Social History: Class Struggle as Subject and Object," in their *Fruits of Merchant Capital* (Oxford: Oxford University Press, 1983), pp. 179–212.

5. For an analysis of the *Annales* school and the particular problems it presents for historical theorizing, see Lynn Hunt, "French History in the Last Twenty Years," *Journal of Contemporary History* (1986), 21:209–224.

6. See, for example, the ambivalent, but ultimately judicious, review by Lawrence Stone of Gertrude Himmelfarb, *The New History and the Old*, titled "Resisting the New," *New York Review of Books*, December 17, 1987.

7. E. P. Thompson, *The Making of the English Working Class* (New York: Vintage Books, 1963), p. 10.

8. John E. Toews, "Intellectual History After the Linguist Turn," *American Historical Review* (1987), 92:879–908; quote on pp. 901–902.

9. See James Clifford and George E. Marcus, eds., *Writing Culture: The Poetics and Politics of Ethnography* (Berkeley; University of California Press, 1986), and Hayden White, *Metahistory: The Historical Imagination in Nineteenth-Century Europe* (Baltimore: Johns Hopkins University Press, 1973).

10. Clifford Geertz, *The Interpretation of Cultures* (New York: Basic Books, 1973), p. 14.

11. Clifford Geertz, "Blurred Genres: The Refiguration of Social Thought," in *Local Knowledge: Further Essays in Interpretive Anthropology* (New York: Basic Books, 1983), p. 30.

12. Vincent Crapanzano, "Hermes' Dilemma: The Masking of Subversion in Ethnographic Description," in Clifford and Marcus, eds., *Writing Culture*, pp. 51–76; quote, p. 76.

13. Ronald G. Walters, "Signs of the Times: Clifford Geertz and Historians," *Social Research* (1980), 47:537–556; quotes, pp. 543 and 553.

14. Giles Gunn, *The Culture of Criticism and the Criticism of Culture* (New York: Oxford University Press, 1987), p. 110.

15. For an analysis of intellectual historians' uses of discursive models, see Toews, "Intellectual History." As this review shows, even intellectual historians interested in the premises of structuralist and poststructuralist discursive models often eschew the use of them in their own work. They write about those models; they do not apply them.

16. See Thomas Kuhn, *The Structure of Scientific Revolutions* (Chicago: University of Chicago Press, 1962).

17. Toews, "Intellectual History," p. 906.

18. For a more detailed development of this view, see Hunt, "French History in the Last Twenty Years."

19. See, for example, Joan Scott, "Gender: A Useful Category of Historical Analysis," *American Historical Review* (1986), 91:1053–1075.

20. Review by Norman Hampson, *Eighteenth-Century Studies* (1985), 19:297–300.

21. Robert Darnton, "Revolution sans Revolutionaries," *New York Review of Books,* January 31, 1985, p. 23.

22. Darnton, "Revolution sans Revolutionaries," p. 23. Of course, Darnton's own recent work is influenced by the same tendencies, as he himself recognizes.

23. Toews, "Intellectual History," p. 906.

24. Lynn Hunt, *Politics, Culture, and Class in the French Revolution* (Berkeley: University of California Press, 1984), p. 13.

25. See the discussion by Lionel Gossman, "History and Literature: Reproduction or Signification," in Robert H. Canary and Henry Kozicki, eds., *The Writing of History: Literary Form and Historical Understanding* (Madison: University of Wisconsin Press, 1978), pp. 3–39, especially pp. 32–36.

26. François Furet tries to work this distinction, but I do not find it convincing in *Interpreting the French Revolution,* tr. Elborg Forster (Cambridge: Cambridge University Press, 1981).

27. See Fredric Jameson, *The Political Unconscious: Narrative as a Socially Symbolic Act* (Ithaca: Cornell University Press, 1981).

28. See especially Hayden White, "The Question of Narrative in Contemporary Historical Theory," in his *The Content of the Form: Narrative Discourse and Historical Representation* (Baltimore: Johns Hopkins University Press, 1987), pp. 26–57.

29. Sande Cohen, *Historical Culture: On the Recoding of an Academic Discipline* (Berkeley: University of California Press, 1986), p. 77.

30. White, *The Content of the Form,* pp. 1 and 168.

31. Giles Gunn, *The Culture of Criticism,* pp. 74–75.

4
MACHIAVELLI: HISTORY, POLITICS, DISCOURSE
Claude Lefort

IN HIS introduction to the *Discorsi*, Machiavelli begins boldly by claiming the originality of his enterprise. He says that he has "resolved to open a new route, which has not yet been followed by anyone" and compares his enterprise to "the exploration of unknown seas and continents."[1] However, this declaration is immediately followed by another statement that perplexes us. His purpose, he announces, is to persuade his contemporaries to transfer their desire to imitate the examples of the ancients in art, law, and medicine to the domain of politics and military art.

This connection of the two statements is something of a paradox. While presenting himself as an innovator, the author appeals to readers of his *Discorsi* to return to the ancient world. It is as though the discovery of the New and the Unknown coincides with the rediscovery of the past. Then, Machiavelli accounts for the rejection of the political examples of the ancients in two fashions. On the one hand, he speaks of the "weakness to which the vices of our education have reduced the world"; on the other hand, he underlines "the evils caused by the proud indolence which prevails in most of the Christian States, and to the lack of real knowledge of history, the true sense of which is not known, or the spirit of which they do not comprehend" (p. 104). Most important in this context is the second remark. In sum, the Florentines are merely titillated by hearing of the various incidents of history; they become no more than spectators of the scene of the past, without understanding that they live in the same world. So they adopt a contemplative or purely aesthetic view, by forgetting that past and present are not different from one another. "Thus

the majority of those who read [history] take pleasure only in the variety of the events which history relates, without ever thinking of imitating the noble actions [of the ancients,] deeming that not only difficult but impossible; as though heaven, the sun, the elements, and Man had changed the order of their motions, and power was different from what it was in ancient times" (pp. 104–105). Proceeding from these first remarks, Machiavelli intends to make the stories (storie) attractive anew and to draw attention to Livy's works which are still available to the public. He appeals to this public to read them again, not without specifying that his own commentaries result from "a comparison between ancient and modern events," which seems to him "necessary to facilitate their proper understanding" (p. 105). This last sentence is worth emphasizing.

Let us sum up the argument of the introduction at this point. First, the imitation of the examples of the ancients is linked to the search for the unknown. Second, such ability to imitate presupposes the understanding that past and present are included in one unique time. Third, nonetheless, past and present are not directly observable or given to us; they require the mediation of Livy to be properly appreciated and compared. Fourth, Livy's work itself needs to be clarified through an inquiry into various events. So neither the history of Rome, nor that of Florence, nor the Livian text is significant in itself. They have to be deciphered, as it were, reconstituted, through one another.

Many commentators have missed the paradox inherent in Machiavelli's way of introducing his considerations on Roman history. They have preferred to compare the Discourses with The Prince. It has often been claimed that after being disappointed by the reception of The Prince, Machiavelli returned to long-term study of Rome in order to demonstrate the superiority of a republican form of government, of which Rome provided the best example. However, by contrast, Machiavelli could not help but pursue the task he had devoted himself to in The Prince. Considering the behavior of the various Roman leaders, he supposedly found a new means of rationalizing political action, and thus he constantly oscillated between a moral and an amoral view of Roman virtue.

We are indebted to Leo Strauss for the thesis, presented in a masterly fashion, that like *The Prince*, the *Discourses* contained subversive teaching, and, under the cover of praising the Roman republic and the virtues of its citizens, launched a vigorous attack against the classical tradition.[2] Indeed, while admiring the Roman republic, Machiavelli makes a devastating criticism of good government such as it was conceived by classical authors—that is, the government that was the product of wise legislators and that maintained strict order and stability in the city. While celebrating the virtues of the citizens, he shows that they can be praised or blamed according to the ways they evaluated the chances of acting in an institutional framework under determined circumstances. While dealing with Livy's work as the great authority, he leads his readers (step by step) to question the validity of Livy's commentary and to free themselves from his aristocratic assumptions.

First of all, I wish to draw attention to a striking argument of the first book of the *Discorsi*. After comparing the respective advantages of Spartan and Roman constitutions in an apparently objective fashion, Machiavelli observes that Rome's greatness did not at first result from good legislation but was gradually achieved by means of various events. So he suggests that a good constitution in itself does not necessarily prevent corruption. The events from which Rome particularly benefited are related to the incessant conflicts between the Senate and the Plebes, in such a way that civil struggle (Machiavelli says *desunione*) finally appears as the driving force of the growth of the republic. At this point, Machiavelli says he is moving away from common opinion *(opinione di molti)*: "those who blame the quarrels of the Senate and the people of Rome condemn that which was the very origin of liberty, and they were probably more impressed by the cries and noises which these disturbances occasioned in the public places, than by the good effect which they produced" (p. 119). In opposition to the traditional thesis that what makes a good law is its capacity to raise a barrier against the demands of the populace, Machiavelli argues that "good laws in their turn spring from those very agitations which have been so inconsiderately condemned by many." He goes on to say that "the demands of a free

people are rarely pernicious to their liberty, they are generally inspired by oppressions, experienced or apprehended" (p. 120). So law is set apart from moderation. It no longer results from the initiative of the rulers. The law is born of the inordinate desire for freedom—a desire which cannot be separated from the appetites of the oppressed. Although the oppressed are driven by envy, their desire is pure negativity, the refusal of oppression, not the desire to have, but the desire to be. Finally, in one of the last chapters of Book 1, after a long discussion about the character of the populace, Machiavelli goes so far as to attack Livy himself— he has just called him "our Livy"—along with all other historians, by saying that the populace is wiser and more constant than a prince.

By reminding you of this argument—which I could have linked to a few others of the same sort—I wanted to show how new was Machiavelli's way of presenting the history of Rome. Her institutions were neither good in themselves, nor were her citizens virtuous by nature (in fact, a lot of examples testify to the ambitious projects of many of them, including conspiracies). Nevertheless, Machiavelli presents Rome as the city that, rather than attempting to close itself off, accepted quarrels and tumults, and succeeded in taking advantage of them to avoid both tyranny and license. Such a pattern, it is suggested, made clear the requirements for successful policy, or, to put it another way, generated both individual initiative and discipline. Indeed, discipline did not prevent one from occasionally transgressing the established rules, since authority was never petrified but always exposed to contestation, whereas initiative did not prevent one from obeying the law, since the people always kept an eye on the ambitious individuals and suspicion always bridled ambition.

I should like to pause briefly at this point to remark how complex the relationships between the ancients and the moderns appear in the *Discorsi*. First, in a sense, the moderns are inferior, owing their obedience to a Christian ethic that prevents them from searching for the right criteria of action in this world and from appreciating the value of a civic way of life. Because people are frightened of the image of God, they do not dare act and think by themselves. In the modern world the many resign themselves

to oppression whereas the few feel they are entitled to tyrannize them. Second, in Rome, although the means employed to maintain freedom were successful, most of the historians or philosophers were not capable of appreciating them correctly. They rather covered the real social relationships with a veil by praising civil harmony and the primacy of the virtuous citizens destined to rule over the people. They agreed with the official speeches which relied upon aristocratic prejudices. Third, regarding human history, we must admit that all men have the same general character. The ancients and the moderns are made of the same stuff. What changes is the way people respond to permanent questions concerning what is the best social order and what the relationships should be between those who want to command and to oppress others and the people who do not want to be commanded, who do not want to be oppressed. So the ancients make us discover the appropriate responses to these questions and the superiority of the Roman republic. Fourth, while being at present inferior to the ancients, the moderns are the ones who for the first time are capable of discovering the general principles of politics. Provided that they strive to link together the desire to reform the present state of things and the desire to know, they can understand the meaning of ancient actions and institutions, which remained hidden or misinterpreted by classical authors themselves. So, by exploring the past, the moderns can open a new route, or as Machiavelli says, they can discover *ordini nuovi*.

Yet we have to understand better why Machiavelli's interpretation of the history of Rome was of such great significance in Florence in his own time. Leo Strauss insisted principally on the criticism Machiavelli made of classical theory by giving up the notion of good government and by exploiting the Roman examples in order to substitute the criterion of "Being" (*la verita effetuale*) for the criterion of "what ought to be." I would like to show that Machiavelli aimed at a target other than classical philosophy and that we cannot account for his enterprise by staying within the boundaries of the history of philosophy. Indeed, we have to discover the questions he was confronted with in his time and evaluate the impact upon his contemporaries of his new view of the Roman republic. I do not mean at all that we should leave

the domain of philosophy and adopt a historicist point of view. I mean rather that philosophy is not included only in the works of the philosophers. It lives in contact with and in relation to common opinion and especially the modes of rationalizing political practices that lay claim to general validity. So, by referring to the debate on the nature of the Florentine regime and on the history of Florence, I want to draw attention to another sort of discourse, the background against which Machiavelli's work gains a new meaning.

I'll limit myself to mentioning a few facts of particular relevance. First, before being written, the *Discorsi* were, at least in part, discussed within a circle of young men attached to the cause of republicanism. We know that later a few of them took part in a plot against Cardinal Guilano Medici in 1522. Considering the important reflections on the conspiracies in the *Discorsi*, we can suppose that Machiavelli tended to demonstrate that such enterprises were useless unless they were carefully prepared and accompanied by a patient search for new orders (*ordini nuovi*) in rupture with the traditional republican ethics. Second, the meetings in which Machiavelli participated took place in the gardens (*Orti Orricellari*) of a well-known palace, where a few years earlier one of the most important leaders of the oligarchic faction (Bernardo Rucellai, brother-in-law of Lorenzo Medici) had already often discussed Roman history and Livy's works. So we are also allowed to suppose that Machiavelli developed a counterteaching in order to destroy the myth of a primary, peaceful, harmonious, good city gradually ruined by the tumults of the Plebes. Third, the reviews of the councils' meetings periodically convened by the Florentine governor Soderini before the return to power of the Medici clearly reveal the predominance of three kinds of discourse, as the historian Felix Gilbert has brought to light.[3]

One discourse was realistic, even cynical, and dealt with politics in terms of power relationships; this is the discourse that Machiavelli ironically assigned to the "wise people of our time" (*i savii di nostri tempi*), and that a number of commentators paradoxically have attributed to him. Another discourse was inspired by the Christian values that founded civic virtues upon

morality; this is the discourse Machiavelli assigned to the *piagnoni* (the ex-Savanoralians who used to shed tears). As for the third, the humanist's discourse, it praised wisdom, prudence, and moderation in the state's affairs and brought all arguments back to the notion of a well-hierarchized and stable body politic. While being divergent, these discourses were close to one another on important points. Necessity, Providence, and Fortune tended to exercise the same function. Each spoke of the needs of civic unity (*unione*), the dangers of dissent and the mutations always considered to result from factions, the virtue of original institutions (*antiqui ordini*), and the defense of the status quo in Italy, along with the advantages of the middle way (*la via del mezzo*) and temporization.

Thus, reading Machiavelli we can see how much he was intent on dissipating a threefold illusion while speaking to young men searching for a new way: the illusion that the old Florentine leaders were experts in political science (in fact, they constantly made wrong evaluations of power relationships); the illusion that Florence (as the city of St. John) benefited from a particular protection of Providence; the illusion that it had inherited the *virtus romana* and, more generally, the principles of ancient wisdom. These illusions, Machiavelli suggests, covered over the maintenance of an oligarchic system, deprived the people at large of their political rights, and kept them disarmed, whereas, in order to conserve itself, the city was even disposed to welcoming foreign invaders.

Let's proceed a bit further in this short historical investigation. The idealization of Rome had long been a characteristic of Florentine thought. It is true that Machiavelli said that the great examples of Roman citizens had been forgotten or ignored. However, everything depends on the examples he was referring to. In fact, as soon as the Florentine bourgeois liberated their city from the nobles by destroying the fortress surrounding the city, they identified themselves with the Romans. The Florentines did not limit themselves to imitating the Romans as did the French revolutionaries a few centuries later. They claimed to be their descendants, and they affirmed that Roman blood was flowing in their veins. Since the date of the first Chronicle (*Chronica de origine*

civitatis, 1225), it had been established that Florence was founded by the legions of Caesar and consequently deserved the name of *parva Roma.* So the inheritance was said to be not only spiritual but effective. Dante himself in his *Convivia* called Florence the "bellissima et famosissima figlia di Roma."

I leave aside the fascinating story of the successive re-elaborations of Florence's origins. What is the most relevant for my purpose is the fact that, in the last decades of the Trecento and the beginning of the Quattrocento, the development of a new humanist trend (which Hans Baron has called "civic humanism")[4] accompanied a new way of depicting the Roman forefathers and gave birth to a new sort of identification. In brief, the foundation of Florence was no longer brought back to the time of Caesar, but appeared as the work of the legions of Sylla. Instead of being the daughter of imperial Rome, Florence turned out to be the daughter of the Roman republic. It was said again and again that the Romans' blood flowed in the veins of the Florentines, but now it was the blood of a free people. From that date on, freedom and virtue became the property of the Florentines by nature. The new version of the origins of the city was connected to a new view of its history and its destiny. So, when a war between Florence and Milan broke out, the humanists, especially Coluccio Salutati and Leonardo Bruni, presented it as a struggle in the name of freedom against despotism and assigned to Florence the mission of defending the sacred cause of all oppressed people. By the same token, the entire past of Florence was reinterpreted as a series of episodes that testified to the constant will to maintain freedom within the city and to withstand the attacks of foreigners.

At this time an original image of civic virtues and republican values merged. *Virtus romana* was supposed to live in the hearts of outstanding citizens, whatever the character of their activities, whether they were merchants, captains, holders of public office, or devoted to the *studia humanitatis*: they were said to have similarly contributed to the growth of Florence and demonstrate the superiority of the *vita activa.* Reciprocally, the virtues of the citizens appeared as if resulting from the good effects of the republican government. Equality before the law and periodic re-distribution of public offices among those who were legally qual-

ified to exercise civil rights brought with them a new pattern of morality.

Although civic humanism was apparently buried from the time Cosimo Medici became the master of the Florentine government, its principles continued to be secretly respected by a minority throughout the entire fifteenth century. Moreover, we are able to find in this theoretical revolution the matrix of republicanism in Europe. Nevertheless, as soon as we ask what was in reality the character of the Florentine government that the humanists had so brilliantly celebrated, we must admit that it was far from corresponding to the image they had given it. This is the paradox: humanist speeches and writings came about at a time marked not by the widening but by the weakening of democratic relationships. In fact, the fight for civil rights had been intensified since the middle of the fourteenth century and reached its peak at the moment the Ciompi's rebellion erupted. After its defeat, Florence, through successive reforms, experienced a government under which public offices were more and more confiscated by closed elitist groups. So, civic humanism came along to counter this political reaction. Founded upon universal values, theoretically progressive, Salutati's or Bruni's discourses served also to mask the advent of a new oligarchic order.

Against this background, the idealization of the Roman republic exercised a privileged function. According to Bruni, the Florentines must feel that they are the descendants of the virtuous Roman citizens, given their incessant demand not to be oppressed by anyone. They must hate Caesar and admire Brutus. They must place the law above private interests. On the other hand, at the same time they have to recognize that the great achievements of Rome resulted from the wise policy of the Senate, that the fall of Rome was a consequence of its internal divisions provoked by the sordid appetites of the Plebes. They had to keep in mind the advantages of harmony, stability, moderation and the *via del mezzo*.

If we now turn back to Machiavelli, his deliberate distance from civic humanism becomes obvious. On the one hand, he inherited from it a number of his key ideas: the greatness of the Roman republic, the connection between the virtues of the free

institutions and the virtues of the citizens, the superiority of the *vita activa* over the *vita contemplativa*. However, he was fully aware of the function of humanist discourse in an oligarchic policy and attempted to reveal it. He showed that the humanist concept of civic virtue went hand in hand with Christian morality, which maintained the respect of the people for the established order and prevented them from criticizing public servants under the pretext that one must not *dire male del male*. He showed that the praise of the *vita activa* masked the breach between the bourgeois and the citizen—a breach that the utilization of mercenary or foreign armies for the defense of the city clearly revealed. He showed that the few, namely, the rich who presented themselves as the wise protectors of liberties, disguised their private interest. What the Florentines, for him, could learn from the tumultous history of Rome was the lesson that people who wanted to reform the political oder must not believe in the virtue of harmony and moderation and must not trust their adversaries—a lesson well illustrated by the failure of progressive policy of Governor Soderini. In opposition to civic humanism, Machiavelli not only praised the republican constitution but also drew attention to the proper requirements of political action, under different circumstances and within the framework of different regimes. This is why many commentators have spoken of the neutrality and the amoralism of Machiavelli. However, Machiavelli's objective analysis of each point of view, that of the prince, the conspirator, the tyrant, and the republican reformer, cannot be separated from his reflections on each kind of constitution and on the crucial distinction he clearly established between sound and corrupt regimes.

To summarize that last argument, I could say that Machiavelli turned away from the teaching of classical philosophers—Plato, Aristotle, and Cicero—by recognizing how civic humanism exploited this teaching in the service of an idealization of both the Roman republic and an oligarchic concept of politics in Florence. Humanists had falsely presented the Roman republic as a harmonious community, that is, they denied its social divisions, whereas they justified a mode of governing that excluded the people at large from public affairs. In this sense, civic humanism appeared

to have an *ideological* function. At the same time, the criticism of modern ideology went along with the criticism of Livian discourse on which it depended. I should add—without having time to develop this point—that what was at stake was not only the Livian and Ciceronian representations of the good, harmonious government but also the representations of most of the Roman leaders from the time of the foundation of the republic. These leaders presented their city as a community whose unity depended on the wise policy of the Senate and as the founder of a radically new order. Indeed Machiavelli did not hesitate to point out that Rome had destroyed the small Etruscan republics and erased any trace of freedom in Italy. However, Machiavelli's criticism of idealization at different levels did not prevent him from considering the growth of the Roman republic exemplary. Far from adopting a realistic, cynical point of view, he noted all the signs that revealed how civil struggles maintained freedom, how close were the links between the power of the people at large and the power of Rome. For Machiavelli, returning to reality meant discovering the marks of social division and the inseparability of good and evil. Returning to reality was not turning back to something directly observable, independent of established representations. It was linked to his critical analysis of modern and ancient theoretical discourses by which authority is conferred, as well as to his analysis of dominant collective speeches about the true and the untrue, the just and the unjust.

To take up again the meaning of the break between Machiavelli's teaching and the teaching of the ancient philosophers, I would propose an interpretation which differs from that of Leo Strauss. Machiavelli, he suggested, decided to explore the conditions of effective action under different circumstances. Whatever his preferences, he was firstly concerned with *verita effetuale* without taking into consideration the ultimate ends of Man. However, Strauss' views encourage us to forget that the classical search for the best government proceeded from the experience of and the critical reflection on corrupt regimes. It is a fact, for Machiavelli, that, through historical developments, the assumptions of the ancient philosophers have come to justify new forms of corruption. So he was induced to introduce a question of a new kind:

does division within Man and the city signify only the degrada-
tion of Being? For the thinker, is the experience of conflict not a
source of endless questioning? For the political actor, is it not a
reason for accepting ultimate indeterminacy, whenever he is con-
fronted with the requirements of judging and acting? For the city,
is it not an incentive for historical creation?

Notes

1. Machiavelli, *The Prince and The Discourses*, tr. by Christian E. Detmold
(New York: Random House, 1950), p. 103.

2. Leo Strauss, *Thoughts on Machiavelli* (Glencoe: The Free Press, 1959).

3. Felix Gilbert, *Machiavelli and Guicciardini: Politics and History in Six-
teenth-Century Florence* (Princeton: Princeton University Press, 1965).

4. Hans Baron, *The Crisis of the Early Italian Renaissance: Civic Humanism
and Republican Liberties in an Age of Classicism and Tyranny* (Princeton: Prince-
ton University Press, 1955).

5

SPATIAL EQUIVALENTS: POSTMODERN ARCHITECTURE AND THE WORLD SYSTEM
Fredric Jameson

POSTMODERN ARCHITECTURE presents us with a contradiction in the form of a conundrum: since one of the specific and indeed constitutive features of modernism lies in its claim to produce a radically new and utopian kind of space, does it follow that postmodernism displays its credentials and demonstrates its own "originality" as a new period by renouncing any claim to the restructuration of space? In that case, its affirmation of epistemic novelty could only be validated by our own agreement that no *Novum* is in question here, that the established order and conventions are maintained (perhaps by way of traditional modernist subversions such as irony?), and that no news is good news. Loser wins, as Sartre used to say; or winner loses, I forget which.

All of which is considerably clarified and de-paralogicized by mentioning the unmentionable, and respecifying the political (or even protopolitical) content of the modernist notion of utopian space—at least here, as it is repudiated by the postmodernists. What they renounce is not the chance at new aesthetic forms, but rather the implicit or explicit conviction (if not the pretense) that such new forms also designated new social solutions. It was my own use of the word "space," above, that confused the issue, at the same time dramatizing the value of this supremely mediatory concept, which makes it impossible for us to evoke the aesthetic without at once beginning to slip into the cognitive on the one hand, and the sociopolitical on the other.

The problem of innovation thus remains on the agenda, if not

of postmodernism, then at least of its critics and theorists. (The problem of the relationship between architectural space and social life and experience persists on some greatly expanded agenda of architectural criticism and theory itself.) I will address both problems by way of one of the few postmodern buildings that does seem to have some powerful claim on revolutionary spatiality, and that is the house or single family dwelling that the Canadian-American architect Frank Gehry built (or rebuilt) for himself in Santa Monica, California, in 1979. Problems enshroud even this starting point, however, for one thing, it is not clear how Gehry thinks of himself in relationship to postmodern architecture more generally. His style certainly has little enough in common with the ostentatious decorative frivolity and historicist allusion of Michael Graves, or Charles Moore, or even Robert Venturi himself. Gehry has indeed observed that Venturi "is into storytelling. . . . I'm really interested in this hands-on thing, and not in telling stories"[1]: an apt enough characterization of the passion for periodization from which (among other things) the concept of postmodernism comes. Meanwhile, the single family dwelling may also be less characteristic of the projects of the postmodern: the grandeur of the palace or the villa is clearly increasingly inappropriate to an age which began with the "death of the subject" in the first place. Nor is the nuclear family a specifically postmodern interest or concern. Here too, then, if we win, we may actually have lost; and the more original Gehry's building turns out to be, the less generalizable may be its features for postmodernism in general.

The house is located on the corner of 22d Street and Washington Avenue and is not properly speaking a new building, but the reconstruction of an older, very conventional frame dwelling.

Diamonstein One of the works of art that you did manage to create, however, is your very own house. It has been described as suburban anonymity. The original structure was a two-story gambrel-roof clapboard house. You proceeded to build a one-and-one-half-story-high wall of corrugated metal around it, but behind the

wall the original structure pokes up from inside the new structure. Can you tell us what your intentions were there?

Gehry It had to do with my wife. She found this nice house—and I love my wife—this cute little house with antiques in it. Very sweet little thing. And we were having a lot of problems finding a new house. We bought in Santa Monica at the height of the real estate boom. We paid the highest price possible.

Diamonstein A hundred and sixty thousand dollars, I read.

Gehry A hundred and sixty thousand.

Diamonstein A lot of money.

Gehry A year earlier it was forty. Talk about desperate moves. I always do that. And we could have lived in that house fine. There was enough room in it and everything.

Diamonstein A pink house with green shingles?

Gehry It was all pink asbestos shingle over white clapboard. It had several layers on it. It was already layered, which is a heavy term these days, layering.

Diamonstein That's part of the appeal to you.

Gehry Anyway, I decided to get into a dialogue with the old house, which is no different, you know from what I was saying about the Ron Davis house, where the interiors would join in a dialogue with the exteriors. Here I had it easy, because the old house was already a different aesthetic, and I could play off of it. But I wanted to explore the relationship between the two. I got fascinated with the idea that the old house should appear to remain totally intact from the outside, and that you could look through the new house, and see the old house as though it was now packaged in this new skin. The new skin and the windows in the new house would be of a totally different aesthetic than the windows in the old house. So they would constantly be in tension, or whatever, with

each other. I wanted each window to have a
different aesthetic, which I couldn't accom-
plish at that time.

Diamonstein So, the old house was the core, and the new
house is the wrapper. Of course, you've used
a number of the materials that are familiar in
your own vocabulary—metal, plywood, glass,
and chain link fencing—all very inexpensive.
On one hand, the house looks unfinished and
rough—

Gehry I'm not sure if it is finished.

Diamonstein You're not sure?

Gehry No.

Diamonstein Is one ever sure?

Gehry It's confusing. I was wondering the other day
what effect this had on my family. I've noticed
my wife leaves papers and stuff around on the
table so there's a kind of chaos in the organi-
zation of how we live in the house. I was
beginning to think that it had something to do
with her not knowing whether I'm finished or
not.[2]

For my objects of analysis, in what follows, I rely heavily on
Gavin Maccrae-Gibson's The Secret Life of Buildings,[3] which in-
cludes some fine pieces of phenomenological and formal descrip-
tion. I have visited the house myself, and am anxious to avoid the
stark methodological aporia of Barthes' System of Fashion (which
analyzed the writing about fashion rather than the physical ob-
jects themselves); but it is certain that even the most seemingly
physical or sensory approaches to the architectural "text" are
only apparently opposed to expression or interpretation (some-
thing we will confront in the very peculiar phenomenon of the
architectural photograph).

But Maccrae-Gibson's book has an even stronger claim on our
interest here, owing to the character of its interpretive framework,
which remains that of an older high modernism, and which can
therefore, at crucial conjunctures between description and inter-
pretation, tell us something as revealing about the difference

between modernism and postmodernism as Gehry's construction itself.

Maccrae-Gibson sorts the Gehry house out into three types of space; we will not retain this three-fold differentiation as such later on, but it affords us a useful way in:

First, a group of small rooms at the back of the house on both floors consisting of stairs, bedrooms, bathrooms, and closets. Second, the major spaces of the old house, which have become the living room on the ground floor and the master bedroom on the first floor. Lastly, the complex atten-uated spaces of the new spatial wrapper, consisting of the entry spaces, kitchen and dining areas, which are five steps below the living room. (pp. 16–18).

Let's work our way back through these three types of space: "the house consists of a corrugated metal shell wrapped around three sides of an existing pretty, pink, shingled 1920s house in a way that creates new spaces between the wheel and the old exterior walls" (p. 2). The old wooden frame remains as a kind of scaffolding memory in places, but the dining area and kitchen have now expanded beyond it and are now essentially located in the former driveway and yard ("five steps below" the level of the former ground floor). These new areas, between the frame and the wrapper, are mostly glassed in and therefore visually open to and indistinguishable from the former "outside" or "outdoors": which is to say that whatever esthetic thrill we get from this formal innovation (it might be a thrill of discomfort or malaise, but on the other hand, Philip Johnson, who had breakfast there, found it quite *gemütlich*) will clearly have had something to do with an effacement of categories of inside/outside, or a rearrangement of them.

Meanwhile, besides the stark effect of the corrugated metal frame which seems ruthlessly to cut across the older house and brutally to stamp the mark and sign of "modern art" on it, yet without wholly dissolving it, as though the peremptory gesture of "art" had been interrupted and abandoned in mid-process—be-sides this dramatic formal intervention (whose use of cheap junk

material must also be retained, as we shall see in a moment), the other dramatic feature of the newly wrapped house involves the glassing of the driveway area and in particular the new skylighting of the kitchen, which, seen from the outside of the house, appears to protrude into outer space like an enormous glass cube —the "tumbling cube," Gehry has called it, that "marks the junction of the streets with what during the day is a receding void and at night is an advancing solid, like a beacon" (*Secret Life of Buildings*, p. 2). This characterization by Maccrae-Gibson strikes me as interesting, but his interpretation of the cube, which returns to Malevich's mystic quadrilaterals (Gehry once designed a Malevich exhibit, so the reference is not as arbitrary as it might seem), seems to me completely misguided, a willful attempt to reinscribe the old-clothes junk aesthetic of a certain postmodernism within the loftiest metaphysical vocations of an older high modernism. Gehry has himself often insisted on what is obvious to any viewer of his buildings, namely, the cheapness of their materials—"cheapskate architecture," he called it once; besides the corrugated aluminum of this building, he has an obvious predilection for steel mesh, raw plywood, cinder block, telephone poles, and the like, and even at one time in his career designed (astonishingly ornate) cardboard furniture. Such materials clearly "connote"[4]; they annul the projected syntheses of matter and form of the great modern buildings, and they also inscribe what are clearly economic or infrastructural "themes" in this work— reminding us of the cost of housing and building, and, by extension, of the speculation in land values and in general, of that constitutive seam between the economic organization of society and the aesthetic production of its (spatial) art, which architecture must live more dramatically than any of the other fine arts save perhaps film, but whose scars it bears more visibly even than film itself, which must necessarily repress and conceal its economic determinations.

The cube and the slab (of corrugated metal): these ostentatious markers, planted in the older building like some lethal strut transfixing the body of a car crash victim, clearly shatter any illusions of organic form that might be entertained about this construction (and that are among the constitutive ideals of the older modern-

ism). These two spatial phenomena make up the "wrapper"; they violate the older space and are now both parts of the newer construction and at a distance from it, like "foreign bodies." They also correspond, in my opinion, to the two great constitutive elements of architecture itself which in his postmodern manifesto *Learning from Las Vegas* Robert Venturi disengages from the tradition in order to reformulate the tasks and vocation of the newer aesthetic: namely, the opposition between the façade (or "store front") and the shed behind or barnlike space of the building itself. But Gehry does not remain within this contradiction, playing each term off against the other to produce some interesting but provisional "solution"; rather, it seems to me that the corrugated metal front and the tumbling cube *allude* to the two terms of this dilemma, which they attach to something else, the remains of the older house, the persistence of history and the past: a content that can still be seen through the newer elements, literally, as when the simulated window opening of the corrugated wrapper discloses the older windows of the frame house behind them.

But if this is so, then we find ourselves obliged to reorganize Maccrae-Gibson's tripartite scheme. His first category—that of the remnants of traditional suburban space—we retain as such, to be dealt with later on. If, however, the wrapper—cube and slab—takes on a life of its own here, as the visible agent of architectural transformation-in-course, then it must be assigned category status in its own right, while Maccrae-Gibson's final two types of space—the older "major spaces" along with the new "entry" and kitchen spaces—will be in what follows amalgamated, as the joint results of the intersection of the first two categories, of the intervention of the "wrapper" into the traditional house.

For our purposes, therefore, the fact that the living room emerges in a space already built in the older house, while the kitchen is in effect an additional room outside of that, does not seem as significant as the sense that both are somehow equally new, in a way that remains to be evaluated. Indeed, both the now sunken living room, and the dining areas and kitchen opened up between the loosely draped external wrapper and the "withering away" of

the now unnecessary structural frame—both areas now seem to
me (at least) the thing itself, the new postmodern space proper,
which our bodies live in malaise or delight, trying to shed the
older habits of inside/outside categories and perceptions, still
longing for the bourgeois privacy of solid walls (enclosures like
the old centered bourgeois ego), yet grateful for the novelty of the
incorporation of yucca plants and what Barthes would have called
Californianity into our newly reconstructed environment. We must
insist, over and over again, in a variety of ways, on the troubling
ambiguities of this new "hyperspace." This is how Maccrae-Gibson
does it, evoking

> numerous contradictory perspective lines going to numer-
> ous vanishing points above and below a wide variety of
> horizons. . . . When nothing is at right angles, nothing seems
> to vanish to the same point. . . . Gehry's distorted perspec-
> tive planes and illusionistic use of framing members engen-
> der the same feeling in the beholder . . . [as do Ronald Davis'
> paintings where] the viewer is suspended above the warped
> perspective grids and tipped towards them. . . . The tilting
> of planes expected to be horizontal or vertical and the con-
> verging of studwork members cause one to feel suspended
> and tipped in various directions oneself. . . . For Gehry the
> world vanishes to a multitude of points, and he does not
> presuppose that any are related to the standing human being.
> The human eye is still of critical importance in Gehry's
> world, but the sense of center no longer has its traditional
> symbolic value. (*Secret Life of Buildings*, pp. 12, 14, 16)

What this account suggests is nothing quite so much as the
alienation of the older phenomenological body (with its right/left,
front/back, up/down coordinates) within the outer space of Ku-
brick's *2001*, with the security of the Newtonian earth withdrawn.
The feeling is certainly related to the new shapeless space, nei-
ther mass nor volume, which characterizes Portman's vast lob-
bies,[5] and in which streamers and hangings remind us, like ghostly
remanences, of older partitioning and structuring boundaries and
enclosure categories, while also withdrawing those and offering
the illusion of some new and meretricious spatial liberation and
play. Gehry's space is, to be sure, far more precise and sculpted

than those enormous and crudely melodramatic containers; in a more articulated way, it confronts us with the paradoxical impossibilities (not least, the impossibilities of representation) that are inherent in this latest evolutionary mutation of late capitalism towards "something else," which is no longer family or neighborhood, city or state, nor even nation, but as abstract and nonsituated as the placelessness of a room in an international chain of motels or the anonymous space of airport terminals that all run together in your mind.

There are, however, other ways of coming at the nature of hyperspace, and Gehry mentioned a different one in the interview I've already quoted when he spoke about the chaos of things inside the house. After all, Venturi's "decorated shed" suggests that contents are relatively indifferent, and might as well be strewn all over as stacked neatly in a corner somewhere. This is also how Gehry describes the rebuildable studio he made for Ron Davis, such structures "create a shell. Then the user comes in, and puts his junk in the shell in some way. The house I did for Ron Davis was that idea. I built the most beautiful shell I could do, and then let him bring his stuff to it, and convert it to his use."[6] But Gehry's remarks on the messiness of his own house betray a faint malaise which may be worth tracking further (particularly since the continuation of the dialogue introduces a new topic—photography—to which we will be returning shortly):

> *Diamonstein* There might have been another cue that you have given to the occupants. When that house was photographed, in contrast to most shelter magazine photographs with three perfect lilies in one place, and two books in another— you had soap powder for the kitchen sink on the kitchen sink, and some of the cupboard doors open. It was very much a lived-in environment. It seemed evident that this was a deliberate structuring of the photo to reflect an environment in which real people lived real lives.
>
> *Gehry* Actually, it wasn't structuring the photo.
>
> *Diamonstein* It was taking a photo of the way you live?

Gehry Yeah. Well, what happens is—I've had a lot
of photographers there now. Each one comes
in and has a different idea of how the place
should look. So they start moving the furni-
ture around. If I get there in time I start put-
ting everything back.[7]

Such discussions imply a placing of the architectural space such
that the position of contents—objects and human bodies alike—
becomes problematical. It is a feeling that can only be properly
evaluated in a historical and comparative context, and in my
opinion on the basis of the following proposition: namely, that if
the great negative emotions of the modernist moment were anxi-
ety, terror, the being-unto-death and Kurtz's "horror," what char-
acterizes the newer "intensities" of the postmodern, which have
also been characterized in terms of the "bad trip" and of schizo-
phrenic submersion, can just as well be formulated in terms of
the messiness of a dispersed existence, existential messiness, the
perpetual temporal distraction of post-1960s life. Indeed, one is
tempted (without wishing to overload a very minor feature of
Gehry's building) to evoke the more general informing context of
some larger virtual nightmare, which can be identified as the
sixties gone toxic, a whole historical and countercultural "bad
trip" in which psychic fragmentation is raised to a qualitatively
new power, the structural distraction of the decentered subject
now promoted to the very motor and existential logic of late
capitalism itself.

At any rate, all of these features—the strange new feeling of an
absence of inside and outside, the bewilderment and loss of spa-
tial orientation in Portman's hotels, the messiness of an environ-
ment in which things and people no longer find their "place"—
offer useful symptomal approaches to the nature of postmodern
hyperspace itself, without giving us any model or explanation of
the thing itself.

But such hyperspace—Maccrae-Gibson's second and third types
of space—is itself the result of the tension between two terms or
poles, two distinct kinds of spatial structure and experience, of
which we have so far only mentioned one (namely, the cube and
the corrugated wall, the external wrapping). We must now there-

fore proceed on to the most archaic parts of the house itself, the older surviving "stairs, bedrooms, bathrooms and closets"—not merely to see what it was that had to be even partially transformed, but also whether that traditional syntax and grammar is susceptible to utopian transformation in the first place.

In fact, such rooms are preserved as in a museum: untouched, intact, yet now somehow "quoted," and, as in the transformation of something into an image of itself, without the slightest modification emptied of its concrete life, like a Disneyland preserved and perpetuated by Martians for their own delectation and historical research. As you go up the still old-fashioned stairs of the Gehry house, you reach an old-fashioned door, through which you enter an old-fashioned maid's room (although it might have been the bedroom of a teenager equally well). The door is a time-travel device; when you close it you are back in the old twentieth-century American suburb, the old concept of the room, which includes my privacy, my treasures and my kitsch, chintzes, old teddy-bears, old LP records.

But the time-travel evocation is misleading: on the one hand, we have here praxis and reconstruction, much as in Philip K. Dick's "Wash-36,"[8] a lovingly authentic reconstruction of the Washington of his boyhood in 1936 by a three-hundred-year-old millionaire on a satellite planet (or, if you prefer a quicker reference, like Disneyland or Epcot Center); while on the other hand, it is not exactly a reconstruction of the past at all, since this enclave space is our present, and replicates the real dwelling spaces of the other houses on this street or elsewhere in Los Angeles today. Yet that is a present reality which has been transformed into a simulacrum by the process of wrapping or quotation, and has thereby become, not historical, but historicist: an allusion to a present out of real history that might just as well be a past removed from real history. The quoted room therefore also has affinities with what in film has come to be called *la mode rétro*, or nostalgia film—the past as fashionplate and glossy image.

Suddenly, therefore, this area, retained and preserved from that older house with which Gehry is pursuing a "dialogue," resonates as an aesthetic phenomenon with a whole range of other, very different and nonarchitectural phenomena in post-

modern art and theory: the transformation into the image or si-
mulacrum, historicism as a substitute for history, quotation, en-
claves within the cultural sphere, and so forth. I am even tempted
here to reintroduce the whole problem of reference itself, so
paradoxical when one has to do with buildings, which, presum-
ably "realer" than the content of literature, painting, or film, are
then somehow their own referent. But the theoretical problem of
how a building could have a "referent" (as opposed to a signified
or a meaning of some kind) loses its estrangement capacity and
its shock value when it slips into the weaker issue of what the
building might refer to. I mention this because this last is another
move in Maccrae-Gibson's "modernizing" interpretation of the
house, and results in a brilliant essay on the way in which the
house *alludes* to its own position in Santa Monica with a host of
marine allusions and imagery. This is a kind of reading we are
accustomed to in analyses of works by Le Corbusier or Frank
Lloyd Wright, where the operation of such allusions seems per-
fectly consistent, not merely with the modernist aesthetic of such
buildings, but also with their particular social space and histori-
cal situation. If, however, one feels that the city space of the 1980s
has for all kinds of multiple and overdetermined reasons lost that
particular materiality and placeness or situatedness—that is, if
we no longer feel Santa Monica in this way as a place, whose
sites stand in determinate relations to the beach or the freeway
and so forth—then such exegesis will come to seem misguided
or irrelevant: not wrong, necessarily, for these structures may be
the remnants of an older modernist language subsumed and vir-
tually cancelled by the new one, yet persisting feebly and in a
pinch decryptable by a bright and stubborn, backward-looking
reader and critic.

There are, however, other ways in which the theoretical issue
of reference might be framed: most notably, a perspective in
which the room itself—characteristic of that mainstream Ameri-
can society and social space into which the Gehry house has been
inserted—stands as some last minimal remnant of that older
space as it is worked over, cancelled, surcharged, volatilized,
sublimated or transformed by some newer system. In that case,
the traditional room could be seen as some feeble, ultimate, ten-

uous reference, or as the last stubborn truncated core of a referent in the process of wholesale dissolution and liquidation. I believe that nothing like this can be shown for the space of Portman's Bonaventure, unless it be the now marginalized apparatus of the traditional hotel: the wings and stories of claustrophobic and uncomfortable bedrooms hidden away in the towers, a traditional hotel living space whose decorations were so notorious that they have been altered several times since the inauguration of the building, for whose architect they were clearly the least interesting matter on the agenda. In Portman, therefore, reference—the traditional room, the traditional language and category—is brutally dissociated from the newer postmodern space of the euphoric central lobby, and left to etiolate and dangle slowly in the wind. The force of Gehry's structure would then stem from the active dialectical way in which the tension between the two kinds of space is maintained and exacerbated (if this is a "dialogue," then it has little of the complacency of a Gadamer or of Richard Rorty's "conversations").

I want to add that this conception of reference, which is social and spatial all at once, has real content and can be developed in very concrete directions: for example, this quoted enclave space is in fact a maid's room, and thereby becomes invested at once with the content of various kinds of social subalternity, remnants of older hierarchy in the family, and gender and ethnic divisions of labor.

We have essentially rewritten Maccrae-Gibson's enumeration of three types of space (traditional rooms, the newer living spaces, and the cube and corrugated wall) into a dynamic model in which two very distinct kinds of space—the bedroom and the abstract postmodern forms that open up the older house—intersect to produce new kinds of space—the kitchen and dining area, the living room—space that includes old and new, inside and outside, the framed platforms of the older house and the reconstituted yet strangely amorphous areas between the frame and the "wrapper." It is essentially only this last type of space—the result of a dialectical engagement between the two others—that can be characterized as postmodern, that is, as some radically new spatiality beyond the traditional and the modern alike which

seems to make some historical claim for radical difference and originality. The question of interpretation arises when we try to evaluate this claim and to propose hypotheses as to its possible "meaning"; put somewhat differently, such hypotheses necessarily constitute transcoding operations in which we frame equivalents for this architectural and spatial phenomenon in other codes or theoretical languages, or, to use yet another kind of language, they constitute the allegorical projection of the structure the analysis models. So here, for example, it is evident at the outset that an allegory is being told whereby, from out of what is either a traditional or a "realistic" moment (but then perhaps the realism of Hollywood rather than that of Balzac), the lightning bolt of "modernism" seems to generate the postmodern "proper." (Gehry's own private allegorization seems to involve the adaptation or rebuilding of Judaism for a new function, if not simply a survival, in the modern, or even the postmodern, world: Gehry's grandfather "was president of his synagogue, a small, remodeled houselike building, his grandson later recalled, similar, in some ways, to the house in Santa Monica that he, himself, would remodel in the 1970s. 'My house reminds me of that old building,' Gehry confessed, 'and I frequently think of it when I'm here.' "[9])

Even if, as with Kant, such narratives lie exclusively in the eye of the beholder, they require historical explanation and some account of their conditions of possibility, and the reasons why we seem to feel this to be a logical sequence, if not a complete story or narrative. But other allegorical constructs are also possible, which will commit us to a long detour back through Maccrae-Gibson's interpretive system, which is in my opinion (as I've said) an essentially modernist one.

I have touched on several interpretive moves in Maccrae-Gibson's article without recording the basic formulations in which he frames his sense of the function of this new kind of building. These are as follows: "Perspective illusion and perspective contradiction are used throughout Gehry's house, and many of his other projects, to prevent the formation of an intellectual picture that might destroy the continual immediacy of perceptual shock. . . . Such illusions and contradictions force one to continually question the nature of what one sees, to alter the definition of

reality, in the end, from the memory of a thing to the perception of that thing."[10] In such formulations, with their familiar stress on the vocation of art to restimulate perception, to reconquer a freshness of experience back from the habituated and reified numbness of everyday life in the fallen world, we are at the very heart of the essential modernism of Maccrae-Gibson's aesthetic. The Russian Formalists, of course, codified such views the most powerfully and durably, but something similar can be found in all the modernist theories, from Pound to surrealism and phenomenology, and across all the arts, from architecture to music and literature (and even film).

I believe, for a number of reasons, that this remarkable aesthetic is today meaningless and must be admired as one of the most intense historical achievements of the cultural past (along with the Renaissance or the Greeks, or the Tang Dynasty). In the wholly built and constructed universe of late capitalism, from which nature has at last been effectively abolished and in which human praxis—in the degraded form of information, manipulation, and reification—has penetrated the older autonomous sphere of culture and even the unconscious itself, the utopia of a renewal of perception has no place to go. It is not clear, in other words, to put it crudely and succinctly, why, in an environment of sheer advertising simulacra and images, we should even want to sharpen and renew our perception of those things. Can some other function, then, be conceived for culture in our time? The question at least offers a standard by which to evaluate the claims of contemporary postmodernism to some genuine formal and spatial originality; it can at least do so negatively by starkly disclosing the remnants of an unacceptable modernism still at work in the various postmodern manifestos: the concept of "irony" in Venturi, for example, just as fully as that of "defamiliarization" in this book by Maccrae-Gibson. Such older modernist themes prove to be appealed to in extremis, when the newer theories require some ultimate conceptual grounding that they cannot generate out of their own internal economies (and this not least because the very logic of postmodern theory is inconsistent with and hostile to "grounding" in the first place, or what is sometimes also called essentialism or foundationalism). I will add that I must also re-

fuse Maccrae-Gibson's account on a more empirical basis, since, in my experience, the Gehry house does not particularly correspond to this defamiliarizing and perception-renewing description.

Nonetheless I am interested in the description from a somewhat different angle, which is that of its continuing possibility in a postmodernist framework. The account is still plausible, although it should not be any longer, and I think we also need an explanation of why this should be so. Let's look again at the specifics, which suggest that the building has as its primary aesthetic function to subvert (or to block) "the formation of an intellectual picture that might destroy the continual immediacy of perceptual shock." A few sentences later this "intellectual picture" (which must be resisted, subverted, or blocked) is assimilated to the "*memory* of a thing" (as distinguished from the positive value of the "*perception* of that thing"). We may here detect a slight modification of the older modernist paradigm in the reinforcement and increasing specification of the negative term (that which is to be fragmented, undermined, forestalled). In the older modernisms, that negative term was still relatively general in character, and evocative of the nature of social life in a kind of global way; this is the case, for example, with the Formalist conception of "habituation" as a condition of modern life, as well as with the Marxist conception of "reification" when used in an older systemic way, and even with concepts of the "stereotypical," as in Flaubert's *bêtise* and *lieux communs*, when these are taken to characterize the increasingly standardized "consciousness" of the modern or bourgeois person. My sense is that in recent years, although the general binary scaffolding of the modernist aesthetic remains intact in many otherwise seemingly more advanced theories, the content of this negative term becomes modified in what then become historically interesting and symptomatic ways. In particular, from a general characterization of social life or consciousness, the negative term now comes to be reconstituted as a specific sign system. Thus, it is no longer fallen social life generally that is opposed to the brutal freshness of the aesthetic renewal of perception, but, as it were, two types of perception, two kinds of sign systems, that are now in opposition.

This is a development that can be dramatically documented in the newer film theory and in particular in the so-called representation debate, where despite the essentially modernist cast of the argument and its aesthetic priorities and solutions, the slogan "representation" now designates something far more organized and semiotic than older conceptions of habit or even Flaubert's stereotypes (which are still, despite their novelistic precision, general characteristics of bourgeois consciousness). "Representation" is both some vague bourgeois conception of reality and also a specific sign-system (in the event of Hollywood film) which must now be defamiliarized, not by the intervention of great or authentic art, but by *another* art, by a radically different practice of signs.

If this is true, then it becomes interesting to detain Maccrae-Gibson's modernist formulations for another moment and to interrogate them a little more insistently. What would be then, for him, this "intellectual picture" that blocks the more authentic perceptual processes of art? I think that more is at stake here than the simple traditional opposition of the abstract and the concrete, between intellectualizing and seeing, between reason or thinking and concrete perception. Still, it would seem paradoxical to thematize such a concept of the "intellectual picture" in terms of memory (the opposition between the memory of a thing and the perception of the thing), in a situation in which both personal and collective memory have become functions in crisis, to which it is increasingly problematical to appeal. Proust, you will "remember," did it just the other way round, and tried to show that it is only by way of memory that some genuine and more authentic perception of the thing can be reconstructed. Yet the reference to nostalgia film suggests that Maccrae-Gibson's contemporary formulation is not without some justice, if we suppose that memory itself has become the degraded repository of images and simulacra, and that the remembered image of the thing now effectively inserts the reified and the stereotypical between the subject and reality or the past itself.

But I believe that we can now identify Maccrae-Gibson's "intellectual picture" a little more precisely and concretely: it is, I think, simply the photograph itself and photographic representa-

tion, the perception by the machine—a formulation meant to be a little stronger than the more acceptable idea of perception *mediated* by the machine. For bodily perception is already a perception by the physical and organic machine, but we have continued to think of it, over a long tradition, as a matter of consciousness —the mind confronting visible reality, or the spiritual body of phenomenology exploring being itself. But supposing, as Derrida says somewhere, there is no such thing as perception in that sense, supposing that it is already an illusion to imagine ourselves before a building in the process of grasping its perspectival unities in the form of some glorious image-thing. The invention of photography and of the various machineries of recording and projecting now suddenly disclose or deconceal the fundamental materiality of that formerly spiritual act of vision. You will understand that I'm trying to displace the architectural question of the unity of a building in much the same way as, in recent film theory, reflections on the filmic apparatus, inserted into a rewriting of the history of painterly perspective, and reinforced by Lacanian notions of subject construction and subject position and their relationship to the specular, have displaced older psychological questions of identification and the like in the discussion of the filmic object.

Such displacements are already everywhere in contemporary architectural criticism, where a clear tension has long been established between the concrete or already constructed building and that representation of the building to be constructed which is the architect's *project*, the various drawn and designed sketches of the thing to be and this to the point where the work of a certain number of very interesting contemporary or postcontemporary architects consists exclusively of the drawing of imaginary buildings that will never cast a real shadow in the light of day. The project, the drawing, is then one reified substitute for the real building, but a "good" one, which makes infinite utopian freedom possible. The photograph of the already existing building is another one, but let us say a "bad" reification—the illicit substitution of one order of things for another, transformation of the building into the image of itself, and a spurious image at that. Thus, in our architectural histories and journals, we consume so

many photographic images of the classical or the modern build-
ings, coming at length to believe that these are somehow the
things themselves. At least since Proust's pictures of Venice we
all try to retain our sensitivity to the constitutive visual decep-
tiveness of the photograph, whose frame and angle always give
us something by comparison with which the building itself is
always something else, something slightly different. All the more
is this so with color photography, where a new set of libidinal
forces comes into play, so that it is no longer even the building
that is consumed, having itself become a mere pretext for the
intensities of the color stock and the gloss of the stiff paper. "The
image," said Debord in a famous theoretical move, "is the final
form of commodity reification": but he should have added, the
material image, the photographic reproduction. At that point,
then, and with those qualifications, we may accept Maccrae-Gib-
son's formulation that the peculiar structure of the Gehry house
aims at "preventing the formation of an intellectual picture that
might destroy the continual immediacy of perceptual shock": it
does this by blocking the choice of photographic point of view,
evading the image-imperialism of photography, securing a situa-
tion in which no photograph of this house will ever be quite right
—for it is the photograph alone that offers the possibility of an
"intellectual picture" in this sense.

Yet other possible meanings of this curious expression "intel-
lectual picture" suggest themselves if we now lift it completely
out of its context; there are, for example, maps, which are both
pictorial and cognitive, but in a very different way from the visual
abstractions of photography. This new tack will lead me on to my
final thoughts on interpretation itself, and on alternative interpre-
tive options from the modernist one that we have already dis-
cussed and rejected. In his recent book _Cinéma_, Gilles Deleuze
argues that film is a way of thinking, that is, it is also a way of
doing philosophy, but in purely filmic terms, its concrete philo-
sophizing has nothing to do with the way in which some film or
other might _illustrate_ a philosophical concept, and that very pre-
cisely because the philosophical concepts of film are filmic con-
cepts and not ideational or linguistic ones. In a similar move, I
would like to argue that architectural space is also a way of

thinking and of philosophizing, of trying to solve philosophical or cognitive problems. To be sure, everyone agrees that architecture is a way of solving architectural problems, just as the novel is a way of solving narrative problems, and the painting a way of solving visual ones. I want to presuppose that level of the history of each art as a set of problems and solutions, and to posit, above that, a very different type of perplexity or object of thought (or of pensée sauvage).

Yet such allegorical transcoding must still begin with space, for if Gehry's house is the meditation on a problem, that problem must initially be a spatial one, or at least be susceptible to formulation and to incarnation in properly spatial terms. We have already in fact worked up the elements of an account of such a problem; it will then somehow involve the incommensurability between the space of the traditional room and tract house and that other space here marked by the corrugated wall and the "tumbling cube." To what kind of problem could this tension and incommensurability correspond? How can we invent a mediation whereby the spatial language in which we describe this purely architectural contradiction can then be rewritten in other nonarchitectural languages and codes?

Maccrae-Gibson, as we know, wishes to inscribe the tumbling cube in the tradition of utopian and mystical modernism, most specifically of Malevich, a reading that would oblige us to rewrite the fundamental contradiction in the house as one between traditional American life and modernist utopianism. Let's look a little more closely:

> What looks like a cube could hardly be more deceptive. The surface that is squashed up against the plane of the exterior wall is rectangular rather than square, and the back face of the cube has been pushed sideways and sheared upwards so that no framing member forms a right angle with any other, except in the front plane. As a result, while the panels of glass in the front plane may be rectangular, those on all the other faces are all parallelograms. (Secret Life of Buildings, p. 27)

What we can retain from this description is the sense of a space existing in two distinct dimensions at once, in one of which it

leads a rectangular existence, while in that other simultaneous and unrelated world it is a parallelogram. There can be no question of linking these worlds or spaces, or fusing them into some organic synthesis: at best the peculiar shape dramatizes the impossible task of such representation, all the while indicating its impossibility (and thereby perhaps at some curious second-degree level representing it all at once anyhow).

So the "problem"—whatever it turns out to be—will be twofold: its own internal content as problem or dilemma, and also the secondary problem (presumably, however, at one with and "the same as" that one) of even representing itself as a problem in the first place. Let me now dogmatically and allegorically, in an a priori way, say what I think that spatial problem is. We have refused Maccrae-Gibson's account of the symbolic way in which the house anchors itself in its space, which is that of Santa Monica and the relationship to the sea and the city behind it, the ranges of hills, the other urban prolongations along the coast.[11] This theoretical refusal was based on the conviction that in that simpler phenomenological sense, "place" in the United States today no longer exists, or more precisely, exists at much feebler level, surcharged by all kinds of other more powerful but also more abstract spaces. By these last I mean not only Los Angeles itself, as some new hyperurban configuration, but beyond it all of the increasingly abstract (and communicational) networks of American reality whose extreme form is the power network of so-called multinational capitalism itself. As individuals, we are in and out of all these overlapping dimensions all the time, something which makes an older kind of existential positioning of ourselves in Being—the human body in the natural landscape, the individual in the older village or organic community, even the citizen in the nation-state—exceedingly problematical. I have found it useful, for an earlier stage of this historical dissolution of place, to refer to a series of once popular novels which are no longer very much read, in which (essentially for the New Deal period) John O'Hara charts the progressive enlargements of power around but also away from the small town, as these migrate to the higher dialectical levels of the state and finally the federal government. Could one imagine this now projected and intensified at a

new global level, some new and more acute sense of the problems of contemporary "mapping," and of the positioning in this system of the older individual, might be achieved. The problem is still one of representation, and also of representability, we know that we are caught within these more complex global networks, since we palpably suffer the prolongations of corporate space everywhere in our daily lives, yet we have no way of thinking about them, of modeling them, however abstractly, in our mind's eye.

This cognitive "problem" is then the thing to be thought, the impossible mental puzzle or paradox exemplified by the "tumbling cube." And if it is observed that the cube is not the only novel spatial intervention here, and that we have not yet made any interpretive allowance for the wall or fence of corrugated metal, then I will observe that the two features do indeed characterize the problem of thinking about contemporary America. The corrugated aluminum, the chain-linked balcony above—this is, one would think, the junk or Third World side of American life today: the production of poverty and misery, people not only out of work but without a place to live, bag people, waste and industrial pollution, squalor, garbage, and obsolescent machinery—all of this is surely a very realistic truth, and an inescapable fact, of the most recent years of the superstate. The cognitive and representational problem comes when we try to combine that palpable reality with the equally unquestionable other representation of the United States that inhabits a different and unrelated compartment of our collective mind, namely, the postmodern United States of extraordinary technological and scientific achievement, the most "advanced" country in the world in all the science-fictional senses and connotations of that figure, accompanied by an inconceivable financial system and a combination of abstract wealth and real power in which all of us believe, without many of us ever really knowing what that might be or look like. These are the two antithetical and incommensurable features, then, of abstract American space, of the superstate or multinational capitalism today, which the cube and the wall mark for us (without offering representational options for them).

The problem, then, which the Gehry house tries to think is the relationship between that abstract knowledge and conviction or

belief about the superstate, and the existential daily life of people in their traditional rooms and tract houses. There must be a relationship between those two realms or dimensions of reality or else we are altogether within science fiction without realizing it. But the nature of that relationship eludes the mind. The building then tries to think through this spatial problem in spatial terms. What would be the mark or sign, the index, of a successful resolution, of a solution to this cognitive but also spatial problem? It could be detected, one would think, in the quality of the new intermediary space itself—the new living space produced by the interaction of the other poles. If that space is meaningful, if you can live in it, if it is somehow comfortable, but in a new way, opening up historically new and original ways of living—and generating so to speak a new utopian spatial language, a new kind of sentence, a new kind of syntax, radically new words, beyond our own grammar—then, one would think, the dilemma, the aporia, has been resolved, if only on the level of space itself. I will not decide that, nor dare to evaluate the outcome. What does seem certain to me is the more modest proposition, that Frank Gehry's house is to be considered the attempt to think a material thought.

Notes

1. Frank Gehry, quoted in Barbara Diamonstein, *American Architecture Now* (New York: Rizzoli, 1980), p. 46.
2. Ibid., pp. 43–44.
3. Maccrae-Gibson, *The Secret Life of Buildings* (Cambridge: MIT Press, 1985).
4. Raw materials are also ways of evoking tools as such; and Gehry's biographers trace his fascination with both back to jobs in his grandfather's hardware store when he was young (see Henry Cobb, ed., *The Architecture of Frank Gehry* [New York: Rizzoli, 1986], p. 12). The only other generally late modern or postmodern work in which tools and materials are so insistently foregrounded is Claude Simon's *Leçon de choses*, a conscious reply to "Marxism" and a work that, along with the Gehry house, raises the question of the comparative capacities of realism and postmodernism respectively to convey the reality and the being of labor and of what Heidegger called *das Gestell* (instrumentation).
5. See my analysis of Portman in "Postmodernism, Or, The Cultural Logic of Late Capitalism," *New Left Review* (July/August 1984), 146:52–92.
6. Diamonstein, pp. 37, 40.
7. Ibid., p. 44.
8. The reference is to Dick's novel *Now Wait for Last Year* (New York: DAW,

1966). I discuss the relationship between Dick and a more properly postmodernist historicism more extensively in my "Nostalgia for the Present," *SAQ*, forthcoming.

9. Cobb, p. 12.

10. Maccrae-Gibson, p. 12.

11. See, for cognitive mapping of all this, Rayner Banham's beautiful *Los Angeles: The Architecture of Four Ecologies* (Harmondsworth: Penguin, 1973).

6

FINITE HISTORY

Jean-Luc Nancy

THIS PAPER sketches only the outline of a possible approach to thinking history today. It does not develop, nor even present, the whole system of topics and arguments that should be involved in such a project (in particular, a discussion of the problem of history in Heidegger, Benjamin, Arendt, Adorno, Foucault, Paturca, or Ricoeur). For this reason, I will indicate some of those topics or arguments only through brief remarks, explicitly indicated as "parentheses."

For the same reason, I want to give first, as a kind of epigraph, the thesis or hypothesis itself toward which I shall attempt to move: history—if we can remove this word from its metaphysical, and therefore historical, determination—does not belong primarily to time, nor to succession, nor to causality, but to community, or to being-in-common.

And this is so because community itself is something historical. Which means that it is not a substance, nor a subject; it is not a common being, which could be the goal or culmination of a progressive process. It is rather a being-in-common which only *happens*, or which is happening, an event, more than a *"being."* I shall attempt to present this happening of being itself, the noninfinity of its own existence, as *finite history.*

It is therefore the question of what happens when we risk saying "we are inaugurating history," instead of simply saying "this has been history"—in other words, when we treat historicity as performance rather than as narrative and knowledge.

We shall begin with the following premise: what today *is past,* what *our time* recognizes as *being past,* is no longer nature (which can be claimed to have already, long ago, become part of history); it is history itself.

Our time is no longer the time of history, and therefore, history itself appears to have become part of history. Our time is the time, or a time (this difference between articles by itself implies a radical difference in the thinking of history) of the *suspense* or *suspension* of history—in the sense both of a certain rhythm and of uneasy expectation. History is suspended, without movement, and we can anticipate only with uncertainty or with anxiety what will happen if it moves forward again (if it is still possible to imagine something like a "forward movement"), or if it does not move at all. All this, of course, is well known, but, as Hegel says, "What is well known is not known at all." Let us summarize, then, even if it is only to repeat, what constitutes the contemporary suspension of history.

First of all, history is suspended, or even finished, as *sense*, as the directional and teleological path that it has been considered to be since the beginning of modern historical thinking. History no longer *has* a goal or a purpose, and therefore, history no longer *is* determined by the individual (the general or the generic individual) or the autonomous person that Marx frequently criticized in the speculative, post-Hegelian way of thinking.[1] This also consequently means that history can no longer be presented as—to use Lyotard's term—a "grand narrative," the narrative of some grand, collective destiny of mankind (of Humanity, of Liberty, etc.), a narrative that was grand because it was great, and that was great, because its ultimate destination was considered good. Our time is the time, or a time, when this history at least has been suspended: total war, genocide, the challenge of nuclear powers, implacable technology, hunger, and absolute misery, all these are, at the least, evident signs of self-destroying mankind, of self-annihilating history, without any possibility of the dialectic work of the negative.

Parenthesis one: Perhaps one of the best literary presentations of this is found in Elsa Morante's, History: A Novel,[2] *a book which has a "double conclusion." The first is a "fictive" conclusion: "With that Monday in June 1947, the poor history of Iduzza Ramundo was ended" (p. 548). The second, after one last reminder of the most important "real" world events since 1947,*

says: ". . . and history continues . . ." (p. 555). This could also mean that historicity and narrativity have the same "history," and that, at the end of history, we reach—or we already have reached—the end of narrative. Unlike Lyotard, I would claim this of any narrative, big or small. The History that "continues," our time as it occurs as a time, continues beyond history and the novel. In this case, the literary mode, or the mode of discursivity accorded to this "historicity," would be quite different. As we shall see later on, it could be a certain mode of declaration, of announcement or of promise.

Parenthesis two: It is not without interest to remark that this narrative of history, from its beginning or almost from it, has also been curiously involved in a dramatic, tragic, and even desperate consideration of the same universal stream of events whose narration it was supposed to be. Hegel, even Hegel, spoke about history as "a picture of most fearful aspect [that] excites emotions of the profoundest and most hopeless sadness, counterbalanced by no consolatory result. We endure in beholding it a mental torture."[3] From its own beginning, history as narrative is and must be a theodicy within thought, but it remains at the same time paralyzed in its feelings by the evil in itself.

Therefore, our time no longer believes in history as being the "ruse of reason," the ruse by which reason would make the rose of ultimate, rational truth bloom. Also, our time is no longer a time able to feel and represent itself as a time *making* history, as a time producing the greatness of History as such. Our time is conscious of itself as a nonhistorical time. But it is also a time without nature. Therefore, it remains only the time of historicism or of historization, which means that all knowledge (except technological knowledge, which has no need of its own history), is unable to open itself to any future (even if rediscovering from time to time the idea of "utopia"), and unable to determine any historical present. It projects all its objects (and even the object "history" as such) under the unique, vague or indefinite law of a "historical determination," a kind of para-Hegelianism or para-Marxism. This "historical determination" indicates only *that* everything is historically determined but not *how* "determina-

tion" works, for "determination" is precisely understood as historical causality, and history is understood as a complex, interacting, even unstable network of causalities.

The secret of history is thus causality, and the secret of causality is history. History therefore becomes a causality of causalities, which means the unending production of *effects*—but never the *effectivity* of a beginning. But it is precisely the question of beginning, of inaugurating or entering history, which should constitute the core of the thinking of history. Historicism in general is the way of thinking that *presupposes* that history has always already begun, and that therefore it always merely continues. Historicism presupposes history, instead of taking it as what shall be thought. And this is true of every kind of historicism, monological or polylogical, simple or complex, teleological or nonteleological. As Adorno writes: "When history is transposed into the *existentiale* of historicality, the salt of the historical will lose its savor."[4] According to the historizing way of thinking, one could say that everything is historical, but also that nothing is "historic." I refer, of course, to the representation and use of history by our time. I do not want to criticize the outstanding historical work done by historians *and* the considerable reworking of historical knowledge that has been accomplished with the help of sociology, anthropology, biology or the physical sciences. And neither do I want to erase the unerasable truth that everything—including "nature"—becomes and has become historical, always inscribed in change and becoming, always carrying the many marks of this inscription. This, moreover, is also the condition of the thinking of history itself and implies that a history of the many historical ways of thinking history could never itself be historicist. It should achieve a quite different status in terms of its own "historicity." But, as Nietzsche already knew, the more history becomes a broad and rich knowledge, the less we know what "history" means, even if historical knowledge is also an excellent critical and political tool in the fight against ideological representations and their power. It does not, however, at the same time allow for the possibility of a radical questioning of the representation—and/or the presentation—of history as such. And, therefore, this word runs the risk either of silently keeping a kind of para- or post-

Hegelian meaning or slowly returning to the Greek meaning of *historia:* the collection of data.

If historicity—if we can retain this word, which is in this case necessary and impossible at the same time—if the historicity of the truth is at least one of the most important indicators of our time, then it should mean, first of all, that the truth of this "historicity" cannot be given or measured by any history or historical thinking. The "historicity" of truth cannot be simply a qualification of truth (as it is often understood): it has to be a transformation of its concept or thinking—and therefore it implies a transformation of the concept or thinking of "historicity" itself, as far as this "historicity" remains caught in a pre-historic thinking of truth.

Parenthesis three: Understanding everything in terms of "historical determination," which is quite different from thinking of the historicity of the truth, was not, at least after 1844, the method of Marx himself, of the Marx who with Engels wrote that "History does nothing," meaning by history what has become "the history of the abstract spirit of mankind, thus a spirit beyond a real man,"[5] *or what he called in his "Response to Mikhailovski" "an all-purpose historico-philosophical theory whose supreme virtue is to be supra-historical."*

Parenthesis four: At the same time—in our time—we have become conscious that historical reality cannot be separated from the "literary artefact" (Hayden White's term) in or through which it is read. But it is as if we were acknowledging that history is our modern form of myth, and that, at the same time, a certain "historical reality" remained, behind textuality and subjectivity, as the real, infinite or indefinite development of time. It is as if we were suspended between both: either something happens that we cannot grasp in our representation, or nothing happens but the production of historico-fictitious narratives.

Now, philosophically understood, history, behind its watered-down historicist form, is the ontological constitution of the subject itself. The proper mode of subjectivity—its essence and its structure—is for the subject to become itself by inscribing *in its* "becoming" the *law of the self itself,* and inscribing in the self the law and the impulse of the process of becoming. The subject

becomes what it is (its own essence) by representing itself to itself (as you know, the original and proper meaning of "representation" is not a "second presentation," but "a presentation to the self"), by becoming visible to itself in its true form, in its true *eidos* or *idea*. The end of history means, therefore, that history no longer represents or reveals the *Idea* of the self, or *the Idea* itself. But because metaphysical history, by developing the visibility of the Idea (and the ideality of the visible world) not only develops "content," but also develops itself as the "form" and the "formation" of all its contents (in fact, the true form is the form of the continuous formation of any "content"), we shall conclude that history now no longer presents or represents any history, any *idea of history*. (There is thus no longer any History of the Idea, any Idea of History.) For example, this, I believe, is what Jean-François Lyotard means when he says that there is no place for a "philosophy of history" within the form of "critical thinking" he claims as his own.[6] But this is precisely what philosophy now should think. I mean that it should think of history as that which would be *per essentiam* without an Idea (which means, finally, *per essentiam sine essentia*), unable to be made visible, unable to be idealized or theorized, even in historicist terms. This does not mean, however, that historicity is something that is not offered to thinking; the historicity of history could in fact today be what provokes thinking to think "beyond the Idea."

We shall come back to this later, but let us remember that the Idea of history—History itself as an idea, and the Idea History should reveal or produce—is nothing but the Idea of humanity, or Humanity as an Idea, as the completed, presented shape of Humanity. However—and that is what our time, at least, knows —the accomplishment of any kind of presented essence (which is the "Idea") necessarily puts an end to history *as* the movement, the becoming and the production of the Idea. Accomplished Humanity is no longer historical (just as accomplished History is perhaps no longer human). This is why Derrida wrote: "History has always been conceived as the movement of a resumption of history." (Or: "The very concept of history has lived only upon the possibility of meaning, upon the past, present or promised presence of meaning and truth"—where "presence" here corre-

sponds to "resumption."[7] Resumed history is presented history; the presence of subjectivity to itself, the presence of time as the essence of time, which is the *present* itself (the past, the present, and the future made present), time as the subject.

This is the most intimate as well as the ultimate contradiction of history. Not the dialectical contradiction within a historical process, but the contradiction, beyond or behind dialectics (or at its heart), between moving history and resumed history, between subjectivity as process toward itself and subjectivity as presence to itself, between history as becoming and happening and history as sense, direction, and Idea. (And this is true even for history thought as an indefinite or perpetual process: for subjectivity, in this case, presents itself to itself *as* the process itself, or, what amounts to the same thing, as the subject always already present *to* its own becoming.) This is the "double bind" of history— which is easy to find in every philosophical theory of history.

Insofar as history has already resumed itself as an Idea (and even as its own Idea), we are, if one can say this, outside history. But insofar as this resumption *happened* as such in our recent past (or has been happening since the beginning of philosophy), and insofar as we already have a "historical" relationship with it, we are perhaps exposed to another kind of "history," to another meaning of it or perhaps to another history of history. (Once again, it was Marx who wrote: "World history has not always existed; history as world history is a result"—and those sentences are preceded by some notes: "*This conception appears as a necessary development. But, there is the legitimation of chance* [of freedom also among other things]."[8] Between both possibilities, to be outside history, or to enter another history (for which the name "history" no longer perhaps applies) is the "suspense" that would be specific to our time.

But what does "our time" mean? "Our time" means precisely, first of all, a certain suspension of time, of time conceived as always flowing. A pure flow of time could not be "ours." The appropriation that the "our" indicates (we will have later to ask about this very special kind of appropriation) is something like an immobilization—or, better, it indicates that some aspect of time, without stopping time, or without stopping to be time, that

some aspect of temporality, as temporality, becomes something like a certain space, a certain field, which could be for us the domain, in a very strange, uncanny fashion, of property. It is not that we dominate this time—our time—(indeed, how little we do!). But it is much more that time presents itself to us as this spatiality or "spacing" (espacement) of a certain suspension— which is nothing else than the epoch, which, of course, means "suspension" in Greek.

What is the proper operation of space? "Space 'spaces' "— "das Raum raumt," as Heidegger writes.[9] What is spaced in and by the epoch? Not some spatial points, which are already spaced, but the points of temporality itself, which are nothing but the always becoming and disappearing presents of time. This spacing (which is, as such, a temporal operation: space and time are here inextricable, and they are no longer able to be thought according to any of their traditional philosophical models)—this spacing spaces time itself, spacing it from its continuous present. This means that something happens: to happen is neither to flow nor to be present. A happening happens between present and present, between the flow and itself. In the continuous flow, or in the pure present (which is finally the same thing, if we remember what Kant claimed in the First Critique and elsewhere: namely, that in time everything passes, but time itself), nothing can happen. And this is why historicity itself is resumed in history conceived as time, as succession and causality within time. Nothing can take place, because there is no place (no "spacing") between the presents of time, nor between time and itself.) There is no place "from time to time" (but one could also say: there is no time). The happening consists in bringing forth a certain spacing of time, where something takes place, in inaugurating time itself. Today, it is the resumption of history that takes place as our historical event, as the way we eventually are in history.

But how does it take place? By being ours. The possibility of saying "our time" and the possibility of this making sense (if it does) is given by a reciprocity between "our" and "time." This does not imply a collective property, as if first we exist, and then we possess a certain time. On the contrary, time gives us, by its spacing, the possibility of being we, or at least the possibility of

saying "we" and "our." In order to say "we," we have to be in a certain common space of time—even if by our "we," "we" mean to include all mankind. According to such a statement, the common space of time is some several million years (but it is not by chance that such a statement is rarely made; a million-year-old community is not easy to conceive). According to this other statement, "our time is no longer the time of history," the common space of time is from thirty to fifty years. But it is, of course, not a matter of chronological time. It can exist—or it can happen—for only one day; that is, "our time" can be the history of one single day. This is finite history—and there is perhaps no other kind. It is a matter of the space of time, of spacing time and/or of spaced time, which gives to "us" the possibility of saying "we"—that is, the possibility of being in common, and of presenting or representing ourselves as a community—a community which shares or which partakes of the same space of time, for community itself is this space.

The determination of history as something common, or its determination as the time of community—the time in which something happens to the community, or the time in which the community itself happens—is nothing new. From the beginning of historical time, that is, from the beginning of history, history belonged to community, and community to history. The story of a single person, or of a single family, becomes historical only insofar as it belongs to a community. That means also that history belongs to politics, if politics means (as it does throughout our entire history) building, managing, and representing being-in-common as such (and not only as the social transaction of individual or particular needs and forces). The "communitarian" aspect of history or even, I would say, the "communist" aspect of history (which is perhaps not just one "aspect" among others) is the only permanent thing we can find in our history, as the history of history. And we can and must recognize it even in the age of the end of history, for this age is our time.

Because we partake in the end of history, and because this issue leads us to exchange opinions about it or dispute it, we are in this way given to ourselves, by time, in a certain kind of community—which is, at least for us, perhaps not exactly a sign

of history, but at least a certain opening, without either definite signs or ideas, onto some "history," as well as onto "us."

How can we think of history in a new fashion, or perhaps, how can we think of something "beyond history," if "history" has only its philosophical-historical meaning? How can we do this in terms of community?

Parenthesis five: The fact that "history," perhaps like many other concepts within our discourse, has no other meaning than its philosophical-historical one, implies two different things. It means first that the meaning or the several meanings of "history" are established and enclosed within a certain epoch of history— or within history itself as an epoch. And this epoch is precisely the epoch of the establishment and enclosure of meaning as such, or of signification as such, that is, of the presented ideality and of the idealized or "eidetic" presence of the "signified" of a "signifier." Insofar as "history" means the signification or the significability of human time (of man as temporal and of temporality as human), with or without some final, "eternal" signification, it is in this sense (in the semiological-philosophical sense of sense) definitely closed. But this also means, in a second sense, that the meaning of "history," or that "history" as meaning—as the process of meaning itself—has happened, and that it has happened not only within our history, but as our history—which means also that Western thought (or Western community), as the thought that thinks of itself as historical, has happened, and that, by definition, "history" is no longer relevant for this "happening" as such. However, this does not mean that sense has nothing to do with happening. On the contrary, sense, understood if possible as being different from signification, as the element within which something like signification or nonsignification is possible, sense as our existential/transcendental condition—which means, the condition where existence is itself the transcendental, and therefore the condition in which we are not simply and immediately what we are—sense in this "sense" is not the meaning of any happening, nor of any historical process; sense is not the signification of what happens, but it is only that something happens. This is the sense within which we exist, even if we think of ourselves as non-sense, even if we transform history into

absurdity (as we regularly do throughout our entire history). Sense is perhaps itself the happening, or what always happens through the happening, behind and/or beyond the resumption of history in its signification.

Let us now come to community. We shall proceed with a brief analysis of this concept, in order then to come back to history. Since this can only be a brief detour, I am forced to summarize what I have developed elsewhere on this topic.

What is community? Community is not a gathering of individuals, posterior to the elaboration of individuality, for individuality as such can be given only *within* such a gathering. This can be thought in different ways: in Hegel, for example, self-consciousness becomes what it is only if the subject is recognized as a self by another self. The subject desires that recognition, and because of this desire, it is already not identical to itself, not the subject that it is. In other words, it is a question of what is stable in the meaning of "I"—that is, for an "I" to have its own meaning, it, like any other signification, must be capable of being repeated outside of the presence of the thing signified. This can only happen either by means of the "I" of another individual. or by means of the "you" with which the person addresses me. In each case, "I" am not before this commutation and communication of the "I." Community and communication are constitutive of individuality, rather than the reverse, and individuality is perhaps, in the final analysis, only a *boundary* of community. But community is no longer the essense of all individuals, an essence that is given prior to them. For community does not consist of anything other than the communication of separate "beings," which exist as such only through communication.

Community therefore is neither an abstract or immaterial relationship, nor a common substance. It is not *a* common *being;* it is to be *in* common, or to be *with* each other, or to be *together.* And "together" means something that is neither inside nor outside one's being. "Together" is an ontological modality different from any substantial constitution, as well as from any kind of relation (logical, mechanical, sensitive, intellectual, mystical, etc.). "Together" (and the possibility of saying "we") takes place where the inside, as an inside, becomes an outside; that is, where, without

building any common "inside," it is given as an external interiority. "Together" means: not being by oneself and having one's own essence neither in oneself nor in another self. It is a way of not having any essence at all. This is *existence*: not having any essence, but having being, as existence, as one's only essence (and thus this essence is no longer an essence). This is the principal notion on which Heidegger's *Dasein* is founded—if it can be called a foundation. To exist does not mean simply "to be." On the contrary: to exist means *not* to be in the immediate presence or in the immanency of a "being-thing." To exist is not to be immanent, or not to be present to oneself, and not to be sent forth *by* oneself. To exist, therefore, is to hold one's "selfness" as an "otherness," and in such a way that no essence, no subject, no place can present *this otherness in itself*—either as the proper selfness of an other, or an "other," or a common being (life or substance). The otherness of existence happens only as "togetherness." As Marx wrote: "It seems to be correct to begin with . . . society, which is the foundation and the subject of the entire social act of production. However, on closer examination this proves false. Society is an abstraction." [10] Community is the community of *others*, which does not mean that several individuals possess some common nature in spite of their differences, but rather that they partake only of their otherness. Otherness, at each moment, is the otherness of each "myself," which is "myself" only as an other. Otherness is not a common substance, but it is on the contrary the nonsubstantiality of each "self" and of its relationship *with* the others. All the selves are related through their otherness, which means that they are not "related"; in any case, not in any determinable sense of relationship. They are together, but togetherness is otherness.

To be together, or to be *in* common, therefore, is the proper mode of being of existence as such, which is the mode where being as such is put into play, where being as such is risked or exposed. I am "I" (I exist) only if I can say "we." (And this is also true of the Cartesian *ego*, whose certitude is for Descartes himself a common one, the most common of certitudes, but which we each time partake in only as an other.) This means that I exist only as (un)related to the existence of others, to other existences,

and to the otherness of existence. The otherness of existence consists in its nonpresence to itself, which comes from its birth and death. We are *others*—each one for the other and each for him/herself—through birth and death, which expose our finitude.[11] *Finitude* does not mean that we are noninfinite—like small, insignificant beings within a grand, universal, and continuous being—but it means that we are *infinitely* finite, infinitely exposed to our existence as a nonessence, infinitely exposed to the otherness of our own "being" (or that being is in us exposed to its own otherness). We begin and we end without beginning and ending: without having a beginning and an end that is *ours*, but having (or being) them only as others', and through others. My beginning and my end are precisely what I cannot have as mine, and what no one can have as his/her own.

What results is that we *happen*—if to happen is to take place, as other, in time, as otherness (and what is time, if not the radical otherness of each moment of time?). We are not a "being" but a "happening" (or rather, being is in us exposed to the happening). This happening as the "essential" otherness of existence is given to us as *we*, which is nothing but the otherness of existence (more than the existence of otherness). The "we" is nothing but finitude as a subject, if subjectivity could ever be finite (rather, it is, as such, infinite). And this is the reason that the "we" is a strange subject: who is speaking when I say "we"? *We* are not—the "we" is not—but we happen, and the "we" happens, and each individual happening happens only through this community of happening, which is our community. Community is finite community, that is, the community of otherness, of happening. And this is history. As Heidegger writes: "History [Geschichte] has its essential importance neither in what is past, nor in the 'today' and its 'connection' with what is past, but in the proper happening [Geschehen] of existence."[12]

Community, therefore, is not historical as if it were a permanently changing subject within (or below, as the subject was once defined) a permanently flowing time (or having this time as its subject or as its subjectivity, which is the metaphysical ground of any historicism—and which could be said, to some extent, to be the case even for Heidegger). But history is community, that is,

the happening of a certain space of time—as a certain spacing of time, which is the spacing of a "we." This spacing gives space to community and spaces it, which means that it exposes it to it(self). And this is the explanation for this very simple and obvious fact: for why history was never thought as the sum of individual stories but always as the proper and singular mode of common existence, which is itself the proper mode of existence.[13]

One could even say that the "minimum meaning" of the word "history," or its *nucleus semanticus*, is not history as the succession of events, but as their common dimension. It is "the common" as such, as it happens, which means precisely that "the" common is not given as a substance or a subject, not even as the subject-time, nor present as a subject, but that it happens, it is given as "historic."

In this sense, history is finite. This means exactly the opposite of finished history. Finished history is, from its beginning, the presentation of being through (or as) the process of time: the "resumption of history." It is history maintaining its end and presenting it, from its beginning (either as a catastrophe or as an apotheosis, either as an infinite accumulation or as a sudden transfiguration). Finite history is the happening of the time of existence, or of existence as time, spacing time, spacing the presence and the present of time. It does not have its essence in itself, nor anywhere else (for there is no "anywhere else"). It is then "essentially" exposed, *infinitely exposed to its own finite happening as such.*

Finite history is the occurrence of existence, in common, for it is the "togetherness of otherness." This also means that it is the occurrence of the freedom and decision to exist.

Parenthesis six: I cannot develop here the implications of the phrase "the freedom and decision to exist." It should not be interpreted in the sense of subjective freedom, which implies either a free subject with regard to history—in fact, a subject freed from historical limitations—or history itself as a subject, as Hegel envisioned it (to a certain extent), or perhaps in a more naive form, as Spengler or Toynbee conceived of it. Freedom shall be understood precisely as the proper character of the happening and exposure of existence. Not simply a way of being

"free" of causality or destiny, but a way of being destined to deal with them, to be exposed to these factors (which, in themselves, do not constitute history). Freedom would mean: to have history, in its happening, as one's destiny. It does not imply any sort of "metahistorical" causality or necessity. It means that only freedom can originally open us—or open "being" as such—up to something like "causality" or "destiny," or "necessity" or "decision." It means that we are entirely historical beings (and not being whose history would be either an accident or a determined process). This again means that history is the proper exposition of existence, which we are destined (this is "freedom") to think and/or to manage as causality and/or chance, as process and/or happening, as necessity and/or liberty, as fugacity and/or eternity, as unity and/or multiplicity, etc.[14]

Finite history is the presentation or the becoming present of existence insofar as existence itself is finite, and therefore common—which means, once again, that it does not have an essence, but that it *is*, in its "essence," the happening (or, better, the happening of the possibility of something happening or not happening). Community does not mean a common happening, but the happening itself, history (the *Geschehen* of the *Geschichte* of the community). Community is the "we" happening as the togetherness of otherness. As a singular being, I have a singular history (I exist) only insofar as I am exposed to and as I am within community, even if I do not have any special or important role to play with respect to community. "I" within "we" and "we" as "we" *are* historical because we belong, in our essence, to this happening which is *the finitude of Being itself*. The fact that Being itself is finite means that it is neither substance nor subject, but its being (or its *sense*) consists only in being *offered in* existence and *to* existence. Being is the offer of existence—and it is of the specific character of the offer to happen (to be offered). This is what one could call our "historical communism": what happens as, or to, the *we*.

Finite history, then, does not consist of the accomplishment or representation of the subject. It is neither mind nor man, neither liberty nor necessity, neither one Idea nor another, not even the Idea of otherness, which would be the Idea of time and the Idea

of History itself. Otherness has no Idea, but it only happens—as togetherness.

Parenthesis seven: This could be the starting point for a rereading of Hegel's philosophy of history, or of Hegel's philosophy as history. Because if history is the history of mind, or of reason, as it is in Hegel's Philosophy of History, this means that reason itself is immanent to historical existence and that it realizes itself in this existence and through it. Now, this could also imply that reason is nothing but historical existence, that reason becomes reason insomuch as it is the "happening" of historical existence. (In this way, dialectics "can be seen," as Suzanne Gearhart writes, "to work against itself."[15] *In this sense, reason would not be so much the essence or the subject of history, as history would be the only existence of reason. Therefore, the rationality of this reason would have to be understood in a quite different way than the ordinary "Hegelian" way. This rereading of Hegel would be a rereading of the philosophical discourse of history in general. Its principle or its schema would be that philosophical history, as the processing of the identity of the mind (or of man, mankind, etc.), as the identification of identity as such, has always been at the same time the infinite difference or differentiation of identity.*

Finite history: it should be clear by now that finitude and history are the same, and that the term "finite history" is a tautology, that is, it is as long as "history" is considered apart from its self-resumption. Finite history, or history as history, history in its historicity (assuming that the word "history" is still appropriate), is not the presentation of any accomplishment, or any essence—not even of its own process or flow. It is the presentation of the nonessence of existence. (Which is itself, as the concept and discourse of "existence," an element of a philosophy that puts itself into question, a historical event, the happening of History revealing itself as an epoch.)

Finite history is the presentation of existence as it is, qua existence and qua community, never present to itself. When we enunciate in a historical context any "they," such as "they, the Greeks," or "they, the Founding Fathers," or "they, the members of the Russian Soviets in 1917," when we enunciate this "they," which is, properly speaking, to write history, we say in their

place the "we" that simultaneously belongs to "them" and does not belong to "them," because it is their historical or historic community, which appears only through history, through our making of history. When the Greeks themselves said "the Greeks," something of "the Greeks" was already lost and a new spacing of time was already opening the "Greek" community to its own future. Historical existence is always existence outside presence. The "they" the historian writes shows that the "we" it implies is not and was never, as such, present. The "we" comes always from the future. So does our "our," when we think of ourselves as the community occupying the space of time of the end of History.

History, in its happening, is what we are never able to be present to, and *this* is our existence and our "we." Our "we" is constituted by this nonpresence, which is not a presence at all, but which is the happening as such. To write history—which is always the way history is made (even when we think and speak of *making* history in the "present," of being at a historic opening, we speak of *"writing"* history)—is not to re-present some past or present presence. It is to trace the otherness of existence within its own present and presence. And this is why history is essentially *writing*, if writing is the tracing of difference through the difference of the trace. As Werner Hamacher writes, to write history is "a 'farewell' to the presence of the historical event"; in German, "Was geschieht ist Abschied" (what happens is farewell, and/or separation, which is the literal meaning of *abschied*).[16] To be present in history and to history (to make judgments, decisions, choices in terms of a future) is never to be present to oneself as historic. It is to be "spaced"—or to be written—by the spacing of time itself, by this spacing which opens the possibility of history and of community. This always comes from the future; but this "future" no longer is a future present, coming to us through its representation. "Future" means the spacing of time, the difference which is not *in* time, but which is the difference *of* time—the space by means of which time *differs* itself, and which is the space of community in its existence.

If time is understood as permanent succession and flow (and there is no other understanding of time as such), history does not

belong to time, or history requires a quite different thinking of time—a thinking of its spacing (espacement). (And for the same reason, history does not belong to causality, either as a unity or multiplicity of causal series—even if causality is not given, but only represented as an Idea.[17]) For the permanency of the permanently changing times (time as substance, according to Kant) is presence present to itself—even if it never gives a presentation of itself. History, however, is a "coming-into-presence," it is the coming ("from the future") as coming, as happening, which means: as not present. This is not the permanency of a becoming. History becomes nothing—for history is not becoming, but coming. It does not belong to the present of time, to the times of presence (as the present-past, the present, the present-future). Nor does it belong to memory. Memory is the (re)presentation of the past. It is the living past. History begins where memory ends. It begins where representation ends. The historian's work—which is never a work of memory—is a work of representation in many senses, but it is representation with respect to something that is not representable, and that is history itself. History is nonrepresentable, not in the sense that it would be some presence hidden behind the representations, but because it is the coming into presence, as the happening. What is to come? What is the peculiar constitution of "to come," beyond presence and absence?—that would be the question of a more precise approach to history than this one.

As Hannah Arendt emphasizes in her essay "The Concept of History,"[18] only the modern thinking of history gives us the understanding of time as a temporal succession in the first place. One can add that the concept of causality is implicated in this way of thinking. Causality does not allow for happening as such —it does not allow for the happening as it happens, but only as one event succeeding another. It ignores the happening as it comes. Temporality and causality do not have to do with the happening. They only have to do with change, which is still the change of particular substances or subjects, and they never become the happening (the birth or death) of the substance or subject in itself (that is what Kant says about causality). This means that temporality and causality belong to a nature, and history in

this sense is a natural process, or it is (it was) nature as a process, the process of mankind as a growing nature (even if "nature" was thought to be the process itself).

The time of succession is the self-succession of time. It is, to speak in Kantian terms, the succession of phenomena, and the phenomenon of succession, but it is not the happening of phenomenalization as such. It is not the birth or the death of something. It is not the *taking place* of something, the spacing that allows its singular emergence or disappearance.

This spacing of time itself is nothing else than otherness, heterogeneity emerging in time. What does "emerging in time" mean? It means that something that is not time, neither a presence, nor a succession of presences, nor the substance of the process, occurs in time, but not in a temporal fashion—which means not emerging "out of" time back "into" time, not self-succeeding, but emerging out of nothing—or going into nothing (birth or death). This nothing—which is always "future"—is *nothing*: it is not another, negative substance beside the self-succeeding one. This nothing means that nothing *takes place* in the happening, for there is no place to take; but there is the spacing of a *place* as such, the nothingness spacing time, opening up in it an otherness, the heterogeneity of existence.

Parenthesis eight: In a sense that we should carefully distinguish from its ordinary meanings, this nothing, or this emerging of nothing as the opening of time, is eternity. Eternity shall not be understood here as being outside of time, nor as coming after time (as another future time). Eternity is existence emerging in time. This is history, which is therefore our finite eternity. Eternity is finite, because it does not have its essence in itself. Eternity is nothing else than the exposure to the time of existence, as well as the exposure of this time. This topic should also involve a rereading of Hegel (especially his Encyclopedia, *paragraph 258), as well as Benjamin's "Theses on the Philosophy of History."* [19]

Whatever happens—or rather, *that* something happens—does not come from the homogeneity of a temporal process, nor from the homogeneous production of this process out of an origin. Happening means, on the contrary, that the origin is not and was

never present. This is the same as to say, with Heidegger, that Being *is* not: this also means that *we* do not succeed ourselves in the pure continuity of a substantial process, neither individually nor collectively, but that *we* appear as *we*, in the heterogeneity of community, which is history, because we do not share any "commonness" and thus we are not a common being. We do not have and we are not our own origin. History in this sense means *the heterogeneity of the origin*, of Being, and of "ourselves."

Such an heterogeneity, however, is nothing but the heterogeneity of time itself; for succession would never be succession if it was not a heterogeneity between the first and the second time— between the different "presents" of time. Between the presents, there is no longer time, there is no longer the permanent substance and presence of time. To *emerge*, as the happening does, or to emerge in time, means that time itself emerges out of itself, emerges out of its self. It is the timelessness of time—which is, in a certain sense, the same as a "timefullness"—it is also the "event," time full of its own heterogeneity, and therefore, spaced. Existence, as the ontological condition of finite being, is time outside itself, the opening of a space of time in time, which is also the space of the "we," the space of community, which is open and "founded" by nothing other than this spacing of time.

"Foundation" can be seen as a model for the "historic" event. Then, what is foundation besides the spacing of time and heterogeneity? Foundation does not, as such, come after anything else. Foundation has, by definition, no foundation. Foundation is nothing but the tracing of a limit that spaces time, that opens up a new time, or that opens up a time within time. Each time, what is opened up is a *world*, if "world" does not mean universe or cosmos, but the proper place of existence as such, the place in which one is "given to the world" or where one "comes into the world." A world is neither space nor time; it is the way we exist together. It is our world, the world of *us*, not as a belonging, but as the appropriation of existence insofar as it is finite, insofar as it is its own essence, which is to *exist*, to come into a world and to open up this world at the same time. But this time is not the time of an origin, nor the origin of time: it is the spacing of time, the opening up of the possibility of saying "we" and enunciating

and announcing by this "we" the historicity of existence. History is not a narrative or a statement, but the announcement of a "we" (history is writing in this sense).

Parenthesis nine: In this sense, any foundation of an institution—or, if one prefers, any institution, as such, in its own instituting happening—is a kind of spacing, an opening up of the spaced time of history, notwithstanding the closed and enclosing space it can produce at the same time.

Parenthesis ten: Obviously, this is nothing other than an attempt to comment on or develop (even if it does not directly engage Heidegger's theory of history) the Ereignis of Heidegger—that is, Being itself as the happening that appropriates existence to itself, and therefore to its finitude in the sense of nonappropriated existence or nonessentiality. The logic of Ereignis is what Derrida expressed as the logic of "differance," which is the logic of what in itself differs from itself. I would add that this is the logic of existence and (as) community, not as they exist or are "given," but as they are offered. We are offered to ourselves, and this is our way to be and not to be—to exist (and not to be present or to be) only in the presence of the offering. The presence of the offering is its coming, or its future. To be offered, or to receive the offer of the future, is to be historical.

I am very aware that those three concepts (Ereignis, differance, offering) cannot be taken precisely as "concepts" and that using them one cannot build another, "new theory" of "history," of "community" or of "existence." For they are themselves only offered at the boundaries of an epoch and at the limits of a discourse that are ours and are no longer ours at the same time (the time of the end of "History"). Therefore, they only *offer* us the chance to proceed from them—from their meanings and from their absence of meaning—to another space of time and of discourse. Through these fragile "signals" (rather than "signs"), it is history that is offering itself to us. It is the chance, which we have to take, to have another history come, to have another utterance of the "we," another enunciation of a future. This is not a theory, for it does not belong to a discourse about (or above) history and community. But this is—these words, concepts, or signals are— the way history offers itself, as the happening, to a way of think-

ing that can no longer be the thinking of "History." To offer is to present or to propose—not to impose the present, like a gift. In the offer, the gift is not given. To offer implies the future of a gift, and/or the not-yet-given gift of a future. With respect to the offer, we have something to *do*, which is: to accept it or not. We have to decide, without knowing *what* is offered, because it is not given (it is not a concept, it is not a theory). The historicity of the truth lies in the fact that it offers itself to our decision and is never given.

Time opened up as a world (and this means that "historic" time is always the time of the changing of the world, which is to say, in a certain sense, of a *revolution*), time opened up and spaced as the "we" of a world, for a world or to a world, is the time of history. The time or the timing of nothing—or, at the same time, the time of a filling, of a fulfilling. "Historic" time is always a *full* time, a time filled by its own *espacement*. Benjamin writes: "History is the object of a construction whose place is not homogeneous, empty time, but time filled by the 'now' *[Jetzt-zeit]*."[20] Yet, what is "now," and what does it mean to be filled by "the now?" "Now" does not mean the present, nor does it represent the present. "Now" presents the present, or makes it *emerge*. The present, as we know, throughout our entire tradition, is not presentable. The present of the "now," which is the present of the happening, is never present. But "now" (and not "the now," not a substantive, but "now" as a performed word, as the utterance which can be *ours*, performing the "we" as well as the "now") presents this lack of presence, which is also the coming of "we" and of history. A time full of "now" is a time full of openness and heterogeneity. "Now" says "our time;" and "our time" says: "We, filling the space of time with existence." This is not an accomplishment; this is happening. Happening accomplishes—happening. History accomplishes—history. This is to be destined or exposed to history, that is, the exposition to existence is a way of being without accomplishment, without accomplished presence. And this is, for *us*, *today*, the way of Being as such. As Henri Birault writes: "Being in its entirety is destined to history."[21] That is, all of being *is* nothing but this destination or exposition, the finite exposition of existence to existence—of our

existence, which is the possibility and the chance to say "we, now."

"We, now" does not mean that we are present in a given historical situation. We are no longer able to understand ourselves as a determined step within a determined process (although we cannot represent ourselves except as the result of the whole epoch of history, as a process of determination). But we have to partake in a space of time just as we have to partake of a community. To partake of community is to partake of existence, which is not to share any common substance, but to be exposed together to ourselves as to heterogeneity, to the happening of ourselves. This also means that we have to partake of history as a finitude. This is not to receive what we are from any essence or origin but to decide to be *historic*. "History" is not always and automatically historic. It has to be taken as an offer and to be decided. We no longer receive our sense from history—history no longer gives or enunciates sense. But we have to decide to enunciate our "we," our community, in order to enter history.

We have to decide to—and decide how to—be *in* common, to allow our existence to exist. This is not only at each moment a political decision; it is a decision about politics, about if and how we allow our otherness to exist, to inscribe itself as community and history. We have to decide to make—to write—history, which is to expose ourselves to the nonpresence of our present, and to its *coming* (as a "future" which does not succeed the present, but which is the coming of *our* present). Finite history is this infinite decision *toward* history—if we can still use the word "history," as I have tried to do, at least for today. In time, today is already yesterday. But every "today" is also the offer of the chance to "space time" and to decide how it will no longer just be time, but *our* time.

Notes

1. Marx never accepted the representation of history as a subject. He always insisted that history is "the activity of man." In this sense—and not to mention the additional analysis of Marx that would be necessary here—I am attempting here nothing other than a reelaboration, in a quite different historico-philosophical context, of this indication. I take the occasion of this first note to apologize for

my poor English, which makes not only the language poor, but also the discourse rough. But I express my gratitude to those who helped me to make, at least, this experience possible: Elizabeth Bloomfield, Bryan Holmes.

2. Else Morante, History: A Novel, tr. by William Weaver (New York: Alfred A. Knopf, 1977).

3. Georg Wilhelm Friedrich Hegel, "Introduction," in The Philosophy of History, tr. by J. Sibree (New York: Dover Publications, 1956), p. 21.

4. Theodor W. Adorno, Negative Dialectics, tr. by E. B. Ashton (New York: Continuum, 1983), p. 129.

5. Karl Marx, The Holy Family, in Writings of the Young Marx on Philosophy and Society, tr. by Easton and Guddat (New York: Anchor Books, 1967), pp. 385, 382.

6. Jean-François Lyotard, L'enthousiasme (Paris: Galilée, 1986), p. 77.

7. Jacques Derrida, Writing and Difference, tr. by Allan Bass (Chicago: University of Chicago Press, 1978), p. 291; Dissemination, tr. by Barbara Johnson (Chicago: University of Chicago Press, 1981), p. 184. Similar remarks can already be found in The Origin of Geometry.

8. Karl Marx, Grundrisse: Introduction to the Critique of Political Economy, tr. by Martin Nicolaus (New York: Vintage, 1973), p. 109.

9. Martin Heidegger, "Art and Space," tr. by Charles H. Seibert, in Man and World (1973), 6:5; translation modified.

10. Marx, Grundrisse, p. 100.

11. See Martin Heidegger, Being and Time, tr. by John Macquarrie and Edward Robinson (New York: Harper and Row, 1962); Derrida, Writing and Difference, p. 114; and Christopher Fynsk, Heidegger: Thought and Historicity (Ithaca: Cornell University Press, 1986), p. 47.

12. Heidegger, Being and Time, paragraph 74, p. 438; translation modified.

13. See Heidegger, Being and Time, paragraph 84, and the commentary by Paul Ricoeur in vol. 3 of Time and Narrative, tr. by Kathleen Blamey and David Pellauer (Chicago: University of Chicago Press, 1988).

14. Cf. my L'expérience de la Liberté (Paris: Galilée, 1988).

15. Suzanne Gearhart, "The Critical Moment of (the Philosophy of) History," manuscript.

16. Werner Hamacher, "Ueber einige Unterschiede zwischen der Geschichte literarischer und der Geschichte phänomenuler Ereignissen." Akten der 7en Inter nationalen Germanisher Kongress, Göttingen, 1985, Bd. 11.

17. As Lyotard claims in L'enthousiasme, pp. 45–46.

18. Hannah Arendt, "The Concept of History," appears in Between Past and Future (New York: Penguin Books, 1968).

19. Walter Benjamin, "Theses on the Philosophy of History," appears in Illuminations, tr. by Harry Zohn (New York: Schocken Books, 1969).

20. Walter Benjamin, "Theses on the Philosophy of History," Thesis 14, in Illuminations, p. 261; translation modified.

21. Henri Birault, Heidegger et l'expérience de la pensée (Paris: Gallimard, 1979), p. 545.

THE QUESTION
OF AESTHETICS

7
THE BLINK OF AN EYE
Rosalind E. Krauss

The images of nature, at any rate,
are not conventional signs, like the
words of human language, but show
a real visual resemblance, not only
to our eyes or our culture but also
to birds or beasts.
—Ernst Gombrich, on the work of
Konrad Lorenz

THE ART historian has little use for any of those moves, argu-
ments, theories, that have long since acted to reorient the human
sciences around the structural conditions of the sign, the opera-
tions of the signifier, the properties of discourse. For him or her,
the domain of painting is that of the natural sign. It is a domain
thus immune to all those analyses that depend on the sign as
conventional, arbitrary, constructed. Those theorizations of the
textual, the written, the grammatological are, to art historians,
irrelevant to the visual, natural, conditions of the visual arts.
They shrug. They ask themselves what use deconstruction could
possibly be to them, the scientists of the natural sign.

It is around the conviction that the directness, the immediacy,
the instantaneousness of showing is what is specific to painting,
that most art historians would unite. Painting's truth, its specific-
ity, they would argue, has no use for, no need of this spinning out
of the immediate into the lengthened and tangled skein of the
textual. Its gesture, which can be read in that instantaneity that
we can refer to as a blink of the eye, can only be traduced by all
those moves of deconstruction to reduce the irreducible visual-
ness of the pictorial—to double what is single, to defer what is
immediate, to repeat what is unique, in short to translate the

visual into the written, the graphic, the grammatological. For such translation, in rendering the visualness of the picture unrecognizable, is on the face of it—to art historians, as they shrug their shoulders—useless, unusable, beside-the-point.

That eye around which the art historian models so much of what he thinks occurs before it blinks, that eye is the one that stares, forever open and fixated, into the visual pyramid of the legitimate construction. That eye, from which the perspective symmetrically unfolds and to which it just as symmetrically returns, that eye is the logical guarantor that the plane of the projection—the painting—will be the mimetically truthful double of any transverse plane in the original field of vision. But that eye's logic guarantees more than the way that representation can always be folded back on itself in a miming that renders itself transparent to the original experience, transforming re-presentation into a calling up of the original, in a continually renewed presentation of it, producing thereby a forever renewable present. That eye's logic specifies that present as itself contracted to a point—occupying the geometry of the limit, understood as the infinitely small or brief or contracted. The vanishing point's infinity is mirrored in that of the viewing point, a concentration at this end into the infinitely short duration of the "now," a present which is—as it achieves this limit—indivisibly brief and thus irreducibly unassimilable to time. The rapidity of this blink thus annihilates, structurally and logically, all possibility within it of past and future. The eye of the legitimate construction regards its prospect from the vantage of a perpetual now.

We are, of course, familiar with Derrida's analysis of this now and the role it plays in Husserl's phenomenology—an analysis that challenges this "now" by calling it myth, spatial or mechanical metaphor, and inherited metaphysical concept. Derrida's *Speech and Phenomena* acknowledges the importance to Husserl's project of preserving the instant as a point, so that the identity of experience will be seen to be instantaneously present to itself.[1] Indeed, if self-presence must be produced in the undivided unity of a temporal present, this is because it must have nothing to reveal to itself by the agency of signs. As Husserl writes in *Ideen*, "between perception on the one hand and the

symbolic representation by means of images or signs on the other, there exists an insurmountable eidetic difference" (cited in *Speech and Phenomena*, p. 60).

But this is an eidetic difference which is eroded by Husserl's own description of the experience of this "now" in its inextricable continuousness with a past prolonged into the present in the form of retentions and protentions, or memory and expectation. Husserl as he describes this gives it a surprisingly carnal form as he explains that "the now-apprehension is, as it were, the nucleus of a comet's tail of retentions," adding that "a punctual phase is actually present as now at any given moment, while the others are connected as a retentional train" (cited in *Speech and Phenomena*, p. 62). The fact of retention—as nonpresent carried into the present, as not-now infecting the now—suggests a temporality which, however, phenomenology cannot acknowledge. "As soon as we admit this continuity of the now and the not-now, perception and nonperception," Derrida writes, "in the zone of primordiality common to primordial impression and primordial retention, we admit the other into the self-identity of the Augenblick; nonpresence and nonevidence are admitted into the blink of the instant. There is a duration to the blink, and it closes the eye" (*Speech and Phenomena*, p. 65).

And onto the screen of this closed eye is projected—against Husserl's will—the scene of writing and the structure of signs. Retention—which Husserl calls "primoridal memory," in order to try to separate it from the re-presentation of secondary memory —retention, Derrida argues, has the same form of nonpresence that memory has, and thus shares with re-presentation a common root. This root, "the possibility of re-petition in its most general form, that is, the constitution of a trace in the most universal sense—is a possibility," Derrida argues, "which not only must inhabit the pure actuality of the now but must constitute it through the very movement of difference it introduces. Such a trace . . . is more 'primoridal' than what is phenomenologically primordial. For the ideality of the form of presence itself implies that it be infinitely re-peatable, that its re-turn, as a return of the same, is necessary ad infinitum and is inscribed in presence itself" (*Speech and Phenomena*, p. 68).

. . .

THERE IS a painting by Marcel Duchamp which the most art historically faithful among his interpreters see as a pitting against the incursions of modernism of the analytical truths of the legitimate construction. Painted on glass, *To be Looked at (from the Other Side of the Glass), with One Eye, Close to, for Almost an Hour* (1918) seems explicitly to call up the transparency of the plane of perspective construction and to combine it with various allusions to the mechanisms of geometric projection. The picture's vertical bar, we are told, is "not unreminiscent of the perspective instrument called a *portillon*, a stylus placed upright in the center of a graduated dial, with a lens at its tip."[2] The viewer's eye, it is argued, if brought "close to," as instructed, will enter the scopic machinery of this ideated seeing, occupying the perpetual "now" of the Augenblick's disembodied vision.

But Duchamp, it must be noted, adds to his instructions something that enters the machine of visual transparency to foul the smoothness of its operations—because the direction to see, also, "from the other side of the glass" suggests a kind of vision in which seeing is a process of encountering the body of the seeing subject, and thus the staging of an incarnated viewing that has nothing to do with the legitimate construction.

The experience of this moment when the body enters the field of the gaze has been rehearsed for us in a variety of ways. In the extraordinary section of *Being and Nothingness* on The Look, Sartre produces this moment in a manner strangely close to Duchamp's when he depicts himself poised at a keyhole that has become nothing but transparent vehicle for his gaze to penetrate, a keyhole that, as he says, "is given as 'to be looked through close by and a little to one side.' "[3] And if, in this position, hunched and peering, Sartre is no longer for-himself, it is because his consciousness leaps out beyond him towards the still unseen spectacle of lasciviousness that unfolds behind the as-yet unbreached opacity of the door. Yet in this scenario, as we know, what comes next is not the realization of the spectacle, but the interruption of the act. For the sound of footsteps announces that the gaze of someone else has taken him both by surprise and from behind.

It is as this pinioned object, this body bent-over-the-keyhole, this carnal being trapped in the searchlight of the other's gaze, that Sartre thickens into an object for himself. For in this position he is no longer pure, transparent intentionality beamed at what is on the door's far side, but rather, simply as body caught on *this* side, he has become a self that exists on the level of all other objects of the world, a self which has suddenly become opaque to his own consciousness, a self which he therefore cannot *know* but only *be*, a self which for that reason is nothing but a pure reference to the Other. And it is a self which is defined by shame. "It is shame," Sartre writes, "which reveals to me the Other's look and myself at the end of that look. It is the shame . . . which makes me *live*, not *know* the situation of being looked at" (*Being and Nothingness*, p. 352).

To be discovered at the keyhole is, thus, to be discovered as a body; it is to thicken the situation given to consciousness to include the hither space of the door, and to make the viewing body an object for consciousness. In answer to what kind of object, Sartre defines this only in relation to the Other—the consciousness of the one who discovers him, and in whose look he ceases totally to master his world. As for himself, this thickened, carnal object produces as the content of *his* consciousness the carnation of shame.

In the project he was to call *Etant donnés*, a project begun in 1946 and thus following *Being and Nothingness* by only a few years, Duchamp also interrogates the scene of solid door, hidden spectacle, peephole and gaze.[4] But unlike Sartre's scenario, nothing here breaks the circuit of the gaze's connection to its object or interrupts the satisfaction of its desire. Having sought the peephole of *Etant donnés*, Duchamp's viewer has in fact entered a kind of optical machine through which it is impossible *not* to see.

Jean-François Lyotard has characterized that optical machine as one that is both based on the system of classical perspective and is maliciously at work to lay bare its hidden assumptions. For the perspective system is, as we know, constructed around the theoretical identity between viewpoint and vanishing point, an identity that undergirds the geometrical symmetry, securing the image on the retina as a mirror of the image propagated from

the point of emanation of the rays of light. Now if in the *Etant donnés* the vertical plane that intersects the visual pyramid of classical perspective is materialized not by a picture surface but by a brick wall—the transparency of which is not a function of pictorial illusion but of the literal breaching of the wall by a ragged opening—the two other parts of the system, viewpoint and vanishing point, are similarly incarnated. Vanishing point, or the goal of vision, is manifested by the dark interior of a bodily orifice, the optically impenetrable cavity of the spread-eagled nude, a physical rather than a geometrical limit to the reach of vision. And viewing point is likewise a hole: thick, inelegant, material. "The dispositif will be specular," Lyotard writes. "The plane of the breach will be that of a picture that will intersect the focal pyramids having for their summits the viewing- or peepholes. In this type of organization, the viewpoint and the vanishing point are symmetrical. Thus if it is true that the latter is the vulva, this is the specular image of the peeping eyes; such that: when these think they're seeing the vulva, they see themselves. *Con celui qui voit*," Lyotard concludes, "He who sees is a cunt."[5]

Now this viewer, specified thus by Duchamp as essentially carnal, caught up in a cat's-cradle of identification with what he or she sees, is also—like Sartre at his keyhole—a prey to the intervention of the Other. For Duchamp, leaving nothing up to his old buddy Chance, willed that the scene of *Etant donnés* be set within a museum, which is to say, within an unavoidably public space. And this means that the scenario of the voyeur-caught-by-another-in-the-very-midst-of-taking-his-pleasure is never far from consciousness as one plies the peepholes of Duchamp's construction, doubly become a body aware that its rear-guard is down.

When Kant displaced the space of beauty from the empirical realm to the wholly subjective one, declaring taste a function of a judgment stripped of concepts, he nonethless preserved the public dimension of this subjectivity by decreeing that such judgments are necessarily, categorically, universal. Their very logic is that they are communicable, sharable, a function of the concept of the "universal voice." Aesthetic experience's pleasure, diverted from the exercise of desire, is channeled precisely into a

reflection on the possibility of universal communicability. It is only this, Kant says in the Second Moment of the Analytic of the Beautiful, "that is to be acknowledged in the judgment of taste about the representation of the object."[6] Doubly paradoxical, then, such experiences of the beautiful are conceived as pleasure disincarnated because without desire, and as pure individuality that can only act by assuming the assent of others.

This space of cognitive access to the universality of the language of art describes, of course, not just a theory of aesthetic judgment, but its institutionalization in the great museums that are part of the development of nineteenth- and twentieth-century culture. For the museum as we know it was constructed around the shared space of the visual founded on the collectivization of individual subjects. It is the system of this museum, however, that *Etant donnés* enters only to disrupt by "making strange." For, threatened by discovery on the part of his fellow viewer, the purely cognitive subject of Kant's aesthetic experience is redefined in this setting as the subject of desire, and subjectivity itself is taken from the faculty of cognition and reinscribed in the carnal body.

Twice over, the vision of this viewer is hooked up to that glandular system that has nothing to do with the pineal connection, and everything to do with the secretions of sex and fear. Descartes' notion of the bridge between the physical and the mental carefully preserved the autonomy of the latter. But the optic chiasma that Duchamp suggests is unthinkable apart from a vision that is carnal through and through. *Con*, as it's been said, *celui qui voit.*

TITLING THE book from which that phrase is taken *Les TRANS-formateurs DUchamp*, Lyotard thus partitions Duchamp's name in order to rehearse, among other things, the nominal rifts through which Duchamp himself severed his person into a redistribution over the pictorial surface. One of the notes Marcel Duchamp made for the *Large Glass* is a sketch of the work's two-tiered format—bride above, bachelor below—the former labeled MAR, the latter carrying CEL, so that Mar/cel will lend itself both to the female of *mariée* and the male of *célibataires*, to enact the drama

of the *Bride Stripped Bare by Her Bachelors, Even (La mariée mise à nu par ses célibataires, même*, 1915–1923; also referred to as the *Large Glass*) over the disbursed bodily field of its author. But Lyotard's splitting of DUchamp suggests a different order of redistribution, one that makes the signifier "Duchamp" the operator in the center of a field of transformations which are also a transformation of fields—both the visual field itself, and the field of art history—that attempts to account for the intelligibility of the field of vision.

If I wish in what follows to trace Duchamp's progress in that transformation of the field—both of vision and of the account of vision—it is because I feel that the issue of deconstruction's "use" to art history is unintelligible within a field that has not been so transformed. For apart from such transformation, deconstruction can only be inserted into an unchanged disciplinary domain as so many occasions for thematization: the thematizing of writing, of the frame, of the supplement.

LYOTARD HAS been alone, as far as I know, in pushing this notion of the carnality of vision deep into the heart of Duchamp's production, which is to say, onto the very surface of the *Large Glass*. For by carnality one wants to be quite specific here. And Lyotard is talking about the body as a psychophysiological system. Speaking of Duchamp's statement that the *Glass* is intended to "isolate the sign of accordance between a state of rest" and a series of possible facts, Lyotard continues, "Now, the Glass is indeed this isolated sign, this immobile sensitive surface (the retina) onto which the diverse facts of the account come to be inscribed according to the possibilities scrupulously chosen by Duchamp and such that the viewer will literally have nothing to see if he disregards them."[7] And, going even further than this, Lyotard characterizes the *Glass* as a display, not of the facts of the event but of the physiological surfaces onto which they are registered. "What the viewer sees on the Glass," he concludes, "is the eye and even the brain in the process of forming its objects; he sees the images of these imprinting the retina and the cortex according to the laws of (de)formation that are inherent to each and that organize the screen of glass ... The Large Glass, being the film, makes

visible the conditions of impression which reign at the interior of the optical chamber. . . ."[8]

That the Glass was conceived as a surface of impression such that its figurative marks would in the main bear an indexical rather than an iconic relation to their signifieds[9]—this is borne out not only by what the Glass now contains—mirrored fields, accumulations of dust,[10] shapes transferred from photographic imprints—but also by Duchamp's initial desire that part of the upper half of the Glass be coated with a bromide emulsion. Had this plan been feasible, the whole lascivious unfolding of the Bride's Blossoming would have been materialized through the registration of a photosensitive plate.[11]

Further, in entertaining Lyotard's suggestion, we can point to other features of the Glass that allude to the neurophysiology of the optic track. The seives, for example, through which the illuminating gas is processed are referred to in Duchamp's writing as "cones," and he is explicit that it is in the labyrinthine passage through these cones that a transformation of the gas takes place.[12] For what he calls the "spangles of the illuminating gas"—which we might interpret here as light in its form as a pulsion from the visible band of the electromagnetic spectrum hitting the retinal field—these spangles get "straightened out" as they move through the seives; and due to this straightening, "they lose their sense of up and down."[13]

Now the fact that the image on the retina is inverted with respect to reality, top and bottom, right and left, was emblematic of the larger problem facing the physiological optics of the late nineteenth century, namely, the question of the transmission of information from eye to brain. At the heart of physiological inquiry into vision was the problem of just how the (geometrical) optical display, focused by the lens of the eye onto the retina, is transformed to an entirely different order of signal through which information is transmitted to the higher neurological centers where, in the "reading" of the signal, the conditions of the body's real orientation to the world are synthesized. Duchamp's words place both illuminating gas and seives (or what he calls the *"labyrinth of the 3 directions"*) within this problematic. "The spangles dazed by this progressive turning," he writes, "imperceptibly lose . . .

their *designation* of left, right, up, down, etc., lose their aware-
ness of position." But in relation to this loss, Duchamp adds the
qualification *"provisionally,"* for, as he reminds himself, "they
will find it again later," that being suggestive of the level of
cortical synthesis.

It is possible to fill in other terms of the neurooptical system in
relation to the *Glass*. Electricity, the form of the body's nerve
signals, is of course continually invoked by the notes describing
the Bachelor Apparatus. But even more explicitly, in the late
drawing *Cols alités* (1959), where Duchamp returns to the *Glass*,
we are shown a telegraph pole on the right, hooked up to the
apparatus itself, telegraphy having served as a useful analogy in
ninteenth-century discussions of nerve transmission, as in Helm-
holtz's remark: "The nerve fibres have been often compared with
telegraphic wires traversing a country, and the comparison is well
fitted to illustrate this striking and important peculiarity of their
mode of action."[14]

Although one could go on multiplying the symptoms through
which the *Large Glass* manifests itself as conditioned by physio-
logical optics' understanding of embodied vision, the point of
this analysis is certainly *not* to add yet one more totalizing ex-
planatory schema to the considerable number now in contention
for the title of *key* to the mysteries of the *Large Glass*. I am not
attempting to substitute the laws of physiological optics for any
of those other master codes—such as the practices of alchemy, or
the rituals of courtly love, or the incestuous secrets of a possible
psychobiography, or the rules of n-dimensional geometry—codes
that have been proposed as a hermeneutic for Duchamp's work.
Attending to these features is meant instead to bring us up against
a kind of interpretive paradox, through which, in the light of
Duchamp's vehement and insistent rejection of the "retinal," we
have nonetheless to acknowledge the presence of physiological
optics at work within Duchamp's thinking and production. This
presence, as we shall see, is not just manifested by the *Glass*, but
also by that whole cycle of objects from the 1920s and 1930s to
which Duchamp referred when he described himself on his busi-
ness card as Rrose Sélavy, specialist in "Oculisme de Préci-
sion."[15] The whole of "Precision Optics"—the *Rotoreliefs* (1935)

and the *Rotary Demisphere* (1925), but also stereoscopy and ana-glyphy as well as the pure exercise in simultaneous contrast of *Coeur volant* (1936)—all of this reaches back into the experimen-tal and theoretical situation of the psychophysiology of vision. And none of it seems to concur with Duchamp's professed anti-retinalism. Since what could "retinal painting" be if it is not exemplified by the turn that painting took in the grip of the discoveries of Helmholtz and Chevreul, the discoveries promul-gated by Charles Blanc and Ogden Rood?

Indeed, Duchamp was explicit that he had Impressionism in mind as a premier example of the retinal. "Since the advent of Impressionism," he told an interviewer, "visual productions stop at the retina. Impressionism, fauvism, cubism, abstraction, it's always a matter of retinal painting. Their physical preoccupa-tions: the reactions of colors, etc., put the reactions of the gray matter in the background. This doesn't apply to all the protago-nists of these movements. Certain of them have passed beyond the retina. The great merit of surrealism is to have tried to rid itself of retinal satisfaction, of the 'arrest at the retina.' I don't want to imply that it is necessary to reintroduce anecdote into painting," Duchamp then cautions. "Some men, such as Seurat or such as Mondrian, were not retinalists, even in wholly seeming to be so."[16]

The distinction Duchamp makes at the end of this statement is important to keep in mind as we try to come to terms with the critique he is launching on the whole system of the visual as that is put into place by mainstream modernism—the line that moves from Impressionism to abstraction by way of cubism—because those terms cannot be arrived at by assuming that Duchamp's rejection was simply a wholesale condemnation of all those as-pects of science that modernism had thought to appropriate. Rather, judging from the exception he makes of Seurat, he was fully admiring of real rigor in the application of the principles of modern optics. More precisely, what he objects to is the "arrêt à la rétine," the stopping of the analytic process at the retina, the making of the interactions between the nerve endings—their co-ordinated stimulation and innervation—a kind of self-sufficient or autonomous realm of activity. The result of this was, within

the development of modernist painting, the reification of the retinal surface and the conviction that by knowing the laws of its interactive relationships, one then possessed the algorithm of sight. The mapping of the retinal field onto the modernist pictorial plane with the positivist expectation that the laws of the one would legislate and underwrite the autonomy of the operations of the other, is typical of the form in which high modernism established and then fetishized an autonomous realm of the visual.

This is the logic that one hears, for example, in Delaunay's pronouncements that the laws of simultaneous contrast (as formulated by Young-Helmholtz) and the laws of painting are one and the same. "Color," he frequently declared, "colors with their laws, their contrasts, their slow vibrations in relation to the fast or extra-fast colors, their interval. All these relations form the foundation of a painting that is no longer imitative, but creative through the technique itself." What makes this possible, he would reiterate, is a scientifically wrought understanding of "simultaneous contrast, [of the] creation of profundity by means of complementary and dissonant colors, which give volume direction. . . . To create," he insists, "is to produce new unities with the help of new laws."[17]

It was the idea of the self-sufficiency and the closed logic of this newly conceived retino-pictorial surface that gave a program to early abstract painting such as Delaunay's, and a coherence to much of modernist theory. It is this logic that refuses to "go beyond" the retina to the grey matter, and it is to this refusal that Duchamp objects.[18] But the "grey matter," as I will argue, though it undoubtedly refers to the cerebral cortex, does not thereby invoke a disembodied faculty of cognition or reflection, does not propose the transcendental ego's relation to its sensory field. The cerebral cortex is not above the body in an ideal or ideated remove; it is, instead, *of* the body, such that the reflex arc of which it is part connects it to a whole field of stimuli between which it cannot distinguish. These stimuli may come from outside the body, as in the case of normal perception, but they may also erupt internally, giving rise, for example, to what Goethe celebrated as "physiological colors," or those sensations of vision that are generated entirely by the body of the viewer. The production of

sensory stimulation from within the body's own field, the optical system's porousness to the operations of its internal organs—this fact forever undermines the idea of vision's transparency to itself, substituting for that transparency a density and opacity of the viewing subject as the very precondition of his or her access to sight.

Duchamp's view of the grey matter—that part that exists beyond the retina—cannot be separated from other kinds of organic activity within the corporeal continuum. For to do so would leave one, for example, with no way of interpreting the visual activity projected within the domain of the Bride in the upper half of the *Large Glass*. Duchamp describes the Bride's blossoming—which is to say the orgasmic event towards which the whole mechanism of the *Glass* is laboring—as an ellipse with two foci, an ellipse through which the circuitry of the Bachelor Machine connects to that of the Bride. The first of the foci, which he designates as the stripping by the Bachelors, seems to relate to the perceptual part of the arc he is mapping. But the second focus, the Bride's "voluntarily imagined blossoming," connects the reflex arc of this ellipse to an organically conditioned source of the drive, an organ which Duchamp says "is activated by the love gasoline, a secretion of the bride's sexual glands and by the electric sparks of the stripping."[19]

If the mechanism of the *Large Glass* obeys Duchamp's dictum of "going beyond" the retina, it does so not to achieve the condition of vision's transparency to itself—which is suggested by the model of classical perspective when applied to the *Glass*—but rather, quite obviously, to arrive at the threshold of desire-in-vision, which is to say to construct vision itself within the opacity of the organs and the invisibility of the unconscious.

With these two notions—desire-in-vision and the unconscious as the condition of invisibility—I have obviously brought this discussion to a point where the status of the subject of consciousness that Duchamp is projecting is directly at stake. Arguments about the subject of the *Large Glass*—as about the subject put in place by the rest of Duchamp's work—and whether it can be conceived of as a transcendental subject, or whether, like the subject of psychoanalysis or of associationist psychology, it can-

not, are obviously brought to a head by the conflict between the two models of vision that two different interpretive traditions want to bring to bear on the *Glass*. The first is a geometrical model accountable to a higher logic, a model that operates in either the classical perspective discussions of the *Glass* or in the n-dimensional ones; the second is a psychophysiological model that has entirely different implications for the epistemological status of the Duchampian subject.

The difference between these two models is extremely clear, as are the implications that follow from them for Duchamp's historical position. What continues to vex the attempt to sort out their respective claims, however, is that, in order to prove its point, each of these opposed positions has recourse to Duchamp's exploitation of photography. The psychophysiological model feels itself buttressed by the *Glass*'s condition—both in theory and in actuality—as a light-sensitive surface of impression, thus simultaneously a sensory field and a photogrammatic one. The geometrical-perspective model, on the other hand, sees itself strengthened by the obvious connection between photography and optics, a connection that seems to situate the photographic camera as the modern descendant of the camera obscura, and photographic vision as an extension of all those models that tied the analysis of seeing to the understanding of image-formation performed by seventeenth- and eighteenth-century optics. According to this argument the *Glass*'s condition as a kind of mammoth photographic plate only binds it that more closely to the model of the camera obscura and its *a priorism* with regard to sight.[20]

But the evolutionist view that the photographic camera is just one more version of the camera obscura, and that as such it performs a kind of technological mediation between the optical models of a ninteenth-century analysis of vision and those of the seventeenth, cannot stand up to a rigorous archeological analysis that would examine its specific historical grounds. And indeed, a recent study by Jonathan Crary strongly contests this position, arguing that "the camera obscura and the photographic camera, as practices, as ideas and social objects, belong to two fundamentally different organizations of representation and of the observer's relation to the visible."[21]

Beaming light through a pin-hole into a darkened room, the camera obscura focuses that light on the opposite wall, allowing the observer—whether it is Newton for his *Optics* or Descartes for his *Dioptrique*—to view that plane as something independent of his own powers of synthesis, something that he, as a detached subject, can therefore observe. It was due to this structural disconnection between plane of focus and observing subject that the camera obscura came, in the seventeenth century, to function as an epistemological model. Richard Rorty, for example, characterizes both Descartes' and Locke's use of this model in terms of "the conception of the human mind as an inner space in which both pains and clear and distinct ideas passed in review before an Inner Eye. . . . The novelty was the notion of a single inner space in which bodily and perceptual sensations . . . were objects of quasi-observations."[22]

Now this epistemic subject, Crary argues, is only made explicable insofar as he is the observor of a projection onto a field exterior to himself. So that,

whether it is Berkeley's divine signs of God arrayed on a diaphanous plane, Locke's sensations 'imprinted' on a white page, or Leibniz' elastic screen, the 18th century observer confronts a unified space of order, unmodified by his own sensory apparatus, fully independent of his own body subjectivity, on which the contents of the world could be studied and compared, known in terms of a multitude of relationships. In Rorty's words, "It is as if the *tabula rasa* were perpetually under the gaze of the unblinking Eye of the Mind . . . it becomes obvious that the imprinting is of less interest than the observation of the imprint—all the knowing gets done, so to speak, by the Eye which observes the imprinted tablet, rather than by the tablet itself. (*Modernity*, p. 51)

But at the end of this period, the single most evocative image of the camera obscura's having ceased to serve as the model of vision is Goethe's direction in the *Farbenlehre* (1810) that in the darkened room, the subject, after looking at the bright point of light entering through an opening, close off that fissure so that the phenomenon of the after-image might appear. With this severing

of the dark room's relation to the external field, Goethe initiates
the study of a physiology—and no longer an optics—of vision, a
physiology that understands the body of the viewer as the active
producer of optical experience. It is this shutting of the room,
Crary maintains, that "signals a negation of the camera obscura
as both an optical system and epistemological principle" (p. 64).
Color, which can simply be produced by electrical stimulation of
the optic nerve, is henceforth severed from a specifically spatial
referent. Color, the form of the body's registration of light, is thus
conceived as always potentially "atopic," so that the natural sign's
necessary connection to the visual field can no longer be main-
tained. And now, fully imbedded within the nervous weft of the
body's tissues, color comes to be understood as well as something
subject to the temporality of the nervous system itself, to its
access to fatigue, to its necessary rhythm of innervation, to that
which causes color to ebb and flow within experience in an
infinitely mutable evanescence.[23]

In taking over from the camera obscura as the conveyor of the
image, the body, solid and dense, becomes instead the producer
of that image, a producer who must forge a perception of the real
from a field of scattered signs. "None of our sensations," Helm-
holtz explained in 1867, "give us anything more than 'signs' for
external objects and movements," so that what we call seeing is
really learning "how to interpret these signs by means of experi-
ence and practice." With regard to the signs provided by retinal
excitation, he added, "It is not at all necessary to suppose any
kind of correspondence between these local signs and the actual
differences of locality [in the empirical field] which they sig-
nify."[24]

Typically, in this lecture presenting "The Recent Progress of
the Theory of Vision," these facts are brought home by the ex-
ample of the stereoscope's capacity to use two flat pictures to
simulate, with uncanny conviction, the depth perception of nor-
mal binocular vision. What the steroscope demonstrates, Helm-
holtz says, is that "two distinct sensations are transmitted from
the two eyes, and reach the consciousness at the same time and
without coalescing; that accordingly the combination of these two
sensations into the single picture of the external world of which

we are conscious in ordinary vision is not produced by any anatomical mechanism of sensation, but by a mental act" (p. 110).

The specific stereoscopic instrument to which Helmholtz refers his audience could not make his point more graphically. For the Wheatstone stereoscope, a product of physiological research in the 1830s, was constructed to produce its experience of depth in a way that proved to be much more powerful than later devices such as the Holmes or Brewster stereoscopes—a way, indeed that Duchamp would later capture by the coinage of his term *mirrorique*. In the Wheatstone apparatus the viewer would actually look—one eye on each—at two mirrors set at a 90° angle to one another, onto which would be reflected the two slightly divergent images, these held in slots at the sides of the device such that they were actually parallel to the viewer's line of sight and totally out of his field of vision.

Nothing could more effectively shatter the idea projected by the camera obscura model, in which the relationship between the viewer and his world is pictured as fundamentally scenic, than this literal dispersal of the stimulus field. "The stereoscopic spectator," Crary writes,

> sees neither the identity of a copy nor the coherence guaranteed by the frame of a window. Rather, what appears is the technical reconstitution of an already-reproduced world fragmented into *two* non-identical models, models that precede any experience of their subsequent experience as unified or tangible. It is a radical repositioning of the observed relation to visual representation. . . . The stereoscope signals an eradication of "the point of view" around which, for several centuries, meanings had been assigned reciprocally to an observer and the object of his/her vision. There is no longer the possibility of perspective under such a technique of beholding. The relation of observer to image is no longer to an object quantified in relation to a position in space but rather to two dissimilar images whose position simulates the anatomical structure of the observer's body. (Modernity, pp. 127–128)

The stereoscope's relevance is limited, of course, to the observation of objects in near vision. The importance of binocular

Marcel Duchamp, *To Be Looked At (From the Other Side of the Glass) with One Eye, Close To, for Almost an Hour,* 1918. Oil paint, silver leaf, lead wire, and magnifying lens on glass, 19½ × 15⅝ inches. Collection, The Museum of Modern Art, New York, Katherine S. Dreier Bequest.

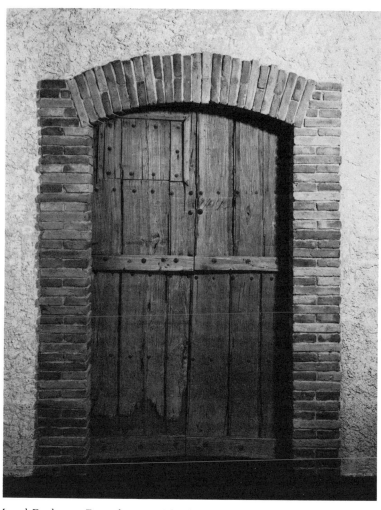

Marcel Duchamp, *Etant donnés: 1° la chute d'eau, 2° le gaz d'éclairage, 1945–66*; exterior view. Mixed-media assemblage, 95⅕ × 70 inches. Philadelphia Museum of Art, Gift of the Cassandra Foundation.

Duchamp, *Etant donnés;* view through the door.

Diagram of Duchamp's *Etant donnés*. From Jean-François Lyotard, *Les TRANS-formateurs DUchamp* (Paris, Galilée, 1977).

Albrecht Dürer, *De Symmetria Partium Humanorum Corporum*, Nuremberg, 1532. The Metropolitan Museum of Art, Gift of Felix M. Warburg, 1918 (18.58.3).

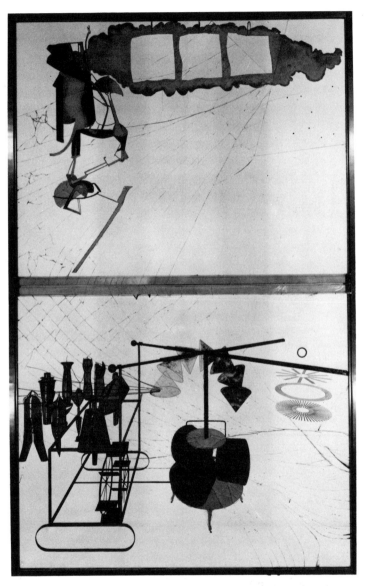

Marcel Duchamp, *La mariée mise à nu par ses célibataires, même (Le Grand Verre)*, 1915–23. Oil, varnish, lead foil, lead wire, and dust on two glass panels, 109¼ × 69¼ inches. Collection, Philadelphia Museum of Art, Katherine S. Dreier Bequest.

Wheatstone stereoscope, 1830.

Marcel Duchamp, *Handmade Stereopticon Slide*, 1918–19. Pencil over photographic stereopticon slide, each image 2¼ × 2¼ inches. Collection, The Museum of Modern Art, New York, Katherine S. Dreier Bequest.

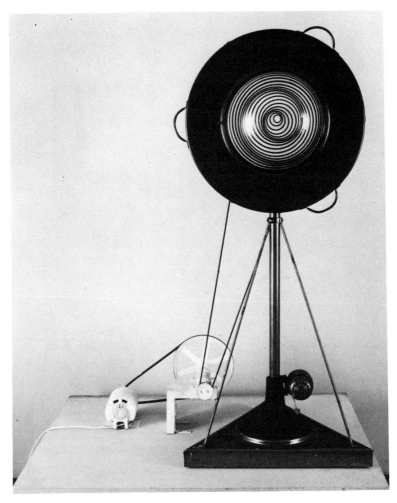

Marcel Duchamp, *Rotary Demisphere (Precision Optics)*, 1925. Motor-driven construction, 58½ × 25¼ × 24 inches. Collection, The Museum of Modern Art, New York, Gift of Mrs. William Sisler and Edward James Fund.

Marcel Duchamp, *Rotorelief ("Corolles")*, 1935. Cardboard, printed by offset lithography, 7⅞ inches diameter. Collection, The Museum of Modern Art, New York, Gift of the Riklis Collection of The McCrory Corporation.

Marcel Duchamp, *Rotorelief ("Chinese Lantern")*, 1935. Cardboard, printed by offset lithography, 7⅞ inches diameter. Collection, The Museum of Modern Art, New York, Gift of the Riklis Collection of The McCrory Corporation.

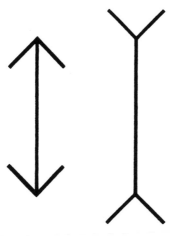

The Müller-Lyer illusion.

difference is only felt where the optic axes are forced to converge
and thereby to register a different perspective on each eye; for a
distant scene the optic axes are so nearly parallel that the appear-
ance to the two eyes is the same as if it had been viewed by only
one eye. Duchamp's *Handmade Stereopticon Slide* (1918–1919),
with its looming foreground figure made extremely disjunct from
the distant background, reflects these differing consequences of
near and far for the stereoscopic production of volume. And
indeed, one can imagine that in penciling in the figurative event
of the double pyramid against a photographically wrought empty
sea, Duchamp is maintaining the distinction between the stereo-
scopic phenomenon—which was explored before the inven-
tion of photography and is independent of it—and stereoscopy's
subsequent mass marketing as an exclusively photographic me-
dium. Made in Buenos Aires in 1919, *To Be Looked at (from the
Other Side of the Glass) with One Eye, Close to, for Almost an
Hour* seems to maintain this same specificity of attention to the
point of the distinctions that physiological optics was making
within the apparatus of vision.

It is, however, within the phenomenon of what Duchamp was
to call "Precision Optics" that one feels both closest to the exper-
imental ground of psychophysiological research and to a connec-
tion between this ground and vision's relation to desire, which is
to say, the operations of the unconscious in vision. For on the
one hand, it is extremely hard to consider Duchamp's different
projects for spinning discs apart from the various devices that
were used to explore optical mixing and subjective color. Both
the spiral-inscribed discs suggested for the latter and the pedes-
taled stands on which to mount Maxwell's discs in order to rotate
them to produce the former are illustrated in O. N. Rood's *Modern
Chromatics*, perhaps the most widely disseminated manual on
optical color.[25] And indeed, Duchamp spoke of the production of
the illusion of three dimensionality achieved by the rotation of
his discs as something achieved, "not with a complicated ma-
chine and a complex technology, but in the eyes of the spectator,
by a psychophysiological process."[26] But on the other hand, it is
equally hard to view the *Rotary Demisphere* or the *Discs Bearing
Spirals* (1923), activated into motion by the film *Anémic Cinema*

(1925), without witnessing that, by adding a virtual third dimension, Duchamp has simultaneously defined the vision in question as erotic. One of Duchamp's critics describes this effect of turning through space as "an oscillating action of systole and diastole, screwing and unscrewing itself in an obsessional pulsation that could be associated to copulatory movements."[27] And another agrees that in some of the discs, "the indication of the central cavity through the volutes of the spirals clearly evokes vaginal penetration. The fact that the eye, by means of optical illusion, perceives an in-and-out motion, establishes at an abstract level a literal allusion to the sexual act."[28] The sexual innuendos of the texts that accompany the discs in *Anémic Cinéma* thus only double at the level of language what is already evoked within the realm of vision.

That the erotic theater of Duchamp's "Precision Optics" in all its various forms is staged within the space of optical illusion places this enterprise at a kind of threshold or bridge moment between a ninteenth-century psychophysiological theory of vision and a later, psychoanalytic one. For the phenomenon of the optical illusion was an important, because troubling, issue within the associationist explanatory model to which physiological optics had recourse. Helmholtz's famous positing of "unconscious inference" as the psychological ground of all perception—unconscious inference being a process of subconscious, inductive reasoning from the basis of past experience—was continually brought up short by the obvious exception of the optical illusions. "An objection to the Empirical Theory of Vision," he admitted, "might be found in the fact that illusions of the senses are possible; for if we have learnt the meaning of our sensations from experience, they ought always to agree with experience."[29] The possibility of false inductions rendered by these "unconscious judgments" urgently needed to be accounted for if the theory were to be viable.

Attempts to provide purely physiological explanations having failed, Helmholtz had recourse to an associationist psychological one.[30] "The explanation of the possibility of illusions," he maintained, "lies in the fact that we transfer the notions of external objects, which would be correct under normal conditions, to cases in which unusual circumstances have altered the retinal

pictures." Specifically, in the case of those famous optical illusions spawned by physiological research's attempts to solve the perceptual puzzle—the Müller-Lyer illusion, the Ponzo illusion, the Zöllner or Hering illusions—unconscious inference reasons from the inappropriate application of perspective cues. Memory is seen as three dimensionally contextualizing these figures so that in the acute-arrow part of the Müller-Lyer pair, for example, what is supplied through association is the past experience of retinal images obtained when the vertical line is the closest part of a three-dimensional figure, such as the edge of a building nearest the observer; while for the obtuse-arrow half, the context provided refers to images projected when the vertical line is the most distant part, such as the far corner of a room in which the viewer stands. The Ponzo figure, sometimes called the railroad track illusion, is similarly referred to the mistaken inference of perspective convergence and the resultant miscuing of the viewer with regard to relative size.

The fact that the physiologist Helmholtz breathed the word "unconscious" into the discourse of empirical science raised a storm of protest that would dog him all his life. But for Sartre, later assessing the theoretical grounds of the associationist psychology Helmholtz was advocating, it was obvious that such an explanatory model would be utterly incoherent did it not posit (no matter how covertly) an unconscious. The memory image sitting in the brain below the threshold of consciousness, a sensory content waiting to be revived and newly animated by thought, was, Sartre maintained, not only the very picture of the unconscious, but as such it was theoretically untenable. Sartre's famous rejection of the concept of the unconscious applied not only to the Freudian version but to the associationist one as well. Whereas, he held, there can be only two types of things, the in-itself of objects or the for-itself of consciousness, the idea of the unconscious posits the ontologically impossible condition of an in-and-for-itself. There can be nothing in consciousness which is unavailable to it, which is not already in the form of thought. Once thought is "hypostatized and hardened into the notion of an unconscious," Sartre argued, "such thought is no longer accessible to itself."[31]

Although Sartre insisted that there was no distinction to be drawn between the unconscious of perceptual psychology and that of psychoanalysis, and indeed the former's "laws of association" had already put in place the relations of metaphor and metonymy, or condensation and displacement, long before Freud availed himself of these terms, associationism obviously veers off from psychoanalysis in that it posits no mechanism of repression. The unconscious on which Helmholtz's theory of vision relies is, like that of associationism in general, a store of memory, and thus a reserve of consciousness. It is psychoanalysis that would view the unconscious as divisive, as the turbulent source of a conflict with consciousness. The only point of recognition within associationist theory that consciousness might be shot through by unconscious conflict, and that taking place at the very heart of perception, occurred when it had to confront its own peculiar laboratory rat: the optical illusion. And there it found itself staring at something like "optical unconscious."

It is in that languidly unreeling pulsation, that hypnotically erotic visual throb of Duchamp's "Precision Optics," that one encounters the *body* of physiological optics' seeing fully enmeshed in the temoral dimension of nervous life, as it is also fully awash in optical illusion's "false induction." But it is here, as well, that one connects to this body as the site of libidinal pressure on the visual organ, so that the pulse of desire is simultaneously felt as the beat of repression.

The rhythm of the turning discs is the rhythm of substitution, as, at an iconic level, various organs replace one another in an utterly circular associative chain. First there is the disc as eye, an eye which, in Lebel's words, is "animated by a rotary movement, a sort of gigantesque cyclops whose pupil serves as the screen for suggestive metamorphoses."[32] Metamorphosis then transforms eye into breast, a soft mound surmounted by a slightly trembling nipple. This then gives way to the fictive presence of a uterine cavity and the implication of sexual penetration. And within this pulse, as it carries one from part-object to part-object, advancing and receding through the illusion of this three-dimensional space, there is also a hint of the persecutory threat that the object poses for the viewer, a threat carried by the very metamorphic rhythm

itself, as its constant thrusting of the form into a state of dissolve brings on the experience of formlessness, seeming to overwhelm the once-bounded object with the condition of the *informe*.

Writing about "psychogenic visual disturbance" in 1910, Freud speaks of the various bodily organs' accessibility to both the sexual and the ego instincts: "Sexual pleasure is not connected only with the function of the genitals; the mouth serves for kissing as well as for eating and speaking, the eyes perceive not only those modifications in the external world which are of import for the preservation of life, but also the attributes of objects by means of which these may be exalted as objects of erotic selection."[33] The problem for the organ can arise when there is a struggle between these two instincts and "a repression is set up on the part of the ego against the sexual component-instinct in question." Applying this to the eye and the faculty of vision, Freud continues, "If the sexual component-instinct which makes use of sight —the sexual 'lust of the eye'—has drawn down upon itself, through its exorbitant demands, some retaliatory measure from the side of the ego-instincts, so that the ideas which represent the content of its strivings are subject to repression and withheld from consciousness, the general relation of the eye and the faculty of vision to the ego and to consciousness is radically disturbed." The result of repression is then, on the one hand, the creation of substitute-formations at the level of the libido, and on the other, the onset of reaction-formation within the operations of the ego.

The sequence of substitutions within "Precision Optics" and the sense of perceptual undecidability projected through the object's condition as a state of perpetual disappearance, all this rehearses the Freudian scenario of the unavailability of what is repressed and the structural insatiability of desire. For desire-in-vision is formed not through the unified moment of visual simultaneity of the camera obscura's optical display, but through the temporal arc of the body's fibres. It is an effect of the two-step through which the object is eroticized. Freud's theory of eroticization (or anaclisis), as set forth by Jean Laplanche, accounts for among other things the scopophilic impulse.[34] It is a theory of the two-step. According to the anaclitic model, all sexual instincts lean on the self-preservative or ego instincts, but they only come

to do so at a second moment, always a beat after the self-preservative impulse. Thus the baby sucks out of a need for sustenance, and in the course of gratifying that need receives pleasure as well. And desire occurs at this second moment, as the longing to repeat the first one, understood not as milk but as pleasure, understood, that is, *as* the satisfaction of desire. Thus it searches for an object of original satisfaction where there is none. There is only milk, which can satisfy the need, but cannot satisfy the desire, since it has become something that the little hiccup of substitution will always produce as insufficient. What this model clarifies is the way the need can be satisfied, while the desire cannot.

In relating this psychoanalytic model of desire's longing for a lost origin and a structurally irretrievable object to the experience of "Precision Optics," I am attempting to capture the effect of this projection of desire into the field of vision. And I am trying to hold onto that field as something that is both carnally constituted and, through the activity of the unconscious, the permanent domain of a kind of opacity, or of a visibility invisible to itself. That oscillation between the transparent and the opaque, an oscillation that seems to operate in Duchamp's work at all the levels of his practice, is revealed here. I am suggesting, as the very precondition of any visual activity at all.

There is no way to concentrate on the threshold of vision, to capture something—as Duchamp would say—en *tournant la tête,* without siting vision in the body and positioning that body, in turn, within the grip of desire. Vision is then caught up within the meshes of projection and identification, within the specularity of substitution that is also a search for an origin lost. *Con,* as they say, *celui qui voit.*

Notes

1. Jacques Derrida, *Speech and Phenomena,* tr. by David B. Allison (Evanston: Northwestern University Press, 1973), p. 61.

2. Jean Clair, "Duchamp and the Classical Perspectivists," *Artforum* (March 1978), 16:44.

3. Jean-Paul Sartre, *Being and Nothingness,* tr. by Hazel E. Barnes (New York: Washington Square Press, 1966), p. 348.

4. Installed in the Philadelphia Museum of Art in 1966, the work is to be

found in a small room that opens off the Arensberg Collection (containing many works by Duchamp, including the *Large Glass*). This room, which feels like a cul de sac, at first glance seems to contain nothing; for all one sees is a rustic, oaken door set into its far wall. It is behind this door that the diorama-like spectacle is arranged—a nude girl, her legs spread, her face invisible, lying on a pile of branches in front of a landscape—although the only access to it for the visitor is through two peepholes that are drilled into the door.

5. "Le dispositif serait spéculaire. . . . Le plan de la brèche serait celui d'un tableau qui couperait les pyramides visives ayant pour sommets les trous du voyeur. Dans une organisation de ce type, le point de vue et le point de fuite sont symétriques : s'il est vrai que le second est la vulve, celle-ci est l'image spéculaire des yeux voyeurs; ou : quand ceux-ci croient voir la vulve, ils se voient. Con celui qui voit." Jean-François Lyotard, *Les TRANSformateurs DUchamp* (Paris: Galilée, 1977), pp. 137–138.

6. Immanuel Kant, *Critique of Judgement*, tr. by J. H. Bernard (New York: Hafner Press, 1951), p. 51.

7. "Or le Verre est bien en effet ce signe isolé, surface sensible (rétine) immobile ou viennent s'inscrire les faits divers du récit selon des possibilités minutieusement choisies par Duchamp, et telles que le regardeur n'aura littéralement rien à voir s'il les néglige." Lyotard, *Les TRANSformateurs DUchamp*, p. 133.

8. "Ce que le regardeur voit sur le Verre, c'est l'oeil et même le cerveau en train de composer ses objets, il voit les images de ceux-ci impressionner la rétine et le cortex selon des lois de (dé)formation qui sont les leurs et qui organisent la paroi de verre . . . Le Verre, étant la péllicule, donne à voir les conditions d'impression qui règent à l'intérieur de la boite optîque. . . . Ibid., p. 134.

9. See my "Notes on the Index," *October* (Spring 1977), no. 3, reprinted in my *The Originality of the Avant-Garde and Other Modernist Myths* (Cambridge: MIT Press, 1986).

10. The various studies comparing Duchamp to Leonardo da Vinci refer to the note in Leonardo's sketchbooks in which he directs himself to collect dust on a plate of glass as an index of the passage of time, and make a connection between this and the *Dust Breeding* project of the *Large Glass*. See Jean Clair, "Duchamp, Léonard, la tradition maniériste," in *Duchamp: Colloque de Cerisy* (Paris: 10/18, 1979), p. 128; and Theodore Reff, "Duchamp & Leonardo: L.H.O.O.Q.—Alikes," *Art in America* (January 1977), vol. 65.

11. See Marcel Duchamp, *Duchamp du Signe: Ecrits*, ed. Michel Sanouillet (Paris: Flammarion, 1975), pp. 57–58; an English translation appears in *Salt Seller: The Writings of Marcel Duchamp (Marchand du Sel)*, ed. Michel Sanouillet and Elmer Peterson (New York: Oxford University Press, 1973), p. 38 (hereafter, *Duchamp du Signe* and *Salt Seller*, respectively). That the *Large Glass* is itself conceived as an enormous photographic plate, a "delay in glass," is the argument Jean Clair makes in *Duchamp et la photographie* (Paris: Editions du Chêne, 1977), pp. 44–62. It is my argument also in "Notes on the Index."

12. See Arturo Schwarz, *La Mariée mise à nu chez Marcel Duchamp, même* (Paris: Editions Georges Fall, 1974), p. 160.

13. Duchamp, *Salt Seller*, p. 49; *Duchamp du Signe*, pp. 73–74.

14. *Helmholtz on Perception*, eds. Richard Warren and Roslyn Warren (New York: John Wiley & Sons, 1968), p. 83.

15. *Duchamp du Signe*, p. 153; *Salt Seller*, p. 105.

16. Alain Jouffroy, *Une révolution du regard* (Paris: Gallimard, 1964), p. 110.

17. Robert Delaunay, *The New Act of Color*, ed. Arthur Cohen (New York: Viking Press, 1978), pp. 35, 41, 63.

18. Thierry de Duve has situated Duchamp's "nominalist" relation to color and his conception of the readymade within the history of abstract painting's reception of nineteenth-century optical and color theory. His argument, which describes two separate theoretical traditions—Goethe's *Farbenlehre*, which fuels a symbolist/expressionist practice, and Chevreul's *De la loi du contraste simultané*, which founds a more objective and ultimately structuralist one—emphasizes the need on the part of modernist artists to legitimate abstraction, to defend it from the arbitrariness of "mere" decoration. See Thierry de Duve, *Nominalisme Pictural* (Paris: Editions de Minuit, 1984), pp. 211–227.

19. *Salt Seller*, pp. 42–43; *Duchamp du Signe*, pp. 64–65.

20. See Jean Clair, "Duchamp and the Classical Perspectivists," and *Duchamp et la photographie*.

21. Jonathan Knight Crary, Modernity and the Formation of the Observer, 1810–1845, "Ph.D. diss. (Columbia Unviersity, 1987), p. 33. The following discussion of the archaeology of the camera in relation to nineteenth-century optics is indebted to this study.

22. Richard Rorty, *Philosophy and the Mirror of Nature* (Princeton: Princeton University Press, 1979), pp. 49–50; cited in Crary, p. 40.

23. For Goethe's relation to this notion of the transience of vision, see Elaine Escoubas, "L'Oeil (du) teinturier," *Critique* (March 1982), 37:233–234.

24. *Helmholtz on Perception*, p. 110.

25. Ogden N. Rood, *Modern Chromatics with Application to Art and Industry* (London, 1879); French translation, *Théorie scientifique des couleurs* (Paris, 1881).

26. Hans Richter, *Dada: Art and Anti-Art* (London: Thames and Hudson, 1965), p. 99.

27. Laurence D. Steefel, Jr., "The Position of *La Mariée Mise à nu par ses célibataires même* (1915–1923) in the Stylistic and Iconographic Development of the Art of Marcel Duchamp," Ph.D. diss. (Princeton University, 1960), p. 56.

28. Toby Mussman, "Anémic Cinéma," *Art and Artists* (July 1966), 1:51.

29. *Helmholtz on Perception*, p. 129.

30. See Richard Gregory, *Eye and Brain* (New York: World University Library, 1978), pp. 142–143.

31. Jean-Paul Sartre, *Imagination, a Psychological Critique*, tr. by Forrest Williams (Ann Arbor: University of Michigan Press, 1962), p. 71. For an important discussion of Sartre's relation to associationism and to Charcot, see Joan Copjec, "Favit et Dissipati Sunt," *October* (Fall 1981), no. 18, pp. 21–40.

32. "Un oeil animé d'un mouvement de rotation, sorte de gigantesque cyclope dont la prunelle sert d'écran à de suggestives métamorphoses." Robert Lebel, *Sur Marcel Duchamp* (Paris: Editions Trianon, 1959), p. 52.

33. Sigmund Freud, "Psychogenic Visual Disturbance According to Psychoanalytical Conceptions," (1910), *Character and Culture*, ed. Philip Roeff (New York: Collier Books, 1963), p. 55.

34. See Jean Laplanche, *Life and Death in Psychoanalysis*, tr. by Jeffrey Mehlman (Baltimore: Johns Hopkins University Press, 1976), chapters 1 and 5.

8
THE AESTHETIC AND
THE IMAGINARY
Wolfgang Iser

WHAT I should like to suggest is that we conceive of the aesthetic as an offshoot of the imaginary. I deliberately use the term "imaginary" as a comparatively neutral concept that has as yet not been disfigured by the multiple traditional associations which terms like "imagination" and "fantasy" carry in their wake.

As a first step I shall try to inspect at close range three basic attributes with which the imaginary as a potential has traditionally been identified: a) as a human faculty, b) as a creative activity, and c) as 'Urfantasy' or *materia prima*. These overarching classifications tend to obscure certain important features pertaining to the imaginary which, in turn, are responsible for the production of the aesthetic dimension which is not confined to works of art only, but is to be discerned in other basic human activities as well. For this reason, the workings of the imaginary as *faculty*, as *creative potential*, and as 'Urfantasy' have to be distinguished and analyzed in order to pinpoint the aesthetic which ensues from it and which assumes paradigmatic prominence in art.

There is a noticeable trend to be observed since the sixteenth century: the distinction between feigning and imagining. Sidney's *Defense of Poesie* is an important case in point. The poet is advised to use the utmost cunning in order "to conjure you to beleeve for true, what he writeth,"[1] as it is his intention to "infect" the fancy of the recipient. For this reason, the poet has to invent images which allow for conceivability of the otherwise

Within the framework of the colloquium "The States of 'Theory,' " for which this essay was written, my assignment was to make a "plea" for the aesthetic. The following is that "plea."

intangible. The invention becomes successful to the degree to which both a conscious and an imaginary activity work together.[2] Although these activities are closely intertwined, Sidney nevertheless clearly distinguishes between the component parts of the image, which feigns something nonexistent by both mobilizing fancy and channelling its potential into the required situation.[3] An intentional act, therefore, has to tap the spontaneity of fancy, thereby imposing a shape onto it, which, in turn, allows it "to speak" to the recipients' fancy for the purpose of moving them.

Now, this admonition of Sidney's points to the fact that feigning as a conscious act not only scans an uncharted territory,[4] but also allows it to be peopled by the shapes into which the tapped spontaneity of the imaginary is cast. If this is so, we might already draw a conclusion at this stage of the argument: without a mobilized spontaneity the act of feigning would remain empty, and without being tapped by a conscious act the spontaneity could not be released and would remain featureless. In this case the imaginary—or the imagination, for that matter—cannot be conceived as a self-activating entity. It does not mold the very shapes in which it manifests itself, and yet, though released and patterned by a conscious act, it simultaneously has the tendency to swamp the intentions which in the first instance are designed to activate it.

This interrelationship makes it seem strange that the imagination has been conceived in its history as a self-stimulating potential. The very fact that the imagination has a history at all is in itself sufficient reason to alert us to the fact that it may have been misconceived when considered in terms of a self-sufficient substance.

This becomes all the more obvious when we look at the three overarching categories by means of which the imagination has been conceptualized. We cannot help noticing alien features responsible for stimulating the imaginary. Probably the most persistent definition of the imagination, ranging from Aristotle to Kant, is that of a faculty. For this reason it might not be inappropriate to have a closer look at Coleridge's conception of this faculty. The much-quoted definition from the *Biographia Literaria*[5] has very seldom been related to an equally important notion which per-

vades the very same book: that is, the concept of desynonimiza-tion,[6] which Coleridge considers to be of seminal importance. Initially Coleridge applied the idea of desynonimization to lan-guage in order to explain the means by which language moves towards perfection. Desynonimization is an introduction of the distinction between words that, according to Coleridge, were ini-tially equivalent or even indistinct. If one relates that concept to the imagination as a faculty, its "desynonimization" turns out to be a differentiation, which departmentalizes the imagination.

It is therefore plausible that Coleridge talks in terms of both primary and secondary imagination as well as of fancy. The seem-ingly monolithic faculty is split up into three different operations to be clearly marked off from one another. Fancy concerns itself with "counters and fixities," which it combines. Secondary imag-ination embodies the introjection into the human subject of the creative process operative in nature, and primary imagination highlights the all-encompassing impulse of the imagination di-rected towards charting the void and thus revealing itself as a projection of totality.

In each of these cases the split faculty is in part conditioned and consequently patterned by what it is assumed to achieve: fancy by the data to be combined, secondary imagination by the way in which the subject introjects "the eternal I am," and pri-mary imagination by turning featurelessness into a patterned to-tality, thus representing that which the soul, in eighteenth-cen-tury terms, was designed to fulfill. What is to be inferred from this division of a hitherto monolithically conceived human fac-ulty?

By differentiating—or, in Coleridge's own terms, by desynon-imizing—imagination, he gave priority to its workings and not to its ontological status, let alone its assumed foundation. In unfold-ing the imagination according to the principle of differentiation, Coleridge endowed it with a striking doubleness: imagination is both a differentiation of itself and the simultaneous encompass-ing of its differences, without unifying the various divisions by which it is marked.

Thus the imagination assumes a tangibility which Coleridge has described as follows: "As soon as it is fixed in one image, it

becomes understanding; but while it is unfixed and wavering between them, attaching itself permanently to none, it is imagination. . . . The grandest efforts of poetry are where the imagination is called forth, not to produce a distinct form, but a strong working of the mind, still offering what is still repelled, and again creating what is again rejected."[7] Whenever differences are resolved, imagination issues into a product which is, however, not identical to the imagination. As long as the "wavering," in Coleridge's terms, goes on, imagination presents itself in—to use a Kantian term—an amphibolic state, or is of a centauric nature. It is half imagination proper, as all the divisions of the faculty are clearly to be discerned, thus enabling the "wavering" between what is divided. Yet it is also half a product, as the "wavering" in itself is something generated by the various differences to be observed. Now, if imagination can only present itself in this amphibolic state, the question arises whether the divisions by which the faculty is marked are self-induced. As the faculty never manifests itself in its totality, but only in its distinctly separated operations—which, in turn, are conditioned by what is to be achieved—self-dividing is not an activity inherent in the imagination. Instead, differentiation occurs when the imagination is activated, and that requires both a goal and an activating agent.

Imagination, therefore, as a faculty would be forever sealed off both from our knowledge and its operations if it were not tapped by a conscious or intentional act, which shapes its potential according to the situation into which it is to be funneled. What Coleridge termed "wavering" is grasping the imagination at a moment when it turns into a product, or, better still, when it turns into a generative matrix.

BEFORE WE draw any further conclusions from what this seemingly self-dividing faculty appears to indicate, we should have a look at the workings of the imaginary when it is conceived in terms of a creative activity. In this respect, Sartre is an interesting case in point. He signaled an important switch by breaking away from faculty psychology altogether, in consequence of which he was able to conceive of the imaginary in terms of relationships. Incidentally, this break-away manifested itself in a change of

terminology: the imagination was replaced by the imaginary. Furthermore, Sartre also divided consciousness into differently related activities, which made him focus right from the beginning on the interpenetration of the conscious and the imaginary.

Sartre started out by differentiating perception from ideation. Perception indicates the grasping of an object, ideation the relationship formed between consciousness and an object.[8] Moreover, ideation entails that the intentional object is not given, but has to be posited either as absent, as elsewhere existing, or even as nonexistent (p. 75). Therefore, Sartre maintained that in such an imaginary object there is always an ingredient of nothingness (p. 25f.). Although this object is posited by a conscious act, situations may arise in which the positing consciousness is enthralled by what it has stimulated.

The dream is a case in point in which consciousness, according to Sartre, becomes imprisoned in its own self-produced imagery (pp. 213ff.). Consciousness, then, is deprived of its intentionality, and all its activities can only be executed in terms of images and symbols. In being enslaved by the latter, consciousness is cut off from its moorings in the world. If that is so, then the relationship between a positing consciousness and the imaginary object posited is basically volatile. To posit an imaginary object that gives presence to something absent, elsewhere existent, or nonexistent entails constituting something by means of which existing realities are outstripped. The imaginary object has freed itself from existing realities, and in so doing negates them. Therefore, Sartre was able to maintain that the imaginary is a negating act, although this negating activity carries the negated world in its wake (pp. 235ff.).

For example, in order to posit a centaur as an imaginary object, this unreal object simultaneously requires the conception of a world in which the centaur does not exist. The unreal is invoked by a consciousness that is firmly anchored in the existing world, thus allowing for a form of doubling to occur by making the imaginary appear against the backdrop of that very reality it has implicitly negated. The imaginary figures as something which— though posited by a conscious act—nevertheless oversteps the boundary of that very world in which the conscious act is rooted.

Now the question arises: Is the imaginary conditioned by a positing consciousness, or does the imaginary condition the consciousness by allowing it to come to fruition? Well, consciousness without positing something would remain empty, and the imaginary, in turn, is not a self-activating potential. Although Sartre made an undeniable distinction between the conscious and the imaginary, they are basically so intertwined that they seem to be inseparable from one another. If consciousness gives presence to something absent or nonexistent by means of positing an imaginary object, it appears as if the imaginary were subservient to consciousness, because the latter performs the active part. Yet in dreaming and fantasizing, the imaginary appears to be the active part, casting a spell over what otherwise is considered to be the agent responsible for the very existence of the imaginary object. This obvious inseparability allows for shifting relationships which come about in the constant interplay between the conscious and the imaginary. *S - what is the dreaming phenomena ?*

This interplay, however, can be equated neither with the imaginary nor with a conscious activity. It appears to be an offshoot of the imaginary when spurred into action by an intentional activity, and it is undone when consciousness loses control over what it intends to shape, as in dreaming and fantasizing.

Thus the interplay turns out to be both a product and a producing activity, and this might be termed the aesthetic, highlighting the interpenetration of the imaginary and the conscious. Coleridge seems to have had something similar in mind when he tried to capture the workings of the imagination by what he called "wavering" as a mode of operation between given positions. Interplay epitomizes this in-betweenness that is operative in all acts of ideation. In conceiving something, that is, in picturing something absent, elsewhere existent, or nonexistent, the interplay functions as a regulator between the imaginary and the conscious, as evidenced by the hybrid nature of the image, which is a manifestation of this interplay. The image is hybrid insofar as it is both semisemantic and semivisual. The more preponderant intentionality becomes as an inducement for what is to be pictured, the more reduced are the imaginary components of the object to be conceived, and vice versa. Thus the mutual inter-

pe netration of the components in the mental image constantly tilts the balance between spontaneity and control, which is basic to the act of ideation.

As this shift in balance is brought about by the interplay, we are able to pinpoint the role the aesthetic performs in all our acts of ideation. It is, according to a concept proposed by Casey, the "role of possibilizing."[8] The way in which this role functions and is put into operation depends upon the pragmatic purposes to be aimed at. Ideational acts in our day-to-day living are purpose-oriented, and hence the role of possibilizing is subservient to definite ends. But the role can also be released from this subservience, and the more free reign it is given, the more it extends the range of the possible. The less it is hedged in by pragmatic needs as in ideation or perception even, the more it manifests itself as freeplay, the patterning of which is basic to the work of art. Yet what the work of art epitomizes is also operative in our acts of ideation, in which the "role of possibilizing" can equally undo what it has brought forth. Thus the volatility of the aesthetic becomes palpable.

BEFORE WE draw a conclusion from our exposition of the imaginary thus far, we must have a brief look at the conceptualization of the imaginary as 'Urfantasy' or materia prima. Viewing the imaginary as the underlying be-all and end-all of what there is makes it distinctly different from conceiving it as either a faculty or a creative activity. For proponents of the imaginary as 'Urfantasy' we have, of course, several candidates, of whom Freud is, no doubt, the most prominent. But there are others whose findings appear to be equally revealing. As Freud's concept is so well-known, I should like to turn to the 'Urfantasy' propounded in the anthropology of Gehlen, although I am greatly tempted to substitute Castoriadis for Gehlen, because he considered the imaginary as the origin of all social processes. What distinguishes both Gehlen and Castoriadis from Freud in their attempt to postulate an 'Urfantasy' is the fact that they do not make the latter reel back into its antecedents, and so they avoid the pitfall of equating 'Urfantasy' with myth.

What Gehlen's idea of the imaginary as materia prima, how-

Kant - begins with minor stage (reengrowing who is not you)
-last half of the century is concerned with The Other

ever, has in common with the imaginary both as a faculty and as a creative activity is that it also comes to fruition through the difference inscribed into it. The relationship between the imaginary and the self on which Gehlen focuses did not seem to pose a problem to the phenomenological psychology advanced by Sartre. The self seemed to be a given when the workings of the imaginary came under scrutiny. Gehlen, however, maintains that there is no such thing as a self that can be presupposed or taken for granted. Instead, there is an 'Urfantasy,' which Gehlen also calls an état imaginaire,[10] whose all-encompassing state leaves the self in a form of semialienation. This alienation has to be overcome by lifting oneself out of it, thereby placing oneself in a different space and in a different time (p. 343). This means that the état imaginaire has to be split up, and the stepping out of it is directed towards otherness (p. 344).

There is no need here to criticize this postulate for our purpose, as we have accepted the imaginary equally as a faculty and a creative activity.

But why do we have to step out of ourselves? The answer given by Gehlen is that our instinctual system is defunct (p. 35), and therefore we are called upon by our urge for self-preservation to repair this deficiency. In splitting up the unstructured état imaginaire, fantasy allows the self to step out of this semialienation for the sake of establishing relationships with itself. Again, Gehlen asks, why do we have to do this? And he answers: Because man is under constant pressure to meet the challenge of his surroundings, to which he is no longer geared (p. 348). Therefore he has to project himself beyond what he is into a future, which entails an overcoming of the distinction between real and imagined situations. A challenging reality has constantly to be overlaid by projections. The prime reason for this operation is, according to Gehlen, the fact that man stands in need of a temporary deliverance from the demanding realities to which he is exposed. He requires this short-term relief (p. 38) because, whenever he acts, he projects a clear-cut intention into the future, and this intention assumes the character of reality for him, in consequence of which he is pushed into a position ahead of himself. In such constantly occurring situations he hangs between what he is at a

given moment and what he has reached out to be (p. 347). Such an activity places the self between what it has been so far and what its otherness will impose on it. This in-between state is not one to linger in; instead, it has to be acted out.

Transposing oneself into otherness in order to gain an experience of oneself triggers a movement of back and forth. This movement is indicative of the fact that the self is identical neither with its *état imaginaire* nor with its otherness, let alone with the oscillation operative between the two. Rather, the back-and-forth movement highlights the subject's self as a constantly shifting differential between *état imaginaire* and otherness. Furthermore, if the self appears to be a constantly shifting differential, it cannot be equated with a goal either, in spite of the fact that its kaleidoscopically changing features give the impression that it is on the way to becoming something. It emerges at any given time as a discrete entity, and it simultaneously articulates the back-and-forth movement which, in turn, is tangible only in the shifting profiles of the self.

This back-and forth movement is basically one of play,[11] which arises out of the split *état imaginaire*. The play-movement provides the possibility of transposing oneself into the other in order to establish shifting relationships with oneself. These relationships open the opportunity of a constant self-fashioning, which is first and foremost an attempt at both coping with and responding to the challenges of reality. Self-fashioning has internalized the play-movement by imprinting the assumed attitude of the other onto the self,[12] in order to anticipate what it might have to respond to in view of the unbounded openness of the world. Self-fashioning therefore results in a constant assuming and casting aside of shapes the self has acquired. In its dynamics, self-fashioning points to its antecedent, which is the unstable play-movement out of which it perpetually arises (p. 222).

This in-between state as an outgrowth of an initial splitting up of the *état imaginaire* is aesthetic by nature. And this is so mainly for two reasons: 1. Imaginary and conscious components neatly dovetail in the play-movement, even to the extent that both the instability of relationships and the structured play-strategies highlight their merger. Though instability may tip the balance in

favor of the imaginary, and the play-strategies in favor of the conscious, neither of them would be able to operate without the support or the countervailing direction of the other. Instability is basic to play, and opens up the space within which the back-and-forth movement operates. The play-strategies bear the imprint of the imaginary insofar as the constantly shifting relationships of the self with itself require a certain amount of inventiveness. Inventiveness points to the fact that the imaginary is molded by a conscious activity indicating that challenges have to be met. 2. A further reason for qualifying the in-betweenness as aesthetic is the fact that the play between the subject's *état imaginaire* and its otherness is highly volatile and thus calls for resolution. Whenever such resolution is brought about by establishing a relationship of the self with itself, be it in terms of self-experience, or in terms of obtaining consciousness of itself, the aesthetic evaporates.

However, it does not vanish totally. It inscribes itself into the act of self-fashioning insofar as each discrete entity of the self is nothing but a manifestation in the form of a perpetually moving differential between the self as *état imaginaire* and its otherness. Although self-fashioning is not in itself aesthetic, the aesthetic manifested in the back-and-forth movement is instrumental in enabling the shifting profiles of the self to emerge. If self-fashioning is an operation to be executed differently in each of its instances, the aesthetic, then, is not something in the nature of a substance, nor is it a mere nothing. Instead, it features the self as a graded transmutation of itself.

NOW, BEFORE we try to pinpoint the aesthetic in art, let us briefly summarize what we have arrived at so far. Irrespective of whether the imaginary is conceived in terms of a faculty, a creative activity, or an 'Urfantasy,' it is marked by a split. This split is not self-inflicted, but caused either by pragmatic needs or by conscious acts. Thus the imaginary is not a self-activating potential, and it would not become operative without its being split. The split highlights an interaction. In the case of the imaginary as a faculty, the interaction occurs between fancy (in Coleridge's use of the term) and data, or between the imagination and the laws of na-

ture, thereby reproducing within the human self an otherwise ungraspable totality.

In the case of the imaginary as a creative potential, the interaction occurs between consciousness and a posited imaginary object, resulting in ideation.

In the case of the imaginary as '*Urfantasy*,' the interaction occurs between an *état imaginaire* and otherness, resulting in graduated self-fashioning.

In each of these instances, however, the interaction assumes different shapes. This may be due to the fact that the interaction itself is to be identified neither with the imaginary nor with the various stimulating agents which both tap and channel the potential. As long as faculty is the overriding notion by which the imaginary is to be grasped, the interaction is a "wavering." When conceived as a creative activity, the interaction assumes "the role of possibilizing." And when considered as '*Urfantasy*,' the interaction is one of a back-and-forth movement, which is basic to play.

Wavering, possibilizing, and the *play-movement* arise out of different conditioned interactions, which are aesthetic by nature owing to their instability, their transience, and the transmutations effected by them. The aesthetic is differently cast according to the purpose for which it is to be utilized, and so each of these instances reveals a further dimension of the aesthetic as an in-between state. As an offshoot of the interactions outlined, its transitoriness is either frozen or shaped according to its use, so that the aesthetic evaporates in the very result it has helped to bring about.

So far I have deliberately tried to pinpoint the aesthetic in fields of reference outside the realm of art, in order to draw attention to the multifarious aspects it assumes according to the prevailing pragmatics by which it is cast.

Therefore, we must have a final glance at the aesthetic dimension in art, where both the production of the aesthetic dimension and its subsequent molding are epitomized. In this respect, Adorno's *Aesthetic Theory* is a revealing case in point, not least because Adorno is under no suspicion of privileging the aesthetic over the social sphere. A genuine work of art, Adorno maintains,

is permeated by a basic rift.[13] The rift resembles the split that marks the imaginary in all of the instances discussed. Moreover, the rift itself comes about by countervailing activities of the imagination owing to a dual function which highlights its workings.

In the first instance, the imagination operative in the creation of an artwork relates to the beautiful in nature, which it intends to reproduce.[14] Already on that level, the imagination is permeated by an intentionality that points to the fact that the imaginary and the conscious never exist separately from one another; they rather coalesce into a nondivisible alloy. In imitating the beautiful in nature, however, the imagination creates appearances which, in turn, feature the presence of something nonexistent. It is the hallmark of the artwork that it provides appearance for something inconceivable, thereby endowing a figment with illusory reality. The offshoot of this endeavor is, in Adorno's terms, *imagerie* (pp. 125, 128, 131), which he simultaneously qualifies as apparitions, in order to spotlight the illusory moment. Now, the *imagerie*, as the apparent surplus in relation to what there is, is bound to be decomposed when verbalized. Verbalization entails the exposing of the illusion inherent in the appearances, which feign something nonexistent as real. Therefore, the *imagerie* has to be destroyed (p. 131), and this is brought about by the countervailing impulse operative in the imagination—an impulse that embodies itself within the artwork as the decomposition of its own product.

The outcome of this inherent interaction between producing and negating operations is semblance, which, however, is highly duplex. Semblance[15] features both the punctured illusion and the illusion of an appearance of something nonexistent. The duality consists in the simultaneity of the mutually exclusive, which has arisen out of the countervailing impulses by which the imaginary is marked.

As an offshoot of the imaginary, semblance is aesthetic by nature, for its duality is not a resolution so much as a spotlighting of the rift by which the artwork is distinguished (p. 161). While semblance as the embodiment of the rift exhibits the nature of the artwork, it simultaneously gives rise to multiple interpretations of the world. The rift may indicate irreconcilability between the

— Marxism could not account for creativity

existent and the nonexistent. Yet for such a difference to become palpable, the semblance of reconcilability has both to be upheld and undone.

The rift may equally indicate that by yoking separate worlds together, a dynamism is unleashed that overshoots everything that is. Semblance, then, highlights the rift as a constant overturning of the positions assembled in the artwork.

In the first instance, semblance as reconciliation of the irreconcilable turns into a representation of reality. In the second instance, semblance epitomizes the rift as a matrix for the performative character of the artwork. Moreover, semblance is able to combine these two basic manifestations of the rift in the artwork. In its mimetic function, the rift represents the nonexistent within what is (pp. 129,138,188ff,200,219). To achieve this purpose, its performative function has to be activated, which entails negating the representative imagery in order to give presence to what eludes the mimetic grasp.

Semblance, then, is not so much a deception as a stimulating agent for a guided performative act. It is guided insofar as the mimetic aspect inherent in reconciling what seems irreconcilable maps out an orientation. It is performative insofar as the cancellation of what is represented points to a nonverbalized motivation, which underlies the apparent negation. And finally, it is an act insofar as something nonexistent is lured into presence—a presence, however, which remains inauthentic, as it cannot be backed up by or equated even with anything there is. Semblance, then, reveals itself as the gestalt according to which the aesthetic in the artwork is fashioned, and it is thereby thrown into relief against the other shapes of the aesthetic noted so far.

Yet semblance is at best an overriding category of the artwork by means of which the latter's aesthetic dimension is to be pinpointed. Therefore it only provides a framework within which we can observe how the aesthetic functions in art.

AND SO the question arises as to the constitutive features operative in semblance as a guided performative act. To answer that question, let us have a brief glance at what happens when we look at a painting. Strictly speaking, we perceive only an object

consisting of canvas and paint. Perception, we have to remind ourselves, entails the actual presence of the object to be seen. Canvas and paint, however, are not there for their own sake, but function as carriers of something they are not. The perceivable physical object pales into insignificance so that the *sujet* of the painting can emerge. The *sujet*, in turn, is not an object; it only assumes the appearance of one, and hence it is only a figment. Thus the perceivable object of the painting, and the figment made present, do not coincide; instead they begin to interact, and in doing so, they interchange their attributes. What can be perceived —the object of canvas and paint—dwindles to invisibility, and what cannot be perceived—the *sujet*—is endowed with the visibility of an object.[16] This interchange, however, does not eradicate the difference by which the painting is marked: rather, the difference is acted out in the painting. If the object to be perceived is both material and simultaneously the carrier for something to be figured—which is certainly not canvas and paint—then the duality initiates countervailing movements in the painting, the outcome of which is the following: the physical object to be perceived is toppled or overturned by the *sujet* which presents itself as if it were a perceivable object. However, the physical object, though toppled and overturned as regards its materiality, inscribes itself into the *sujet*, thus qualifying it as a mode of appearance. Now, the *sujet* as a seemingly perceptible object begins to topple and is turned into a phantasm. A phantasm bears the hallmark of not being an object—its form only provides guidance for the conceivability of something which it is not.[17] Therefore, the *sujet* does not represent perceivable objects; instead, it triggers projections, stimulates the production of symbols, and suggests analogies enabling the nonperceivable and yet conceivable object of the painting to come into being.

What does this interlinkage reveal? The materiality of the painting is made to topple in order for the *sujet* to emerge. The *sujet*, in turn, is made to topple in order to prevent it from being taken as a perceivable object. This mutual toppling—arising out of the basic duality of the painting as a perceivable physical object and carrier of something which it is not—reveals the aesthetic dimension as a generative matrix operative in the painting.

It prevents the figment from turning into a perceivable object, and makes the materiality of the painting dwindle to invisibility, just as it prevents the figment from turning into a hallucination by making the physical object encroach on what appears to be a seemingly perceivable object.

In order to corroborate this view of the aesthetic as a mutually toppling operation of whatever positions are brought together in an artwork, we only have to remind ourselves of what happens in the performance of the play. The reality of the actor as a human being is faded out and a phantasm is faded in. What we are watching, then, is a perceivable figment—perceivable insofar as the actor is a human being who stands for something else, thus turning into a phantasm. Yet we never perceived the phantasm as a hallucination, because the duality of the countervailing movement is ever-present. Whatever we perceive as objects is cancelled out and thus toppled, but simultaneously—owing to the presence of the actor as a human being—the seemingly perceivable figment does not assume the character of an object.

If the mutual toppling exhibits the inner workings of semblance, which, as a guided performative act, is an epitome of the aesthetic, then toppling or overturning may assume different shapes according to the function to be fulfilled. The question which now poses itself is: are these shapes always individual, or is there a generic coherence between these individual manifestations? If so, what could it be? The answer is *play*, as is to be observed in the literary text.

in - between as total

I HAVE described elsewhere a basic constituent of the literary text[18] which is the doubling effect brought about on different levels. By way of selection the text makes inroads into extratextual fields of reference, and by disrupting them creates an eventful disorder, in consequence of which both the structure and the semantics of these fields are subjected to certain deformations, with their respective constituents being differently weighted according to the various deletions and additions.

The items selected, however, function properly because they carry the outstripped fields of reference in their wake, according to which they now begin to unfold unforeseeably shifting rela-

tionships both with their old context and with the new one into which they have been transplanted. This turns the text into a kind of junction where other texts, norms, and values meet and work upon each other, thus opening up a play-space between the text and its extratextual references.

The same doubling effect occurs intratextually when the items selected are combined with one another. The words become dialogic owing to the grafting of a new meaning onto the old or lexical one. And a great many semantic fields are doubled by others, for instance, when the hero in a narrative crosses boundaries that mark off different semantic enclosures from one another.

A similar doubling effect and hence a play-space comes about through the literary text's disclosure of itself as fictionality. If the text reveals itself not as discourse, but as enacted discourse, asking only that the world it represents should be taken as if it were a real world, then the recipient is called upon to suspend his or her natural attitudes toward the thing represented (i.e., the external world). If we regard the world of the text as being bracketed off from the world it represents, it follows that that which is within the brackets is separated from the world in which it has been embedded. Consequently, there will be a continual oscillation between the bracketed world and that from which it has been separated. And whatever may be the relation between the two, it is the "as-if" world that brings about the interplay between them.

We need not go into further details as regards the doubling effect that occurs on various levels, other than to point out that it is marked both by a difference and by the attempt to overcome that difference. Thus, not only is a play-space opened up and a play-movement triggered, but also play itself is set in motion. Play turns out to be a basic constituent of the text, and it may be called a paradigmatic manifestation of the aesthetic as it makes the imaginary and the conscious coalesce.[19] Doubling occurs as a result of the conscious act on the various levels referred to. Yet the conscious act is unable to control totally what happens between the realms and positions split apart. Thus, the imaginary —basically featureless and totally arbitrary, as Husserl once qual-

ified it—is present as a constant modification of the realms and
positions split apart by conscious acts. In play they appear to be
totally intertwined, as in each ludic operation the conscious is
doubled by the imaginary, and vice versa, with the intrinsic ten-
dency of the one overturning the other. Play, then, could be
considered the generic manifestation of the aesthetic in the text.
It gives shape to the interpenetration of the conscious and the
imaginary.

Play, however, also has a pragmatic component highlighted by
winning or losing, which usually marks the end of play. When-
ever that happens the aesthetic evaporates, and so the question
arises: does it also evaporate in the literary text? Well, texts
comprise not only playing but also the games that are played.
Four basic types of gaming can be discerned in the text, and in
order to distinguish them I use the terms that have now become
standard in game theory: *agon, alea, mimicry,* and *ilinx.*[20] *Agon*
is a fight or contest, and is a common pattern of play when the
text centers on conflicting norms and values. *Alea* is a game based
on chance and the unforeseeable, its main textual thrust being
defamiliarization. *Mimicry* generates illusion, whether depicting
a world as if it were real, or—when punctured—turning that
world into a mirror-image of the referential world outside the
text. *Ilinx* is a game which subverts, undercuts, cancels or even
carnivalizes the various positions as they are played off against
one another.

Each of these games, when played by itself, issues into a result,
which terminates it. In a literary text the games are not only
multifariously combined with one another, but more often than
not played against each other. For instance, if *ilinx* plays against
or is combined with *agon*, there may be two possible types of
game: *ilinx* gains the upper hand, in which case the contest
between norms and values becomes illusory, or *agon* dominates,
and then the contest becomes more differentiated.

These strategies can even be inverted, playing against their
own underlying intentions. For example, *agon* appears to be di-
rected towards winning the game, but in postmodern literature it
is frequently used to play a losing game. The type of game played

in the text is certainly indicative of a pragmatic intention, yet the multiplicity of these games definitely prevents the pragmatics from gaining the upper hand.

Furthermore, the combination of games in the text can be played according to different sets of rules: in game theory they are called "conservative" and "dissipative" rules. With regard to the text, they may be called "regulative" (which function according to stabilized conventions), and "aleatory" (which set free whatever has been restrained by conventions). Aleatory rules apply to what cannot be controlled in relation to the positions mapped out by the game, whereas regulatory rules organize what the game intends to bring about in terms of hierarchical, causal, subservient, or supportive relationships. Aleatory rules unleash what regulative rules have tied up, and thus they allow for freeplay within an otherwise restricted game.

Thus aleatory rules are operative in particular when games are combined or played against one another in the text. And it is that type of rule, as well as the multifarious combinations of games, which keeps the aesthetic in the text from evaporating into a definite result. Thus the aesthetic—manifesting itself in the text as play, which can be played not only according to different types of games, but also, and even more significantly, according to a diversity of combinations—turns out to be a generative matrix of transmutations, which appears to be powerful enough even to overturn the respective meanings that are arrived at and only temporarily end the playing. The multiplicity of gaming comprises both difference and the attempt to overcome it. Play as a particular gestalt of the aesthetic comprises the coexistence of what is mutually exclusive, and it is able to do so because it is not subjugated to any definite pragmantic end. In the final analysis, the combination of games dissipates the pragmatic element inherent in gaming. And so the interconnected games of the text lead to a charting of territory which is at one and the same time precise and ever-changing.

Notes

1. *The Prose Works of Sir Philip Sidney III*, ed. by Albert Feuillerat (Cambridge: Cambridge University Press, 1962), p. 29.
2. In contrasting historians with poets, Sidney maintains "as in historie looking for truth, they may go away full fraught with falsehood: So in *Poesie*, looking but for fiction, they shal use the narration but as an imaginative groundplat of a profitable invention." Ibid.
3. See Sidney, p. 30.
4. For which, according to Sidney, "uttermost comming [cunning] is imploied. . . . And that the Poet hath that *Idea*, is manifest, by delivering them foorth in such excellencie as he has imagined them: which delivering foorth, also is not wholly imaginative, as we are wont to say by thē that build Castles in the aire." Ibid., p. 8.
5. See Samuel Taylor Coleridge, *Biographia Literaria*, ed. by J. Shawcross (Oxford: Oxford University Press, 1958), 1:202.
6. See ibid., pp. 61 and 64.
7. Samuel Taylor Coleridge, *Shakespearean Criticism*, ed. by Th. M. Raysor (London: Everyman's Library, 1967), 2:103.
8. Jean Paul Sartre, *L'imaginaire. Psychologie phénoménologique de l' imagination* (Paris: Gallimard, 1940), p. 17f.
9. Edward S. Casey, *Imagining: A Phenomenological Study* (Bloomington and London: Indiana University Press, 1976), pp. 205ff.
10. See Arnold Gehlen, *Der Mensch: Seine Natur und seine Stellung in der Welt* (Bonn: Athenäum, 1950), pp. 346ff.
11. For the intimate relationship between phantasy and play, see ibid., pp. 222ff.
12. Gehlen develops this idea in relation to George H. Mead's concept of the "generalized other"; see Gehlen, *Der Mensch*, p. 224ff.; see also Gerda Pagel, *Narziss und Prometheus: Die Theorie der Phantasie bei Freud und Gehlen* (Würzburg: Könighausen Neumann, 1984), pp. 84 and 87.
13. This is the underlying concept of Theodor W. Adorno's *Ästhetische Theorie*, vol. 7 of *Gesammelte Schriften* (Frankfurt/M: Suhrkamp, 1970).
14. Adorno, *Ästhetische Theorie*, pp. 110ff.
15. The notion of "semblance" looms large in Adorno's aesthetics, not least because it is endowed with multifarious and even contradictory meanings; see *Ästhetische Theorie*, pp. 129, 161, 163ff., 168, and 347.
16. For a detailed discussion of such an interrelationship, see Edmund Husserl, *Phantasie, Bildbewusstsein, Erinnerung*, vol. 23 of *Gesammele Werke*, ed. by Eduard Marbach (The Hague, Boston, and London: Nijhoff, 1980), pp. 28ff.
17. See Husserl, *Phantasie*, pp. 80ff.
18. See my essay "Feigning in Fiction," in *The Identity of the Literary Text*, ed. by Mario J. Valdés and Owen Miller (Toronto: University of Toronto Press, 1985), pp. 204–228.
19. For further details, see my "The Play of the Text" in my forthcoming

collection of essays, *Prospecting: From Reader Response to Literary Anthropology* (Baltimore: Johns Hopkins University Press, 1989).

20. These types of gaming were put forward and developed by Roger Caillois in *Man, Play, and Games,* tr. by Meyer Barash (Glencoe: The Free Press of Glencoe, Inc., 1961).

9
THE SEMIOTIC DESIRE FOR THE NATURAL SIGN: POETIC USES AND POLITICAL ABUSES
Murray Krieger

LITERARY HISTORY is hardly an insulated philosophical discipline. Commentators on its many historical moments cannot help but relate it to other expressions of the general intellectual climate and to those social-political forces that help produce that climate. Yet I suggest that literary theory, because it is explicitly concerned with the intricate workings of language, may play a special role in revealing the semiotic ground for the philosophical structures that—at various moments in its history—it shares with other discursive modes, thereby serving as a primary entry for our understanding of those structures and their hidden motives.

I am going to propose some broad—but I hope not too easy—analogies between the more or the less repressive tendencies in the prescriptions of literary theories and the more or the less repressive tendencies in the philosophical (and, by implication, the social-political) attitudes that may be seen as sponsoring these theories. Behind these analogies are some suggestions about the ways in which the myth of the so-called natural sign—or at least our semiotic desire for the natural sign—has been encouraged to function in the aesthetic realm in order to help promulgate claims for natural-sign legitimation outside the realm of art. The myth and the desire, once embodied for us in art, are to encourage the claim of being authorized by "nature" to function in the "real" social-political realm, which is to say, in those other, power-imposing discourses that—nevertheless—may take their semio-

tic habits from those sorts of texts whose objectives seem predominantly aesthetic.

What I call our semiotic desire for the natural sign is a reflection of our ontological yearning: our anxiety to find an order or structure objectively, "naturally," "out there"—beyond society as well as ourselves—to authorize the signs and forms which our subjectivity projects and which we then want (nay, require) others to respond to and acknowledge. It is an anxiety exploited by all holders of power and bearers of doctrines which they seek to impose through the claim to a natural authority. This attempted imposition so often succeeds because it meets and satisfies our semiotic desire for the natural sign, as it confers the special privilege of nature upon the conventional—and arbitrary—signs dictated by various motives, most of them suspect. These are the signs that, however deceptively, function for a culture as its "nature"; signs that are extrapolated in order to be insisted upon as everybody's "nature," and to be thus acknowledged universally.

I see the arts, in their illusionary character, as leading the way to the culture's cultivation of its signs as "natural." It was this illusionary objective for the arts (mimesis in its most extreme, and innocent, sense) that made the arts of sculpture and painting, intended—presumably—as transparent representations of, or even as substitutes for, "real" objects, the model arts for the other arts to emulate. The primacy of the visual in Plato led, in his followers, to a "visual epistemology"[1] that would have the arts, in their mission to function as natural signs, aspire to the trompe l'oeil. In other words, the arts, as would-be natural signs, were to seek an ever closer resemblance to their referents (their "originals in nature," the eighteenth century would say), a semiotic accord that would approach equivalence. And, through much of the earlier history of aesthetics, even the verbal arts were encouraged —as best they could, despite their conventional and arbitrary materials—to join in this illusionary mission.

It would seem to be a strange and severe requirement to insist upon for the verbal arts, though from their earliest days critics found one kind among these arts—the dramatic—that could emulate the more "natural" nonverbal arts, the visual arts, in its apparent dedication to the natural sign. Indeed, the very mimetic

arguments that called for such emulation—arguments fashioned in accord with the unproblematic resemblances to their objects found in sculpture and painting—could serve to raise the drama beyond those very plastic arts in its capacity to produce the illusion of "reality." The drama, with its flesh-and-blood creatures—rather than unmoving replicas in a lifeless material medium—constitutes signs that far more closely resemble the living world beyond, far more easily fool the more naive among us, than sculpture or painting does. We can say with Lessing that drama is more faithful than the spatial arts to our invariably temporal experience, since it presents "moving pictures" instead of still pictures. (Indeed, in the captivating spirit of the illusion we could go further and say that drama presents not pictures at all but the persons and things themselves.) Nevertheless, for Lessing, as for most of those stretching back from him to Plato, there was little questioning of the arts' generic pictorial intent.

The need to link the verbal arts to the obvious arts of visual illusion narrowed the range of what could be represented in the drama as the one explicitly visual verbal art. The restriction of represented objects to the visible was thereby also a restriction of them to natural signs. If, then, all the arts, and the dramatic art preeminently, were only to be illusionary—"airy" embodiments of nature—then the arts were to fool us, to trick the eye, showing the way to all discourse that was to parade its claims as if they were naturally authorized—and they alone—to the exclusion of all other claimants. In this way the arts could serve the ambitions of ideology in its quest to dominate, so that even the verbal arts, at least in their dramatic form, could be emblematic of the illusionary function of would-be natural signs in a culture that would use such signs to authorize its repressiveness.

Thus, I will argue, many literary theories since Plato have put forth drama as our most restrictive literary genre, to correlate with the tightest of those discursive institutions of which it is to function as an aesthetic representation. The drama, I have suggested, seems the most restrictive in that it is the most "natural" of verbal genres, the verbal genre most rigorously tied to the "natural sign," so that it overcomes the arbitrary stuff of its composition. It is the literary genre whose fictions most nakedly seek the status of

natural-sign representation. Throughout the history of literary theory, critics have distinguished drama by this special representational character that they see in it, in contrast to narrative and lyric genres. Since I have dealt elsewhere at length with the history of dramatic theory (from Plato and Aristotle through Lessing by way of French seventeenth-century theory) as a different and specialized—often privileged—variety of literary theory, distinguished from that of nondramatic genres, I will simply summarize here the consequences I draw for my argument from that history.

From the first, the privileging difference between drama and the other literary genres was grounded in the distinction between what was thought of as "real" (that is, sensible) representation—in effect, a natural sign—and intelligible (merely verbal, and thus mentally mediated) representation, carried by conventional, though only arbitrary, signs. Once Plato, in Book 3 of the *Republic*, narrows his meaning of poetic "imitation" so that it applies only to drama (except for here and there—in passages of actual quotations—in narrative), we have in literary theory a difference between those representations of people in action by people in action (that is, by actors masquerading as characters who represent people), and those representations of people in action by words spoken or written by a single speaker or writer. In effect, it is the difference between actions we are allowed to witness and actions about which we are being told. The actors stand as natural signs in their semiotic relation to their characters (who stand as natural signs, thanks to the actors, in their semiotic relation to "real" persons), while a narrative voice, spoken or written, only supplies the words that our minds must convert to the actions we seek inwardly to see.

Drama, in other words, is the only true verbal "imitation" (in this narrow sense), if we are speaking of the literal mimicking of persons in real life. (Of course, Plato reverts to his more usually expanded notion of imitation elsewhere in the *Republic*, although the ghost of this literal notion persists, here and in other dialogues, especially because it makes the parallel between poetry and painting or sculpture so workable.) I have shown in detail elsewhere that the specialness of the dramatic mode of represen-

tation sets in motion, from Aristotle onward, a poetics of drama set apart from poetics at large; and it is a poetics that remains privileged so long as painting and sculpture, as natural-sign arts, remain the model for poetry to seek to emulate: so long, in other words, as the mimetic aesthetic remains in force and the notion of the mimetic is taken narrowly and literally.

The literal restriction of "imitation" leads to a highly exclusive regulation of the drama: only what is visually representable can be represented. The natural sign is to be a transparent sign, transparent and thus immediate to the senses. The stage can represent only the limited things that can be shown, in contrast to the almost unlimited things that, by way of narrative, can be told. Since, however, for Aristotle, compactness, efficiency, and exclusion are prized aesthetic virtues, it is not surprising that those unrepresentable marvels or wonders admissible in the epic are not only outside what is permitted the drama, but their inclusion in the epic—for all their wonder—helps make the epic a genre inferior to the pristinely exclusive drama. In the ambivalence of chapter 24 of the *Poetics*, Aristotle adopts Plato's equation of "imitation" with impersonating another's speech and attributes unqualified imitation to drama alone among the verbal arts, but he thereby cuts drama off from the representation of anything that is not, in more than one sense of the word, "sensible." The narrative poet, whose represented persons are not seen, may indulge fantasies that could not be brought onstage or, even if they could, would appear ludicrous. Though Aristotle thus bequeaths to Renaissance theory the notion that the marvelous or wonderful (what Renaissance critics also constituted as the "admirable") is the proper end of epic, he means no elevation of the genre by it. The drama dare not be monstrous (that is, dare not include the representation of monsters as the unreal) in so rigorously formalistic a doctrine. Instead it was to exclude all that was not, without strain or absurdity, representable onstage.

Renaissance theorists, thanks in large part to their neo-Platonism, read the wonderful and marvelous more favorably. They looked to poetry to represent those things that exceeded the domain of sense and hence of sensible representation, and thus, because of epic's power to do so, elevated it over drama. On these

grounds, which raised the epic to becoming the model literary art, they could even encourage Renaissance dramatic practice to emulate the epic by expanding into the monstrous the limits of what might be represented onstage. The pursuit of the wonderful was part of the Platonic rejection of the sensible for the intelligible, and with it the abandonment of the limited natural sign for the free realm of the arbitrary; for it marks the transcendence of the finite picture by the infinite potentialities of the word.

We see an exemplary version of this theoretical transformation in Jacopo Mazzoni's defense of Dante's *Commedia*. The attack (Bulgarini's) against which he formulates his defense charges that Dante's visionary poem eludes the world of palpable action, the realm of human history, in order to indulge the private phantasms of his mind. This line of attack permits Mazzoni to reformulate Plato's distinction between the *icastic* (now seen as limited to the external world of the senses) and the *phantastic* (now seen as the mental images limited only by "the caprice of the artist"). Despite his Platonic objective, Mazzoni writes as a proper Aristotelian, though in an inverted way, in his preference for narrative over drama on the grounds that narrative, with its unseen actions, is the more appropriate instrument of the phantastic, while drama, controlled by the sensible limits of the stage, is the more appropriate instrument of the icastic. Following upon Aristotle's suggested distinction, Mazzoni could allow the drama to be concerned with the sensibly representable, while reserving for narrative the freedom to explore the domain of the wonderful without worrying about credibility, since, composed of nonnatural, supersensible signs, it appealed to the intelligible. And in the Platonic hierarchy this could be a transcendent virtue. Hence the phantastic could be inscribed in narrative without concern for the constraints that dramatic representation inevitably carried within itself.

Mazzoni is therefore theoretically comfortable about defending the *Commedia*, since for him the defense of narrative of the most promising sort is one with his defense of the phantastic, a free-ranging domain well beyond the mundane (icastic and thus mimetic) restrictions indigenous to the drama, even the stretched versions of drama permitted in the Renaissance.[2] In that comfort-

able relationship between his theory and the work used to demonstrate it, Mazzoni is in a more fortunate position than Lessing much later was in his *Laokoon*. Especially as we compare Lessing's statements there to what he says in several other places, we find a certain theoretical embarrassment accompanying the *Laokoon*. For in that treatise Lessing has to construct his argument by constant reference to the epic, even though his major claim— that poems must use their arbitrary signs to persuade us of a status that appears like that of a natural sign—must rest upon his appeal to the drama, which he elsewhere does acknowledge to be the one poetic form that approaches being seen as a natural sign. Despite the similarity in the two theorists of the Aristotelian (based on earlier Platonic) grounds for their distinction between drama and narrative, we see that Lessing must return to the primacy of drama in his desire to return to the sensible realm of the natural sign.

But Lessing's distinctions, and his preferences within them, are recognizable as the other side of Mazzoni's. (And by now we have traced a series of these distinctions that slide into and support one another. I now summarize the series:) In both critics it is the conjunction of the *sensible* with the *natural* sign, the *icastic* as the *representable*, that both enables and tightly limits the functioning of the *drama;* on the other side, the *intelligible* is conjoined with the *arbitrary* sign, the *phantastic* as that which is sensibly *unrepresentable*, which permits the freer realm of *narrative*.

In the Renaissance the one cross-over between these opposing pairs occurs when, because of the primacy granted the epic as the model literary art, the drama is encouraged to expand its own restrictive bounds in the direction of what would have been considered unrepresentable—in the direction, that is, of narrative inclusiveness. This violation of narrow criteria for dramatic propriety is hardly surprising when we consider the contempt for the enclosing finitude of the sensible that the Renaissance inherited from Plato. So long as the sensible defined the limits of drama as would-be natural sign, neo-Platonic critics would elevate the narrative over drama.[3]

If we use Mazzoni as our exemplary Renaissance critic, we see

this favoring of narrative as an appeal to a freedom of vision over
the icastic-dramatic imitation-as-limitation: it is, if only sublimi-
nally, a political appeal. And the liberalizing of literature, by the
move from the sensible to the intelligible—through the attempt
to represent the unrepresentable—permitted narrative benefits
that were now, by extension, to be bestowed upon a loosened
version of drama that might now indulge its own monsters. Clearly
what is implied in this political trope is an image of drama as an
over-regulated body politic in need of liberalizing, if not of revo-
lution: in need of being free of its bondage to the limited world of
sensible representation. (I am reminded here of Pope's defense of
Shakespeare's irregularities against legalistic criticism, in the
preface to his edition of the plays more than a hundred years
later: "To judge therefore of Shakespeare by Aristotle's rules is
like trying a man by the laws of one country who acted under
those of another.")

It was this broadening of the criterion of what was includable
in the drama that prompted—as a reaction against it—the ulti-
mate restrictiveness of French seventeenth-century dramatic the-
ory, which rejected as monstrosities any extension of a minimal-
ist notion of the representable. Not only does that purest of
theoretical moments return to the restrictions of the sensible world,
but it shows us the farthest and most literalistic version of drama
as a would-be natural sign, caught within the narrowest limits
upon what is taken to be representable, upon what is to be shown
onstage. It thus puts forward the most extreme identification of
the natural sign with the sensible sign (by implication leaving for
Platonists the opposing identification of the arbitrary sign—as
supersensible—with the intelligible sign).

Clearly the intention of the French theorist was, as much as
possible, to reduce represented time and space onstage to the
realities, the empirical limitations, of the time and space of the
audience in the theater. Claiming that any lapse in time or shift
in place would violate the play's credibility for any spectator
(who had neither moved in space nor had the continuity of time
disrupted), the theorist was, in effect, asking for the play to be
seen as if it were a real event. In other words, he was asking for
all "unreal," "unnatural," merely conventional elements to be

suppressed, all the elements that might encourage us to see the play as only play and the actors as only actors.[4] The neoclassical desire to eliminate gaps or leaps led, in its extreme French form, even to the admonition that there be a liaison between scenes by keeping a character onstage. For discontinuities in time or space are only "unreal" dramatic conventions, running counter to "nature" as we observers are experiencing it.

The objective, then, is to force the represented life onstage to imitate the conditions of the empirical life of those witnessing it in the theater. In effect, it is to allow the drama to move beyond being a fictonalized imitation or a conventionalized representation of actual events; it is to allow the drama to be mistaken for actual events. It is, in short, to make the drama into nothing short of a natural sign, if not to make us believe in the drama as nature itself. (This is the theoretical intent, even though, ironically, in practice it creates an extreme version of dramatic artifice and conventionality, as critics of this drama, like Dryden and Johnson, never tired of pointing out.) Here is the ultimate realization of Plato's original effort to reduce dramatic *mimesis* to total deception, a natural sign that functions as an emblem of the deceptions (in the metaphysical deprivations) of the natural world.

But the purity of seventeenth-century French theory rebounds on itself. The severity of the restrictions upon what may be shown onstage leads, not only to dramatic conventionality, but—even more self-defeatingly—to the need for actors to tell one another a great deal of the action taking place offstage, so that they (and we) may know what must be known. In other words, the exclusions by the dramatic form result in necessary intrusions by narrative. And there is an inverse proportion between the dramatic and the narrative: the tighter the restrictions on what the drama can show, the more frequent and fulsome the narrative intrusions. Hence the irony of this theory in its inadvertent consequences: where its demands serve the purity of the dramatic genre and the natural-sign aesthetic, they produce the very conditions that lead to the impurities of mixed genres (*genera mixta*) in an appeal to the arbitrary signs of narration.

It is a self-defeating paradox: the narrative is a subversive force that intrudes itself just where the impurities it brings are most

forbidden. The exclusionary extreme permits—nay, requires—the very uninhibited inclusions it would repress. In this way even the drama, as the tightest of genres, becomes subject to the Bakhtinian carnival, the *heteroglossia* that Bakhtin himself reserved for the mixed genre (or antigenre) of the novel. Through exclusion, pressed to its limits, the drama must let *everything* in, if only through the back door of narrative, to disfigure it. There may even be a place for the "wonderful," and thus the unrepresentable, carried to extremes in the Renaissance antigenre of the romance, as the drama is forced to concede that the unrepresentable may be able to find a mode of representation for itself after all, though beyond the realm of the natural sign. The drama, as minirepublic, must yield through its own devices to the threatening, disruptive force that, far from being excluded by the form, breaks it open.

From this theoretical perspective, drama, required to be repressive if it is to satisfy the interests of order and generic neatness, invites in what it would repress. Surely the political trope beckons: by making its claims in the name of the "natural," as an emblem of the natural sign, drama may also be seen as reactionary—or at least as being put in the service of a reactionary aesthetic that is itself in the service of a reactionary social structure in search of being legitimized as "natural" and thus as unassailable. Drama thus stands in need of being rescued by that which destroys the purity of genres: the narrative intrusion that, as intelligible rather than sensible, functions as a Platonically sanctioned freedom from the distorting limits of the *merely* sensible and representable, in order to pursue the visions of the capriciously unpredictable mind. The phantastic, unrestrained by dramatic propriety, breaks out of the repressive limits of the natural sign—withdrawing from the "nature" to which Plato's condemned "mimetic tribe" would bind the sign—to let loose the arbitrary sign that indulges the intelligible realm, the realm of dream, whether nightmare or, as in romance, of the nightmare overcome.

AS MANY seventeenth (and early eighteenth) century theorists demonstrate, however, there are strong conservative forces, fearful of the threat from an untamed caprice in the poet's mind and

blind to the futility of their mission, that would continue to work for the natural-sign aesthetic and, with it, for a *mimesis* that is unaware of the naiveté of its unquestioning pursuit of semiotic fidelity. As I have suggested, these conservative forces reveal themselves not only in their literary and aesthetic affiliations, but also in their philosophical attachment to a dogmatic Realism and —behind this—in their social-political commitment to an inflexible notion of order.

Now the theoretical pressure to establish the authority of "nature" and the natural is never innocent (merely aesthetic)—not metaphysically innocent and, more insidiously, not politically innocent. Behind the effort to convert the humanly created sign into an immediate surrogate for the objective natural truth is, needless to say, the ontological dependence on an unchanging, transhistorical, universally available external reality. That dependence arises from our confidence in that firm, spatial structure out there, whose solid objects, as objects of imitation, authorize their imitations while assuring them their lesser, secondary status as mere appearances, to which, since Plato, we have habitually condescended. Still, a natural-sign art validates nature for us as an ontologically grounded authority to which all our activities and languages are referred for sanction. Nature, then, is both archetype and objective, the origin and measure of its illusive representation.

We have a prideful confession of this position in its extremity in Alexander Pope's well-known injunction to critics (in his *Essay on Criticism*, 1711), with implications that are obvious for poets as well:

> First, follow Nature, and your judgement frame
> By her just standard, which is still the same:
> Unerring Nature, still divinely bright,
> One clear, unchanged, and universal light,
> Life, force, and beauty, must to all impart,
> At once the source, and end, and test of Art.

The "still" confers permanence, a rootedness to regulate whatever humanly contrived flowers we may seek to manufacture. Under such dispensation the prescribed principles for poetic

making are *found* in the order of things as necessary, and not
arbitrarily invented by human caprice: "Those rules of old dis-
covered, not devised,/Are Nature still, but Nature methodized."
The rules are summoned in imitation of the natural order; they
are discovered *in* the natural order, and convert that order into
literary method. Thus these discoveries permit us to transcribe
nature's method into our discourse. Indeed, most of those treated
in my survey so far, in reducing the order of signs to "nature
methodized," have sought, by conversion, to make theirs into a
method naturalized.

Consequently, Pope tell us, when the poet (e.g., Virgil) seeks to
copy nature, he finds himself doing again what other poets (e.g.,
Homer) have done before. ("Nature and Homer were, he found,
the same." What follows? "Learn hence for ancient rules a just
esteem;/To copy Nature is to copy them.") Since Nature has been,
is, and remains "still the same," "still divinely bright," a natural
sign is a natural sign is a natural sign, referable immediately to
nature. With nature so constant a referent, the signs that would
represent nature must resemble one another. One can only redis-
cover that which has been discovered: there can be nothing new
under the sun any more than the sun can itself be new.

The critic, then, may well creep behind the scientist, subject-
ing the discourse in his charge to the order displayed by scientific
discovery. It is no wonder that Aristotle, primal scientist ("natu-
ral philosopher"), was accepted as the critic to tame the poets:
they "received his laws" because they were "convinced 'twas fit,/
Who conquered Nature, should preside o'er Wit." And nature as
a total—and totally explicable—order could be revealed in its
completeness and without aporia by the scientist-metaphysician.
To the nonscientist, the foolishly prideful layman, these laws, as
organizational principles for all that is, may not be understood,
but—in the first Epistle of his *Essay on Man* (1733)—Pope takes
on the role of the all-revealing scientist-metaphysician who makes
the order clear.

This Epistle represents the ultimate act of methodizing nature
and naturalizing method. Following the instructions given in the
Essay on Criticism, Pope has become the master-critic of the
masterwork of art of the Primal Artist.[5] Viewed this way, the

concluding couplets of the first Epistle are perfectly reasonable, indeed inevitable:

> All Nature is but Art, unknown to thee;
> All Chance, Direction, which thou canst not see . . .

In such a perfect spatial structure, characterized by the totalizing metaphors of the Newtonian world-machine and the great chain of being, the impulse toward change is the major antagonist, instigated at once by human pride and metaphysical error. There can be no errant particulars wandering free of their home in the all-inclusive universals of the "universal frame." This frame, of course, must be conceived as utterly immune to historical contingency. Indeed, how could any metaphysical structure be conceived in which history was more completely ignored, or more irrelevant, in which time was more unqualifiedly the enemy of the unfettered spatial imagination?

One need not press this spatial language, or its metaphysical construct, very hard before sensing its social-political implications. And in the social-political may we not perhaps find a motive for the aesthetic and the metaphysic (really the aesthetic *as* the metaphysic, or the metaphysic *as* the aesthetic) rather than the consequence of them? The rule of absolute stasis is an indispensable ideological ground for a society whose hierarchical character was to be fixed. Hence one proclaims a structure—apparently metaphysical, though founded on aesthetic norms and hiding political compulsion—whose perfection had a place for all things, but, more importantly, sought to keep everything in its place.

> Vast chain of Being! which from God began,
> Natures ethereal, human, angel, man,
> Beast, bird, fish, insect, what no eye can see,
> No glass can reach; from Infinite to thee,
> From thee to Nothing. On superior powers
> Were we to press, inferior might on ours:
> Or in the full creation leave a void,
> Where, one step broken, the great scale's destroyed:
> From Nature's chain whatever link you strike,
> Tenth or ten thousandth, breaks the chain alike.

At moments the political significance of the language becomes explicit and the metaphors literalized ("On superior powers/Were we to press, inferior might on ours"). The price of any aggrandizement of power is a blurring of spatial distinction which threatens to explode the entire structure.

> And, if each system in gradation roll
> Alike essential to th' amazing Whole,
> The least confusion but in one, not all
> That system only, but the Whole must fall.
> Let Earth unbalanced from her orbit fly,
> Planets and Suns run lawless through the sky;
> Let ruling Angels from their spheres be hurled,
> Being on Being wrecked, and world on world;
> Heaven's whole foundations to their centre nod,
> And Nature tremble to the throne of God.

It is the ambition to achieve power ("superior" power) beyond one's station that so darkly threatens the metaphysical-aesthetic order, now revealed to be a political order. ("All this dread Order break—for whom? for thee?/Vile worm!—Oh Madness! Pride! Impiety!") As always in this vast, machine-like structure, the similarity among the operational principles that govern its many parts and subsystems permit the rule of analogical argument to go unchallenged:

> What if the foot, ordained the dust to tread,
> Or hand, to toil, aspired to be the head?
> What if the head, the eye, or ear repined
> To serve mere engines to the ruling Mind?
> Just as absurd, to mourn the tasks or pains,
> The great directing Mind of All ordains.

It is obvious that Pope has, on Nature's sublime and unquestionable authority, raised the status quo—the notion of place as a permanent station—to an absolute and universal principle that holds equally, through analogy, in all areas of human activity. As in the neoclassical idea of drama, the spatial structure is so complete, so perfect, in its fixity that no change can be permitted in the disposition of its part without leaving an unfillable gap that would undermine its working altogether. There can be no unau-

thorized movement, no slightest alteration, that is other than utterly subversive, producing the explosion of total revolution.

This doctrine clearly is a politically convenient one for the protection of a static, hierarchical social order, though its appeal to the sanction of nature as god ("The great directing Mind of All") invariably rests on a secure metaphysic whose only justification seems to be a spatially complete aesthetic construct controlled by a system of analogies. Once human thought projects nature as a perfect work of art, made by the Sublime Artist, to be interpreted by the scientist-critic, a system of signs has been constructed which denies the contingently historical conditions of its creation by declaring the system "natural" and necessary rather than conventional and arbitrary. The ideal spatial structure need suffer no modifications from the human realm of temporality. Indeed, if nature is conceived as a perfect work of art from which the possibility of all chance or change has been removed, then how could any humanly created sign presume to be other than a natural sign? Instead, it must seek, through imitation, to attain that status of a natural sign, a sign authorized by nature to create human institutions and—despite our own understanding of this genesis—not the other way round.

It was Dr. Johnson himself who, in opposition to such dogma, pointed out the extent to which human artifacts, and the rules that govern them, are subject, not to nature, but to the conventional—and even the merely nominal—character of human invention.[6] In distinguishing human institutions from nature, Johnson implicitly makes the extension from the aesthetic to the political. For example, in his blistering review of the Soame Jenyns treatise he warns against the dangers of succumbing naively to the semiotic desire for the natural sign: he attacks the outrageously callous claim that the several economic levels of a largely suffering humanity are justified by the permanent laws of nature which uphold the great chain of being and the immutable, unquestionable demarcations between its links.

As Johnson's critique indicates, the naive rationalist's appeal to the universal hegemony of nature, as the all-controlling out-there, occurs within an invented narrative that repeats the myth of the natural sign. There is no room in this "nature," transcen-

dent protagonist of this narrative, for the constructive (*and* oppressive) role of human institutions and the transforming role of history. At a later historical moment these institutions and the sense of history's role were to undo the dogma of a free-standing nature and have it reduced to themselves. From this perspective, the universal nature, "which [for Pope] is still the same," is never again the same: it not only was changed but was itself made to disappear by reductive concepts that new historical circumstances brought into play.

What we call "nature" thus comes more and more to be deconstructed into a mirror of our own historically conditioned selves, of our desires, and our desire to validate those desires by grounding them in an objective nature out there. But, in the words that Shakespeare, that sublime deconstructor, applies to everything except transcendent love, our several conceptions of nature—far from spatially secure—turn out to be "subject to Time's love or to Time's hate,/Weeds among weeds, or flowers with flowers gathered" (Sonnet 124). They are thrall to "policy, that heretic/Which works on leases of short-numb'red hours." Nature, untransformed by love, is thus reduced to being politically "subject" to time's caprice, *its* politics. Such political insecurity, awaiting destruction and replacement, is seen in "Time's fickle glass, his sickle hour" (Sonnet 126): a concept of fragile, temporary nature that self-destructs under the pressure of its own temporal character. This pre-Popean view of history's deconstructive and reconstructive power comes to be revived and institutionalized in the historicizing of our concepts of nature in the past two centuries.

Once nature is thus relativized so that it loses its ontological grounding, it can of course serve no longer as the fixed referent for a natural sign. And the natural sign, no longer authorized, will be consigned to the realm of myth and will give way to the conventional sign. There is a lengthy history of the different semiotic and—consequently—the different aesthetic that a less dogmatic view of nature permits. Even more than language, art as a human construct can emphasize its character as a *made* object, product of men and women, themselves products of history and its institutions: it must be seen as consisting of conventional rather than natural signs.

We have seen how, as the ultimate extension of the natural-sign aesthetic, the most tightly neoclassical formula for drama cannot avoid undermining itself, proclaiming its own artificiality in the midst of its claim to naturalness, and breaking its form, mixing its representational modes, in the midst of its quest for an austere purity. With narrative as the antagonistic intruder that it has invited in, the very restraints that the drama has imposed on itself leads it to expose its artifice, its awareness of its own failed deceptiveness, its consciousness of the doubleness—and unreality—of its illusionary pretensions.

If we have sold ourselves on the myth of the natural sign, we can view the drama, in light of its peculiar representational character and its peculiar theoretical history, as the example *par excellence*—indeed as the allegory—of how the natural-sign aesthetic could turn its deceived worshippers into willing victims of the temptation to convert aesthetic illusions into delusions of the real, the natural. It thus can be seen as a leading agent in creating an accommodation between the doctrines of a culture and those who are persuaded to accept them as part of a naturally sanctioned system. One may see the drama—and, through it, the natural-sign aesthetic itself—as being put to shrewd use by the dominant culture: the illusionary naturalization of the literary sign is to lead the way to the naturalization of other, less persuasively illusionary signs that the culture would impose upon its members. Indeed, in our time Brecht saw drama this way; for him this imposed naturalization, which would seize and take in the audience—and take them in politically through taking them in aesthetically—led to a call for a theater of alienation, a theater that forces the audience to emancipate themselves from being dominated by the natural sign in drama and, consequently, by the natural sign in the social-political realm. An alternative to illusionistic drama is seen as a political necessity.

But we have seen, in spite of the tightest version of dramatic theory as would-be natural sign, that its view of drama is driven to undo *itself*. So, besides what I have described as its coercive function, the drama, through its inevitable self-contradictions and self-exposure, also helps the aesthetic to produce its own model corrective that should produce a resistance to being taken in by

the myth of the natural sign—in society as in art, though thanks to art. Its dependence on—despite its avoidance of—non–natural-sign representational forms such as narrative forces the drama to disclose its own conventional (and arbitrary), and other-than-natural, character. Consequently, the drama's consciousness of itself as merely a representation—emptily mimetic—and not the thing itself reveals the illusionary character of the aesthetic sign's *apparent* ("as if") pretensions to be a natural sign and stands as an emblematic warning against all claims to natural authority.

Not long after Johnson delivered the ultimate and devastating critique of the natural-sign aesthetic in the form given it by dramatic theory in its strict, neoclassical version, that aesthetic was abandoned in its naiveté. It is an unhappy consequence (for I think it is no mere coincidence) that, once the natural-sign aesthetic is displaced, the drama itself appears to suffer its own decline among competing literary genres, as a newer theory authorizes a semiotic that privileges other kinds of verbal representation, mainly the novel and the lyric. However, as we shall see, this theory will come to justify these genres as alternatives to the apparently natural signs of the drama by using a formalism to objectify the individual text, and thereby find only another way of achieving an illusionary naturalization of its conventional signs. So, despite the disclaimers about the aesthetic of natural signs, it is the attempted naturalization of the literary signs by formalism that, still addressed to our semiotic desire for the natural sign, would continue to put art to work as a persuasive agent in doing the coercive work of its culture. However different in its appeal, this theory may also be traced back to political sources or forward to political consequences—though, as with natural-sign theory, there will be an unsettling rebound produced by the stubborn resilience of literary signs.

WE CAN find ample precedent in earlier criticism for theory that would not be primarily concerned with the mimetic representations of spatially defined external objects and with the natural-sign status of those representations. This alternative theoretical direction remained a minority strain for many centuries, but it does constitute a tradition to be joined and extended by those

who return to it in the late eighteenth century. Indeed, we can trace that tradition back to Longinus as one that changes the conditions on which we would characterize the several arts as either natural or artificial. As we have observed, those conditions were set for critics ever since Plato conceived language as an aesthetic medium that threatens to be an arbitrary and conventional intervention upon arts whose nature it was to prize the immediacy and naturalness of an unimpeded visual representation.

In an important passage in *On the Sublime*, however, Longinus appears to reject the equation of language with the other-than-natural, the arbitrary. He suggests, indeed, that it is language alone that has the claim on naturalness. Late in his argument on behalf of flawed greatness in preference to moderate perfection (chapters 33–36), Longinus associates perfection with art and greatness with nature: "... in art the utmost exactitude is admired, grandeur in the works of nature." He goes on to insist "that it is by nature that man is a being gifted with speech," so that the verbal arts must reach toward grandeur ("in discourse we demand . . . that which transcends the human"). Presumably those arts (like the plastic arts) which require the employment of implements external to ourselves—and the training, knowledge, and decision to use them—derive from artifice rather than nature, the latter being the source for language and hence for the language arts.

We must observe, in what seems to be a reversal of the way nature relates to the verbal arts on the one hand and to the plastic arts on the other, that Longinus is talking, not about the resemblance between artistic representation and its object, but about the sources of art-making—in the natural gift of language for the verbal arts or in the manufactured artifact for the plastic arts. The natural-sign art, when the arts are viewed as representation, is different from the art considered closest to nature when the arts are viewed as modes of expression. In the latter consideration— that of Longinus and those who later take up the Longinian tradition—it will follow that drama is a far less appropriate literary kind than those verbal arts that are the external (and "natural") expression of a single internal voice.

There is an attempt to expand and systematize these notions in the treatise on the sublime and the beautiful by that Longinian, Edmund Burke, who insists that the language arts have a special hold on our emotions, our inner reality, in contrast to the visual arts, whose power was limited to exact, if unmoving, reflections of outer reality. Burke emphasizes poetry's effects on the audience or reader rather than its expressive relations to its author, but still his thrust is familiar. In the work of Schiller we can trace a systematic development of this subjectivity of the "natural" and the privileging of the verbal-intelligible over the visual-sensible.

A more explicit statement of this claim occurs late in this tradition when, in his *Defence of Poetry* (1821), Shelley also privileges lyric poetry among the arts because of its "natural" relation to its author as an immediately expressive vehicle for his internality. This relation can be traced to poetry's intimate alliance with the imagination, "whose throne is curtained within the invisible nature of man." Inner human nature supersedes external nature as the nature to which art—a freer art—is responsible. Shelley sees language as "a more direct [that is, unmediated] representation . . . of our internal being . . . than colour, form, or motion" because it is "more plastic and obedient to the control" of the imagination. Indeed, "language is arbitrarily produced by the imagination," unlike "colour, form, or motion," the "materials, instruments, and conditions" of the other arts, the nonverbal arts. These materials, instruments, and conditions "limit and interpose between conception and expression," while, more ideally, language as instrument of the imagination acts "as a mirror which reflects" the first ("conception") in the second ("expression"). On the other side, far from reflecting "the light" of the imagination, the nonverbal arts—dependent on the manipulation of materials external to the human mind—are relegated to functioning "as a cloud which enfeebles" that light.

No wonder, then, that Shelley considers the verbal art as the very "hieroglyphic" of thought, its character a natural emanation of human internality, almost as if he were endorsing some sort of automatic writing.[7] It is the nonverbal arts, as the voluntary working with external instruments and materials, that must reconcile themselves to being distanced from and artificially related to their

source. As with Longinus, the ground for assigning immediate and natural, rather than mediate and artificial, roles to the several arts rests not on representational accuracy but on closeness to the source of expression. Signs are to be related internally to their author (subject) rather than externally, as vehicles of representation, to their object. In the preference among literary kinds, the ascendancy of lyric poetry over the older notions of drama is a necessary accompaniment to this shift in both semiotics and epistemology.

So we have arrived at an aesthetic that, in contrast to the natural-sign aesthetic, emphasizes the work of art as the product of the human mind and human labor rather than as the reflection of an external reality. As the aesthetics of organicism is formulated at the end of the eighteenth and start of the nineteenth centuries, the expressive emphasis of the human being as a speaking creature is joined to the making emphasis of the human being as poet. It has to follow that the concern with the poem as a reflection of external reality was either rejected or utterly transformed. In consequence, interest has been transferred from the "real" *objects* being represented by natural signs to the constructed *object* produced by mind and labor. But we have seen that, in the tradition from Longinus to Burke to Shelley, an attempt has been made to claim this sort of object as "natural" too (especially when it is a verbal object), even if one must redefine what "nature" is—from nature out there as knowable to human nature as internal but expressible—to make the connection work.

As organicism is most consistently defined, the work of art, now shaped as it emerges from the human creator instead of imitating nature's shape, yet achieves its own special relation to nature. Captivated—and captured—by the organic metaphor, theorists attribute to the work the natural form, the integral system of internal relations, of a biological entity. Signs that, in their deprivation, may have been arbitrary and conventional are so arranged and transformed by the poet that, as they emerge from him, they take on a sense of inevitability and necessity aroused in us by the organic forms of living nature.

This is essentially the role given the poet by Aristotle, who is the first to adapt the biological model to literature, more specifi-

cally by him to the description of the forms of dramatic plots. He sees the essence of these forms as their capacity to reshape their external objects, the casual realities of history as it happens, into the poem as object, a causally complete system of internal relations operating in accordance with our logic and not with the chronology of happenstance.[8] If we remember Aristotle's desire to elevate the "probable" over the merely "possible," (chapter 24), we can understand that the controlling principle behind the sequence of incidents in drama requires that human logic triumph over chronological accident; it is to persuade us as aroused witnesses that the humanly created order *is* the natural order.

Aristotle shifts easily from the drama as an objective structure to audience response without concerning himself about the differences required by this shift. He seems to expect us to accept the shift from what is logically "probable" in the action to what the audience can be induced to find "credible," believing the order to be "natural" because it is logical.[9] The action should be taken as the idealized version of the natural order and, as a logical transformation of it, an improved order that we should accept as a substitute for the nature we see, that we should accept as nature's ultimate form. The proper drama is, in effect, more than a natural sign as nature's transparent representation; it is, as substitute for visible nature, the primal creation that speaks for nature itself. As an object *for* imitation, it is as fixed and absolute as nature itself *seems* for the Platonists; no, more so, since it has the philosophical authority of Aristotle's teleology, his final cause, behind it to lend it substance.

Thus it is that the poet fosters within the viewer or reader the illusion that human logic has produced a self-sealing organism. If the dramatic system of causal relations is all it should be, then it creates the impression of biological nature's growth and fulfillment. As Aristotle claims in his *Physics*, chapter 2, the artist partly imitates nature and partly surpasses it[10]: the objects borrowed from without for imitation must be made to appear as if they develop *naturally* into what becomes their fixed pattern (as if they develop *naturally* into "the finality of their form," if I may borrow Kant's words for my purposes). The imposition worked by the poet upon his materials from a position outside them is

forced to seem like a flowering from inside (and my vegetable metaphor is deliberate). It is this infusion of organic vitality into otherwise inert materials that, for the later organicist Coleridge, turns the poet's act into an imitation of God's. The poet's own I AM gives life to its objects, transforming them into the mutually sustaining elements of the self-sufficient world it has created, in effect giving birth to what Renaissance critics would have called a "second nature," in its way an improvement over the first.

Here, then, is a return to nature by signs that, as arbitrary and conventional, had begun their career in alienation from it. The vision of the poem as a perfect emblem of organic nature requires a totalized concept of the aesthetic object resting on a teleology (what Kant termed "internal purposiveness") that converts every wayward element into an inevitable and indispensable part of the created pattern. But of course the organic aesthetic carries with it a mystification with almost as much power to deceive as those simpler claims for nature made on behalf of the mimetic aesthetic of natural signs that we examined earlier.

The making of a "second nature" by the poet's I AM asserts human mastery over accident, a godlike act of genesis that subdues the unshaped in the name of power, the creative power. Seen thus, this relentless power, which absorbs all into the shapes formed in accordance with humanly imposed ends, can be viewed as an aesthetic reflection—an idealized version—of the dream of private enterprise, as the purest extension of the humanistic dominance produced by an ultimate engineering. Indeed, the rising idolatry of the national state as an organic construct is another reflection of a language that permits the aesthetic to be extended to the social-political realm, so that it is seen as a reflection of that realm, or even, perhaps, as a result of the rhetorical motives generated by that realm.

Accordingly, we must view the theory with suspicion, questioning the disinterestedness of its supposedly disinterested aesthetic. With organic theorists we are of course far removed from the world of Pope and the reactionary motives I suggested earlier which his rhetoric may have preferred to conceal; but the relationship between the rhetoric of the organic aesthetic and either its social-political consequences or its social-political motives is

similar. Once again the arbitrary play of institutional power seems to be guiding the aesthetic much as it does the other elements of culture as an ongoing arena of conflict. And the claims that the literary work possesses a normative power backed by an objective natural authority are reduced by our own rhetoric of suspicion to historically contingent, institutionally instructed biases.

AS CRITICISM in our own century systematically projected this formalism with its spatial fixity upon literature's temporality, the mystifications of organicism expanded into the worship of form by literary modernism. In the formalist tradition from Aristotle on, the conflict in literature between the temporality of sequence and the spatiality of the form that freezes this sequence is re-solved on the side of space. As the New Criticism turned the claims of the Coleridgean formulations into an ultimate critical method, the spatialization of temporal sequence in literature be-came the object of aesthetic worship. The attachment to myth-as-human narrative (at the expense of history as an indifferent, inhuman out-there) in a T. S. Eliot or a Cleanth Brooks, or—more explicitly for my purposes—in the valorization of "spatial form" by Joseph Frank, may be seen as the crowning idolatry of fixed poetic structure in the modernist movement in both poetry and criticism.[11]

As we have seen, the idolatry of the spatial in the theory sponsored by the modernist tradition springs from sources far different from the neoclassical desire, also spatial, for a natural-sign art in the seventeenth and eighteenth centuries. For the discrediting of the natural-sign aesthetic from that late eighteenth-century moment cannot be undone, nor would the modernist wish to undo it. Ever since the work of Edmund Burke and before, the rejection of a hierarchy based on the hegemony of natural signs led theorists to flee from the limiting, externally controlled precision of visual representation, to grasp the verbal arts as superior to the plastic, and, as this theoretical direction devel-oped in the nineteenth century, to value music—the art farthest removed from natural-sign representation for Addison—as the condition toward which all the arts should aspire.

But, having freed literature from a dependence on visual pre-

cision so that it can explore the greater and less controlled range of verbal expression, having allowed literature to escape spatial fixity in order to indulge temporal expansiveness, the history of theory under modernism moves to reverse itself, pressured by the modernist commitment to closure, as it seeks to force literature to turn away from time and to fight its way back to space. However, the spatial is no longer related in any way either to natural signs or to picture-making. Instead, the spatial is now to be achieved by a transformative use of language as poetic medium that takes arbitrary signs and *literally* changes their nature in spite of their prepoetic tendencies, freezing them into a spatial fix, making them into their own emblem, though hardly a picturable one. We are to define the spatial no longer by way of the visual so much as by way of the material embodiment of the object, as taking up its own place: the art object, as spatial, is now to lead, not elsewhere to a something seen, but to its own naturelike organic thinghood, rooted in its own integrity. Words in poems are to take on a substantive "nature" as they turn from arbitrary and conventional to inevitable and indispensable. Their activity accordingly changes so that it deserves to be described by metaphors that treat words as bodies, as living things, occupying spaces that grow into a pattern, instead of treating them as passing sounds in an endless string coming before and going after.

Now all this is a good deal for critics like Joseph Frank to claim, as they turn poems into spatial entities whose form triumphs over sequence, changing befores and afters into the simultaneity of juxtaposition, thanks to a controlled parade of modulations, repetitions, and echoes. Postmodernist theoretical developments since the New Criticism have attacked that movement's formalistic confidence in the poet's spatial power to impose closure despite the usual way words work, despite—that is—the unending openness of what it used to treat condescendingly as "normal" discourse. These recent theorists have, in effect, unpacked Frank's spatial metaphors, seen in the antitemporal notion of juxtaposition, and revealed the self-mystifying consequence of taking them literally. What they are resisting is the aesthetic desire for a totalized verbal system, the very heart of organicism from the first. Their resistance reflects their desire to deny to the poem the

opportunity to achieve the status of an idealized natural object, emblem of teleological fulfillment. Instead, poems, like all verbal compositions, are to accept the fate of arbitrary, temporal signs and not to seek to inflate metonymic modesty into metaphoric grandiloquence, justified only by metaphysical bad faith.

Much of Paul de Man's most trenchant work constituted a polemic against the pretensions of such an aesthetics of verbal presence. Instead, he speaks in a minor key for aporia and an open temporality, for the necessary gap between word and hope in a textual universe at the mercy of a self-abnegating law that rules only in the name of the arbitrary. If Frank would use his spatial form to achieve a "juxtaposition of past and present" that rescues us from history by converting it into the "timeless unity" of myth, the "natural supernaturalism" of M. H. Abrams, de Man reminds us of the mythic basis of that myth and drags us back to the human condition as the verbal condition.

Beside those in the deconstructionist line whom I have represented here by de Man, there are many theorists in recent years, whether deriving from Marx or Foucault, who would insist upon the political risks implicit in the totalizations of the organically "natural." They would expose the fetishizing of "nature," of natural authority, in the rhetorical subservience of the organicist's language to the sway of social-political forces. All these theorists in their different ways remind us to be wary of the metaphysical dream behind the timeless myth of "nature" and wary also of post-Romantic voluntarism, of humanistic aggrandizement, of the worship of private power, behind the modernist's will to totalization, to genesis revisited.

Behind modernism's myth, then, we still can find an appeal to nature, as Schiller long ago reminded us; an appeal to nature as model if no longer as object, though it is an appeal even more presumptuous than that which we observed in the natural-sign aesthetic. What the two aesthetics share is a flight from the arbitrary as insecure and the desire to claim an authority beyond the fleeting vagaries of time. Hence the return to spatiality by modernism, even in a metaphysical context which has acknowledged the epistemological dominance of the temporal. This return to spatiality, as we have seen it in one of its most extreme statements

in the work of Frank, has been made on language's terms and not
on those of the visual arts, in that the spatiality achieved in words
must be a hard-won victory over the inherent transience of verbal
sequence. It is accomplished, Frank insists, in defiance of the
admonitions of Lessing, although Frank concedes Lessing to be
correct in gauging the limited spatial possibilities of paintings so
long as they are confined to the literal representation of their
objects.

But for modernism, language, unlike the visual arts, can have
it both ways, sharing the temporality of experience and yet giving
that temporality the unity of human comprehension by imposing
spatial form upon it.[12] If the natural-sign aesthetic was doomed
in part because a temporal epistemology, sensitive to history,
replaced the spatial ontology of rationalism, modernism returned
spatiality to aesthetics only while continuing to recognize expe-
rience as irreducibly temporal, thereby holding out to poetry the
special task of running along like experience and yet rebounding
like a human shape. Poetry sits atop the hierarchy of the arts by
virtue of this double power, allowing its creator the most formi-
dable of displays precisely because of that which leaves language
as the least natural (i.e., most arbitrary and most conventional) of
mediums: the display of a victory over time in time. The concep-
tion of time as abandoned to Bergsonian fluidity only heightens
the aesthetic accomplishment that seizes it and then displays
what it has seized. Further, in its sophistication, the modernist
literary work is encouraged to display its own awareness of its
doubleness, to call attention to its own artifice even as it creates
out of it a new nature for us to believe in.

Now, as a reversal of the old hierarchy among the arts, it is for
the visual arts to ape the semiotic duplicity of the verbal arts (ut
poesis pictura), although at the cost of distancing themselves the
more self-consciously from any attempt to function as natural
signs. And, abandoning naive mimesis, theorists increasingly
learned to see the extent to which all the arts function as linguis-
tic signs requiring interpretation. The universalizing discipline of
semiotics is recent evidence of the imposition of language as the
model for all sign systems, including—of course—the visual. As
we can observe in developments for many decades now in the

plastic arts, *all* aesthetic signs come to be taken as both arbitrary and conventional, indeed as anything but natural, abandoning the natural sign as even an extreme possibility for the few kinds of art for which it might appear to be at least superficially appropriate. Presumably even so-called realistic paintings and sculptures, like so-called realistic dramas, are not exempt from this toppling of any remnant of the authority of mimesis, of the natural-sign dream, even as it might be applied to the few remaining cases in the arts that still seem to be obvious candidates.

Theorists could point to the formidable work of E. H. Gombrich in the history of the plastic arts as licensing their increasing awareness of the need to subordinate any mimetic consequence of the arts (even in what seemed to be the least problematic of the visual arts) to the conventions governing the way art was made and perceived. Emphasizing "the beholder's share" and the role of the visual habits—optical and cultural—in shaping what that beholder sees, Gombrich's *Art and Illusion* (1959) encourages its reader to attend to the technical and perceptual devices, derived from convention, which create what we, as human perceivers within our historically bound cultural habits, see as pattern. Once aware of these devices shaped by the artist out of an aesthetic medium, we should not be deceived by what presents itself to our naive response as a natural sign. And the art work, indulging in self-reference, will encourage the sophistication of our response. Gombrich extends this sense of play to his own confrontation with the Socrates of the *Cratylus*, as he attacks Socrates' support for the mimetic pretensions of the would-be natural sign: one should account for form, Gombrich argues, by relating it to function rather than to the external object.[13] Hence the Gombrichian motto, "making before matching."

Despite such promising theoretical developments that follow upon the antimimetic interest in the conventional basis of the production and reception of art, the myth of the natural sign dies hard—even for Gombrich himself, who was credited with burying it for good. Indeed, for Gombrich it never died, and recently has been reemerging explicitly—and embarrassingly, for those of us who have been following him. Many of Gombrich's readers saw his earlier arguments as leading to the claim that all art arises

out of, and functions only by way of, conventional signs. But Gombrich was himself to reject this reading of his work as he has rejected what he terms "conventionalism." [14]

The temptation to hang onto the belief that the "nature" of one's own culture is *nature* for all leads its victim to believe that he or she knows what nature objectively is, what it demands, and what it looks like for all who imitate it. It leads both to cultural provincialism and to cultural imperialism. In the face of all he contributed to the treatment of art as a series of interpretable codes, Gombrich remains such a victim of the temptation held out by the natural-sign aesthetic, though his distinctive authority comes from his apparent resistance to that temptation. In retreat from the denials (attributed to him) of nature's singleness, knowability, and supremacy, Gombrich now rather denies that his theory "lent support to an aesthetics in which the notions of reality and nature had no place," denies that he "had subverted the old idea of mimesis and that all that remained were different systems of conventional signs which were made to stand for an unknowable reality." [15] Assured of the universal dominion of the reality established by and for the English scientific tradition from the original Royal Society to his colleague, the perceptual psychologist James J. Gibson, Gombrich must reject such readings of his work with the familiar charge that they represent "an out-and-out relativism," presumably the enemy to British scientific hegemony, here made synonymous with the pursuit of truth.

My language here makes evident my own conviction that there are social-political causes for (and, perhaps more importantly, consequences of) one's commitment to a monolithic concept of nature, a commitment that would project the arbitrary and yet conventional product of intellectual institutions into universally controlling forms "out there" in "nature." Subliminally, if unconsciously, ethnocentric, it cannot help but try to be hegemonic, even in so innocuous a disguise as that of an aesthetic theory. Yet, in its yearning for the "natural," it can use the aesthetic for a subliminal political persuasiveness. In my survey here we have seen how, under the pressures of a philosophical tradition and the hierarchy that follows from it, convention intrudes upon the arbitrary, catering to our desire to see it too as natural, and in a

way that connects semiotic explorations in aesthetics to our atti-
tudes toward sign-functioning in social-political areas of human
concern. Seen from this perspective, the history of sign-function-
ing as attributed to the arts by aesthetic theory, with its narrative
of conflicts and delusions in the alternating fortunes of natural
and arbitrary-conventional signs, can be viewed as an allegory—
with the special illusionary purity of an aesthetic allegory, if you
will—of the story of signs, with their dangerous and error-filled
pretenses to authority, in society's long chase after the power of
enforcement that claims to derive from "nature." But we have
seen also that the aesthetic can have its revenge upon ideology,
revealing a power to complicate that is also a power to under-
mine.

Indeed, I do not mean to dissipate the aesthetic, with its depen-
dence on the recurring illusion of the natural sign, by reducing it
altogether to the interests and powers of social-political reality.
The history of the tenacity of the natural-sign aesthetic is more
than the history of error (and, when spread into other areas, of
dangerous error), though it is that. It is also the history of the
semiotic desire for the natural sign, the history of the necessary
longing, in the individual and in culture, to find and to nourish a
language authorized by its mirroring of the external reality we
call "nature," though only in accordance with our imperialistic
tendency to see contingencies in all conceptions of what is "nat-
ural" *except* our own. It is a longing we have noted ever since the
desperate, and desperately complex, ironies of Plato's *Cratylus*,
and it is one of the more potent stimuli for culture's persistent
indulgence of the arts. It accounts for the pleasure that Aristotle
reminds us we take in imitation, and for the fact that some trace
of the mimetic appeal of art pops up again each time we think it
obliterated. So we ignore this longing at our peril. It will not go
away, no matter how we deconstruct it, so that we may be better
off trying to understand it and how to live with it, to allow it its
role in our anthropological fullness, though without succumbing
to it.

The work of art thus takes on the social function of serving as
a model for less aesthetic discourse, and drama may still be our
most instructive example. In its illusionary character it is both

exhilarating and dangerously deceptive. It is exhilarating in its appeal to our semiotic desire for the natural sign, but it can be admittedly deceptive in the illusory nature of that appeal, as—in our best cases—it appears to confess whenever, in self-reference, it reveals its merely conventional basis. It is, then, our lighthouse —both beacon and warning—as it demonstrates what discourse, less self-enveloped discourse, can lead us to accept as "natural."

This, then, is one of the major functions of art in culture: within the received language of a culture, the arbitrary-conventional comes to take on the appearance of the "natural," and its arts flourish to the extent that they create their illusionary "realities" that, under the spell of aesthetic experience, carry the conviction of their naturalness, whether on canvas, in stone, on stage or page. In sophisticated cultures they also undercut that conviction by their self-consciousness, their confession of the art they are and the reality they are not. It is a self-consciousness to be encouraged, for in this reflexive action they serve their culture well, as emblems of the semiotic ambivalence each healthy culture ought to have, cherishing the illusions it has created, provided it never stops distrusting them and their claims to be its "natural" reality. In examining those illusions and those claims, a culture discovers itself as it questions its reasons for attaching itself to them. And self-discovery, with its attendant skepticism, would constitute a worthy end for the cultivation of all the arts.

Notes

1. I borrow the phrase from Forrest G. Robinson, *The Shape of Things Known: Sidney's Apology in Its Philosophical Tradition* (Cambridge: Harvard University Press, 1972). See especially ch. 1, "The Tradition of Visual Epistemology."

2. See the series of distinctions in which Mazzoni couples all the variables involving the two opposing pairs, drama vs. narrative and phantastic vs. icastic. These appear in the Introduction to *On the Defense of the Comedy of Dante* (1587), tr. by Allan H. Gilbert, in *Literary Criticism Plato to Dryden*, ed. Allan H. Gilbert (New York: American Book Company, 1940), especially pp. 360–362.

3. There are, of course, several other, more frequently cited reasons for the elevation of epic over tragedy in the Renaissance by far more conservative, more Horatian critics. Their appeals to the didactic and to "Virgil-worship" are well documented in the standard histories of Renaissance criticism.

4. My obvious allusion here is to Johnson's criticism of the inflexible neoclassical position in the well-known passage from his "Preface to Shakespeare": "The

truth is, that the spectators are always in their senses, and know, from the first act to the last, that the stage is only a stage, and that the players are only players."

5. I have argued that there is a common metaphysical grounding for the *Essay on Criticism* and the *Essay on Man* despite the considerable distance of time (more than two decades) that separates them. See my *Theory of Criticism* (Baltimore: Johns Hopkins University Press, 1976), p. 104 and the discussion that follows.

6. Thus Johnson defends the mixing of genres in Shakespeare by characterizing the pure genres of tragedy and comedy not as justified in the nature of things, but as created "according to the laws which *custom* had prescribed," out of which "rose the two modes of imitation, known by the *names* of *tragedy* and *comedy*." These dramatic conventions, as human institutions, are anything but natural, as —according to Johnson—Shakespeare's unconventional plays reveal.

7. In the case of Shelley too I must concede that there would seem to be another, and a contradictory, Shelley, even in the same essay. Just two paragraphs later he treats the language of proper poems also as a medium like the others, requiring similar manipulations of the relation verbal sounds have toward "each other." But Shelley's primary and usual allegiance is to the *immediate* relation between thought or vision and word.

8. Among the many places I could point to in the *Poetics*, I need mention here only Aristotle's argument for logical, rather than chronological, definitions of "beginning," "middle," and "end" in chapter 7, as reinforced by his defense of "unity of plot" over "unity of the hero" in chapter 8 and by his calling in chapter 23 for an epic structure that presents "a single action" and not, like history, "a single period."

9. This shift from the "probable" to the "credible," from action to audience response, anticipated by Aristotle in his chapter 6, becomes a commonplace in sixteenth-century Italian criticism that—though often inaccurately—calls itself Aristotelian.

10. Richard McKeon's commentary is instructive here: "Art imitates nature, Aristotle was fond of repeating, and, at least in the case of the useful arts, the deficiencies of nature are supplemented in the process of that imitation by art following the same methods as nature would have employed. 'Generally, art partly completes what nature cannot bring to a finish, and partly imitates her.' " His quotation is from chapter 2 of the *Physics*. "Literary Criticism and the Concept of Imitation in Antiquity," in *Critics and Criticism, Ancient and Modern*, ed. R. S. Crane (Chicago: University of Chicago Press, 1952), p. 161.

11. The idolatry of myth as spatial form and as a replacement for history conceived as temporal flow is seen everywhere in Eliot—see at least "Tradition and the Individual Talent" and the implied poetic throughout *Four Quartets*— and in the exemplary New Critical writings of Brooks—see his specific defense of "myth" against "history" in "Keats' Sylvan Historian: History Without Footnotes," *The Well Wrought Urn* (New York: Reynal and Hitchcock, 1947), pp. 139–152, especially p. 151. Perhaps Frank is the most explicit in championing the modernist poet's transformation of history into the "timeless unity" of myth in his "Spatial Form in Modern Literature," *The Widening Gyre* (Bloomington: Indiana University Press, 1963), especially pp. 59–60.

12. See my treatment of this doubleness in my gloss of the word "still" in "The Ekphrastic Principle and the Still Movement of Poetry; or *Laokoon* Revis-

ited," *The Play and Place of Criticism* (Baltimore: Johns Hopkins University Press, 1967), pp. 105–128. In the double reach of this word in this essay I believe I was making a prestructuralist attempt to stretch toward Derrida's *"différance."*

13. E. H. Gombrich, *Art and Illusion* (London: Phaidon, 1959), pp. 305–306.

14. This rejection was evident earlier, in Gombrich's response to the work of Nelson Goodman and, more recently, in his vituperative response to my essay on him. See the following sequence of essays in *Critical Inquiry:* my essay, "The Ambiguities of Representation and Illusion: An E. H. Gombrich Retrospective," *Critical Inquiry* (1984), 11:181–194; Gombrich, "Representation and Misrepresentation," *Critical Inquiry* (1984), 11:195–201; and my "Optics and Aesthetic Perception: A Rebuttal," *Critical Inquiry* (1985), 12:502–508.

15. Gombrich, "Representation and Misrepresentation," p. 195.

10
TOWARD A MODEL FOR THE
HISTORY OF THEATER
Juan Villegas

SELECTING THOSE texts which form the corpus of a literary history fulfills a significant political function. A literary history is nothing more than the selection of texts considered representative within a particular cultural tradition. Accordingly, the selection of certain texts over others determines the emergence or disappearance, the weakening or strengthening, of the dominant value systems within social structures. Since the theater is a social and cultural tool of the first rank, the privileging of some theatrical texts serves to validate certain cultural models and devalue others. The hegemonic critical discourse tends to privilege those theatrical texts that, in one way or another, support or are ideologically compatible with its own ideological, cultural, or aesthetic codes. This situation has tended to marginalize discrepant theatrical discourses. To propose, therefore, a new model for the periodization or history of the theater has political as well as pedagogical and academic consequences. The interrelation of discourse and power distances critical discourse on theater from an exclusively aesthetic significance and places it within the struggle for power, not in general terms, but rather in very concrete terms within its own historical situation.

The proposal that follows will be based on and illustrated with examples from twentieth-century Latin American theater, which itself exemplifies the fundamental problem of this essay. While it is a marginal discourse in relation to European theatrical discourse, it is constituted by a hegemonic discourse—which tends to follow the European models—as well as by a great number of

This article has been translated from Spanish in part by Julio Kidder.

theatrical discourses that have been marginalized from history by the hegemonic critical discourse.

Misreading Latin American Theater

MOST HISTORIES of Latin American theater have been histories of dramatic texts—not necessarily staged texts—selected on the basis of a system of values and aesthetic, cultural, and ideological codes embraced by culturally hegemonic sectors with a European bias. This critical discourse, aware of neither its ideological foundation nor its cultural dependency, has produced a partial history, one that privileges Europeanized texts that are ideologically convenient to the social sectors in power. It has simultaneously excluded broad areas of production of theatrical texts that have been almost automatically discriminated against and marginalized. This situation, we should point out, is not unique to Latin American culture. On the contrary, it is possible to demonstrate that in all periods a particular cultural discourse has silenced others, and that the history of literature—of the Latin American theater, in this case—is a monological discourse which tends to silence plurality.

That correcting the misreading of Latin American texts is one of the main tasks of all literary theorists in Latin America has previously been pointed out. In 1972 the Cuban writer Roberto Fernández Retamar stated:

> The theories of Spanish American literature could not be forged by translating and imposing on it criteria that were forged in regard to other literatures, the metropolitan literatures. . . .
> In the last few years, at the same time that Spanish American literature was finding acceptance and international recognition, the incongruity of interpreting it with conceptual tools constructed for other literatures is becoming evident.[1]

Most Latin American critics or theorists of literature used to regard this kind of statement as political pronouncement, with very little foundation or support from a theoretical perspective.

Latin American critics or theoreticians have been convinced that literary theory has to propose "universal" or general models, models without historical limitations, because the "essence" and validity of a literary theory is, precisely, its universality.

The critical discourse produced in North America with regard to Spanish and Latin American texts, for example, has mainly been oriented to deideologize and dehistoricize the Latin American literary discourses and apply to them its own codes, without taking into consideration the aesthetic and ideological codes of the texts produced within a given praxis of literary discourse.

Paradoxically, some contemporary trends in critical theory and some ideas from Europe have lent support to the possibility or necessity of studying marginal literary discourses from a nondependent perspective.[2] Recently the proposal of new models as a means to allow the inclusion of marginal literary discourses is becoming a recurring topic.

> The "inadequacy" or "underdevelopment" that is ascribed to minority texts and/or authors by a dominant humanism in the end only reveals the limiting (and limited) ideological horizons of that dominant ethnocentric perspective. Since the dominant culture occludes minority discourse by making minority texts unavailable—either through publishers or through libraries—and more subtly, by developing an implicit theoretical perspective which is structurally blind to minority concerns, one of the first tasks of a re-emergent minority culture is to break out from such ideological encirclement.[3]

One of the most significant consequences of using a model that does not derive from the object itself is that the model imposes its own frame of reference and it is able to perceive only what fits the preprogrammed model. The European model, for example, affirms as one of the main values of a literary text its "universality." Many Latin American theatrical texts are "aesthetically" disqualified because they are accused of being too limited in their scope or too regional, therefore, supposedly, lacking "universality." Some Marxist studies, and more recently those of Foucault, have argued the historicity, limitations, and the ideological foun-

dations of the concept of universality.[4] Foucault, for example, states that all dominant social formations proclaim their own system of values as "universals" and justify their imperialist attitudes based on that "universality." If such "universality" does not exist, the criteria for discarding or rejecting those texts lose its validity, and the need for new or different criteria emerges. At least, the texts that did not fit the "universality" code are free to be considered or to be read from a different perspective.

In the case of Latin American theater, there are very few plays that have reached official international recognition. There are many plays staged in different places of the world, but usually they are staged for limited special audiences.

The strong presence of a dominant model does not permit the perception of characteristics of the object itself. The critical discourse has the tendency to insert the text within a European "school" or "technique." The task of the critic then becomes to prove that the text fits the model. There are many histories of Latin American theater in which the analysis serves mainly to classify the plays as "expressionist," "surrealist," or "absurdist," all of them European categories. Usually this kind of characterization is considered praiseful and essential to the evaluation of the play.

An interesting example is the insertion of a good number of Latin American plays in the category of the theater of the absurd. Using the traits described by Ionesco or characteristics inferred from plays by Ionesco, Beckett, Adamov, or others, what is usually done is proving the presence of those traits in plays by Osvaldo Dragún (Argentina), Jorge Díaz (Chile), or José Triana (Cuba). The consequence is that they are said to "belong" to the absurdist trend, without considering that they are simply employing some of the absurdist techniques to communicate a valid message to their own countrymen very different from the one Ionesco, for example, intended for his French audience. Within the same perspective, it is interesting to note here, for example, the presence of Brecht in Latin American theater. After 1960 Brecht's system became very important for a sector of committed theater, and it has been discussed and used by leftist directors and authors. The critics, however, have seldom considered the

way Brecht has been adapted, and the differences between the original and the Latin American versions of his influence.

When the critics see the difference, it is generally considered negative or grotesque. The difference is the "other," and, as such, is rejected or valued as "picturesque." Often, this is the only way some plays or Latin American texts are read. If the difference is not seen, similarity is considered lack of originality. "Great" texts are selected on the basis of their similarity to the hegemonic discourse's codes. Once the similarity is proved, it is easy to affirm the lack of originality of the "imitator." It is probable that the change of perspective or a diverse attitude towards the similarities will make evident what is original or innovative in the techniques utilized for the communication of the message within a specific context.

Latin American texts are also read by the hegemonic discourse out of context. This is to say that no attention is paid to the potential reader, neither to a symbolic response to a particular historical situation by the producers as individuals or as part of a social group. In other papers I have shown that the message or meaning of a theatrical text is determined often by the precise date of its production or date of the performance. This transitory meaning is not relevant from the perspective of the universal value required by the dominant critical discourse. The performance of a text proclaiming the virtues of a socialist regime produced in 1972 in Chile—during Allende's regime—by a Marxist writer, for example, has a totally different meaning if the same text is staged in 1975, after Allende's fall. What could have been a conservative text in 1972 could become a revolutionary play in 1975; what could have reinforced the ideology in power or could have been supported by the official institutions could become a marginal discourse, daring and politically representative of a marginal group and an ideology displaced from power. If all the attention is directed towards the satisfaction of some ahistorical aesthetic codes, and no attention is paid to the ideology of the text, nor the world view, nor the emitter's social class, nor the audience ideology, neither do the factors conditioning its performance appear as constitutive elements of the text.[5]

One consequence of this approach is the lack of social rele-

vance of the texts. The dehistoricization and deideologization of the play tends to diminish its social significance at the time of its production or representation on stage. A quick view of playwrights' statements in regard to the function of literature or theater in Latin America shows that most of the playwrights agree on the social and political function of theater and the political intentionality in their "creation." Most of them state that literature in general, but especially theater, is an important tool for social change, as a denunciation of social injustices or an alerting of the bourgeoisie to its responsibility. If we accept this social commitment as a dominant trait in Latin American theater, to silence the political or social significance of a text is to take away a very important component of it.

The dominance of the European model leads to a periodization of Latin American literature mainly following the periods proposed for European literature or culture. Most historians of Latin American literature do not take into consideration the historical and social differences between the historical changes in Europe and Latin America or the different displacements of social groups or economic or industrial changes in both spaces. Even less attention is paid to the historical and social differences in each country. Usually Latin American countries are considered as a whole. The economic and social evolution of these countries, however, is very different. The dominance of European models allows only the possibility of a positive reading for those texts produced within the framework of the model. In Latin America, this limitation has lead to a silencing of important theatrical discourses. Some examples are the theater addressed to such marginal groups as peasants (teatros campesinos), proletarian theater. Although it does not fit exactly in these latter categories, the theater written by women has also been marginal.

It therefore becomes necessary to propose new models for periodizing theater which take into account not only the specifically theatrical, but also the plurality of existing discourses within a specific historical period, the potential addressee and the historic contextuality.[6]

The Potential Addressee and the History of Theater

ANY SYSTEM of periodization for the history of theater must recognize that the function of theater is predominantly one of relevant, active communication for a relatively well-defined audience. This is precisely the view of a faction of the theorists immersed in what is known as reception theory, in which interest is displaced from the producer—the traditional "author"—to the addressee.[7] If at the same time we accept that every communicative act acquires the fullness of its meaning within its context, the message communicated in a theatrical representation has its greatest relevance within the context of this particular triad.

These last observations lead us directly into several variants of those theories dealing with the receiver or addressee of the linguistic act that emphasize the particular case of the theatrical spectator as the basis for the periodizing model we wish to propose. Recent reception theories, for example, propose rejecting the concept of an ahistorical reader or receiver, replacing it with that of a "real" reader under real circumstances, within a specific culture, society, and history.

Marco de Marinis has applied some ideas from reception theory to theater. To this end he has stated the following:

> It means conceiving theatrical reception in a way which is closer to an aesthetic experience involving many other experiences besides the central hermeneutic experience. It means taking reception from the a-temporal and a-historical island where some want it to be confined, and bringing it back to its only real place: *within a culture, hence within society and history*. It is inevitable that the spectator goes to the theater with his/her culture (in an anthropological sense) and knowledge, and that he/she watches the performance through the conceptual and linguistic grid provided by his/her encyclopedia.[8]

The phrase "within a culture" establishes the precedence of the receiver's ideological and cultural codes at the moment of production as an important component of the production of its meaning.

The terms used, however, offer a series of possibilities for signification and combination, each of which leads in different directions and achieves different results. Consequently, it becomes necessary to differentiate the frame in which we will place ourselves, a delimitation that, at the same time, presupposes adopting a theoretical position from which the proposal can be criticized or questioned.

We understand "history" to be a "narrative" that attempts to establish a series of categories and a certain system of order which allow us to locate within it theatrical texts produced throughout a certain period. Confronted with the distinction, which appears to be indispensable in recent theoretical studies of theater, between the "theatrical text"—as staged text—and the "dramatic text"—the literary text—the model we will propose opts for the former. This history must be one of theatrical texts. This choice carries with it the potential for very different results, or "histories." The emphasis on "theatrical text" means that, in the case of Latin America, for example, we would have to eliminate from the corpus those texts that were never staged, or that were staged only outside Latin America, while at the same time studying all, or at least a large part of, the elements that constitute theatrical representation, such as stages, actors, directors, lights, etc. The second option involves marginalizing from the factors under study those components of the object that are specific to theatrical representation, including the most important element in reception theory, the addressee. If one elects to go with theatrical texts, the "receiver" is a "spectator," and, in our example, the Latin American spectator under specific circumstances. This disjunction, therefore, creates two areas of study, as well as potentially disparate histories of Latin American theater.

The premises on which we will base our proposal for a model for a history of theater are the following:

1) The model must include the emitter as well as the addressee of the discourse.

2) It is impossible to isolate the addressee from his part in the communicative process: communication of the specifically theatrical. Therefore, the text must be thought of as the intentionally significant product of an emitter who uses theatrical codes to

communicate with a potential addressee within a communicative and theatrical contextuality.

3) The model must include staged texts as well as nonstaged texts.

4) The model must account for the texts of the past, as well as those of the present and future. The model must account for the whole theatrical and dramatic production of Latin America.

5) The model must account for the ideological foundation as well as the theatrical and aesthetic codes that inform the text.

It is important in our proposal to note the substitution of the term "receiver" for "addressee" and the consequences thereof. "Receiver" suggests a passive role in the act of production of meaning, but an active one in regard to the decoding of the message and the codes used in the text. "Addressee," on the other hand, suggests to us the potential interlocutor, one who is implicitly present in the act of production of meaning which is the production of the theatrical text.

The Dramatic Text as Deictic

THE LACK of either theoretical or practical research regarding the theatrical receptor or the conditions of theatrical representations in Latin America, whether past or present, prevents us from initiating the research on the level of theatrical practice and real spectators. In many instances, the only material for study that we have for reconstruction is a number of dramatic texts with a few occasional references to the conditions of their representation. In other instances we don't even know if they have been staged, or what the physical, political, or theatrical conditions of that staging were. It is useless to wait for the results of these studies regarding the elements or configurations of the theatrical act, including the actual spectator, the social standing of the acting company that staged it, the venue where it took place, etc. Even if we could obtain some of this information, it would hardly be sufficient or complete enough to allow us to reconstruct the theatrical representation of the past as theater.

Terry Eagleton has noted the importance of the mode of production as a component of the text in suggesting that the "literary

mode of production" (LMP) is an essential constituent of the
literary text:

> If LMP are historically extrinsic to particular texts, they are
> equally internal to them: the literary text bears the impress
> of its historical mode of production as surely as any product
> secretes in its form and materials the fashion of its making.[9]

The question still remains as to the particular nature of the
mode of production with respect to theatrical texts. One of Hans
Robert Jauss' theses proposes a valuable distinction:

> The reconstruction of the horizon of expectations, in the
> face of which a work was created and received in the past,
> enables one on the other hand to pose questions that the text
> gave an answer to, and thereby to discover how the contem-
> porary reader could have viewed and understood the work.[10]

This methodological strategy, essential for the following pos-
tulates, implies remembering and insisting upon concepts such
as theatrical contextuality or horizon of expectations. All theatri-
cal discourse—like any discursive activity—is an act of produc-
tion of meaning. Therefore it becomes imperative to take into
account the context of the production of discourse. The theatrical
text implies the use of a system of cultural, ideological, and
theatrical codes functionally integrated to communicate a signifi-
cant message in order to transmit a coherent and believable model
of the world to a specific receiver or addressee.[11] The message is
simultaneously encoded according to the theatrical, ideological,
and political codes that constitute the horizon of expectations of
the potential addressee or receiver, within the historical and so-
cial contexts, at various levels, of the act of production of the text.
To this end Patrice Pavis has suggested a number of ideas directly
related to our proposal, for example:

> At the very most, by reinserting the work in its historical
> context, we might be able to approach this horizon at the
> approximate moment of its creation and entry into literary
> tradition and the ideological ambiance of its time.[12]

The strategy should begin by analyzing the texts themselves as
deictic signs. On the basis of this analysis we believe it is possible

to "construct" their potential addressees. The dramatic text can serve as an indicator of potential receivers. The text is one that is "marked" by its epoch and theatrical contextuality, a speech act that carries with it the specific conditions of its enunciation. It is a discourse that organizes situations and discursive positions based on the codes of theatricality operating within certain potential spectators. Therefore, any text can reveal its theatrical contextuality, since its production has been articulated according to those codes, products of a consensus between producers and addressees with respect to the system of cultural and generic conventions.

The critical tradition regarding literary periodization in Spain or Latin America has privileged the "author," his links to a "generation," or the transformations of the hegemonic cultural discourse. In the case of theater, the displacements of the spectator group, considered as one of a number of factors, determine the mutation of the theatrical codes and messages. We believe that a change in the potential spectator forces the producer of the text to transform the constitutive elements of the text in order to satisfy the interests of the spectator, or functions dialectically with the transformation of the horizon of expectations of the addressee. This shift causes a change in the aesthetic, cultural, ideological, or theatrical codes embedded in the text. On the other hand, the change in the horizon of expectations is a product or consequence of the social and cultural changes within a social structure.

The textual analysis should therefore be directed toward deciphering constitutive elements of the text in light of the horizon of expectations that served as the theatrical frame of its production,[13] assuming that through textual analysis we can construct the horizon of expectations of the theatrical text's potential audience. This "reconstruction" would allow us to propose a model for the history of theater which considers the potential addressee as a constitutive element of theatrical texts, the addressee himself being a "construction," a product based on the evidence in the preserved texts.

As for "producer" or "addressee" as collective entities, we do not consider them to be predetermined and unchanging, whether

because of social standing or other factors in general. Their definitions must be historical and should necessarily suggest their
dynamic quality, as well as the dialectical interrelation between
the various groups of theatrical producers and receivers in a
specific historical moment. The human groups which make up
the categories of potential producers or spectators are not determined by birth or social origin, but rather by a combination of
factors, among which the forces of cultural indoctrination or cultural mediation figure prominently as determinants.

It is not feasible to think of the Latin American "spectator" as
a single entity. The histories and analyses of Latin American
theater have not only neglected to study the addressee of theatrical discourse, but, when they have referred to him or her, it has
been only as a vague entity whose character generally coincides
with the theatrical tastes of the critic. In other words, the critic
envisions an audience that is merely the collectivization of himself. We believe it is necessary to characterize this in historical
terms. Both the producers as well as the potential receivers of
theatrical texts have changed in Latin America along with historical transformations, displacements of power, and the interdependence or discrepancies between cultural power and political
and economic power. It has been suggested, for example, that the
hegemonic theatrical discourse in Latin America has tended to
appeal to the spectator from the cultivated sectors of society, one
who is familiar with the theatrical codes of western European
culture and has "consumerist" pretensions; that is, one who is
concerned with being on top of what is produced in European
and North American theatrical circles. This characterization,
however, is inadequate because of the enormous historical differences among the various countries, since the ideological, economic, and political interests of the social groups that produce
theater vary from country to country in their relation to other
social sectors. It is meaningless to liken, for example, the situation of the middle class in Chile from 1960 to 1970 with that of
the same period in Cuba. While Cuban theatrical discourse was
compromised by the political forces that established as a norm
the value of literary discourse in sustaining or reaffirming the
revolution while simultaneously silencing antagonistic propos-

als, the Chilean theatrical discourse of the same period was characterized by an obvious proliferation of ideological proposals disguised by many types of aesthetic codes. In Chile after 1973, on the other hand, while the type of spectator of the hegemonic theatrical discourse did not change significantly, the relation of the producer of discourse to political power was radically altered. The similarity between the use and exploitation of theatrical procedures is a factor that must necessarily be included within the defining elements of theatrical discourse.

The first instances of Spanish theater in Latin America were probably produced by priests, whose addressees were not contemporary Spaniards, whether educated or not, but rather Latin American natives. Franciscan theater constituted in that historical moment the hegemonic cultural discourse directed toward a culturally marginalized sector of society. The hegemonic theatrical texts of the beginning of the period of Independence, on the other hand, were produced by the educated "liberal" sectors and meant for people of the same social and cultural group, who belonged mainly to the social sectors with agrarian interests.

A *unique* Latin American spectator does not exist, even within those sectors that could be considered hegemonic, which is why ideological and economic interests, as well as historical circumstances, influence the significant idiosyncracies of each country.

The Basic Categories

Types of Theatrical Discourses

WE PROPOSE below the following categories of theatrical discourse: hegemonic, displaced, marginal, and subjugated.[14]

a) *Hegemonic:* The discursive practice of the dominant cultural force within a particular social structure. It is based on the value system and cultural and ideological codes of the dominant cultural group, which is not necessarily—in the case of theater—the same as the dominant political or economic group.

b) *Displaced:* The type of discourse that was once hegemonic during a particular historical moment, but whose domi-

nance has disappeared within hegemonic circles, a dis-
placement which transforms it into an archaic or old-fash-
ioned model. In some cases it becomes hegemonic within
marginalized social or cultural sectors.

c) *Marginal:* The discourse that, while existing alongside he-
gemonic ones, is considered by these to be of lesser value
or lacking relevance. Generally, this discourse's marginal-
ity is a product of its producer's marginalized state, or the
marginality of its potential addressees. Rural theater, for
example, produced by and meant for the rural class, is a
type of marginal theater. It can also develop from the lack
of relevance or dominance of the aesthetic codes of theatri-
cal discourse. The aesthetic codes "marginalize" those dis-
courses not considered aesthetically satisfying, which are
meant for certain sectors outside the cultural elite.

d) *Subjugated:* The theatrical discourse that is prohibited by
the dominant political or cultural power. This prohibition
may be implied or explicit.

These categories are historical, and any theatrical discourse
may become one or the other, depending on the cultural, politi-
cal, or moral group in power.

The Categories for Periodization

THE FIRST step of the proposal is to establish the fundamental
categories that would constitute the basic units of the model as
well as the specific areas to be researched. All the categories
should include the interrelation of the three components of the
communicative process. The producer (emitter) of the discourse
is the point of reference, whose identity defines the basic cate-
gory, the *system.* Changes in the producer give rise to different
systems. The emitter, as we have suggested, adapts his discourse
to the horizon of expectations of the potential spectator, thus
creating *subsystems.* The *system* is made up of one or more types
of theatrical discourse produced by a social or cultural group.
The individual producer—the "author"—or the collective one—
theatrical companies—both belong to specific social sectors that
are ideologically and culturally definable within a social struc-
ture. A *subsystem* is composed of the combination of the various

theatrical discourses of a social group—system—in accordance with the displacements of the discourse's addressee. Therefore, the same type of emitter produces a number of subsystems according to the textual changes predetermined by the potential addressees as a collective entity. Each system can be composed of various subsystems.

We call the combination of systems and subsystems working interrelatedly within a specific historical moment the *macrosystem*, which denotes the synchronic perception of the multiplicity of systems and subsystems. The diachronic perception, which is the periodization model of the history of theater, we call the *megasystem*, which is the integrated and interrelated combination of displacements of substitutions of macrosystems perceived diachronically, as a historical process.

In order to avoid confusion regarding traditional notions of the history of theater, we propose the concept of *theatrical framework*. It differs from the previous categories in that it is not based on an interrelation with either the addressee or producer: it is composed of a combination of theatrical procedures or codes, which can be used in different ways by any system or subsystem as the ideological tools of different types of producers, in spite of the fact that some could mainly be associated within certain cultural groups or ideological trends. In this way, traditional concepts such as "theater of the absurd," "epic theater," or "surrealist theater" could constitute, in theory, *theatrical frameworks*.

Theoretically, for example, the "epic theater" framework has come to be associated with Marxist ideologies, as much because of its origin as because of its political possibilities. The workings of epic theater, however, can well be adapted to other ideological currents for similar didactic ends, even if the ideological results are different. At the same time, it would not be difficult to observe the way in which other theatrical frameworks rely on those procedures generally favored by the epic theater framework. This explains how a certain framework could be used within different, even conflicting, ideologies. These "schools," which we call "theatrical frameworks," can be used by any of the theatrical emitters and directed toward any of the potential spectators. Let us consider, for example, the coexistence of the so-called theater of the

absurd and epic theater in the mid-sixties in Latin America: both belonged to aesthetically Europeanized schools which served to satisfy the aesthetic codes of the educated middle class, those who are inclined to identify "culture" with whatever is produced in Europe. Originally, however, the methods of epic theater were used mainly by leftist Marxist producers trying to create a social conscience in their audience that would be critical of social conditions and their effects on human beings in society.[15] The theater of the absurd, on the other hand, was used by theatrical producers from the same cultural sectors, but who intended to provoke in the same audience a revelation of the evils of society which destroyed the individual, as well as their consequences. More recently, some of these procedures have become part of the theatrical codes without necessarily carrying ideological connotations.

How the Categories Work

THE DIVERSE ideologies of the producers do not necessarily represent different theatrical codes. However, the complete analysis of the ideological position—its world view and value system—combined with the other constituents of the text, forms a unit which reveals the horizon of expectations, a revelation which allows it to determine the potential addressee, as well as the intentions of the producer with respect to his addressee.

The model suggests that it is necessary to analyze the system in relation to its component subsystems in different historical instances. The theatrical producer's selection of a certain type of addressee is based upon the producer's ideological interests and the importance, from the sender's perspective, of the social group represented by the addressee. The change of addressee—substitution of subsystems—indicates a shift in interests, as well as changes in the theatrical and cultural codes of the producers.

The diachronic analysis of a system is also necessary, one which reveals the self-characterization of the producer group, the sectors it has chosen to address, and the variations in the theatrical messages and procedures used in each case.

How the Model Works

GIVEN THE impossibility of projecting this model onto the entire history of Latin American theater, we will conclude by outlining the parameters of a macrosystem within contemporary Latin American theater, with a few specific references to Chilean theatrical discourses and their contextuality. In actual practice, however, normally the schema are richer and the number of types of discourses demand greater flexibility than our model allows. Within each of these categories there are variations according to the multiplicity of cultural groups which make up the addressees, as well as historical and social transformations, the use of theater by the centers of power, or the cultural forces within the historical time frame of the discourses.[16]

An Example of a Macrosystem: Contemporary Latin American Theater

The Hegemonic Sectors as Producers

WE CONSIDER our point of reference to be the theatrical discourse produced mainly by the educated urban middle class. According to our typology, we refer to this system as the theatrical discourse of the hegemonic producer. This system of hegemonic producers (SHP) is composed of, at least, two subsystems:

1. SSHP–HA. A subsystem directed toward the culturally
 hegemonic sectors (hegemonic audience)
2. SSHP–MA. A subsystem directed toward the culturally
 marginalized sectors (marginal audience)

The historical reality, however, is more complex, as we can see in the case of contemporary Latin American theater: the hegemonic theatrical discourse is produced by the educated middle class, with various types of addressees (A), whether they be from the hegemonic sectors (SSHA) or from the marginal sectors (SSMA). For example:

1. SSHP–SSHA. Subsystem directed toward culturally he-
gemonic sectors
SSHP–HA-1: college theaters, etc.
SSHP–HA-2: professional theaters
SSHP–HA-3: children's theater
SSHP–HA-4: women of same social sector
SSHP–HA-n: other possibilities.
2. SSHP–SSMA. Subsystem directed toward marginalized
social sector
SSHP–MA-1: workers
SSHP–MA-2: peasants
SSHP–MA-3: *lumpen*
SSHP–MA-n: other possibilities

In Latin America, most of the canonized authors generally
belong to the category of middle-class producers of theatrical
discourses. This is an interesting fact, since critics have tended to
study some of them as representatives of a marginal, or marginal-
ized, national condition. This is the case with the work of Jorge
Díaz or Egon Wolff. From our perspective, these writers and the
companies that stage their work are middle-class producers who
direct their texts, for the most part, to certain groups within their
same sector. If some critics have taken them for examples of
marginal theater, it is because these critics use political power as
their point of reference. That is to say, these texts are "marginal"
to the centers of political power. They are not marginal, however,
from a theatrical perspective, since they are produced by cultural
sectors traditionally associated with "theatrical power," and meant
for the most part for the usual audience of culturally hegemonic
theater. It is hard to imagine that a text such as *Los invasores* was
produced to raise consciousness among *lumpen*, for example. As
the criticism has pointed out, its intent was to draw attention to
the middle class from the point of view of Christian Democrats in
Chile in 1963, before the victory of Eduardo Frei over Salvador
Allende. In terms of theatrical conventions, it uses a combination
of elements proper to hegemonic theatrical codes. Therefore, within
the schema we have proposed, this text belongs under SSHP–
HA-1: directed toward "progressive" sectors in which it wants to
raise consciousness about the current social or political problems,

insofar as they interest these middle-class sectors. An example of this type is Jorge Díaz's *Topografía de un desnudo*. In spite of its depiction of marginalized or *lumpen* characters, this text is not meant for the marginal sectors, but for the national bourgeoisie and the middle class, at a time when large sectors of marginalized society had acquired, or could potentially acquire, political power.

In our judgment, within the subsystem SSHP–MA category— texts produced by the same culturally hegemonic sector, but meant for marginal sectors—we would find those which Mariá de la Luz Hurtado has studied under the category of "melodrama."[17]—that is, those which are produced by the educated class, but with codes, motifs, characters, and messages that appeal to the less educated sectors. We can classify these texts under the SSHP–MA-n category. Other examples would include the texts directed toward the working class, SSHP–MA-1, or the peasant class, SSHP–MA-2.

The case of the *sainete* (a brief farce featuring stereotyped characters) is a similar one, since it is also generally directed toward the middle class, but in this case to a group of theater aficionados whose taste differs from that of those who establish the aesthetic hierarchy, those whom we have called hegemonic. In the editorial of the September 1984 issue of *Apuntes* dedicated to the *sainete*, it is described as an area of theater seldom studied by the hegemonic critical discourse, which would correspond in our schema to a subsystem SSHP–MA-n, since it is produced by the hegemonic social and theatrical sectors and meant for sectors within the same social class, only with different theatrical interests. These forms constitute for us variants of the same type of producer with texts directed toward different types of receivers.

The Marginal Sectors as Producers

A DIFFERENT situation is that in which members of marginal sectors have produced theatrical texts. The theatrical discourses produced by culturally marginalized sectors will make up the series of the system or systems of marginal producers (SMP). The SMP system is not composed of only one subsystem either, although it is less extensive and varied, we believe, than the theatrical dis

courses produced by the culturally hegemonic sectors, for obvious historical reasons. Since this is the least studied area, our proposals are even more hypothetical. Most of the texts have been studied from the perspective of the value system of the hegemonic theater. Consequently, their characterization from their own perspective becomes, for the moment, more conflicting and imprecise.

The system marginal producer, in the same organizing schema, would consist of at least two subsystems:

1. SSMP–MA. A subsystem directed toward marginal sectors, whether the same as the one which produced the discourse or not.
2. SSMP–HA. A subsystem directed toward culturally hegemonic sectors.

Once again, however, the actual situation is more complex, and offers possibilities such as the following:

1. SSMP–MA. Addressees from the same marginalized cultural sectors.
 SSMP–MA-1: workers
 SSMP–MA-2: peasants
 SSMP–MA-3: *lumpen*
 SSMP–MA-4: women
 SSMP–MA-5: children
2. SSMP–HA. Addressees from hegemonic cultural sectors
 SSMP–HA-1: university sectors
 SSMP–HA-2: sectors normally associated
 with professional theater
 SSMP–HA-n: other possibilities.

An example of theater produced by workers for an audience from the same cultural group is that studied by Pedro Bravo Elizondo, who has undertaken the study of a marginal producer sector of theatrical discourses directed toward the same marginal sectors: the mine workers in the north of Chile from 1900 to 1930.[18] An analysis from our perspective of the information provided by Bravo Elizondo would allow us to outline a subsystem for this period.

The theater of Juan Radrigán presents a difficult case. Theoretically, it is a text produced from the marginal groups, cultural as well as linguistic or social. Those who have studied the texts, however, have emphasized the "marginal" condition of its characters, projecting them onto a "universal" state of marginality or, in other cases, trying to show the modernity of the theatrical codes or the postmodernity of the characters' conditions. It goes without saying that these critics are part of the hegemonic critical discourse, for whom a text's justification is founded precisely on that universalization.[19] An example of this reading is the following paragraph:

> Two central elements are significant as differentiating factors: the characterization of social space and of the problems inherent to marginality, and, derived from this, a novel type of *social* theater on the one hand, and on the other, the aesthetic and dramatic proposition on which it is based, also peculiar to our contemporary theater.[20]

The most obvious observation is that the "author" himself—Radrigán—comes from marginalized social and economic sectors. He has also lived, for the most part, in these sectors. His characters and some of his texts are representative of marginal sectors in a very broad sense. Regarding the addressee, the critics cited above assert that "the stagings of Radrigán have reached syndicates, towns, schools, and, in general, traditionally peripheral places as easily as the main stages of professional theater" (p. 63). From this description we can infer a surprising variety of addressees, a fact that problematizes the proposed theoretical model.

We believe that this discourse belongs in the system in which an emitter from the marginal sector produces the texts, but within a subsystem whose final addressee is actually not the marginal audience, but rather sectors of the hegemonic theatrical space, space that characterizes itself as "marginal" to the dominant political power, but that is not necessarily marginal in terms of theatrical codes. This implied final addressee has ultimately given rise to the fact that within these sectors—marginal with respect

to the country's dominant political power—these texts are valued, not because of their theatrical marginality, but because they can be placed within hegemonic theatrical codes.

Another instance which presents a problem for our theory is the so-called *poblacional* theater.[21] In theory, it consists of the discourse produced by socially marginalized sectors and directed toward these same sectors, members of marginal populations producing texts for their peers. The problem, however, emerges when the hegemonic theatrical sectors intervene in the production of these texts, insofar as they interfere with the imposition or use of theatrical codes from the hegemonic space as tools for the realization of the theatrical and political project with which they aspire to communicate their political message. Usually the groups are organized and sponsored by representatives of the Catholic Church. In spite of this interference, we opt to insert these texts within the subsystem of the marginal producer and marginal addressee.

The theater of the oppressed which Boal discusses is a similar case to that of *poblacional* theater. The hegemonic social and theatrical sectors intervene, but, in the final analysis, both producer and addressee belong to the marginal sectors.[22]

THIS HYPOTHESIS of a historical model—whose validity presupposes a series of provisional practical applications—implies that a history should study each of these possibilities in itself, including its variants and interrelated systems.

This analytical strategy would then lead to the description of a group of similar texts that would make up a subsystem in terms of their similar recurring messages, a common implied image of the world, and a shared system of aesthetic and theatrical codes, all of which would allow us to posit a potential spectator, a type of spectator that would have to be verified through empirical studies. A change of system would presuppose a change of addressee—or audience—since this transformation would require the use of another system of theatrical codes to create the texts produced within the same cultural sector, but meant for audiences that operate within a different ideological, cultural, and theatrical system.

We believe that our categories address the heterogeneity of theatrical texts, establish the possibility of a historical description, diachronic as well as synchronic, allow the defining constituent factors of the theatrical act to acquire primary importance as factors for categorization, and, at the same time, include the ideological dimension of the producer and receiver as an essential element of periodization. The text is understood as a means of communication; therefore, the use of codes and theatrical procedures is useful for the communication of significant messages within a certain historical situation, and according to the horizon of expectations of the potential audience.

The proposal of new models for writing literary history, as we said at the beginning of this essay, implies a subversion of the established criteria for selecting texts and interpreting the cultural map. Literary criticism has always been an unconscious political commitment. To postulate the search for a theoretical model or the understanding of the production of theoretical models as partial contribution to the political denotes that the intellectual activity loses its ludic and intransitive connotations, and the intellectual activity regarding interpretations of literary texts becomes a conscious political act.

Notes

1. "Las teorías de la literatura hispanoamericana, pues, no podrían forjarse trasladándole e imponiéndole en bloque criterios que fueron forjados en relación con otras literaturas, las literaturas metropolitanas. . . . En los últimos años, a medida que la literatura hispanoamericana encontraba acogida y reconocimiento internacional, se ha hecho cada vez más evidente la incongruencia de seguir abordándola con un aparato conceptual forjado a partir de otras literaturas." Roberto Fernández Retamar, "Algunos problemas teóricos de la literatura hispanoamericana," Para una teoria de la literatura hispanoamericana (Mexico City: Editorial de Nuestro Tiempo, 1977), pp. 62, 68.

2. I have expanded this idea in "Utilización y refuncionalidad del discurso crítico hegemónico: El caso del teatro latinoamericano," in Texte, Kontexte, Strukturen: Homenaje a Karl Alfred Blüher (Tübingen: Gunter Narr Verlag Tubingen, 1987), pp. 401–413.

3. Abdul Jan Mohamed and David Lloyd, "Introduction: Toward a Theory of Minority Discourse," Cultural Critique (Spring 1987), 6:8. See this entire Cultural Critique issue on "The Nature and Context of Minority Discourse," especially Mohamed and Lloyd's "Introduction" and the essay by Arif Dirlik, "Culturalism as Hegemonic Ideology and Liberating Practice."

4. See also Edward Said, *The World, the Text, and the Critic.* (Cambridge: Harvard University Press, 1983), especially "Introduction: Secular Criticism," pp. 1–30.

5. I am using the term "ideology" as a descriptive term representing a relatively coherent set of "discourses" of values, representations and beliefs defining the model of the "real" by a social group. From this perspective "ideology" is related to structures of material production, so it reflects the experiential relations of individual subjects to their social and economic conditions. Ideology is a construction, a "model of the world" in the sense used by Lotman. It is a discursive "codification" of the "real" from the perspective of a social group, and in its conflicting relations to other social groups in a given historical period.

6. It is interesting to note that these kinds of proposals are more urgent in marginal cultures. David Kerr has noted the trend in theatrical practice: "All over the Third World aesthetic conventions are being overthrown. Audiences and performers are transforming the codes which govern the relations between them. This is happening not so much when westernized intellectuals react against the outworn aesthetics of the North, but when workers and peasants ally themselves with some committed intellectuals in an attempt to find a cultural weapon for articulating collective grievances." "Theatre and Social Issues in Malawi: Performers, Audiences, Aesthetics," *New Theatre Quarterly* (May 1988), 4 (14):173.

7. See Patrice Pavis, *Languages of the Stage* (New York: Performing Arts Publications, 1982), especially section 2, "Reception of Text and Performance"; Marco de Marinis, *Semiotica del teatro: L'analisi testuale dello spettacolo* (Milan: Bompani, 1982), and "Problemas de semiótica teatral: La relación espectáculo-espectador" *Gestos* (April 1986), 1:11–24; and Herbert Blau, "Ideology and Performance," *Theater Journal* (December 1983), 35(4): 441–460. Fernando de Toro, in *Semiótica del teatro* (Buenos Aires: Galerna, 1987), has applied the theory of reception to Latin American theater.

8. Marinis, "Theatrical Comprehension: A Socio-Semiotic Approach," *Theater* (Winter 1983), pp. 12–17; excerpt from p. 15.

9. Eagleton, *Criticism and Ideology* (London: Verso, 1980), p. 48.

10. Jauss, "Literary History as a Challenge to Literary Theory," *Toward an Aesthetic of Reception* (Minneapolis: University of Minnesota Press, 1982), p. 26.

11. Patrice Pavis cites a sentence of Rainer Warning's that summarizes our position: "Every reception is defined initially as a confrontation between the receiver and a model of reality which, however mediate it may be, constitutes for him a model of his historical situation." Rainer Warning, "Pour une pragmatique du discourse fictionnel," *Poétique* (September 1979), 39:327, quoted by Pavis in *Languages of the Stage,* p. 77.

12. Pavis, "The Aesthetics of Reception: Variations on a Few Relationships," *Languages of the Stage,* p. 76.

13. I use the term "theatrical frame" in the sense used by Keir Elam in *The Semiotics of Theatre and Drama* (London and New York: Methuen, 1980). See especially the section "Theatrical Competence: Frame, Convention and the Role of the Audience," pp. 87–97.

14. I have expanded on these categories in "Historia del teatro hispanoamericano: Tipos de discursos críticos y discursos teatrales," *Dispositio* (forthcoming).

15. See Fernando de Toro, *Brecht en el teatro hispanoamericano contempor-*

áneo: *Acercamiento semiótico al teatro épico en Hispanoamérica* (Ottawa: Girol Books, 1984).

16. I have applied this conception of theater to contemporary Chilean theater. See, for example, my "Teatro chileno afianzamiento de los sectores medios," *Ideologies and Literature* (September-October 1983), 4 (17):306–318; "Teatro y público: El teatro de Jorge Díaz, 1961–1965," *Estreno* (Fall 1983), 9(2):7–9; "El discurso teatral y el discurso crítico: El caso de Chile," *Homenaje a Rodolfo Oroz, Anales de la Universidad de Chile* (1984), no. 5, pp. 317–336; "Discurso dramático teatral latinoamericano y discurso crítico: Algunas aproximaciones estratégicas," *Latin American Theater Review* (Fall 1984), pp. 5–12; "Discurso crítico hegemónico y discursos teatrales marginales: El caso de Chile," *Literatura Chilena: Creación y Crítica* (Spring 1986), 36–37:4–7; "Los marginados como personajes: Teatro chileno de la década de los sesenta," *Latin American Theater Review* (University of Kansas; Spring 1986), pp. 85–95.

17. See *Apuntes* (September 1984), no. 92, especially the essay by María de la Luz Hurtado y Loreto Valenzuela, "Teatro y Sociedad chilena en la mitad del siglo XX: El sainete."

18. See Pedro Bravo Elizondo, *Cultura y teatro obreros en Chile, 1900–1930* (Madrid: Libros del Meridión, 1986).

19. On Radrigán, see "Los niveles de marginalidad en Radrigán" by María de la Luz Hurtado y Juan Andrés Piña, and "Juan Radrigán: Los límites de la imaginación dialógica" by Hernán Vidal, in *Teatro de Juan Radrigán* (Santiago: Editorial Universitaria, 1984). See also Rodrigo Cánovas, "Ictus y Radrigán: Mejorando al hombre," in *Lihn, Zurita, Ictus, Radrigán: Literatura chilena y experiencia autoritaria* (Santiago: Flacso, 1986).

20. Hurtado and Piña, "Los niveles de marginalidad en Radrigán," p. 6.

21. See Carlos Oschsenius, *Encuentro de teatro poblacional* (Santiago: CENECA, 1982). Probably the best translation for *teatro poblacional* is "theater of shanty-towns," or, in some cases, "theater of marginal populations."

22. See Augusto Boal, *Teatro del oprimido y otras poéticas políticas* (Buenos Aires: Ediciones de la Flor, 1974), and *Categorías del teatro popular* (Buenos Aires: Ediciones Cepe, 1972). See also Yan Micalski, "The Active Spectator Takes the Floor: An Interview with Augusto Boal," *Theater* (1980), 12(1):14–18.

11

FACE TO FACE: PLATO'S *PROTAGORAS* AS A MODEL FOR COLLECTIVE RESEARCH IN THE HUMANITIES

J. Hillis Miller

IS COLLECTIVE research in the humanities possible? More narrowly, is collective research in critical theory possible? If it is possible, what would it be like? Is collective research in the humanities in any way tied to the place where it takes place, to the institution that houses it, to the community or the surrounding culture, perhaps even to the geography, the landscape, the climate, so that it would not be an absurdity to speak of "California Criticism"? What would be the nature of that topographical tie? Might our thinking about critical theory here be determined in some obscure way by the fact that it is carried out on the surface of a land that lives not only in the sunshine, between the mountains and the sea, but within the imminence of a catastrophic earthquake, our version of the apocalyptic "There will come a time!"? These last questions may seem absurd, but they bear on the possibility of a difference between research in the sciences and research in the humanities. The sciences, like their basic mathematical languages, may be freely and universally transferable, from climate to climate, from country to country, without essential loss. Research in the humanities, on the other hand, may need to be carried on in a particular idiomatic language that is in some way rooted in the place where it takes place.

Research in the humanities would therefore be impossible to move from one place to another without essential loss or at any rate without fundamental, perhaps productive and creative, transformation. Many thinkers have believed that this is the case.

These are some of the questions posed by the establishment of our Critical Theory Institute. The foundation of the institute presupposes that the answers to the first two questions are positive, that is, that collective research in the humanities and in critical theory in particular are possible. The foundation of our institute also appears to presuppose that we know the answer to the third question, that is, that we know what collective or cooperative research in critical theory is like and that we are ready to get on with it. I am not sure that this is the case, nor even that we think it is so or want to believe that it is so. If we really knew what we are going to do it would not be worth doing. The founding of such a Critical Theory Institute is hazardous, extrapolative, inventive, a launching out into the unknown, like a bridge with one abutment built out into the void. In this paper I propose to identify and test out certain hypothetical models of what collective research in critical theory or in the humanities generally might be like. Such thinking is done best when it is anchored to exempla. My example is Plato's *Protagoras*.

But first a further word about our present situation, here and now, when the Focused Research Program in Contemporary Critical Theory, or FRP, here at Irvine is about to be transformed or translated, so we hope, into an Organized Research Unit, an ORU. These acronyms are borrowed from the sciences, as is the concept of collective research. All of the terms used are problematic and might provide the occasion for lengthy reflection. "Focused"? "Research"? "Program"? "Organized"? "Unit"? We in the humanities imagine the scientists know what they mean by these terms and by the concept of focused or organized collective research that such units in biology or physics or medicine carry on. We imagine an organized group of scientists including graduate students, even undergraduates, postdoctorals, young and older faculty members, research associates, and laboratory technicians engaged in a collective enterprise that is teleological in the sense that it is oriented toward a clear goal, identifing the AIDS virus

and finding out how it works, so a cure for AIDS may be found, or discovering materials that superconduct at higher and higher temperatures, or finding the causes of ozone depletion. Such collective researchers, we humanists imagine, know what they are doing while they are doing it, and they are able to say when they have succeeded in doing it. Such research is guided by that principle of reason, or universal accountability, that is the underlying ground of the modern university in general, of which such focused or organized research programs or units are a conspicuous part. The current rapid increase in the involvement of industry in such scientific research and the shift toward collective research by groups of researchers from more than one university or even from more than one country does not in principle change the presupposed model of collective research in the sciences.

A moment's reflection will show that any collective research that is actually done in the humanities or even contemplated, for example projected in research proposals, matches the scientific model uneasily and imperfectly, with a good deal of metaphorical wrenching. Though we try, for example in research proposals, to describe what we do and what we want to do in terms of clear and measurable goals, it is much more likely to be the case that we do not really know what we are going to find interesting until we do it. The whole process is much messier and more unpredictable than we imagine it is in the sciences.

In addition, the identification of exemplary cases or of worthy projects is much more difficult in the humanities. Whereas in the sciences there appears to be at any one time a fair agreement on what is important and why, in the humanities there is far less agreement about what are the important problems or examples. The choice of a project is far more likely to appear, perhaps in fact to be, random, contingent, ultimately unjustified and unjustifiable, though it may feel like the response to an irresistible exigency. The researcher just happens to get interested in doing a certain piece of work. In the case of the present essay the command on me to read Plato's *Protagoras* occurred by way of a dissertation chapter I was obliged to read. In order to read that reading I had to read the *Protagoras*, and when I did so the demand on me to write about it was compelling, exigent, urgent,

since the dialogue fitted so exactly research I was then doing on narrative and the trope of prosopopoeia.

Though there is of course an abundant secondary literature on the *Protagoras*, the best essay by far on it that I know is that chapter, a brilliant long essay by Thomas Cohen entitled "Hyperbaton." Cohen's essay breaks new ground and presents a radically new way of reading this dialogue. His work recognizes as no previous essay does the relation between formal narrative features and linguistic details, on the one hand, and conceptual meaning, on the other. I found when I read it that Cohen's essay had anticipated what I say about the narrative structure of the dialogue. Cohen had also recognized the role of prosopopoeia in the *Protagoras*, as well as the role of the father-son and brother-brother relations as figures for the conceptual arguments of the dialogue. Cohen's essay, part of his Ph.D. dissertation (Yale, Comparative Literature, 1988), is a comprehensive reading of the *Protagoras* in the context of Plato's other dialogues and in the context of the complex history of interpretations of the *Protagoras*. It will, I hope, soon be published as a book-length study, and it is of course available now from University Microfilms. The relation between his work and mine is a much more common feature of work in the humanities than anything like the side-by-side collaborative work we humanists imagine takes place routinely in the sciences.

If the initiation of research in the humanities is likely to be fortuitous, it is also much more difficult in such research to say when or whether you have really done what you set out to do, more difficult to say when you have reached the goal initially set by the research proposal.

The model of collective teamwork in the sciences, finally, tends to become in the humanities an uneasy mixture of some idea of "dialogue" among humanists brought together temporarily in a "humanities institute," where they are likely to present papers to one another, plus the venerable model of the learned humanist isolated and alone in his study or in the library, carrying out research as an organized unit of one person. Such a unit is a single "I" or subjectivity face to face with the "materials of research," books or manuscripts, taking notes and then writing his

or her book. Such a researcher presents the results of her or his research ultimately as guaranteed only by the wisdom and learning of that sole "I," as in those ritual formulas on the dedicatory page of books in the humanities: "I have been helped by many people, without whom this book could not have been written, but the errors and deficiencies in this book are all my own." I suspect that our image of the solitary researcher in the humanities is a displacement, perhaps a somewhat comical, ironic, or farcical displacement, of the idea of the creative genius, a concept that in its modern form arose more or less at the same time as the idea of the research university governed by the notion that everything can and should be accounted for. Who could think of the "Ode on a Grecian Urn" or *The Critique of Pure Reason* or *Middlemarch* as having being written by an "organized research unit"? The researcher as after all a private "I," plus the notion of a beneficial face-to-face dialogue among such separate selves—that is likely to be the more or less explicit model of collective research in the humanities.

It is the business of our new Organized Research Unit in Contemporary Critical Theory, I take it, among other things, to reflect on the viability of this model and to experiment with other ways of doing collective research in the humanities, to propose and try out new models. This seems to me one of the most exciting and exhilarating prospects for our new Critical Theory Institute. The University of California at Irvine, as a new university with a good deal of openness and flexibility, a university committed, moreover, to "research" in all fields, seems to me an ideal place for such experimentation. We begin this, moreover, at a moment when the traditional university structure in the humanities, with its firm separation between departments, its firm division into undergraduate, graduate, and postdoctoral students, its division into lecture course, seminars, and reading courses, is being replaced by what I am learning to call "the hidden university." This is the vast interlocking network of humanities centers, institutes, interdisciplinary programs, study groups, and ongoing seminars. It involves a shift of collective research in the humanities to much more fluid research and teaching groups, often of students and teachers not even "officially" located at the same uni-

versity. Technological developments such as tape recorders, xe-roxing, word processing computers, and relatively inexpensive telephoning and travel by jetplane obviously are necessary to make this possible. Such research groups already exist in one way or another not only in this country but in England, Germany, Italy, and France, also in Uruguay, to my knowledge, no doubt elsewhere too.

Our new Critical Theory Institute can make an important con-tribution in this frontier area of collective research in the human-ities. It can do this, for example, but it is only one example, by bringing a group of brilliant young theorists and critics from other universities to Irvine, on a regular basis, either at the same time or in sequence, to present their current work to both students and colleagues here over a two- or three-week period in a form neither that of the traditional seminar nor that of the symposium paper or lecture series, but in a new experimental format that it would be one of the objects of the experiment to determine; I imagine something closer to that of an ongoing working research group. This kind of innovation can occur only if we reflect critically and boldly about just what the new developments mean and about how they may best be capitalized on to devise new meanings for "collective research in the humanities."

This means asking yet again: just what do we mean by it, by collective research in the humanities, or even by research in the humanities as such? Plato's *Protagoras* may help here. It presents an extraordinary range or repertoire of different models for re-search in the humanities, cooperative or solitary. I have spoken of "dialogue" as one of our current models for collective research in the humanities. The *Protagoras* is a dialogue of admirable complexity and diversity. Its subject is the question of whether virtue can be taught. Its target is the claim of sophists like Prota-goras that virtue can be taught, as opposed to Socrates' claim that virtue is a matter of innate knowledge. But things are not so simple in the *Protagoras*, as any reader of the dialogue knows. Teaching virtue: surely the *Protagoras* is meant not only to talk about teaching virtue but effectively to do it. And surely the teaching of virtue, in one way or another, is one of the traditional functions of study, teaching, and research in the humanities.

The dialogue presents a multitude of paradigmatic examples of how that might happen. In the opening, or almost opening, discussion between Socrates and the young Hippocrates, the *Protagoras* shows the somewhat older sage teaching the ephebe through a solitary question-and-answer session, something like what we would today call a tutorial. This relation, like other forms of research in the dialogue, is presented as a displacement of the father-son relation that appears repeatedly as a leitmotif and as perhaps the basic pardigm of how virtue should be taught, that is, by a father to his son. Socrates and Hippocrates then go to the house of Callias, where the great Protagoras is pacing back and forth in earnest discussion with a crowd of Athenians and strangers, while Hippias and Prodicus are holding forth to seated auditors in other parts of the house on other porticoes. Each is presenting a kind of discussion seminar.

Protagoras a little later, in answer to Socrates' assertion that he does not believe virtue can be taught, makes a long speech, of the sort for which he was famous. The speech contains the myth of Epimetheus and Prometheus, the first myth in Plato. Protagoras' speech may be thought of either as a lecture, such as we would today present at a symposium or a colloquium, or it might be thought of as the use of a narrative to teach and to carry on research in a topic in the humanities. Later on Socrates ties Protagoras in knots with the ironic question method for which he is famous, but, before that, the pair of them engage in an admirable example of what might be called an extempore public explication of a poem, in this case a poem by Simonides that appears to be self-contradictory on the question of whether it is difficult to become a good man, that is, virtuous. Or one could think of this as a splendid example of the sort of thing that goes on, or ought to go on, today in what are called "study groups," surely an important part of our "hidden university." A group of people gather together around a single text to "read" it.

One would need, in addition, to include among examples of research in the humanities the whole dialogue, with the exception of the first episode. It is a narrative spoken by Socrates to an unnamed friend to excuse himself, to explain why he has been so late for his appointment, just as Prometheus came too late to

prevent his somewhat stupid brother, Epimetheus, from leaving man out in the distribution of the gifts of the gods. Looking at the dialogue this way might remind us that research in the humanities, collective or solitary, is often, perhaps always should be, motivated, that is, aimed not just as producing neutral knowledge, but at being performative, productive, at making something happen.

Then one would need finally, to complete my repertoire of the modes of research in the humanities exemplified here, to think of Plato himself sitting presumably in solitude writing down the text of the *Protagoras*, and then of me today sitting in solitude before my computer writing my commentary on the *Protagoras*. Whatever notorious priority Plato (or Socrates) gave to oral over written discourse, Plato was a writer, as are still most researchers in the humanities today. We are likely to feel that colloquium or symposium or working seminar is not complete or successful until its transactions have been printed as a book of collective essays, often with the record of extempore discussions attached. Such a book then becomes part of the immense and rapidly growing archive of research in the humanities.

All these models for research in the humanities, diverse as they are, depend in one way or another on the notion that such research is personal. Research in the humanities is carried on by one or more persons or selves working either in private or in some kind of face-to-face dialogue. The trope of personification or prosopopoeia, however, on which not only all storytelling but all identification of a particular philosophical position with a person depends, as when we say "Humean skepticism" or "Kantian ethics," or "Joycean narrative technique," is itself discretely made a basic issue in the *Protagoras*, not simply employed. Let me show briefly how that happens and how it is related to the manifest topic of the dialogue, and then return in conclusion to what "Plato's" somewhat covert ideas about prosopopoeia would imply for collective research in the humanities. My remarks on the *Protagoras* focus on a few words in what is an extraordinarily complex narrative and verbal structure, as recent commentators on the *Protagoras* (such as Harry Berger and, most brilliantly, Thomas Cohen) have recognized.

Overt prosopopoeias punctuate the dialogue at crucial places. The motif of the face appears early in the dialogue when Socrates asks the young Hippocrates what would happen if he had "to face [*prosepoito*] the further question" (311e) of what he hopes to become by going to Protagoras.[1] Hippocrates blushes at this, and Socrates reports that he could see the blush on his face by the first glimmer of daylight. Later on, in his description of the crowd at Callias' house listening to Protagoras, Hippias, and Prodicus, Socrates describes the latter two in phrases taken from Odysseus' visit to the underworld, in Book xi of the *Odyssey*. There would be much to say about these allusions, but they would come down to saying that they define the dialogue as a raising of the dead *as dead*, or, in the case of Socrates rather than of Plato, as striking the still living dead by speaking of them as if they were dead, that is, in either case, as an elaborate effect of prosopopoeia. The allusions to Homer identify the epic visit to the underworld as what might be called a prosopopoeia of prosopopoeia, the foregrounding and identification of this trope as the fundamental trope of narrative.

Later on Socrates twice prepares the way for his undoing of Protagoras by getting him to say that the different facets of virtue are related to virtue itself not as parts of a piece of gold to the whole lump, but "in the relation of the parts of a face to the whole [*hosper ta tou prosopon moria echei pros to holon prosopon]*" (329d-e, and see also 349b-d).

The final example of an overt prosopoeia in the *Protagoras* occurs in the context of these previous foregroundings of the trope. It returns the reader to the question of the use of narrative to teach the truth about virtue and to teach virtue. There is time here to talk in a little detail only about this final example of the trope. This extraordinary passage comes just before the end of the dialogue:

> I assure you, said [Socrates], that in asking all these ques-
> tions I have nothing else in view but my desire to learn the
> truth about virtue and what it is in itself. I know that if we
> could be clear about that, it would throw the fullest light on
> the question over which you and I have spun such a coil of
> argument, I maintaining that virtue was not teachable and

you that it was. It seems to me that the present outcome of
our talk [he arti exodos ton logon, more literally "the pres-
ent outcome of the arguments"; logon is plural) is pointing
at us, like a human adversary, the finger of accusation and
scorn. If it had a voice it would say: "What an absurd [ato-
poi] pair you are, Socrates and Protagoras. One of you, hav-
ing said at the beginning that virtue is not teachable, now is
bent upon contradicting himself by trying to demonstrate
that everything is knowledge—justice, temperance, and
courage alike—which is the best way to prove that virtue is
teachable. If virtue were something other than knowledge,
as Protagoras tried to prove, obviously it could not be taught.
But if it turns out to be, as a single whole, knowledge—
which is what you are urging, Socrates—then it will be most
surprising if it cannot be taught. Protagoras on the other
hand, who at the beginning supposed it to be teachable, now
on the contrary seems to be bent on showing that it is almost
anything rather than knowledge, and this would make it
least likely to be teachable." (360e–361c)

"If it had a voice," but of course the "present outcome of our
talk" only has the voice that is ascribed to it by Socrates, who
here shows himself a master of that rhetorical device called pro-
sopopoeia. The function of this final appearance of the trope of
personification just here is subtle and not all that easy to pin
down. Like the questions of what virtue is and whether it can be
taught, it is elusive. At the farthest reaches of their interchange,
at the present end of their "coil of argument," Socrates and Pro-
tagoras have reached an impasse, an "aporia." This aporia takes
the particular form of a chiasmus. Beginning with similar as-
sumptions about virtue (that it is like a face and not like a lump
of gold), but opposite opinions about whether virtue can be taught,
Socrates and Protagoras have crossed one another at some point
in their discussion. Each now appears to hold the opinion for-
merly held by the other. This is a particularly unpleasant form of
madness, if one means by sanity the ability to control one's argu-
ment and remain logically consistent, everywhere and through
time one with oneself, as a coherent self ought to be. It is as
though the "coil of argument" had a life of its own and were able
to depersonalize those caught up in it, forcing them in spite of

themselves to reach positions they thought they were contesting. It appears as if "Socrates" and "Protagoras" are not so much real people as the personification of certain procedures of argumentation. These procedures, moreover, lead those caught up in them to the blankness and logical absurdity of an impasse in the argument beyond which it is not clear that it is possible to progress.

What about Plato himself? Is he not in full control of the dialogue he has so cunningly constructed, with an irony that even outdoes and masters Socrates' own irony? Who, after all, speaks or orchestrates the dialogue, labelling the opening speeches as made by "Friend" or by "Socrates"? The answer is surely that Plato himself is the ultimate authorizing authority, but he exerts that authority through an extravagant use of prosopopoeia, that is, in a way that depersonalizes him, renders him without personal authority. I mean this in the sense that it is impossible to quote any sentence of the dialogue and say, "Plato says this," since everything is spoken by some invented character, with how much or how little irony on Plato's part it is impossible to say. Plato has effaced himself, made himself faceless. He has vanished into the personae of the dialogue. Not only can we not say, "Plato says." We cannot even say, "He (Socrates or Protagoras) says," since the trope of prosopopoeia is dismantled within the text itself. It is shown to be the fictive ascription of personality to an impersonal power of language. We can only say, "Language speaks," but must see that, in the *Protagoras* at least, language speaks in a way that deprives it of the commanding authority of logical coherence.

This incoherence, along with the impossibility of knowing whether anything said by anyone in the dialogue is affirmed by Plato himself, is the particular way in which the *Protagoras* is "unreadable." The reversal of the positions of Socrates and Protagoras that leads the dialogue to end in what Socrates calls "utter confusion" indicates that language itself cannot be trusted to lead to clarify, even by the most extravagant procedures of linguistic hygiene, as Prodicus in the dialogue appears to believe, but rather to a tantalizing lack of clarity and conclusiveness. The chiasmus of Socrates and Protagoras seems rather to demonstrate that if you just go on talking you will ultimately change places with your

adversary. Personification is, therefore, shown both to be neces-
sary to teaching about virtue and to teaching virtue, and at the
same time the use of that trope is shown to deprive the teaching
of whatever authority it might gain from being the unequivocal
affirmation of a sage, a wise man who knows what virtue is and
can speak coherently and persuasively about it.

After all this talk we do not yet know what virtue is and
whether it can be taught. We have not confronted virtue face to
face. But the situation is even worse. As though by another kind
of reflex, reversal, or chiasmus, the depersonalizing of Socrates
and Protagoras, making them into artificial tropes for an imper-
sonal possibility of argument, has led to the personification not
of virtue itself (*that* has slipped away altogether) but of "the
present outcome of our talk." As for Wallace Stevens in so many
of his late poems, the human face remains at the farthest reach of
imagination, blocking the attempt to reach "not ideas about the
thing but the thing itself," so here for Plato the final end of the
coil of argument is the confrontation of a laughing scornful face,
not the face of virtue but the face of the aporia itself, the present
outcome of the talk. This face blocks further progress in the
attempt to reach and face virtue. The fundamental means of the
argument, prosopopoeia, becomes in the end the barrier forbid-
ding further progress beyond what is now presented as no more
than a trope, a rhetorical artifice. "*If* it had a voice, it would say,"
but of course it does not have a face or a voice.

The *Protagoras* ends, then, not with a confrontation with virtue
but with a confrontation of the trope that has both made the
dialogue possible, with all its brilliant narrative complexity, and
at the same time seems to lead in the end only to a confrontation
with itself, not to a clarification of the topic it was meant to
identify and teach. This self-confrontation is mimed by the
embedded or invaginated structure of the narration, as it turns
back on itself or inside itself, like the finger of a glove reversed
within itself, making the inside outside, the outside in. The dia-
logue ends with Socrates about to go late to his appointment with
the friend to whom he presents the whole narrative of his encoun-
ter with Protagoras as an excuse.

Socrates' response to this situation is to say he would like to

start all over again and see if he cannot untangle the confusion and reach the truth about virtue and its teachability. Plato presents Socrates as doing just that, for example in the *Meno*, which follows the *Protagoras* in the usual ordering of Plato's dialogues, though alas the *Meno* too leads once more to uncertainty about what virtue is in itself and how men get it: "But we shall not understand the truth of the matter until, before asking how men get virtue, we try to discover what virtue is in and by itself" (*Meno*, 100b). No doubt we should follow Socrates' lead too and keep searching.

Meanwhile, the present outcome of my argument would seem to indicate that research in the humanities can be collective all right, but in an odd sense, not like the division of labor and cooperative work on a single project that I imagine is the case in the sciences. Nor will Plato give support to the models either of the egological or dialogical kind for research in the humanities. In the case of the humanities the instrument of research is the researcher, a much more delicate, unpredictable, and fortuitous instrument than any machine. Nor is it the case that the researcher in the humanities is an "I" that decides to do certain thinking. The thinking occurs in the mind or on the computer of the researcher. It occurs no doubt in part as a result of circumstances, such as the side by side or face to face presence of others, but not in a way that can be predicted or controlled or institutionalized, nor does it seem determined by the place in which it occurs, though that place, like other historical circumstances, may establish some kind of limit or edge to virtually limitless possibilities. The best you can do is to put some good people together and hope something will happen. Who could have predicted, on the basis of his "historical context," that Plato would write the *Protagoras*? Who can account for it by an account of its antecedents?

The outcome of my reading of a tiny fragment of the *Protagoras* suggests, on the contrary, that research in the humanities is neither the responsibility of the solitary scholar working in private nor the result of the give and take of conversation within a group gathered in the same place. It is rather something that takes place, if it takes place, as the taking possession of this or that "person"

or this or that group of persons by a way of thinking or articulation of thought that so to speak operates of itself. This way of thinking is a demand to think, speak, and write in a certain way, in response to one form or another of an act of reading that is not to be understood according to the metaphor of a "conversation with texts." The way of thinking that constitutes research in the humanities, like reading in general, if it really takes place, is always different from what the researchers intended or expected. In that sense it is out of their control, as Socrates and Protagoras change places without apparently meaning to do so (though it is always difficult to know what Socrates' irony foresees or intends; his expression of surprise, or the expression of scornful surprise he ascribes to the present outcome of the argument, may be ironic).

The outcome of research in the humanities, moreover, whether it is solitary or collective, is always provisional, inconclusive, indecisive, like the outcome of the dialogue between Socrates and Protagoras, which ends in "utter confusion." Research in the humanities always ends in a moment of postponement or deferral. It ends not with the sense of a goal of research triumphantly reached, but with the sense of a need for further talk and further research later on. The ending of the *Protagoras* may be taken as a miniature allegory of that. Protagoras wants nothing more than to escape from being tied in knots by Socrates, and Socrates is late for his appointment:

> [Socrates:] For my part, Protagoras, when I see the subject in such utter confusion I feel the liveliest desire to clear it up. I should like to follow up our present talk with a determined attack on virtue itself and its essential nature. Then we could return to the question whether or not it can be taught. . . .
> [Protagoras:] Well, we will talk of these matters at some future meeting, whenever you like, but now it is time to turn to other things.
> [Socrates:] . . . Indeed I ought long ago to have kept the appointment I mentioned. (361c, e, 362a)

It is now high time for me to end too.

Notes

1. I cite the translation of W. K. C. Guthrie: Plato, *Protagoras* and *Meno* (Harmondsworth, Middlesex, England: Penguin Books, 1982), p. 99. Further citations will be from this edition, identified by the traditional arabic numbers and lower case letters.

12
AFTER THE SUBLIME:
THE STATE OF AESTHETICS
Jean-François Lyotard

I WOULD like to focus the question of the state (or states) of aesthetics on the topic of matter or materia. I shall give here an overview of the general argument.

I believe, first of all, that one cannot avoid returning to the "Analytic of the Sublime" in Kant's *Third Critique*,[1] at least, that is, if one wants to have an idea of what is at stake in modernism, especially in the avant-gardes in painting and music. I propose the following principles for dealing with the phenomenon of modernism.

Since the turn of the century, the arts no longer deal with the beautiful but with something like the sublime. I am not considering here the current trends in painting, architecture, and music, which seem to me to be searching for a return to the traditional values of taste—I mean trans-avant-gardism, new expressionism, new subjectivism, postmodernism, and so on. I consider all these "movements" to be the products of an overlapping between two fields which, I feel, must be posited separately and kept apart from each other: namely, the fields of cultural activities and artistic work. What distinguishes painters and writers is that they must be responsive and responsible to the questions: What is it to write? What is it to paint? They can also, of course, be confronted with demands coming from a real or virtual audience, with the cultural market or industry, but these demands are exterior to their writing or painting. For example, to have to think and to have to teach (which is a cultural activity) are not the same thing. I have no contempt for cultural activities; they are simply totally

This article was written in English, "revisited" by Anne Tomiche.

different from artistic work (which includes what I mean by thinking).

One of the most decisive features uncovered by Kant's analysis of the sublime is the collapse or failure of imagination in the sublime feeling. Imagination is the power of presenting. It is not only the power of presenting *sensoria* but also, when the imagination is freed from the conditions required by the faculty of concepts (understanding), the power of presenting in order to achieve knowledge of an experience. Imagination is then the power of presenting data in general, including "imaginative" or even "created" data. Since every presentation consists in a *mise en forme*, in putting matter into forms, the collapse of imagination must be understood, as Kant shows, as an indication of the irrelevance of forms in the sublime feeling. But then, if forms are no longer there, what about matter? And what about presence?

The resolution of such a paradox, that is, the paradox of an aesthetics without perceivable or imaginative forms, consists in the movement of Kantian thought towards the principle that there is a connection between an Idea of reason and the impotency of imagination. In the sublime "situation," something like an Absolute, either an absolute magnitude or an absolute cause (or power), is made quasiperceivable, thanks to the very failure of the faculty of presentation. This Absolute is nothing other than the object of an Idea of reason.

One can legitimately wonder whether this shift from imagination to pure reason (be it theoretical or practical) leaves any room for an aesthetics. The main *interest* Kant sees in the sublime feeling lies in the fact that it is the "aesthetic" (negative) sign of a transcendency proper to ethics, the transcendency of moral law and freedom. In any case, the sublime cannot be the fact of human art, nor can it be the fact of a meaningful nature. It represents the case where nature ceases to address us in its *Chiffreschrift*, its ciphered script or scripture, or in its forms, which are visual or auditive landscapes and which provide feelings of pure pleasure and induce our mind to decipher those enigmatic signs. Nature, Kant claims, is no longer the addressor of ciphered, tangible, messages whose addressee is imagination. On the contrary,

it is used and even exploited by the mind for a purpose which is not its own, which is not even a purposiveness without purpose, as is the case in the feeling of beauty. The sublime is a *Geistesgefühl*, a feeling of the mind, whereas the beautiful is a feeling stemming from the affinity between nature and mind, or, and it amounts to the same thing, between imagination and understanding. This wedding, or at least this engagement, is broken off by the sublime. The Idea, especially the Idea of pure practical reason—Law and freedom—sketches its own quasipresentation within the split of imagination and finally by means of a lack or a loss of nature. The *Geistesgefühl*, the feeling of the mind, indicates that the mind lacks nature, that nature is missing from it. It can only feel itself. In this sense, the sublime is nothing other than the sacrificial announcement of ethics in the aesthetic field —sacrificial because it requires that the imaginative nature be sacrificed in the interest of practical reason (which entails specific problems regarding the ethical evaluation of the sublime feeling). It announces the end of an aesthetics, the aesthetics of the beautiful, on behalf of the mind's final destination, which is freedom.

Starting out from these considerations, my principal question is: What about *art*, painting or music? That is, what about art and not moral practice within the context of such a disaster? What can an art be when it must operate not only without determining concepts (as shown by the "Analytic of the Beautiful") but also without the spontaneous free forms attributed to it in the case of taste? What could remain at stake for the human mind when it plays with presentation (as is the case for all art), if presentation itself is assumed to be impossible?

We have, I think, an advantage over Kant (it is only a matter of chronology) in that we are able to draw from experiments and experimentations made by Western painters and musicians over the last two centuries. It would be arrogant and stupid to try to assign a univocal interpretation to this flourishing display of plastic and sonic experiments. Nevertheless, I would like to point out and insist on a problem that seems to me highly relevant and enlightening, given the hypothesis of formlessness, which is in-

herited from Kant's analysis of the sublime. The problem is precisely that of matter or materia in fine arts, which, I want to suggest, may in fact be another name for presence.

For two millennia, there has existed, at least in Western thought, the presupposition, even the prejudice, the ready-made attitude, that the process of art had to be understood in accordance with the principle that there is an opposition between matter and form (or mind). The prejudice is still at work in Kant's analysis itself. For example, what guarantees the purity of taste, what preserves aesthetic pleasure from the play of empirical interests and "pathological" preferences, from the fulfillment of particular motivations? It is the mere consideration for form, the contempt for the properly material quality or power of tangible or even imaginative data. Whether you like a flower for its color or a song for its timbre, you are in the same position as when you prefer one type of food to another because of your idiosyncratic temperament. An empirical pleasure of this kind cannot claim to be universally shared. The promise that your taste will be shared by everyone can be based only on the fact that you are sensitive to the *forms* alone of the object of taste. The reason is that forms represent a case, the simplest and perhaps most fundamental case of what constitutes the universal property of mind: its capacity (its power or faculty) to synthesize data, to gather the manifold, the *Mannigfältigkeit*, in general. And matter is represented *par excellence* as diverse, unstable, and vanishing.

Such are the grounds for an aesthetics of the beautiful. What we call formalism is presumably the ultimate attempt to place art within the frame of the beautiful by elaborating the very conditions of presentation.

Mutatis mutandis, one could find this hierarchical opposition in the theme of nature as art and art as nature already elaborated in Aristotelian philosophy. Matter is situated on the side of power, but of a kind of power conceived as potential, an indeterminate state of things, whereas form, in its specific mode of causality, is considered as the act which gives its convenient shape to material things. This "convenience" should be viewed as a correspondence between, on the one hand, a sort of obscure and vague "pushing" (*phusis*, from *phuein*, to push, to grow), a pressure

that is inherent in matter, and, on the other hand, a precise, determining appeal emanating from the final form that the material power is searching for. This approach is entirely consistent with the rule and principle of purposiveness.

With the end of the idea of a natural affinity between matter and form already implied in Kant's analysis of the sublime (even if such a discrepancy has at the same time been both revealed and covered over for a century, especially by the Romantic movement), what is at stake in art (above all music and painting) has become the access to matter itself. This is an access to presence without recourse to the means of presentation. Matter in painting is color; in music, timbre. What is remarkable in both cases is that matter is ungraspable by concepts, measures or even forms. We are able to determine a color or a timbre in terms of vibrations according to pitch, duration, and frequency. But timbres as nuances (and both terms can be applied to the field of sounds as well as that of the visible) are precisely what escapes such determinations. The same holds for forms. In general, we consider the value of a color to be dependent on its place among the others on the canvas, hence dependent on the form of the painting. The problem is that of composition, that is, of comparison. It is difficult to grasp a nuance in itself. Nevertheless, at the price of suspending the aggressive, comparative activity of the mind, one can open oneself to the invasion of nuances.

Nuances and timbres are almost imperceptible differences between two sounds or two colors, which are, however, supposed to be identical, due only to the fact that they are produced by specific means—for example, by a violin, a flute, or a piano in music, by pastel, oil, or watercolor painting. Nuances or timbres are what differ or defer within the identical. I mean that even within the small space of a color or a sound considered as an identity, they are the infinity of harmonies inside the determined or shaped sound or color, the presence of a disparate continuum in the middle of the tentatively clearcut decoupage or composition of sounds and colors in gradual scales and harmonious tones.

In this sense, matter must be immaterial from the point of view of concepts and even forms. It suspends the activity of the mind at least for "an instant." However, this instant cannot be counted

because to count time is an activity of the mind. There must therefore exist a state of the mind where it is prey to "presence" (a presence which is in no way present in the sense of the *here and now*, that is, as what is designated by the deitics of presentation), a state of mind without the mind, a state that is required from the mind not in order for matter to be perceived or conceived, or given or grasped, but rather for something *to be there*. I use the term matter to designate what *"is there,"* this *quod*. This presence in the absence of an active mind is never anything but timbre, tone, nuance, in one form of sensibility or another, in one *sensorium* or another, one of the ways in which the mind is accessible to the material event and can be "touched" by it. It is the peculiar, incomparable quality—unforgettable and immediately forgotten—of the texture of skin or of the grain of wood, of the fragrance of an aroma, of the flavor of a secretion or of flesh, as well as of a timbre or a nuance. All these terms are interchangeable. They all designate the event of a passion, of a suffering for which the mind won't have been prepared, which will have left it at a loss, and for which it only retains the feeling—anxiety and jubilation—of an obscure debt.

In his *Correspondance*,[2] Cézanne wrote that form is achieved when color is at its perfection. This means that what is at stake in painting for him is not to coat colors on the canvas within a previously drawn form nor to fill in well-shaped surfaces with matter. On the contrary, painting starts with a first touch of color, and shades then come up and associate with each other, according to their own requirements and as they are felt on the spot. The same type of statement can be found in Matisse's notes on a large watercolor piece on paper with collage entitled *Océanie*, which is in the Museum of Modern Art in New York. And it is clear that from Debussy and Boulez or Cage through Varese or Nono, the attention of modern musicians is focused on the question of timbre. Timbre is also what is of crucial importance in jazz and electronic music. For with drums, percussions, and synthesizers, musicians gain access to an infinite continuum of nuances.

A part of Minimalism is presumably concerned with this paradox. For the concern of these artists for matter as such conveys a

paradox. Matter is precisely considered as something that isn't finalized, that isn't purposive and designed for anything. It is no longer taken as a *material* whose function would be to fill in a form and to allow it to be realized. I would like to say that matter in this context would essentially be what isn't addressed, what doesn't address the mind (what doesn't in any way partake in a pragmatics of communicational and teleological destination).

The paradox of art "after the sublime" consists in the fact that it turns toward something that doesn't turn toward the mind, toward an unaddressed, unfinalized thing. Matter is *the thing* inasmuch as it is not something that could wait for its destination but rather something that doesn't wait for anything, that doesn't call on the mind. The question is how does the mind posit itself in relation to something that escapes all relation?

It is the destiny or destination of the mind to question. And to question is to try to relate things together. Matter doesn't question the mind; it has no need of the mind. It exists, or rather it *insists*, it *sists* "before" or "outside" questions and answers. It is presence as what is unpresentable to the mind, as that which completely eludes the mind. It denies all dialogue and all dialectics.

In conclusion, let me indicate what could be considered as an equivalent of matter in the field of thinking itself. First of all, it is necessary to ask, is there matter in thought? Can nuance, grain, or timbre be considered the same kind of event in thought itself as that which I have described in the sensorial field? This equivalent event would have to be that of words. Words are matter, nuances, and timbres at the very core of thinking. They are as embarrassing as color is to the painter. They always read or say or sound different from what thought means and wants them to mean when it puts them into forms. Words do not want anything. They are the "non-will," the "non-meaning" of thought, its mass. They are almost not enumerable, like nuances and timbres. They are there, coming from the depths of ages. One can philologize or semioticize words, as one can make a chromatic scale of colors and a range of sounds. But like nuances and timbres, they are at the same time endlessly being born anew. Thought tries to arrange them, to handle and manipulate them, but since they are both infants and aged at the same time, words are not obedient.

To write, as Gertrude Stein could have said, is to respect their candor and their age, just as Cézanne or Karel Appel does with colors.

From this point of view, theory—aesthetic theory—sounds like an attempt to get rid of words, of the matter of which they consist, and finally of matter in general. Fortunately, this attempt is hopeless. One cannot rid oneself of the thing. Always forgotten, it is unforgettable. Matter: it matters as long as it is immaterial.

Notes

1. Immanual Kant, The Critique of Judgement, tr. by James Creed Meredith (Oxford: Oxford University Press, 1978).

2. Paul Cézanne, Correspondance (Paris: Grasset, 1937).

THE CONTRIBUTORS

David Carroll is a professor of French at the University of California, Irvine and was director of the Critical Theory Institute during the years in which this volume was produced. He is the author of *The Subject in Question: The Languages of Theory and the Strategies of Fiction* and *Paraesthetics: Foucault, Lyotard, Derrida*.

Jacques Derrida is Directeur d'Etudes at the Ecole des Hautes Etudes en Science Sociales in Paris and a professor in the Department of French and the Department of English and Comparative Literature at the University of California, Irvine. His recent publications include *Mémoires: For Paul de Man* (recently published in an expanded French edition), *Psyché: Invention de l'autre*, and *De l'esprit: Heidegger et la question* (translation forthcoming).

Lynn Hunt is the Joe and Emily Lowe Foundation Term Professor in the Humanities at the University of Pennsylvania. She is the author of *Politics, Culture, and Class in the French Revolution* and the editor of *The New Cultural History*.

Wolfgang Iser is professor at both the Universität Konstanz and the University of California, Irvine. His books include *The Implied Reader: Patterns of Communication in Prose Fiction from Bunyan to Beckett*, *The Act of Reading: A Theory of Aesthetic Response*, *Laurence Sterne: Tristram Shandy*, and *Prospecting: From Reader Response to Literary Anthropology*, and he is coeditor of *Languages of the Unsayable*.

Fredric Jameson is William A. Lane, Jr. Professor of Comparative Literature at Duke University. His recent books include *The Political Unconscious* and *The Ideologies of Theory*. Three forthcoming books will deal with film, postmodernism, and the philosophy of T. W. Adorno.

Rosalind E. Krauss is Distinguished Professor of Art History at Hunter College and The Graduate Center, CUNY, and co-founder and co-editor of the journal *October*. Her recent books include *The Originality of the Avant-Garde and Other Modernist Myths*, *L'Amour Fou: Surrealism and Photography*, and *Richard Serra, Sculpture*. The essay included in this volume is from material for a work in progress called *The Optical Unconscious*.

Murray Krieger is University Professor of English at the University of California, with Irvine as his home campus. He is also director of the University of California Humanities Research Institute. His recent books include *Theory of Criticism: A Tradition and Its System*, *Poetic Presence and Illusion*, *Words About Words About Words: Theory, Criticism, and the Literary Text*, and *A Reopening of Closure: Organicism Against Itself* (forthcoming in the Wellek Library Lecture Series).

Claude Lefort is Directeur d'Etudes at the Ecole des Hautes Etudes en Science Sociales in Paris. His books include *The Political Forms of Modern Society*, *Democracy and Political Theory*, *Le travail de l'oeuvre: Machiavel*, *Sur une colonne absente: Essais autour de Merleau-Ponty*, and *Un homme en trop: Essai sur Solzenitsyne*.

Jean-François Lyotard is Professor Emeritus at the Université de Paris, Vincennes/Saint-Denis, as well as a professor in the French Department at the University of California, Irvine. His recent books include *Le différend* (recently translated as *The Différend: Phrases in Dispute*), *Peregrinations: Law, Form, Event*, *Heidegger et "les juifs,"* and *L'Inhumain*.

J. Hillis Miller is Distinguished Professor of English and Comparative Literature at the University of California, Irvine. His recent books include *Fiction and Repetition: Seven English Novels*, *The*

Linguistic Moment: From Wordsworth to Stevens, and *The Ethics of Reading: Kant, de Man, Eliot, Trollope, James, and Benjamin.*

Jean-Luc Nancy is a professor of philosophy at the Université de Strasbourg and Visiting Professor of French, University of California, Berkeley. His recent publications include *The Literary Absolute* (with Philippe Lacoue-Labarthe), *Le partage des voix, La communauté désoeuvrée* (forthcoming in translation as *The Inoperative Community*), *L'oubli de la philosophie,* and *L'expérience de la liberté* (translation forthcoming).

Carolyn Porter is a professor in the Department of English at the University of California, Berkeley. She is the author of *Seeing and Being: The Plight of the Participant Observer in Emerson, James, Adams, and Faulkner* and is currently working on a book to be entitled *Discourse and the Other: America's Social Text.*

Juan Villegas is professor of Spanish at the University of California, Irvine and director of the journal *Gestos.* His recent books include *Interpretación y análisis del texto dramático, Teoriá de historia literaria y poesía lírica,* and *Ideología y discurso crítico sobre el teatro de España y América latina.*

INDEX